GUERNICA

BY THE SAME AUTHOR

Art Deco

In the Kitchens of Castile

Gaudí

GUERNICA

The Biography of a
Twentieth-Century Icon

Gijs van Hensbergen

BLOOMSBURY

Published by Bloomsbury Publishing, New York and London
Distributed to the trade by Holtzbrinck Publishers

All papers used by Bloomsbury Publishing are natural, recyclable products made from wood grown in well-managed forests. The manufacturing processes conform to the environmental regulations of the country of origin.

Library of Congress Cataloging-in-Publication Data

Van Hensbergen, Gijs.
Guernica : the biography of a twentieth-century icon / Gijs van Hensbergen.—1st U.S. ed.
p. cm.
Includes bibliographical references and index.
ISBN 1-58234-124-9 (hardcover)
1. Picasso, Pablo, 1881–1973. Guernica. 2. Spain—History—Civil War, 1936–1939—Art and the war. 3. Art—Political aspects—Spain—History—20th century. I. Picasso, Pablo, 1881–1973. II. Title.

ND553.P5A65385 2004
759.6—dc22
2004055054

First U.S. Edition 2004

1 3 5 7 9 10 8 6 4 2

Typeset by Hewer Text Ltd, Edinburgh
Printed in Great Britain by Clays Ltd, St Ives plc

For Tom Titherington,
who has shared so much,
in gratitude.

We artists are indestructible; even in a prison, or in a concentration camp, I would be almighty in my own world of art, even if I had to paint my pictures with my wet tongue on the dusty floor of my cell.

Picasso, *Der Monat*, 1949

Contents

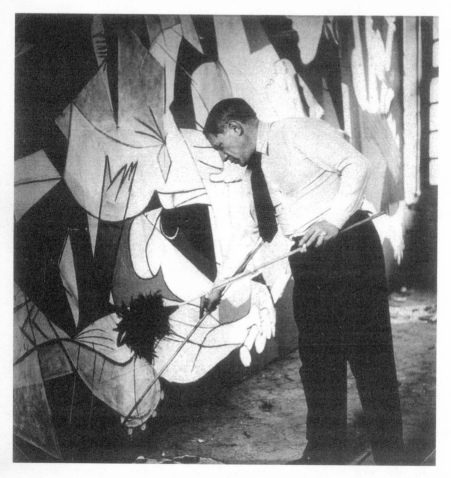

Picasso painting *Guernica*, May 1937.

Introduction

On 3 November 1998 Kofi Annan, Secretary General of the United Nations, stood up to address the International Council of New York's Museum of Modern Art: a world elite of tastemakers and guardians of culture. Referring to the *Guernica* tapestry, a copy of Picasso's original painting, that was hanging in the corridor outside the Security Council chamber room, Annan declared:

> The world has changed a great deal since Picasso painted that first political masterpiece, but it has not necessarily grown easier. We are near the end of a tumultuous century that has witnessed both the best and worst of human endeavour. Peace spreads in one region as genocidal fury rages in another. Unprecedented wealth coexists with terrible deprivation, as a quarter of the world's people remain mired in poverty.

It was a grimly realistic analysis of how far the world had progressed since 1937, when Picasso reacted so powerfully to the catastrophe of the bombing of the Basques' spiritual capital, but also of how far we were from achieving that elusive goal of the UN mandate for enduring world peace. Annan's statement to MOMA's International Council also recognised *Guernica*'s unique position in the history of world art, elevated as it had become to the status of moral exemplar, a universal icon warning that unless we studied its lessons, history was doomed to repeat itself.

Just five years later, in the final week of January 2003 and in the wake of the Twin Towers tragedy, a blue shroud was ignominiously thrown over the Picasso tapestry to hide it from public view.

Considering the central role *Guernica* has played in the UN education programme, it was a strange and highly symbolic decision. According to Fred Eckhard, a UN spokesman who had been given the impossible task of playing down the significance of the action, it was merely that blue was a more appropriate colour as a backdrop for television cameras, in contrast to Picasso's visually confusing mixture of blacks and whites and greys. Other observers, however, were quick to draw their own conclusions. It wasn't colour or shape that was the problem; what the picture showed up was the embarrassing contradiction of presuming to take the moral high ground while simultaneously campaigning for war.

On 5 February Secretary of State Colin Powell, shadowed by George Tenet, Director of the CIA, had been scheduled to brief the Security Council in a last-ditch attempt to win UN approval for the war with Iraq that would start, according to military analysts, with a massive aerial bombardment of Baghdad that was to receive the chilling codename 'Shock and Awe'. That same week Hans Blix was expected to report back on either the discovery, or, as seemed more likely, the lack of any concrete evidence proving that Saddam Hussein had been stockpiling weapons of mass destruction. On an almost daily basis, John Negroponte, US Ambassador to the UN, had come out into the corridor to brief the world's press, while hovering in the background over his shoulder the viewer could easily make out the mutilated bodies and screaming women of Picasso's painting. The presence of Picasso's *Guernica* was, it seemed, confusing the viewer. Painted as a passionate protest against senseless violence, it was once again succeeding only too well, illustrating perfectly the truism that we never seem to learn from our own mistakes.

Defiantly, in response to the cover-up of the painting, Laurie Brereton, a UN delegate representing Australia, pointed out that:

> Throughout the debate on Iraq there has been a remarkable degree of obfuscation, evasion and denial, and never more so than when it comes to the grim realities of military action. We may well live in the

age of the so-called 'smart bomb', but the horror on the ground will be just the same as that visited upon the villagers of Gernika [the Basque spelling of the town] . . . And it won't be possible to pull a curtain over that.

It was obvious that from the day of its creation *Guernica* has never lost its power to shock. Even when reproduced, in tapestry (as here), or in poster form, it still continues to mirror the horror of war and throw a harsh spotlight on our propensity for cruelty. Subtly, over the years, *Guernica* has reinvented itself and changed from being a painting born out of war to one that speaks of reconciliation and the hope for an enduring world peace.

On Monday, 26 April 1937 as Franco's Nationalist forces pushed north to cut off Bilbao and take control of the Basque country, the decision was taken to crush resistance with an overwhelming show of force. At 4 p.m., and for the next three hours, sixty Italian and German planes rained incendiary bombs down on Gernika, reducing it to a burning fireball. Nothing like this had been seen in Europe before. And no single act was so prescient of what the whole world would soon come to understand as the appalling reality of total war, where innocent people are bombed indiscriminately, or strafed by machine-gun fire as they escape from the carnage in the town up into the hills. The newspapers reported graphically on the tragedy, and the shock waves circled the globe.

In Paris, on 1 May, Pablo Picasso, who was by then the world's most famous living artist, started to give concrete form to his powerful sense of revulsion, jotting down at lightning speed some initial ideas. Over the next fortnight preparatory sketches, drawings, and paintings poured out with a feverish passion. By late June 1937 Picasso was ready to put the finishing touches to a painting that had been executed on such a large scale that he had been forced to jam it in at an angle in his enormous studio on rue des Grands-Augustins. The canvas, which had acquired the title *Guernica*, was covered with what at first sight seems a chaotic jumble of animals and contorted human bodies drawn out in an austere palette of

blacks, whites and scumbled greys. Photographs taken by Picasso's new lover Dora Maar show the artist reaching forward from the top rung of a stepladder, stretching out to make a quick addition at the top of the canvas. Sweating, almost manically absorbed, Picasso paces up and down the painting's length, feeling and reading its almost palpable presence and testing out, again and again, the suffocating pressure of its interior space. Torn paper was pasted on to the canvas to try out possible changes and then quickly removed. Ideas and doodles were torn out of the ether, built up and overlayered, one on top of the other, as they were drawn into the painting's creative vortex and hammered into shape. Desperately short of time, Picasso had covered the almost thirty square metres of canvas in little less than six weeks. By any standards it was an extraordinary achievement.

Out of the chaos Picasso had managed to give shape to an arresting and profoundly disturbing image. There was nothing that specifically alluded to Gernika, or the terror that rained down from the skies. Instead, Picasso had resorted to employing images whose simplicity and meaning could travel across every cultural divide. At the base of the painting, decapitated, splintered and crushed, lies the corpse of a dead warrior, strangely reminiscent of a classical bust. Above him the weight of a horse, contorted with pain and clearly in its death throes, threatens to collapse to the ground. On the right, three women in various states of distress look in on the scene. In the background, barely discernible at first, a cockerel is crowing up at the skies from the top of a table. Most poignant of all, at the extreme left edge, the picture is anchored and framed by the tragic image of a mother with the limp body of her dead child held in her arms, who in turn is overshadowed by an impassive bull. Only the ghost of a wind blows across the canvas to lift the beast's tail.

At first sight there seems to be no clear relationship between cause and effect. There is no easy way in to read the story or discover exactly at what point we have joined the narrative. But amongst the shattered walls, blind doorways and roofs we come to a growing realisation that something terrible has happened here.

When first shown in Paris in 1937 at the Exposition, the painting's reception was strangely muted. In fact, considering the coolness with which it was initially received, particularly by the official Basque delegation, it would have been reasonable to assume that *Guernica* might end up rolled and stored in the back of Picasso's Paris studio, like the *Demoiselles d'Avignon*; left to collect dust and haunt those who had seen it with ever fainter echoes of a drama that had long since played itself out. Awkward and difficult to transport, this was perhaps the most likely outcome. After all, in the remaining Republican strongholds of Madrid, Barcelona and Valencia, the most obvious venues for showing the work, it would have served only to demoralise the militiamen who were witnessing daily what was painted out so graphically across Picasso's large backdrop.

During the Second World War, however, and particularly after the bombing of Pearl Harbor, *Guernica*'s imagery became more recognisable, indeed painfully familiar. City after city in Europe was bombed. Finally the catastrophic lessons of Hiroshima and Nagasaki brought the stark realisation that the world would never be the same again. With no hint of irony, the President of the United States, Harry S. Truman, announced sombrely: 'I fear that machines are ahead of morals by some centuries and when morals catch up there'll be no need for any of it.' *Guernica* had been horribly prescient. What it depicts is modern mass slaughter only faintly disguised behind the ancient rituals of death. Every community in the world that has suffered an appalling atrocity has become synonymous with *Guernica* the painting and Gernika the town, the brutalised spiritual heartland of the beleaguered Basques.

As the prolonged sound of air-raid sirens boom out across a threatened city somewhere far away, each new conflict, each new bombing, each act of total devastation begs the question – shall this be the Gernika of our age? Warsaw, Coventry, Dresden, Rotterdam, Hamburg, Stalingrad, Hiroshima, Stalin's Gulag Archipelago, Pol Pot's Cambodia and, closer to us today, Rwanda, Southern Sudan and Srebrenica. Iraqi Kurdistan has its Halabja. Recently, during the

Balkan crisis in Kosovo, Serbs attempted to liquidate the Kosova Liberation Army. Each and every example has been cited as the Gernika of its day.

On 23 September 1998 in Washington DC, Senator John McCain took to the Senate floor:

> We have not lacked for rhetoric, but we have proven woefully inadequate at backing up our words with resolute action . . . Mr President, prominently displayed in the United Nations building in New York is Picasso's famous and haunting *Guernica*. That painting symbolised for the artist the carnage, the human suffering on an enormous scale, that resulted from the Spanish Civil War as prelude to the Second World War. Perhaps it is too abstract for those countries in the United Nations that oppose the use of force to stop the atrocities that have come to symbolise the former Yugoslavia, or that believe the war in Kosovo is the internal business of Serbia.

Just as Anne Frank's story has become symbolic of all the Jewish children lost in the extermination camps, and Auschwitz shorthand for the apocalyptic horror of the Holocaust, *Guernica* has become synonymous with indiscriminate slaughter in whatever corner of the world such tragedy takes place. On any given day, somewhere in the world, in parliaments, council chambers and in open debate, *Guernica* is cited to add a sense of moral suasion and urgency to the argument. Picasso's *Guernica* is the image that draws our constant attention to the proximity of catastrophe. Reproduced by the million, copied by other artists, reinterpreted by even more, *Guernica* remains, none the less, inviolate and unspoilt.

The extraordinary thing about *Guernica* is that despite everything, it refuses to yield and drown under the weight of its own ubiquity. It is still an image that can awaken the nightmares of our historical past whilst also painting a terrifying scenario of what is yet to come. Despite the marketing and the myriad psychological, sociological, historical and art historical interpretations – enough to fill an entire library – it can still be guaranteed to stun the viewer

into silence as he witnesses it afresh. *Guernica* has, and this is even more unusual, the capacity to speak intimately to the individual while also remaining a universal symbol that is understood by all.

From Paris in 1937 to the United Nations today much of the painting's meaning has lain beyond Picasso's reach and control. *Guernica* has had its own life, forging a relationship with its audience that has often been entirely separate from the life of the genius who brought it into our world. Over the years that audience and the historical circumstances have continued to change. And *Guernica*, as is completely inevitable, has become stylistically dated. But while the fabric of the painting – a result of its rich and varied life – has become increasingly fragile, as a work of art it has nevertheless been ageing well. It has never lost its relevance, nor its magnetic, almost haunting appeal. From its first showing in Paris to its arrival in Spain forty-four years later, it has witnessed and helped to define a century. That its lessons have still not been heeded or learnt makes it as relevant and iconic today as it ever was. *Guernica*, for better or for worse, more than any other image in history has helped to shape the way that we see.

1

The Nightmare Made Real

This is a strange new kind of war where you learn just as much as you
are able to believe.

Ernest Hemingway, 'A New Kind of War' (14 April 1937)

When the artist is defeated, it shouldn't surprise us that a Savonarola
comes along to burn his work.

Ernesto Giménez Caballero

In late August 1934 Picasso returned from Paris to Spain, with his
wife Olga and their son Paulo, to follow the bulls. The Picasso
family had done the same the previous year, and it was beginning to
appear a habit, fitting in perfectly with Pablo's growing obsession
with the *corrida*. Travelling in style in the Hispano-Suiza, it was the
kind of treat that Olga loved, a small compensation for the fact that
the Picassos' marriage was effectively on the rocks. Marie-Thérèse
Walter, though still only twenty-four years old, had been Picasso's
mistress for the previous seven years.

The 1934 trip would be memorable for many reasons. There were
plans to see El Escorial and, in passing, an opportunity to study the
frighteningly realistic fourteenth-century Burgos Christ; a Crucifix-
ion covered in flexible cow-hide that had been punctured through
with hyper-realistic lashings and sores, and allegedly sweated every
Friday afternoon. As impressive was a visit to the Museum of
Catalan Art in Barcelona to see romanesque masterpieces like the
Christ in Majesty from the apse of St Climent de Taüll, whose
hypnotic, lozenge-shaped eyes would make a reappearance in the
Guernica bull. But the trip would also be memorable for a more

painful reason: it would be the last time that Picasso ever set foot on Spanish soil.

That August, crossing the border at Irún, Picasso focused his whole attention on the forthcoming drama provided by the bulls. The atmosphere of the *fiesta nacional* was electric, drowning out all thoughts extraneous to the here and now. But it was also ancient and deeply ritualistic. It was not by chance that Picasso had recently been inspired to decorate the cover of Tériade's

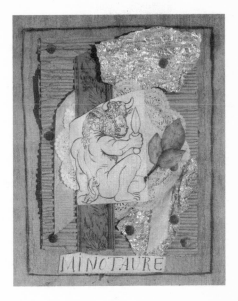

Maquette for the cover of *Minotaure*, May 1933.

magazine *Minotaure* with a collage of the legendary beast, mixing lace, silver paper, thumbtacks and pleated pasteboard into an ensemble that was as tacky and kitsch as aspects of the *fiesta*, and that served to frame a curiously benign image of the bull-headed monster that had terrorised ancient Crete.

For wealthy Spanish aristocrats San Sebastián, the Picasso family's first port of call, was synonymous with the culture of northern Europe: sophisticated, cerebral and civilised. In direct contrast to the Mediterranean, the Atlantic port offered cool weather and cosmopolitan chic. It was a perfect city for Olga.

In the early 1930s, however, a new revival in the avant-garde was shaking up bourgeois complacency. In San Sebastián, Picasso had been invited to attend the inaugural meeting of GU, a cultural and gastronomic club based at the Café Madrid, designed by the brilliant young architect José Manuel Aizpúrua, on the calle Ángel, just off the port. The driving energy behind the Café Madrid, unusually perhaps, was an attempt to wed the revolutionary qualities of the avant-garde with the new Fascist ideology, with much of the inspiration drawn from the Italian Futurist Filippo

Marinetti. Picasso was an unlikely guest at the Café Madrid but admiration for the artist's work could still cross the political divide. Picasso had many friends and acquaintances who accepted the invitation from GU, including García Lorca, Max Aub and the poet Gabriel Celaya. Amongst the other guests was the right-wing writer Rafael Sánchez Mazas, a contributor to the catholic avant-garde magazine *Cruz y Raya*, recently immortalised in Javier Cercas's *Soldiers of Salamis*. If Picasso had gone to GU out of curiosity, their interest in him was far more pragmatic. For the right wing in Spain to win over Picasso's allegiance would represent an extraordinary coup.

The intellectual driving force behind GU was the all-round art provocateur and critic Ernesto Giménez Caballero, who would later graduate to become Franco's speech writer. But central to its success was Aizpúrua, who had recently accepted the post of delegate responsible for National Press and Propaganda within the Junta Nacional de Falange Español, an unashamedly Fascist organisation. It was his political and artistic trajectory that perhaps more than any other provided an insight into GU's appeal. Aizpúrua had been a founder member of GATEPAC, an architectural group founded in Barcelona by the young Catalan architect Josep Lluís Sert, a close friend of Picasso's. At the age of twenty-seven, Aizpúrua had designed the Real Club Náutico, the stylish yacht club, an audacious white Le Corbusier-inspired pavilion that hovered over San Sebastián's La Concha beach. And it was there that Aizpúrua and Giménez Caballero hoped to seduce Picasso and bring him over to the Fascist side. In *Arte y Estado* (*Art and State*), published the following year, 1935, Giménez Caballero recalled that extraordinary encounter.

Picasso, Olga and little Paulo had been relaxing over lunch with friends, when, according to Giménez Caballero, the charismatic leader-in-waiting of the Falange, José Antonio Primo de Rivera, approached their table and sat down. Picasso already knew him, having on one occasion told him that his father, the dictator Miguel Primo de Rivera, had been the only Spanish government official who

had shown any regard for his work. Staring at Picasso across the table, Giménez Caballero was transfixed by the artist's eyes which he noted bore the same penetrating gaze as Benito Mussolini's.

Picasso, who relished gossip, related how on the previous year's visit he had been in discussion with the Republican government about an exhibition, but that the project had faltered when they couldn't afford the insurance. All they could offer, it seemed, was a police escort.

Seizing the moment, José Antonio leant across to Picasso and offered courteously: 'One day we will receive you with an escort of the Guardia Civil, but as a guard of honour, and only then after we've insured your work.'

A year earlier García Lorca had also been approached. While touring with La Barraca he had stopped off at a restaurant to dine still sporting his trademark blue Barraca coveralls. Lorca's biographer Leslie Stainton records the moment that Primo de Rivera entered with three colleagues, each wearing the blue shirt of the Falange. 'Look, there's Jose Antonio,' actor Modesto Higueras whispered to Lorca.

'Yes, I've seen him,' Lorca said nervously. Primo de Rivera recognised Lorca and scribbled something on to a napkin, which he then handed to a waiter to give to the poet. Lorca glanced at the note and hastily slipped it into his pocket. Higueras asked what it said.

'Shhh,' Lorca muttered. 'Don't say anything to me. Don't say anything.' Later Higueras found the napkin and read it. 'Federico,' the Falangist leader had written. 'Don't you think that with your blue coveralls and our blue shirts we could between us forge a better Spain?'

With Lorca, Primo de Rivera's seduction had failed but Picasso might prove a bigger catch.

In *Arte y Estado* Giménez Caballero was quick to pronounce the Picasso meeting a resounding propaganda coup, and declare that the artist had been finally won over to the right by Primo de Rivera's unctuous charm. Blissfully unaware of these conclusions, Picasso

continued on his journey south to Madrid, with further visits planned to Toledo, Zaragoza and Barcelona, before eventually returning to Paris by mid-September. Almost immediately, he was able to re-establish daily contact with Marie-Thérèse, return to the ongoing print series of the *Vollard Suite* and, in particular, attend to the four versions of *Blind Minotaur Guided by a Young Girl*.

Picasso's visit to Spain in August 1934 had coincided with a country in turmoil. Just one month after his return to Paris, on 6 October 1934, in direct response to José Antonio Primo de Rivera's assumption of the Falange leadership as Jefe Nacional, a left-wing uprising was led by the CNT and UGT unions amongst the miners in Asturias. The scale of the repression, enforced by General Franco, was brutal, with a death toll estimated at 4,000 and a further 40,000 arrests. How dramatically things had changed in just one year. In summer 1933 there had been a Republican government, and despite growing outbursts of anarchism and an increased radicalisation in politics, there was still a sense of optimism. Although prone to being romanticised, the brief Golden Age of a Socialist-led Second Republic, that lasted just over two years, from 14 April 1931 to November 1933, was nevertheless a period in which serious attempts had been made to change a society that was grossly inequitable. It had also encouraged a growing renaissance in the arts, as practitioners engaged more directly with the people. For left-wing politicians it was not difficult to find a whole catalogue of grievances that had turned the life of many of their constituents into one of miserable subsistence. In Andalucia, the *braceros*, or landless peasants, were only employed during the five-month harvest season, paid almost nothing, and then discarded for the rest of the year. It was a feudal existence without any of the privileges that derived from the paternalist relationship between vassal and lord, yet managed to deliver all of the pain. The relationship between the masses and the ruling elite was as distant as if each inhabited an entirely different world. Votes, in a country that was supposed to enjoy universal franchise, were often collected by the *caciques*, the

bosses, prior to an election, in return for a quiet and miserable life. In the cities the urban proletariat was ruthlessly exploited, its unions were attacked, its wages cut and its working conditions worsened. There was widespread starvation, frequent outbreaks of epidemics, poor sanitation, and in some places like the isolated valleys of Las Hurdes, near to Salamanca, an almost ancient, troglodyte life of extreme poverty, that came with its concomitant of crippling hereditary disease.

It is indicative that even José Antonio Primo de Rivera was shocked and appalled by what he saw across the country. Education, prior to 1931, had been almost exclusively in the hands of the Catholic Church. More than half the population remained completely illiterate. And that despite the fact that Spanish intellectual life was as vital and engaging as anywhere else, and provided some of the twentieth century's most enduring novelists, artists, academics, medics and musicians, including Miguel de Unamuno, Antonio Machado, Manuel de Falla, Juan Ramón Jiménez, Federico García Lorca, Picasso, Miró, Dalí, Menéndez Pidal, América Castro and Severo Ochoa. Revolutionary and original thought stood in direct opposition to the torpor of an aristocracy trapped in the aspic of a bygone age. Martial values were particularly revered, but that in a country whose military hierarchy was still so antiquated that its percentage of serving generals was the highest in the world. When King Alfonso XIII had gone into exile in 1931, following the failure of Miguel Primo de Rivera's dictatorship, the country was already approaching a flashpoint. The juggernaut that led inexorably towards open conflict was, in the words of Paul Preston, quite simply 'the culmination of a series of uneven struggles between the forces of reform and reaction' and 'the ultimate expression of the attempts by reactionary elements in Spanish politics to crush any reform that might threaten their privileged position'.

When the Second Republic was established on 14 April 1931, it was greeted with wild euphoria. Behind the jubilation, however, for those who listened carefully there was already the disgruntled murmur of the privileged few – the Carlists, Catholics, Fascists,

the military, the young Falange, the constitutional monarchists and conservatives – who each in varying degrees bore the Republic only ill. Any attack on the status quo represented for them a personal attack on their estates and privileges, and threatened their way of life. Not surprisingly, reforming measures like the building of 13,570 new schools in two and a half years, a remarkable achievement, and further moves to legalise divorce were viewed by the Church as the first steps towards moral collapse. Agrarian reforms, in turn, provoked the ire of the landed elite who had often, as in Russia, without any deep attachment to the land, merely viewed their inherited hectares as money-making machines that allowed them to live in style in their palaces. Cultural reforms like the entirely laudable Misiones Pedagógicas, the Teaching Missions, promoting the concept of itinerant education and the bringing of culture to the isolated and dispossessed, was easily transformed by right-wing commentators into a bolshevist conspiracy that just as quickly found itself branded as the diabolical work of Masons and Jews. Playing on fear was perhaps the most effective tactic that the right could use in the face of defeat at the ballot box. And, added to this explosive mixture, both the Basque country and Catalonia felt encouraged to give free voice to their separatist aims.

On Picasso's first trip in summer 1933 he had caught the tail-end of the first left-wing parliament. Many of his friends had played a major role in bringing about change. And much had been achieved. Civil unrest, however, was on the increase as politics became increasingly polarised. Convents were burnt down in a wave of anti-clerical rioting. The government, despite its optimistic forecasts, could never have delivered on all of its utopian reform programmes, and as a result the extreme left felt increasingly betrayed. The right, on the other hand, felt under siege, and in many cases ignored government policy, using the Guardia Civil to put down forcefully what they saw as revolutionary activity. In August 1932 General Sanjurjo, a hero of the Moroccan war, had even led a failed coup attempt. By November 1933, unwilling to work together as a coalition, the different strands of the left had been swept from power by the unified right.

The new right-wing government, led by the cynical ex-radical Alejandro Lerroux, who in his youth as a loud-mouthed rabble-rouser had gone under the soubriquet 'Emperor of the Paralelo', now set about systematically dismantling the previous government's reforms. Overnight the politics of vengeance and reprisal replaced those of misplaced optimism and deliberate provocation. This period, described as the *bienio negro* (the two black years) only served to increase the tension. In contrast to many of his colleagues, Lerroux, despite the fact that he was self-seeking and totally corrupt, was nevertheless still a moderate. In 1933 José María Gil Robles founded the Confederación Española de Derechas Autónomas (CEDA), whose programme espoused the aim 'to bury once and for all the rotting corpse of liberalism'. As mutual tolerance evaporated, a violent solution seemed increasingly likely.

This was the Spain that Picasso had returned to in 1934, a world where highly respected intellectuals like Aizpúrua and Giménez Caballero, seduced by the sophisticated José Antonio Primo de Rívera, had already moved across to the right. Back in Paris that winter, Picasso received updates on the political situation in Spain from his mother, his cousins the Vilatos, and friends in Paris like the two Serts, Josep Lluís, the architect, and his uncle, the fashionable muralist José Maria. At home, however, domestic war was about to break out. Marie-Thérèse was pregnant, and after contemplating a divorce from Olga – an idea dropped almost immediately, due to the repercussions it might have regarding ownership of his work – Picasso settled for an unresolved and increasingly bitter existence. The first victim was his painting, with the artist almost completely paralysed and unable to cross the studio threshold to confront his past captured there in paint. Olga and Paolo had moved to the South of France, to the Hôtel Californie. But Picasso's usual August break to Spain, with summer temperatures up above 30°C and Marie-Thérèse heavily pregnant, was clearly out of the question. Increasingly Picasso turned to poetry as an outlet for his restless talents. But despite his apparent lethargy and psychological resistance, one seminal work, a remarkable print, was produced. *Minotauromachy*, an etching measuring just 50 by 70

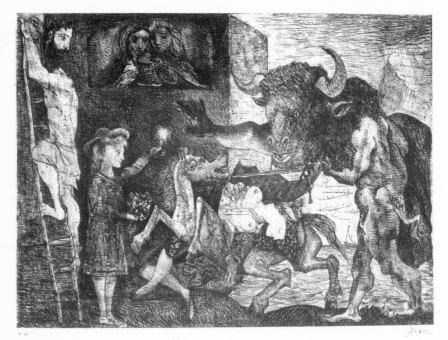

Minotauromachy, Spring 1935.

centimetres, seemed to encapsulate the preoccupations and obsessions of Picasso's entire world.

There are two clearly divided areas within the print: on the right, the open sea threatened only by a sunburst cloud, and on the left, a dark patio that is illuminated only by a candle held on high by an innocent girl. In from the right bursts the violent Minotaur, intruding deep into the scene in pursuit of a horse over which is draped a dishevelled female matador baring her breasts. On the left there is stasis, as two women up in a balcony window, accompanied by their pet dove, look down on the girl with the candle. To her left, framing the print, a man ascends a ladder. Gertrude Stein had frequently witnessed Picasso's need to produce art almost as an emetic:

> Picasso was always possessed by the necessity of emptying himself, of emptying himself completely, of always emptying himself, he is so full of it that all his existence is the repetition of a complete emptying, he must empty himself, he can never empty himself of being Spanish, but

he can empty himself of what he has created. So every one says that he changes but really it is not that, he empties himself and the moment he has completed emptying himself he must recommence emptying himself, he fills himself up again so quickly.

With *Minotauromachy*, produced during a period almost entirely devoid of other works, this observation becomes doubly relevant. The print holds within itself an entire world and an ocean of feeling. William Rubin, however, has rightly warned us that 'as a kind of private allegory the *Minotauromachy* tempts the interpreter. But explanation, whether poetic or pseudo-psychoanalytical, would necessarily be subjective.'

Endless attempts have been made to identify the protagonists and give them their names. Olga. Marie-Thérèse. Picasso the Minotaur. And the man on the ladder doubling as both Picasso and his father – the artist. In that figure Herbert Read has also recognised Christ, in his mythic guise as the Jungian redeemer. Is the figure ascending or descending the ladder, and what does that hesitation imply? There is one intriguing possibility, suggested by Gerald Howson, that takes us out of autobiography and back to politics in Spain. The Minotaur bears a striking resemblance to contemporary photographs of Francisco Largo Caballero, the leader of the extreme left tendency within the Socialist Party. The bearded man climbing the stairs represents an image of the typical Spanish 'searching' intellectual, like Miguel de Unamuno, who is as yet undecided on whether to support the masses or maintain the power and privileges of an intellectual elite.

At the time, Largo Caballero was being courted by Manuel Azaña, leader of the left Republican Party, and Indalecio Prieto, leader of the centrist Socialist Party, to form a coalition under the banner of the 'Popular Front', a term coined at the Seventh World Congress of the Third International. Shocked by Hitler's success, Stalin recognised that Communism in Europe could afford to relax the 'purity' of its aims, in order to defeat the much larger threat of Nazism. In a fine piece of *realpolitik* Communists were encouraged

to make pacts. The left could not afford to repeat the mistake of 1933 and through division cast themselves out into the political wilderness once again. Success depended on Largo Caballero's willingness to stop prevaricating and show the masses leadership. Like the man on the ladder in *Minotauromachy*, trapped in intellectual limbo, could he decide once and for all either to go up and disappear into political obscurity, or come down into the plaza and play an active role? Largo Caballero chose the latter course and in February 1936 the Popular Front won the election by only the narrowest of margins. It was absolutely clear now, if it never had been before, that there were two Spains, opposed and irreconcilable.

Fearing a recurrence of Sanjurjo's coup, army generals assumed to be plotting were sent as far away from Madrid as possible: Mola went to Pamplona and Francisco Franco was sent to the Canary Islands. It was now the turn of the left to sink into a spiral of revenge in return for the indignities they had suffered during the *bienio negro*. In the cities and out on the *latifundias* – the great estates – life descended into anarchy. Falange thugs and the Italian-trained Requetés battled against the anarchists. Gangs of *braceros* (farm labourers) in Andalucia expropriated private estates and declared them 'free collectives'. And throughout the late spring the number of political murders escalated out of control. The time had come at last when the worst predictions of the 'catastrophists' – those who predicted civil war – seemed finally to be coming true.

On 13 July 1936 the right-wing politician Calvo Sotelo was murdered in Madrid. For Franco, who was normally reticent, famously indecisive, and abnormally cautious for a soldier who had won his reputation demonstrating extraordinary levels of bravery in the Moroccan war, this was the defining moment. 'Miss Canary Islands', as he was jokingly called, was ready to support the armed insurrection and made immediate plans to fly to Morocco and join his beloved Foreign Legion. On 18 July 1936 the Spanish Civil War began. The success of the armed insurrection was, however, far from assured. What the rebel generals had hoped for was an immediate realisation by the increasingly disheartened

and beleaguered Republicans that all was lost, followed by a hasty capitulation. This had been the pattern of nineteenth-century *pronuncamientos* by the military, often followed by a bloodless coup. Following this scenario, General Sanjurjo, safely in exile in Portugal, would fly into Spain and 'accept' his role as Head of State. On 19 July, however, Sanjurjo's plane crashed, killing him. Franco, one of the few generals who had enough popular kudos and the respect of his peers to assume leadership, was trapped in Morocco, as the Republican navy assumed control of the Straits. After a few fraught days of intense negotiation, in which Franco's emissaries to Hitler played up the threat of French intervention and the growing Communist menace, it was agreed that Germany would send planes to assist in the airlift of Franco's troops. Hitler's decision to come to the rebels' aid, taken after returning from a viewing at Bayreuth of Wagner's *Siegfried*, was appropriately branded *Unternehmen Feuerzauber* – Operation Magic Fire. That one fateful decision, according to Paul Preston, 'turned a coup d'état that was going wrong into a bloody and prolonged civil war'. And, arguably, it was the 'actual' beginning of the Second World War.

Italian help for the rebels, alongside the German involvement, rapidly escalated the insurrection. In Pamplona General Mola had risen. And in Andalucia, General Yagüe's troops, a mixture of Legionnaries and Moorish mercenaries, were encouraged to sow terror amongst the populace by instigating an orgy of rape and indiscriminate murder in any towns that offered the least resistance to the advancing troops. The legitimate Republican government, fully aware of what was happening and with advanced warning of the possible collapse in law and order, was stunned into inertia. Right to the very last minute President Manuel Azaña refused to believe what had been staring the Cortes in the face for months. The increasingly violent speeches from both the right and the left, delivered respectively by Calvo Sotelo and 'La Pasionaria' (Dolores Ibárurri), had given ample warning that the fiery rhetoric could only continue for so long. Prime Minister Casares Quiroga proved ineffectual, as did his replacement Martínez Barrio whose Premier-

ship lasted all of one day. He was replaced by Professor José Giral on 19 July and it soon became clear that the momentum created by decisive leadership had collapsed. Into the vacuum stepped the left-wing militias and revolutionary bodies who ranged across the full spectrum of the briefly united left, from anarchists to respectable bourgeois republicans. It would soon become clear that there was no single Civil War, just as there had never been a single isolated cause. *Bracero* fought duke, as worker fought factory owner. Catholic fought atheist, as monarchist fought republican. Carlist fought Basque, as centralist fought regionalist. The legitimate government, though, would soon be placed in a position of crippling disadvantage. Hermann Göring had been only too happy to find a practice ground for his state-of-the-art Luftwaffe. Hitler was also seduced by the compensation for military and logistical aid that his participation entailed, amounting to all the mineral rights in the Basque country. The Republican government, on the other hand, initially received nothing but hollow promises.

In France, the Prime Minister Léon Blum was instinctively sympathetic to his Socialist allies south of the Pyrenees and willing to offer help in terms of supplying arms. But France was also anxious not to force a wedge between herself and Britain. British policy, described by many commentators as 'perfidious', favoured caution and 'non-intervention'. Blum, meeting up with Sir Anthony Eden, was told that the Baldwin government had no intention of getting involved. It was almost as if Eden and Baldwin believed that Spain could loose anchor and float away, allowing the war to grind to a halt somewhere out in mid-ocean. For Blum, it was an immensely difficult decision. It was clear that there was great sympathy for France's southern neighbour; indeed both the Basque country and Catalonia crossed over the Pyrenees, deep into French soil. There was some logic, however, to the argument that within France support for the Republic would encourage a much feared right-wing backlash. Britain's choice of 'non-intervention', however, was more cynical, and in practice, a complete farce. George Orwell, a close observer of the Spanish Civil War as it developed, was left in

no doubt. In his essay 'Looking Back on the Spanish War', published in 1943, he wrote a scathing analysis of Britain's foreign policy:

> The most baffling thing in the Spanish war was the behaviour of the great powers. The war was actually won for Franco by the Germans and Italians, whose motives were obvious enough. The motives of France and Britain are less easy to understand. In 1936 it was clear to everyone that if Britain would only help the Spanish government, even to the extent of a few million pounds' worth of arms, Franco would collapse and Germany would be severely dislocated. By that time one did not need to be a clairvoyant to foresee that war between Britain and Germany was coming: one could even foretell within a year or two when it would come. Yet in the most mean, cowardly, hypocritical way the British ruling class did all they could to hand Spain over to Franco and the Nazis. Why? Because they were pro-Fascist, was the obvious answer. Undoubtedly they were, and yet when it came to the final showdown they chose to stand up to Germany. It is still very uncertain what plan they acted on in backing Franco, and they may have had no clear plan at all. Whether the British ruling class are wicked or merely stupid is one of the most difficult questions of our time.

By autumn General Mola was in control of most of northern Spain, apart from the Basque country and Catalonia. The border town Irún, just 10 miles east of San Sebastián, was already being bombed on an almost daily basis by the Italian air force. In the centre of Spain many of the cities of Old Castile had rapidly capitulated to Franco, as too had Granada in the south, where on 19 August Federico García Lorca was executed. In Seville General Quiepo de Llano's control of the city was reinforced by capturing the local airfield at Tablada. He was soon joined by General Franco, who set up headquarters in the Palacio de Yanduri and set about strengthening his hold on power. He manipulated potential rivals into lending their support, and was declared Head of State on 28 September. A week later Franco marched on Madrid and the geographical boundaries between the

warring factions became increasingly clear. The Nationalists held the countryside, except for the Basque lands and much of Catalonia (whose loyalty to the left had been won by a promise of independence), while the Republicans controlled the key industrial cities of Barcelona and Bilbao, the capital Madrid and almost all the coastal cities from Valencia down to Malaga.

In Paris, Picasso, who was now distracted by his new mistress, Dora Maar, could only follow the events in Spain via the newspapers. It was becoming obvious, however, that his political involvement was growing. To celebrate Léon Blum and the Popular Front's election victory, he agreed to design a drop curtain for Romain Rolland's play *Le 14 Juillet*, to be presented at the Alhambra Theatre on 14 July. Based on a watercolour *Composition avec Minotaure*, the scene represents a monstrous birdman carrying a vanquished Minotaur, while a man draped in an entire horse-hide,

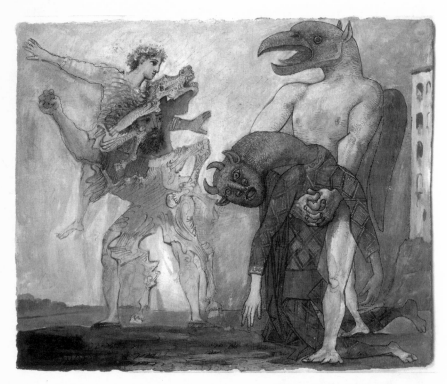

Composition with Minotaur (Curtain for *Le 14 Juillet* by Romain Rolland).

as if caught in a primitive fertility ritual, carries a boy on his shoulders and raises a defiant fist. The gouache has a feeling of the burlesque, where Picasso's true emotions and politics are disguised behind a theatrical mask. Gertje Utley has helped unravel the symbolism. 'At the time, the raised fist was unmistakably recognised as the Communist salute. It also had become the greeting of the Spanish Republicans, serving as a gestural polemic in response to the raised open palm of the Hitler salute, which had been adopted by Franco's supporters.' For Picasso, painting the salute was a brave gesture, drawing attention to himself at a time when there was growing xenophobia in France coupled with the fear that the trickle of Spanish exiles could turn into a deluge. Increasingly, French of all political persuasions saw the foreigner, the *métic*, as the cause of all their woes. Spaniards, Communists and Jews were indivisible. The popular press like *L'Ami du Peuple* and *Le Figaro* were quick to christen Paris as Canaan on the Seine, poisoned by the influx of foreigners. *Composition avec Minotaure* and its employment in *Le 14 Juillet* was a clear statement of Picasso's willingness to enter a war that would be fought with propaganda as well as weapons. Art in the public space, be it in the theatre, through the medium of the propaganda poster or popular print, could also become an effective weapon. Easily read and immediately understood, the best propaganda art mixed the art of persuasion with an almost visceral appeal. *Composition avec Minotaure*'s effectiveness is attested to by the fact that the right-wing sympathiser André Derain could never forgive Picasso this celebration of 14 Juillet.

On 19 September President Azaña, fully aware of the propaganda potential, and at the behest of his Director General of Fine Arts, José Renau, offered Picasso the post of Director of the Prado. In essence, it was an honorary position as he never returned to Spain to see the museum or took the time to oversee personally the removal of its masterpieces after it was bombed. On 6 November, with Madrid surrounded by Franco's Nationalist army, the government retreated to Valencia, followed soon by the Prado collection, which was smuggled out of the city at night in camouflaged vans, to be stored

in Las Torres de Serranos and the Colegio de Patriarco. It was Picasso's friend José Bergamin, poet, writer and habitué of the Café Pombo, who oversaw the exodus of the Prado's collection. The urgency of the removal was dramatically highlighted when the lorry transporting Goya's *Second* and *Third of May* crashed, damaging both paintings, forcing emergency repair in transit. Although Picasso responded with some relief to Bergamin's dramatic reports from Valencia that the collection was finally safely stored, he felt no need to visit Spain even when invited to do so by the Under-Secretary of Public Education and Art, who offered to put a private plane at his disposal. Picasso remembered later: 'I could never touch a penny of my "salary", which was very meagre. After all, I was only the director of a phantom museum, of a Prado emptied of all its masterpieces, which had taken refuge in Valencia.'

That winter the siege of Madrid became the main priority for the Nationalist forces. The Republicans, under the inspiring leadership of General José Miaja and Colonel Vicente Rojo, fought a desperate battle to save their city. Russian supplies had started to arrive, as too had volunteers from many countries who were ready to serve in the International Brigade: these idealists were ready to sacrifice their lives in order to save the principle of democracy. To the Republicans their commitment could only help raise morale.

In Paris, Picasso was also about to put his art at the service of the Republican cause. That he saw his art as a viable weapon is made clear in one of his most widely publicised statements, in the course of an interview at the end of the Second World War. Rattled by the interviewer, Picasso replied:

What do you think an artist is? An imbecile who only has eyes if he is a painter, or ears if he's a musician, or a lyre at every level of his heart if he's a poet, or even, if he's a boxer, just his muscle? On the contrary, he is at the same time a political being, constantly alive to heart-rending, fiery or happy events to which he responds in every way. How could it be possible to feel no interest in other people and by virtue of an ivory indifference to detach yourself from the life

which they so copiously bring you? No, painting is not done to decorate apartments. It's an instrument of war for attack and defence against the enemy.'

In the first week of January 1937 Picasso received the commission that would change his life and give him the opportunity to put his philosophy into practice. At the request of Josep Lluís Sert, he agreed to meet a delegation of Spanish politicians and civil servants. Amongst the group climbing the stairs to his apartment at 23 rue la Boëtie were José Renau, Director General of Bellas Artes and one of the Republic's most accomplished poster designers, as well as Juan Larrea, poet and director of information for the Spanish Embassy's Agence Espagne. (As a renowned collector of pre-Colombian art Larrea was already known to Picasso and would later become the first author of a monograph on *Guernica*.) Sert also brought his architectural partner Luis Lacasa, José Bergamín (safely back in Paris after completing the transferral of the Prado's artworks to Valencia), and the poet Max Aub, whose memoirs *El Laberinto Mágico* (*The Magic Labyrinth*) still give the most poignant insight into life in Spain during the Civil War. The last three were key members of the Alianza de Intelectuales Antifascistas para la Defensa de la Cultura (Alliance of Anti-Fascist Intellectuals for the Defence of Culture), and Aub and Renau also shared the editorship of the Valencian newspaper *Verdad*. They all knew one another well and hoped that their joint effort might persuade Picasso to provide a mural for the Republican Pavilion in the up-and-coming World Fair.

The genesis of the idea for Spain's participation in the international exhibition dated right back to the middle of the *bienio negro* in 1934, when the government had been approached formally for the first time. It had foundered when the Balearic Islands and the regions of Catalonia, Castile and the Basque country requested their own pavilions, and the start of the Civil War had pushed all thoughts of the pavilion into the background. It was only following Largo Caballero's installation as Prime Minister in September 1936, and his inspired appointment of Luis Araquistain

as Spanish Ambassador to France, that serious negotiations began again.

Immediate action was taken to bring in a new team to direct the philosophy, construction and design of the pavilion and its exhibition. José Gaos, the ex-rector of Madrid University, was put in overall charge as *comisario*, and Sert and Lacasa, supported by Antonio Bonet Castellana, were commissioned to complete the design. In charge of the Catalan contribution was Ventura Gassol, and overseeing the Basques was José Maria Ucelay, whose 16-metre-wide mural in Bermeo had drawn some enthusiastic reviews. It was apparent almost immediately that the team had gelled. And the dramatic events unfolding in Spain spurred them on to meet the exhibition's May deadline, and use the pavilion, if possible, as an enormous propaganda coup to alert the world to the Republic's dignity and depth of culture, even when faced with the mortal threat of an internecine war. High on their list as a potential exhibitor was, of course, Picasso. His acceptance of the Directorship of the Prado quite naturally suggested his total support. Picasso, however, was initially wary. He had never worked to order, nor had he been an explicitly political artist before. During his anarchist youth he had of course produced a whole body of work based on Barcelona's dispossessed working class, but any political content had only ever been implicit. What the Pavilion Committee wanted, presumably, was something bold and explicit, something as attention-grabbing as one of Renau's posters. Picasso was loath to promise what he felt he might not be able to supply.

It was clear that Picasso's six visitors were ready to apply the pressure, however. Only the previous summer Josep Lluís Sert had organised the first ever Picasso retrospective, under the auspices of his ADLAN group, Amigos de las Artes Nuevas, that travelled from Barcelona to Madrid and Bilbao, and where the poet Paul Eluard had eulogised the master's work. The Republic needed Picasso. It was desperate for the active support of the world's most famous artist. Especially as Hitler had, on 6 January, offered the Basques the simple but stark choice between surrender or total destruction.

On 8 January 1937, galvanised into action by the meeting, Picasso completed the first plate of the etching *Songe et Mensonge de Franco* (*The Dream and Lie of Franco*) in just one day, creating a savage piece of satire in which Franco's pretensions to greatness are mercilessly mocked. Produced in a limited edition of 1,000, the sales were destined to benefit Spanish Refugee Relief. For his first overtly political creation Picasso chose the format of the old popular religious prints, the *alleluias*, which in horizontal bands of three told a story in the format of a comic strip. So fast did Picasso work that he either failed to register – or just didn't care – that the dating of the print, when the plate was reversed, would appear backwards. He was caught in the white heat of creation, and at his most visually sadistic. This impression of spontaneous explosive anger was further compounded in a poem that accompanied the print. In the avalanche of images that cascade directly from his imagination on to the page, Picasso unleashes his fury:

> fandango of shivering owls souse of swords of evil-omened polyps scouring brush of hairs from priests' tonsures standing naked in the middle of the frying pan – placed upon the ice cream cone of codfish fried in the scabs of his lead-ox heart – his mouth full of the chinch-bug jelly of his words – sleigh-bells of the plate of snails braiding guts – little finger in erection neither grape nor fig – commedia dell'arte of poor weaving and dyeing of clouds – beauty creams from the garbage wagon – rape of maids in tears and in snivels – on his shoulder the shroud stuffed with sausages and mouths – rage distorting the outline of the shadow which flogs his teeth driven in the sand and the horse open wide to the sun which reads it to the flies that stitch to the knots of the net full of anchovies the skyrocket of lilies –

It is an upturned cornucopia shell that spews out image after image without punctuation or syntax, and with no resort to rhyme or reason. The wellspring of images, with its chaotic cacophony, leaves the reader drained and exhausted, trapped in a spinning world of Picasso's making. If there is such a thing as poetic vertigo or nausea, this is it. 'Beauty creams from the garbage wagon', he wrote. But in *Songe et*

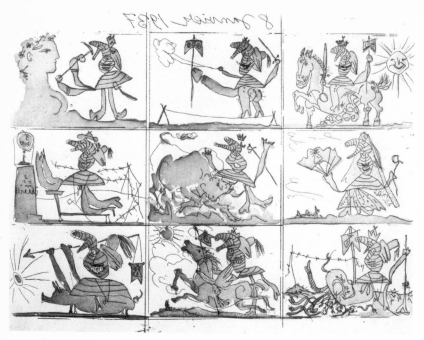

Songe et Mensonge de Franco, I (Dream and Lie of Franco, I), 8 January 1937.

Mensonge there is no beauty, just the piecemeal dismantling of Franco's ludicrous pretensions. Inspired by the seventeenth-century dramatist Calderón de la Barca, who was a favourite of the Teaching Missions, and whose *Life Is a Dream* is one of the great classics of Spanish literature, Picasso holds up a mirror – or nine plate mirrors, to be exact – to reveal in the most populist genre of all, the comic strip, the perversity of a leader nurtured by his years spent in the Foreign Legion, with its absurd necrophiliac battle-cry, 'Long live death.'

Franco appears first as a stage buffoon, on a disembowelled horse whose guts are spilling out. Proud and self-important, this stripy, sword-carrying, turd-like creature prances forward oblivious to the sun behind him that has burst into a smile. Franco is reduced, in the words of Joaquín de la Puente, to a 'grotesque homunculus with a head like a gesticulating and tuberous sweet potato'. Over the series the Franco beast dons a variety of stage-prop hats denoting his station in life and his cynical appropriation of any symbol that fits: the crown, the bishop's mitre, the cardinal's biretta, the Moorish fez,

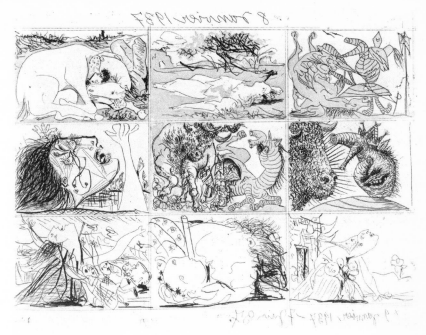

Songe et Mensonge de Franco, II (*Dream and Lie of Franco*, II), 8–9 January–June 1937.

the religious devotee's mantilla. It is the smile 'as sly as a vixen's', with its grinning teeth and mean moustache, that instantly gives this away as a savage depiction of Franco, as cruel a caricature as anything etched by Gillray, Goya, Grosz or Daumier.

In the second image, Franco bestrides a giant phallus with two hairy testicles, and walks the tightrope, as accomplished as any circus performer. In the third, the monster is about to smash a beautiful classical bust. At each turn the figure becomes increasingly ludicrous. Skittled over first by a bull, the figure then leans in prayer at a shrine to worship a *duro*, the slang for a 5-peseta coin. In the final three images, the monster tries out three forms of transport: first a rotting nag that releases serpents from its gaping sexual organ, then a Pegasus that refuses to let him mount, until finally he settles on a fat healthy pig that marches him slowly into the setting sun. It is both comic and unforgiving. In his meeting with Giménez Caballero Picasso had clearly observed that loss of human perspective, and the tendency towards the grotesque that Fascism implied.

On the same day Picasso embarked upon another series, based on the same theme. But of the nine images he only finished five. The rest would have to wait. The large commission for the pavilion was more important. To create a large mural sized painting, dynamic and imposing enough to fill the allotted space (which measured 11 x 4 metres), presented the artist with entirely different problems from etching caricatures the size of postcards. The scale suggested an epic work, but epic paintings also had a tendency to become overblown and unconvincing.

On 27 February 1937, the first stone of the pavilion was laid. From photographic evidence it is certain that Picasso visited the construction early on, to study the space his work was to occupy. From his earliest notations it is clear that he was working with an idea that would echo the open, airy, almost classical feel of a Mediterranean villa that Sert and Lacasa's design evoked. But before Picasso could begin he had to sort out his increasingly stormy private life. Separating from Olga, he had relinquished his studio flat on the rue la Boëtie and installed himself in the Hôtel Bisoon. Dora Maar lived nearby in the Quartier Latin. Marie-Thérèse was out in the country living in Vollard's house, Le Tremblay-sur-Mauldre, where Picasso would visit her and their baby, Maya, at weekends. It had the makings of a Feydeau farce, as Picasso shuttled between three women.

What Picasso desperately needed was a studio large enough to house a painting on the scale of the vast canvases that filled the Louvre. Received wisdom has always credited Dora Maar with finding him 7 rue des Grands-Augustins. However, Fernando Martín Martín in his doctoral thesis *El Pabellón Español* (*The Spanish Pavilion*) points out that it belonged to the Labalette brothers, who were the builders employed by Sert and Lacasa for the construction of the Spanish Pavilion, and used by them as a store for their materials. It was Juan Larrea who negotiated the acquisition of rue des Grands-Augustins for one million francs by the Spanish government for Picasso's exclusive use. It was a building blessed with an appropriately rich past. Balzac had written about it in *Le Chef d'oeuvre inconnu* (*The Unknown Masterpiece*). More recently,

the actor Jean-Louis Barrault, who would later star in Marcel Carné's cinematic masterpiece *Les Enfants du Paradis*, had used the attic as a rehearsal space for his theatre troupe. But perhaps a more exquisite coincidence was that the left-wing group Contre-Attaque, led by the Surrealist pornographer Georges Bataille, had used it for their meetings. Bataille and Dora Maar had been lovers, and it was he who had tutored her in the arcane and dark sexual arts. Rue des Grands-Augustins had a suitable aura, but more importantly, on the top floor, it had a giant attic, nicknamed the Monk's Grain Store – the Grenier – which with some quick restoration work would make a perfect studio.

There was now no excuse for Picasso not to produce. Jaime Vidal, a young artist's assistant, had even come in to make up a stretcher and prepare a blank canvas that measured an imposing 3.51 x 7.82 metres. But, as yet, Picasso had found no inspiration. He continued to paint: still lifes, and also some endearing portraits of Marie-Thérèse in a softened, tender Cubist style that suggests she remained his anchor. But there was still nothing that might translate into the monumentality that the pavilion's design required and, for that

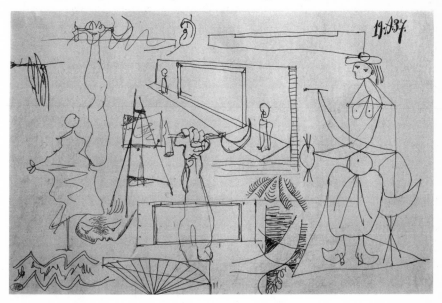

An early design for the Spanish Pavilion mural, *Painter and Model*, 19 April 1937.

matter, the Republic deserved. In the early 1980s, a group of twelve drawings that are clearly studies for the mural were discovered in the archives of the new Musée Picasso. Dated 18 and 19 April 1937, these sketches alert us to the alarming realisation that Picasso was just a month away from the opening of the World Fair with more than 27 metres of canvas to fill. The subject, however, the artist and model, related closely to the subject of Balzac's *Le Chef d'oeuvre inconnu* and focused on Marie-Thérèse's voluptuous curves as they slowly transformed into abstract forms that almost acquired a life of their own. Over the series, however, the tenderness evaporated into sadistic dismemberment, as eyes, swollen fingers and raw red swollen nipples float detached on the white background. Gradually, even Marie-Thérèse is painted out, as the studies focus on the placement of an imaginary canvas in an exhibition space.

On the afternoon of 27 April 1937 a large human rights demonstration, including a contingent of Spanish intellectuals, marched through the centre of Paris. As rumours spread through the crowd it was obvious that something terrible had happened across the border in Spain. Perhaps one of the demonstrators had picked up on the Radio Bilbao broadcast transmitted that same afternoon in which the Basque President José Antonio Aguirre had told the world of an atrocity committed on Basque soil, just twenty-four hours earlier:

> German airmen in the service of the Spanish rebels have bombarded Gernika, burning the historic town that is held in such veneration by all Basques. They have sought to wound us in the most sensitive of our patriotic sentiments, once more making it entirely clear what Euskadi [the Basque name for the Basque country] may expect of those who do not hesitate to destroy us down to the very sanctuary that records the centuries of our liberty and democracy.

The news was met with disbelief. The Basque painter José Maria Ucelay encountered Juan Larrea by chance coming up out of the Métro at Champs-Elysées, and briefly outlined what he had just heard. Larrea immediately took a taxi in the direction of the Café de Flore to find Picasso. According to Ucelay, it was Larrea who told

Picasso that the bombing of Gernika might be the very subject he was looking for. Ucelay remembered that Larrea told him that Picasso claimed not to know what a bombed town looked like. To which Larrea, in search of the most graphic description, told the artist, 'Like a bull in a china shop, run amok.' It is a tidy story, perhaps a little too neat and studied. Years later, in 1979, Ucelay would reveal in an interview his loathing for Picasso, whom he described as an '*inculto*' – an ignoramus. Why did everyone get so excited about *Guernica*, when Ucelay had

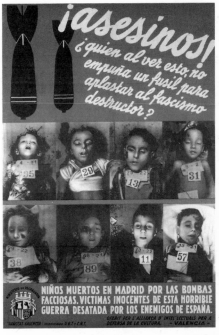

Asesinos (assassins) – republican propaganda poster illustrating dead children from the Madrid bombing, 1937.

painted his 17-metre mural, *The Port of Bermeo*, in no time at all? Ucelay also claimed that when Picasso was asked by the Basque President Aguirre about the woman's swollen fingers in *Guernica*, the artist had replied: 'They're not fingers, they're cocks.'

As a Basque, born in Bermeo, a short distance from Gernika, Ucelay quite understandably felt that the job of painting a memorial to the tragedy should fall to a Basque. His choice was a highly respected traditional painter, Aurelio Arteta, who had also served for a period as Director of Bilbao's Museum of Fine Arts. Phoning Arteta, who had escaped into exile and settled in Biarritz, Ucelay explained his wishes but was flatly rejected. Arteta was on his way to Mexico, and felt that Picasso was a far better man for the job. A few days later Salvador Dalí walked into the Spanish Embassy offering his own services. He had already made his mark with the prophetic *Soft Construction with Boiled Beans: Premonition of Civil War* (1936), but it was clear that Picasso was still preferred.

According to Ucelay, the Arteta proposal still interested President Aguirre and the Basque Minister of Culture José Leizola, who had escaped to Paris after the bombing, and they both wondered if it would not be possible to apply some pressure on Arteta and insist he delay his move to Mexico. But the chaos caused by the bombing meant that the Basque government-in-exile had to deal with the far greater problem of what to do with the 150,000 Basque evacuees who had flooded across the border into France. *Guernica* the painting would have to wait. However, it was also clear that José Gaos, the Spanish Pavilion's *comisario*, and his team were anxious to see some progress. A swift solution was found. In bringing the collection of Bilbao's Museum of Fine Arts across to the safety of France, the Basque goverment had run up an unexpected bill at customs of FF 1,400,000. In a fine piece of pork-barrel politics, Juan Negrín, serving as the central government's Treasury Minister, offered to pick up the

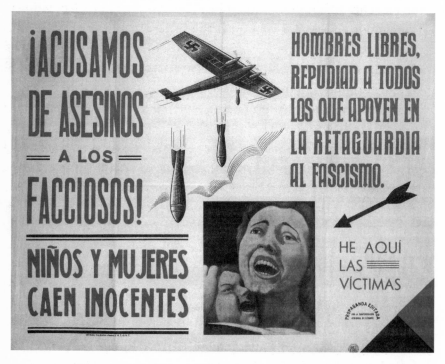

Acusamos (We accuse [the Fascist assassins]) – republican propaganda poster 1937.

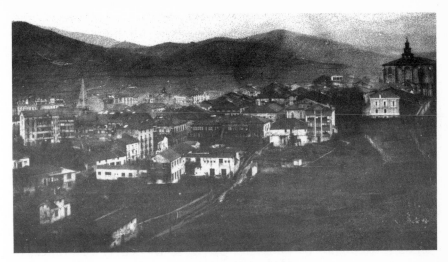

Gernika before the bombing.

bill. *Guernica*, demanded Negrín, or whatever the canvas was going to be called, would be painted by Picasso, as he sincerely believed that 'the presence of a mural painted by Picasso is the equivalent value in propaganda terms of a victory at the front'.

However, in Paris on the afternoon of 27 April 1937 it was still not clear exactly what had happened across the border in Spain. The rumours sounded implausible and, if true, inconceivably barbaric. Surely not even the Nationalists could be so dismissive of world opinion and ignore the possibility of a powerful retaliation. Although it was the spiritual capital of the Basques, Gernika had only recently assumed strategic importance as one of the few escape routes for fleeing Basque troops, the *gudaris*, to take up their defensive positions behind Bilbao's *cinturón de hierro*, ring of iron. Despite the Nationalists' proximity to Gernika, all seemed relatively quiet. The Basques were defiant in the face of General Mola's threat that had been broadcast, and printed in a leaflet and dropped from aircraft on the main towns, on 31 March: 'If submission is not immediate, I will raze Vizcaya to the ground, beginning with the industries of war. I have the means to do so.' Resilient by nature, those living in Gernika were staying put. Their determination had seemed to be vindicated. On Monday, 26 April, the market had

taken place as usual, with farmers leaving their *caserío* smallhold-
ings and joining those in outlying villages on the trek into town. The
only thing slightly out of the ordinary on that sunny spring morning,
as Antonio Ozamiz remembered, was the sight at eleven o' clock of a
reconnaissance plane circling overhead. Some of the shops pulled
down their shutters and closed for the day: they had already seen
enough reports on the earlier bombings that had destroyed Irún,
Durango, Eibar and Ochandiano as part of Franco's policy of
offering those who lay in his path 'moral redemption'. But most
people stayed at the market or chatted in the surrounding bars. At
about three in the afternoon another reconnaissance plane flew in
low over the centre of Gernika. During this period of apparent calm
the Australian reporter for the *Daily Express*, Noël Monks, passed
through Gernika by car, on his way out to the battle front at
Marquina, 30 kilometres east. By 3.45 from the edge of town it
was already possible to see the smoke rising directly east over the
hills from the battle taking place in Marquina. At some time after
four the droning sound of aircraft engines was heard coming directly
from the north as a formation of aircraft followed the Mundaca
river up the estuary towards Gernika. Out at sea a Royal Navy
vessel, HMS *Hood*, had been trying to prevent British merchant
ships from running the Nationalist blockade and breaking the rules
of non-intervention. Michael Culme-Seymour, then a young naval
officer, watched with incredulity as the endless stream of planes,
clearly marked with the black saltire cross, sited up out in the Bay of
Biscay on Bermeo and the mouth of the Mundaca river, ready for the
final run in. 'It was horrific. From out at sea we could see the smoke
rise. Of course, we didn't know then the real target.' From the
lookout on the roof of Los Carmelites, a convent in the centre of
Gernika, the bells of Santa María pealed in warning.

For three hours, in wave after wave, planes dropped a mixture
of 250-kilogram 'splinter' bombs and ECB1 thermite incendiary
bombs, designed to burn at 2,500°C, transforming the city into an
apocalyptic fireball. Those who managed to escape into the
fields or the hills around Urdaibai were strafed from the air with

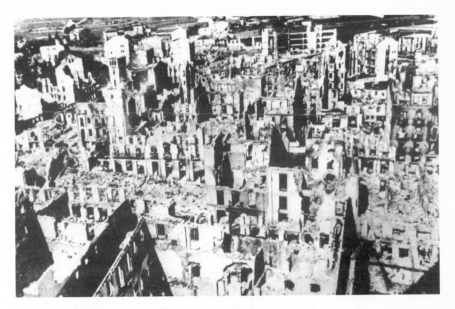

Gernika – a devastated city, May 1937.

machine-gun fire. By 7.45 p.m. almost all of Gernika no longer existed. Only the Astra arms factory, the Rentería bridge and the symbolically important Casa de Juntas with its famous oak tree – where Basques swore their allegiance to the homeland and where President Aguirre, Euskadi's first President, had been ceremonially sworn in – still stood like ghosts amongst the flames, the screams and the acrid smoke. The bombing was to have a devastating effect on morale in Bilbao. Almost immediately thousands of children were evacuated by ship, many coming to Britain.

In total, 23 Junkers Ju 52s, 4 Heinkel IIIs, 10 Heinkel He 51s, 3 Savoia-Marchetti S81 Pipistrelli, 1 Dornier Do 17, 12 Fiat CR 32s and, possibly, Messerchsmitt Bf109's straight off the assembly lines, represented the combined German and Italian air force that had breached the Non-Intervention Pact. It was the first example of saturation bombing ever seen on European soil. As early as 10 November 1932, Stanley Baldwin had stood up to a packed House of Commons and warned, 'In the next war you will find that any town within reach of an aerodrome can be bombed within the first five minutes of war to an extent inconceivable in the last war.' What

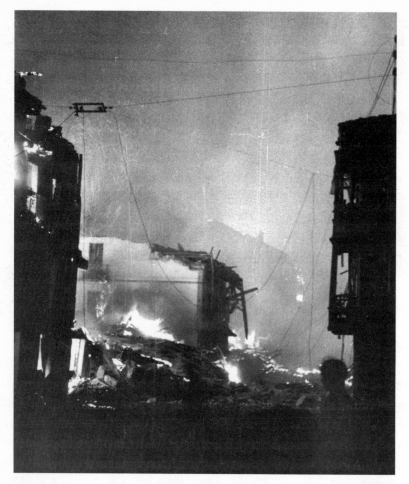

Gernika in flames.

was so horrifying about Gernika for the Allied Western powers was
not that it had come as a total surprise, but quite the opposite. It was
the long-expected nightmare made real.

The German war machine had been waiting for an appropriate
laboratory in which to test out its new tactics and the efficacy of
their new planes. Gernika was that laboratory. For months General
Hugo Sperrle, the head of Germany's 18,000-strong Condor Legion,
had grown increasingly frustrated by Franco's slow progress in
the capture of Madrid and the destruction of resistance in the
Basque country. Franco had his reasons, that amounted to nothing

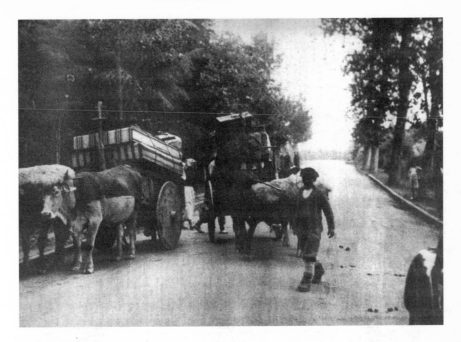

Peasants escaping from Gernika, 27 April 1937.

short of a complete purging of Spain's liberals, Communists and anarchists. But Sperrle couldn't understand his inability to grasp the new type of total war, in which ground and air troops were coordinated in a Blitzkrieg. As they moved north from Madrid Sperrle came to rely increasingly on his Chief of Staff, Lieutenant Colonel Wolfram von Richthofen, a cousin of the First World War flying ace known as the 'Red Baron'. Richthofen's tactic was to devastate all resistance with a massive show of power, and smash completely the last vestige of enemy morale. This, aimed at an undefended target like Gernika, was what we now have come to know as 'total war'. Preparations for the final assault on the Basque country had been under way for months. In the large open plain of Vitoria, Mola and Franco had authorised the building of a new airfield. And, from Burgos and Vitoria a precise and coordinated plan was organised to allow for a rapid refuelling and loading of new ordnance, before the planes were up in the air again ready to deliver their new payload.

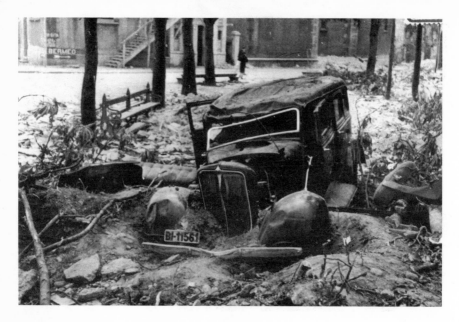

A bombed car in the boulevard San Juan.

On Monday evening in the Torrontegui Hotel in Bilbao the international press corps, safely back from reporting on the battle at Marquina, settled down to dinner. As soon as the terrible news of Gernika reached them they commandeered cars and set off for the ancient town. Amongst the group were Mathieu Corman, a Belgian war reporter working for a new Paris daily, *Ce Soir*; Christopher Holme of Reuters; Noël Monks, and George Lowther Steer of *The Times*. Steer was arguably the most experienced, having witnessed in the Italo-Abyssinian war the use of chemical warfare, which the Italians often directed at Red Cross stations to terrorise the foreign observers. Lampooned by Evelyn Waugh as 'a very gay South African dwarf', Steer was passionate, enterprising and utterly fearless. His sang-froid under fire was legendary: he had even got married in Addis Ababa's British Legation while the city was under attack. A few weeks after Gernika, during the evacuation of Bilbao, he would still find the time to pick cherries like any naughty schoolboy as the city lay under siege and the bombs rained down.

What greeted the reporters on arrival was less a town than a

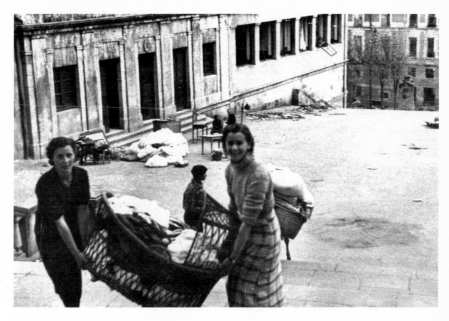

Women salvaging furniture from a girls' school

gigantic funeral pyre. They immediately picked through the ruins and started to interview the survivors. That Gernika is today synonymous with the indiscriminate slaughter of innocent victims is almost entirely due to the fact that international reporters were so close at hand. On the afternoon of 27 April the *Evening News*, feeding off Holme's cable to Reuters, ran the headline 'THE MOST APPALLING AIR RAID EVER KNOWN'. In Paris, as the human rights march was winding to a halt, *Ce Soir* and *Paris Soir* broke the story. The following morning Noël Monks's article in the *Daily Express* began 'I have seen many ghastly sights in Spain in the last six months, but none more terrible than the annihilation of the ancient Basque capital of Guernica by Franco's bombing planes.'

It is Steer's passionate account, published simultaneously in *The Times* and the *New York Times*, that still remains the most influential.

> At 2 a.m. to-day when I visited the town the whole of it was a horrible sight, flaming from end to end. The reflection of the flames could be seen in the clouds of smoke above the mountains from 10 miles away. Throughout the night houses were falling until the streets became

long heaps of red impenetrable débris. Many of the civilians took the
long trek from Guernica to Bilbao in antique solid-wheeled Basque
farm carts drawn by oxen. Carts piled high with such household
possessions as could be saved from the conflagration clogged the
roads all night. Other survivors were evacuated in Government
lorries, but many were forced to remain round the burning town
lying on mattresses or looking for lost relatives and children, while
units of the fire brigades and the Basque motorised police under the
personal direction of the Minister of the Interior, Señor Monzón, and
his wife continued rescue work till dawn.

In the form of its execution and the scale of the destruction it
wrought, no less than in the selection of its objective, the raid on
Guernica is unparalleled in military history. Guernica was not a
military objective. A factory producing war material lay outside the
town and was untouched. So were two barracks some distance from
the town. The town lay far behind the lines. The object of the
bombardment was seemingly the demoralisation of the civil popula-
tion and the destruction of the cradle of the Basque race. Every fact
bears out this appreciation . . .

That night 1,645 people died and a further 889 were injured.
According to the historian Angel Viñas, the moral responsibility
for the atrocity lies undeniably with Franco. Within three days,
however, the Nationalist troops had moved in to occupy Gernika
and the counter-propaganda campaign denying any involvement
went into action. On the night of 27 April *Radio Nacional* aired its
diatribe, 'Lies, Lies, Lies' in which the Basques were accused (as they
had been at Eibar and Irún) of torching their own city to win
international sympathy. At Irún, this policy of 'scorched earth', in
which retreating troops booby-trapped and bombed key buildings,
had actually been implemented. Gernika, however, as all the wit-
nesses knew, was entirely different.

In Paris, this did not hinder newspapers like *Le Jour, L'Echo de
Paris* and *Action française* from insisting that the Basques had
carried out the attack on themselves. The satirical paper, *Le Canard*

enchaîné, suggested that Gernika, like Joan of Arc, had died im-
molated by a fire she herself had lit. For months, the right-wing press
would continue the wicked fabrication: in his book *Visite aux
Espagnols* Claude Farrère stated baldly that 'At Bilbao the Marxists,
retreating, have blown up all six bridges, as they blew up Guernica
which those who hadn't seen it imagine with touching naiveté to
have been destroyed by the bombing of victorious nationalists.' The
propaganda war had reached a new level. But, it was also clear that
in bombing Gernika, Franco had broken the ultimate taboo,
namely, to bomb indiscriminately civilians on European soil. And
it was this that created such a furore around the world.

Gernika was by no means the first example of saturation bomb-
ing. As Sven Lindqvist has convincingly demonstrated in *A History
of Bombing* (2001), the first atrocities were all committed by the
Western powers as part of the colonial apparatus of control. It had a
cruel logic: 'Bombs were a means of civilisation. Those of us who
were already civilised would not be bombed.' The first case of
bombing was that of an isolated oasis in Tripoli in 1911 by the
Italians. From then on the frequency and gravity of each attack
grew: in 1919 the British bombed Dacca, Jalalabad and Kabul; in
1920 they followed with bombing in Iran and Trans-Jordan and
Baghdad. In 1922 the South Africans bombed the Hottentots almost
to extinction. In 1925 volunteer American planes, under orders from
the French Flying Corps, and in service of the Spanish, destroyed
Chechaouen in Morocco; while the French killed more than 1,000 in
Damascus. Between 1928 and 1931 the French managed to reduce
the Arab population in Libya by 37 per cent by aerial attack; in 1932
the Japanese bombed Shanghai; and in 1936 the Italians bombed the
Ethiopians with gas and chemicals, causing Emperor Haile Selassie
to appeal to the League of Nations to stop the 'rain of death'. In the
face of so many vicious acts of destruction, why did Gernika take on
such significance? Lindqvist explains with alarming dispassion: 'Of
all these bombed cities and villages, only Guernica went down in
history, because Guernica lies in Europe. In Guernica, *we* were the
ones who died.' But that was not the only reason.

As Germany and Italy built up their air forces at an unprecedented
rate, war from the air during the 1930s had become the new
obsession. In the French National Congress of 1931 the Socialist
delegates were warned that air warfare might bring death to 'ten
million, fifteen million, twenty million'. In Lyons, Toulon, Dunkirk
and Nancy there had been simulated gas attacks. Such preparations
and the ongoing debate on civil defence provoked fear and an air of
inevitability, leaving the population lethargic, defeatist and demor-
alised. As early as 1929 an International Documentation Centre on
Airborne Chemical Warfare had been set up to monitor the pro-
liferation of bombing attacks, and to record the dramatic change in
the whole psychology of war.

The most influential thinker on the new type of war was the Italian
Giulio Douhet, whose book *Il Dominio dell'Aria* (*Dominion of the
Skies*), came out in 1921. This was followed in 1935 by General
Erich Ludendorff's *Der Totale Krieg* (*Total War*). Both books argued
that any military organisation that failed to live with the new reality
was doomed. The bomber offered salvation to those prepared to use
it to its full potential, sowing terror, death and destruction. Not
surprisingly, there was an explosion of popular books and films that
dealt with the theme. Prophets of doom outdid one another in their
wild predictions of what the future would bring. In 1935, H. G.
Wells's film *Things to Come* showed the public what it most feared;
chaos, anarchy and obliteration. Gernika's total destruction was the
first omen of what the future might bring. Hamburg, Coventry,
Rotterdam, Dresden and Hiroshima were still the names of cities, not
yet codes for catastrophes. In a sense, to the outside world, it was
only Gernika's annihilation that brought the city into existence, and
its name into common parlance. But Gernika the Basque city, which
was now just a pile of smouldering ashes, still had to become
Guernica the painting. On the afternoon of 27 April 1937 in the
Café de Flore, Picasso struggled, as did everyone, to come to terms
with the gravity of what he had just heard, and with its implications,
particularly for his family in Barcelona who, it was reasonable to
assume, might well come to suffer the same fate.

On the morning of 28 April the headline of *L'Humanité*, Picasso's habitual newspaper, screamed out: 'MILLE BOMBES INCENDAIRES lancées par les avions de Hitler et de Mussolini.' Accompanied by pathetic photos of the dead and a panoramic view of a devastated Gernika, the report recorded the tragedy with horrifying immediacy. Picasso had procrastinated too long. Faced with what he saw spread out in front of him, in graphic black and white, the time for inaction was over. On I May, while the capital was overrun with the May Day celebrations, Picasso made his first brief sketch notations for *Guernica*. From the first sketch to the completion of the painting itself, just five weeks later, Picasso unleashed a creative energy that drew together the threads of the Crucifixion, martyrdom, the *corrida* and the life of the Minotaur. Photographed in the process of creation, it is perhaps the best-recorded example of a work in progress in the history of art. Through blind cul-de-sacs, discarded ideas, brief inspirations, transmutations and transformations we can rebuild Picasso's thought processes. He had mused back in 1935:

> It would be most interesting to preserve photographically not the stages but the metamorphoses of a painting. Possibly one would thus be able to discover the path followed by the brain to materialise a dream. But there is something very strange and that is to observe that a painting does not basically change, that the first vision remains almost intact, despite appearances.

Picasso's first sketch, a lightning notation in pencil that took him perhaps less than a minute, measuring just 21 × 27 centimetres, brought together the bull with a bird landing on its back, an agitated shorthand image of a collapsed horse, and above that a woman leaning out of a window holding a beacon or a vase. At the very last second, as if to ground the image and bring balance to its structure, Picasso swept in, returning twice with the pencil to give it extra weight, a semi-circle; a device that almost acts as the boundary lines of a theatre spotlight as it hits the stage. The sketch was a compact elision of many of his

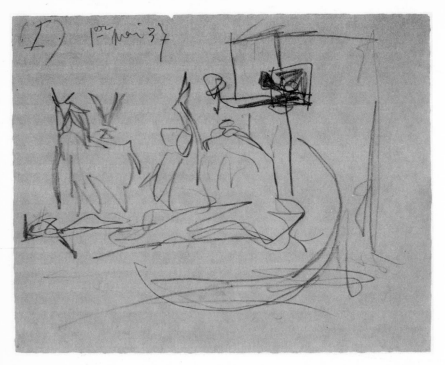

First preparatory sketch for *Guernica*, 1 May 1937.

preoccupations of the previous decade: the Minotaur, the *corrida* and the battle between the sexes. But, as Picasso shrewdly anticipated, the finished image is already taking shape.

It is wrong to insist, as some critics have, that *Guernica*'s gradual evolution began with Picasso's first sketch of the artist and model. Or to suggest, as Zervos has, that some beach scenes based on the horizontal format completed during the gestation period lead on towards the image we know. *Guernica*, as we see it today, was only the second response to the original commission. What is immediately apparent is that there is nothing in the first preparatory sketch for *Guernica* that specifically describes Gernika, the bombing, the planes, the effect of incendiaries, the fingers of flame, or the crashing explosions and the array of corpses. From sketch 2 through to sketch 6, all produced on that first day, Picasso, like a theatre director or a child totally absorbed with his puppets, repositions his actors and discards those extraneous to the plot, slowly refining the

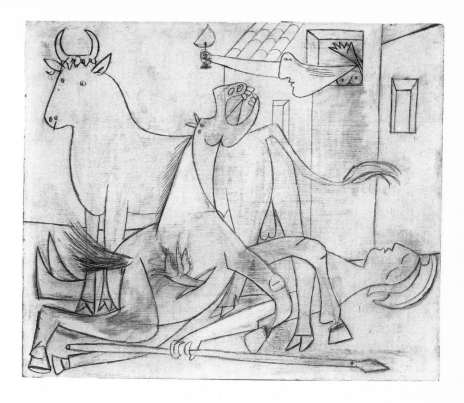

Study no. 6, 1 May 1937.

ideas and paring them back to the 'first vision'. This is what Picasso meant when he said enigmatically that 'a painting is the sum of its destructions'. By the evening of 1 May he had come remarkably close to the finished painting. In sketch 6 there is the bull, the horse and the woman, now clearly with a lamp, and also the fallen warrior. But there were also details that would have to disappear, details that were too overt and literal: the winged Pegasus escaping from a gaping wound in the horse's flank; the warrior's Athenian helmet. Whereas sketches 1 to 5 had all been on a pale blue background, 6 is on white. What Picasso was looking for at the end of the day was the 'feeling' of finish and a sense of the overall composition.

The following day he started, almost like a camera operator, by zooming in on the detail. It was clear at this moment that the horse

would bear most of the weight of the painting's suffering. In the *corrida* – particularly before 1955 when the rules did not permit the horses to wear padding – these tragicomic animals represented the innocent victim. Twice on the blue paper background the screaming horse raises its head to the sky. And then, impatiently, Picasso takes out his oils and spotlights the horse's head dramatically against a black background. Searching for a more resistant surface that lends a greater feeling of permanence, he finds a small panel of wood in the studio. Here at the end of day two the scene becomes increasingly refined with the appearance of another woman placed as a victim, thrown sprawling to the ground, and the jagged architectural backdrop creating a greater sense of claustrophobia.

A week later Picasso returned again to re-address the overall layout of the painting. On 8 May a similar arrangement to sketch 6 is tried out with the further addition, for the first time, of the mother with dead child. Over the next five days Picasso completed another eleven sketches that repeatedly, sometimes in jarring colour, returned to the wounded horse and the mother with dead child. Sometimes the woman was seen climbing up a ladder or represented as a parody of Christ's Descent from the Cross. It was clear, as always with Picasso, that he was trawling through the vast reserves

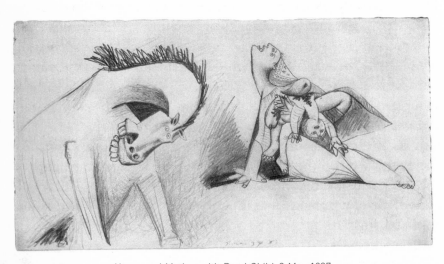

Horse and Mother with Dead Child, 8 May 1937.

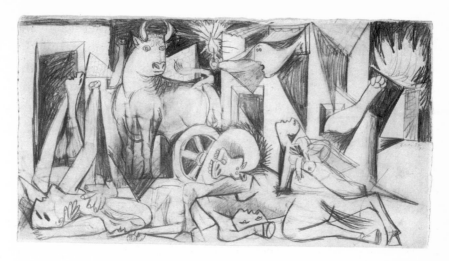

Composition Study, 9 May 1937.

of his pictorial memory, busily editing and refining. What the sketches focus on are the facial expressions, that with the right feeling of drama, border on the caricature. On 9 May, in sketch 15, entitled *Composition Study*, Picasso comes closest to the finished painting to date. Two days later, with the gigantic canvas already stretched up in the Monk's Grain Store – the attic studio at rue des Grands-Augustins – he started to map out the composition. How effectively would a compositional study, measuring a mere 24 × 45.4 centimetres transpose on to a canvas that was almost 250 times as big? Would the interior scale of the painting still work? And would the size of the figures in relationship to the viewer become too overwhelming? By the end of 11 May Picasso had the first state mapped out and invited Dora Maar to make a photographic record.

It became obvious that the pyramidal structure worked but that the painting was too overcrowded. In the foreground, the figure of the fallen warrior, that had now adopted the posture of a crucified Christ, raised a clenched fist defiantly into the sky. But it was too flat, and stuck to the surface, preventing any feeling of recession. Over a period of a month Dora Maar recorded the work in progress a further eight times. At each photographic 'pause' the

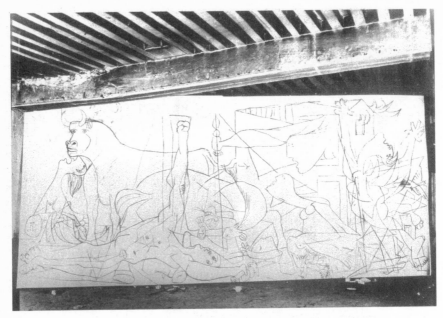

Guernica, state no. 1 – photo by Dora Maar.

painting subtly changed. The horse, in the first photograph, had its head tilted down in submission. Slowly Picasso twisted the head over, but, seeing that even that transformation remained confusing and failed to create the desired effect, the horse's neck was pulled up into the apex of the pyramid. Gradually whole areas of the background, the negative space, were blacked out, creating by contrast a dramatic lighting effect. Between the third and fourth state the painting entered a critical phase. The bull was pulled around 180 degrees, with its tail reaching into the top left-hand corner. Many jokes were made later about the tail being used to cover up a stain created from the leaking attic roof. And, knowing Picasso's Surrealist delight in the chance occurrence, this may well be true. But more radical still was the introduction of the collage technique, as a large patch of coloured wallpaper was attached to the woman entering from the right, to signal a dress, only to be removed again as the painting became increasingly simplified. Herschell B. Chipp is surely right in claiming that this transformation came about as the result of Picasso's visits to the pavilion. It

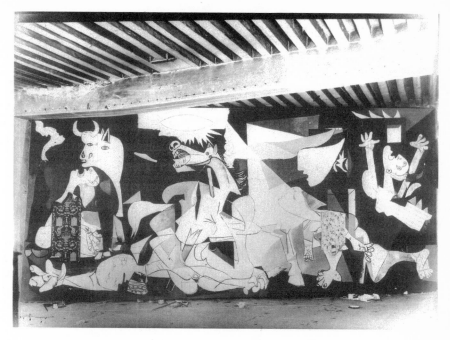

Guernica, state no. 4 – photo by Dora Maar.

had now become clear that *in situ* the painting could only fight the surrounding distractions by remaining bold and simple. Once again, however, Picasso reversed his decision and brought back the collage, and even added more on the left, as if frightened by the painting's austerity.

In late May Henry Moore and Roland Penrose joined Giacometti, Max Ernst, Paul Eluard and André Breton at a large lunch party at rue des Grands-Augustins. Moore reminisced:

> . . . it was all tremendously lively and exciting and we all trooped off to the studio, and I think even Picasso was excited by our visit.
>
> But I remember him lightening the whole mood of the thing, as he loved to do. *Guernica* was still a long way from being finished. It was like a cartoon just laid in black and grey, and he could have coloured it as he coloured the sketches. Anyway, you know the woman who comes running out of the little cabin on the right with one hand held in front of her? Well, Picasso told us that there was something missing

there, and he went and fetched a roll of paper and stuck it in the woman's hand, as much to say that she'd been caught in the bathroom when the bombs came.

'There,' said Picasso, 'that leaves no doubt about the commonest and most primitive effect of fear.' Penrose remembered that 'when visitors arrived he discussed with them the movements of the figures as though the painting were alive'.

And in many ways it was true. *Guernica* had become a collaboration between Picasso's imagination, his phenomenal skill and almost perfect hand-to-eye coordination, his autobiography, the history of art and the present drama in his love life that was playing itself out as the painting progressed.

The pattern of Picasso's days had become increasingly familiar. During the week he would stay in rue des Grands-Augustins close to Dora, and at weekends he would go out to the country to be with Marie-Thérèse and Maya. Curiously, while out in the country he would expunge from himself all the orchestrated anger contained in *Guernica* by painting flower pieces and still lifes.

Not long before the delivery of the painting Marie-Thérèse walked into the studio to find Picasso up on his ladder and Dora at his feet. For Picasso, it remained 'one of his choicest memories'. Françoise Gilot, Picasso's partner after the war, remembered the story as told to her by him:

'I have a child by this man. It's my place to be here with him,' said Marie-Thérèse. 'You can leave right now.' Dora said, 'I have as much reason as you have to be here. I haven't borne him a child but I don't see what difference that makes.'

Picasso refused to intervene, preferring to watch the two women fight it out.

Finally, Marie-Thérèse turned to me and said, 'Make up your mind. Which one of us goes?' It was a hard decision to make. I liked them both, for different reasons: Marie-Thérèse because she was sweet and gentle and did whatever I wanted her to, and Dora because she was

intelligent . . . I told them they'd have to fight it out themselves. So
they began to wrestle.

Both Marie-Thérèse and Dora had made their way into the painting.
Marie-Thérèse's Grecian profile was instantly recognisable in the
woman holding the lamp. But Dora had actually physically parti-
cipated in the painting's creation. Close to *Guernica*'s completion,
she had helped Picasso by painting the pattern of cross-hatching on
the horse's flank. In a more profound way, however, Dora had also
come to represent the emotional tenor of the painting. It was she
who was the 'Weeping Woman': proud, sultry, intelligent, beautiful,
but essentially Kafkaesque and doomed to live an unhappy life.

Guernica was finished. Or as finished as it ever would be. Picasso
was capable of retouching it and repainting it, as he had done with
many other works, until it looked nothing like it had before but
somehow truer to the first idea. He told Sert that he had better come
and collect it. It represented an extraordinary achievement, of which
Picasso said, 'If peace wins in the world, the war I have painted will
be a thing of the past . . . The only blood that flows will be before a
fine drawing, a beautiful picture. People will get too close to it, and
when they scratch it a drop of blood will form, showing that the
work is truly alive.'

2

A Silent Requiem

War is beautiful because it initiates the dreamt-of metalisation of the human body. War is beautiful because it enriches a flowering meadow with the fiery orchids of machine guns. War is beautiful because it combines the cannonades, the cease-fire, the scents, and the stench of putrefaction into a symphony.

F. T. Marinetti

Dark, confused, uncertain images have a greater power on the fancy to form the grander passions than those which are clear and determinate.

Edmund Burke, *Philosophical Enquiry into the Origin of Our Ideas of the Sublime and Beautiful* (1757)

Guernica had been an epic battle for Picasso to wrestle out the forms and harness the daemons. It was curious, Picasso had mused while analysing his singular approach, that 'there are forms that impose themselves on the painter. He doesn't choose them. And they stem sometimes from an atavism that antedates animal life. It's very mysterious, and damned annoying.' What was even more annoying was that, with *Guernica* out in the world, there was an almost pedantic necessity for critics to pin down exactly what Picasso's symbols meant. His old friend Palau I Fabre observed, 'having plumbed the depth of the human soul, he reached both the child and the caveman in himself. He reinvented man's history and then turned it into legend.' What did the bull mean, and what did it symbolise? Was it a self-portrait? Was it, as some critics argued, an escape valve from a reality that was too violent? Or perhaps a mask

behind which the artist had hidden the duality of his feelings? For years the Minotaur had lived its daily existence side by side with Picasso. There were others who saw in the bull the embodiment of evil and therefore, by extension, recognised in it a depiction of Franco. In complete contrast, others read it as symbolising the long-suffering Spanish people. It was impossible to say which interpretation was the most convincing, particularly as Picasso was angered by the critics' need to be so literal and reductive, and he refused to help them in their mission to close the painting down.

For art historians keen to search out *Guernica*'s ancestors in the history of art, the painting also proved a minefield. Picasso had often stressed the need for the modern artist to be a visual kleptomaniac, and with *Guernica* he didn't disappoint. Over the months he had raided the store cupboard of art history and drawn from a myriad of potential sources: from Roman funerary sculpture to David's *Oath of the Horatii*; from the tenth-century *St Sever Apocalypse*, in the Beatus de Liébana codex, to Catalan Primitive art; from the classical *Winged Victory of Samothrace* to Bartholdi's *Statue of Liberty*; from Grünewald's *Isenheim Altarpiece* to Delacroix's *Massacre at Chios*; from Géricault's *Raft of the Medusa* to Rubens' *Horror of War* in Florence's Pitti Palace; from Guido Reni to Poussin; from Pierre Paul Prud'hon to press photographs in *L'Humanité* and *Ce Soir*; from Rogier van der Weyden's *Descent from the Cross* to Goya's *Third of May* and his horrific print series the *Desastres*; and one of the most recent theories suggests inspiration also came from an anonymous Catalan fresco, *The Triumph of Death*, in Palermo's Palazzo Abatellis. All the above works were absorbed, metamorphosed and transformed. Within his own canon of work, Picasso had also cannibalised earlier motifs. In *Guernica* we find passages from *Songe et Mensonge* and *Minotauromachy*, of course, but there is also the *Crucifixion*, the *Three Dancers*, the *Vollard Suite*, early bullfight juvenilia and hundreds of other echoes, including faintly remembered gestures, similar compositions and the employment of his habitual techniques. It mattered little that Picasso sourced so readily from everywhere else; what really mattered was his capacity

to come up with something both shocking and new. What Picasso had performed was a kind of visual alchemy in which the immediate power and presence of the propaganda poster sit side by side with something as ancient and atavistic as the Altamira bull. On 12 July 1937 the doors opened at the Spanish Pavilion and the public could study *Guernica* and decide for themselves.

Few artists in history, excepting Goya, whose *Second* and *Third of May* were produced in just two months, have been capable of imagining and bringing to resolution such a complex and ultimately convincing work in such a short time. Physically, as well as intellectually, it was a remarkable feat. Françoise Gilot, continually surprised by Picasso's extraordinary stamina, wondered as to the physical cost of such an obsessive drive:

> I asked him if it didn't tire him to stand so long in one spot. He shook his head.
>
> 'No,' he said. 'That's why painters live so long. While I work I leave my body outside the door, the way Moslems take off their shoes before entering the mosque.'

Sometime in the second half of June *Guernica* was unpicked, rolled up and delivered to the Spanish Pavilion. The pavilion was already late in opening, but so too were many others. Indeed, the Exposition Internationale des Arts et Techniques dans la Vie Moderne was already two years late, and lucky to open at all, considering that it had been cancelled once already in 1934 following labour riots in the centre of Paris. Prime Minister Blum had invested a huge amount of political capital in the project as the Popular Front's cultural policy hinged on its electoral promise to 'open the gates of culture'. Criticised by the right wing for its obsession with crass and cheap materialism, the Popular Front was desperate for public approval. The grand opening had been planned to coincide with 1 May, in keeping with Blum's wish to see it as a symbolic victory over the powers of international Fascism. However, following an escalation in the ongoing labour disputes, the opening date was set back to

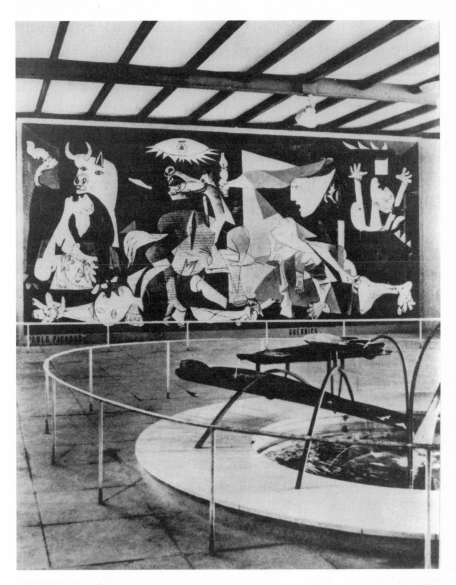

Guernica in the Spanish Pavilion, with Calder's *Mercury Fountain* in the foreground, 1937.

24 May. Right from the beginning the Expo had been plagued by labour unrest, rioting and even the death of six rioters shot by police on 16 March in a battle between the extreme right and left. And to complicate matters even further, a general strike had been called for 18 March. By 24 May only five pavilions were ready – the Russian, German, Italian, Danish and Dutch. The street lighting was not functioning, and some of the streets were still unmetalled. France's President Lebrun, his entourage and the press corps were taken around an elaborate route to avoid the most glaring deficiencies.

In many ways the Expo had been a fudge, whose eventual success depended largely on last-minute improvisation. The Expo's architect-in-chief, Jacques Gréber, was in favour of taking it out of the centre of Paris, and using it as a motor for change, to revive and repopulate an outlying suburb. France's most famous avant-garde architect, Le Corbusier, was also in favour of going for a space that was entirely new, in order to test out his latest theories on urban planning. But it was not to be. Le Corbusier's contribution was minimal; his Pavillon des Temps Nouveaux, a tent construction, was placed in the architectural annexe near the Porte Maillot. Finally, with time running out and the impossibility of supplying a new city zone with the adequate infrastructure, it was decided to go back to the tested and known, and re-use the 1900 exhibition site between the Champ de Mars and the Trocadéro. Once again, the Expo would play with the notion of creating a city within a city. It would be an impermanent city opening a window out on to the world. And, in time of war and the threat of escalation into a broader European conflict, the Expo would be an uplifting experience, celebrating as it did the intimate link between modernity, good design and the latest technology.

Paris had great experience in organising gigantic World Fairs and Expos – in fact, this was its record seventh attempt. The site, though impressive enough in 1900, would be further enlarged to include 2 kilometres of processional avenues on both banks of the Seine. Forty-four countries had been invited to participate, as well as all the other trade stands, restaurants and the necessary infrastructure to cope

with the influx of visitors, that in the end amounted to an astonishing 37 million. One of the most important decisions that was taken early on was to demolish Davioud and Bourdais's palace, designed for the 1878 show, and create a new focal point. The architects Carlu, Boileau, Azéma won the competition to build the Palais de Chaillot on the hill facing directly down the avenue towards the Eiffel Tower, across the Seine. With its half-moon low-lying classical pavilions it was sufficiently aseptic and nondescript to drive Picasso, Matisse, Cocteau and Maillol, amongst others, to sign a petition demanding a change of architect. But decorated with civilising phrases, written by Paul Valéry, the Palais de Chaillot struck the perfect chord of corporate anonymity mixed with the usual aspirations to higher goals. Just down the hill, set on the axis, was the 50-metre-high bronze 'Monument to Peace', based, with apparently no sense of irony, on the blatantly unpacific Trajan's Column. Close by, the Palais de Tokyo, a rather more successful building, was designed as an exhibition space for the display of contemporary art.

The illusory sense of permanency that emanated from these buildings, coupled with the national pavilions and their well-thought-out exhibitions, contrasted with the ephemeral and often spontaneous, last-minute entertainments. Fountains, gardens and the ever-present silhouette of the Eiffel Tower provided the backdrop for spectacular firework displays along the banks of the gently lapping Seine, organised by the Spanish engineer Carlos Buigas, and accompanied by music written especially for the occasion by Honneger, Milhaud, Auric, Ibert and Messiaen. If the Expo was primarily didactic, it was also fun. Electric trams ferried visitors around the site, there was a fun fair, a celebration of French regional cuisine, and every day the loudspeaker systems alerted visitors to the day's extra events. The artist Amédée Ozenfant was swept off his feet. 'It bowled me over, and how! Staggering: talk of grandeur! It is huge, varied, orderly, majestic and absolutely natural, relaxed, young. What a shock . . .'

The Spanish Pavilion opened to the public on 12 July, but closed the next day to finish off the installation as planned. It was the thirty-fifth out of a total of forty-two to open. Although it is a well-worn

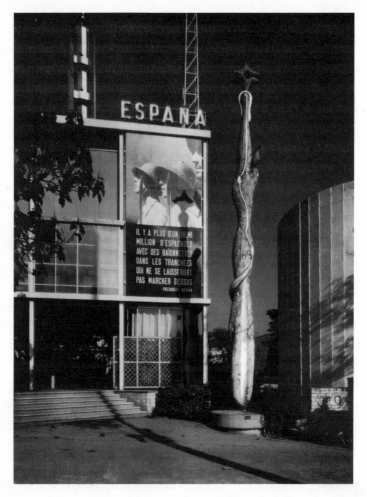

Exterior of the Spanish Pavilion with Alberto's sculpture,
The Spanish people have a path that leads to a star, 1937.

cliché that the Spanish have a particular gift for last-minute improvisation, at the Expo it was especially true. Under the circumstances,
in the middle of a fratricidal war that drained manpower, finances
and the human spirit, it is remarkable that it was finished at all – and a
miracle that it produced art of such enduring quality. In retrospect, it
is perhaps not surprising that the *comisarios* Jose Gaos, Jose Maria
Ucelay and Ventura Gassol were awarded gold medals for their
contribution to the Expo, but during the months April and May
1937 they cut it fine. Julio Gonzalez was not contracted to participate

until mid-April. Picasso had not started to paint until the middle of May. Miró had not yet put up the scaffolding to paint his engaging *Payés Catalán en Revolución (Catalan Peasant in Revolution)*. To get a sense of the overall layout and design philosophy for the exhibition must at times have driven the commissars close to madness.

Today, if the 1937 Exposition Internationale des Arts et Techniques dans la vie moderne is remembered for anything it is for the Spanish Pavilion, and specifically Picasso's *Guernica*. Back in the summer of 1937 it was quite different. Modernism, 'rationalism', or the International Style as it was known, appealed only to a tiny minority. Descending the large processional staircase of the Palais de Chaillot into the exhibition, and on down past the ornamental fountains and the serried ranks of exhibitors' national flags, visitors found that it was the pavilions of the Soviet Union and Nazi Germany's Deutsches Haus, flanking the entrance to the Jena bridge, that immediately stole the show. These two giant stone monoliths were about as blatantly political as architecture ever gets. Albert Speer's classical block was in direct response to his having had a sneak preview of the maquette for Boris Iofán's Soviet Pavilion. And it gave Speer a clear advantage. With scale and simplicity he would dwarf Iofán's advancing blocks of stone. And where Vera Mujina had modelled a massive 25-metre-high sculpture of an idealised pair of workers, anvil and scythe in hand, charging forward to take charge of their proletarian future, Speer countered with a Nazi eagle, claws dug deep into the swastika, peering down ready to pick them off. The two pavilions were united in their opposition, like a Marxist dialectic in stone. It was, in the words of Eric Hobsbawm, nothing more than 'pomp and gigantism', the twentieth century's version of the great pyramids at Gizeh. But Speer was also inspired by the modern, and in particular Raymond Hood's take on the sculptural potential of the skyscraper in New York. What Hood had managed to do at the *Daily News* building and more dramatically at the Chrysler Tower, was to turn architecture into advertising. Ideology and corporate identity are the interchangeable realities of the age of mass production and mass indoctrination.

The Italian Pavilion, designed by Marcello Piacentini, proved that

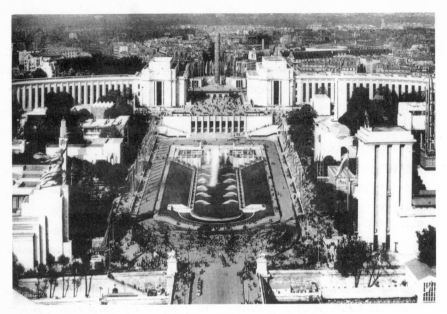

A view of the Exposition Internationale looking towards the Palais de Chaillot, 1937.
In foreground left the Soviet Pavilion and on the right the pavilion of
Nazi Germany, obscuring its neighbour the Spanish Pavilion.

elegance and totalitarian regimes were not mutually exclusive. But the
Expo was not just an opportunity for the new totalitarian states to flex
their architectural muscles. Sakakura's Japanese Pavilion and the
young Alvar Aalto's Finnish Pavilion were both inspirational exam-
ples of the rationalist style, showing off the full expressive potential of
glass and steel. The British Pavilion, designed by Oliver Hill, most
famous for his Midland Hotel at Morecambe Bay, also housed works
by John Nash, Eric Ravilious, Edward McKnight Kauffer and Edward
Bawden. The most stunning exhibit of all was a 30-foot-long engraved
glass panel by Gertrude Hermes. Alongside the craft and trade displays
there was also a parochial selection of hunting, fishing and tennis
scenes that flew straight in the face of the predominant political mood.
It was pure escapism, crowned by the comically appropriate card-
board cutout of Neville Chamberlain, the new Prime Minister, 'gone
fishing', and a bizarre response to the exhibition organiser's guiding
remit to celebrate *Arts et Techniques dans la Vie Moderne.*
 One of the most successful exhibits was the Palais de l'Électricité,

designed by Robert Mallet Stevens, who ended up designing six pavilions. Raoul Dufy completed the largest mural in the world, dedicated to *La Fée électricité* (The Electricity Fairy), measuring an astonishing 10 × 60 metres. In his typically bright palette, Dufy managed to mix the bucolic pleasures of windswept wheatfields with power generators, as a series of benign gods looked down upon a wonderful futurist vision where the rural past and the mechanised future live for ever in perfect harmony. In total, 300 artists of varying renown completed specific commissions for the Expo. Fernand Léger's mural *Le Transport des Forces*, housed in the Palace of Discovery, provided ample proof that an artist's creative capacities didn't need to fall off when faced with a large commission whose subject was already strictly defined. Another impressive series of abstract murals that covered 19,000 square feet of wall at the *Palais de Chemin de Fer*, in an explosion of kaleidoscopic colours, was awarded to Robert and Sonia Delaunay, the stars of the 1925 Exposition des Arts-Décoratifs. Although the pavilions often proved entertaining they were essentially didactic. The Pavillion de la Défense Passive, which came to life with air-raid sirens and exhibits of gas masks, brought the visitor quickly back down to earth.

Next door to the Spanish Pavilion on one side was the Polish Pavilion and behind it the Pontifical Pavilion. Considering the Archbishop of Toledo, Cardinal Isidro Gomá y Tomás's active support for Franco, and his virulent hatred of the 'Reds' – the 'sons of Cain', as they came to be known – it is perhaps not surprising that the Vatican was in favour of exhibiting work that was highly critical of the Republic. Goma's pastoral messages had always been inflammatory but it was at the behest of the Vatican Secretary of State, Cardinal Pacelli, that he put pen to paper and stated his policy on the rebellious Basque Catholics who continued to support the Republican cause. On 1 July 1937, the encyclical 'To the Bishops of the Whole World' was published, in which the Catholic Church legitimised the military rebellion.

On entering the Pontifical Pavilion the spectator was immediately brought face to face with José Maria Sert's huge, 6 × 3-metre canvas, entitled *St Teresa, Ambassadress of Divine Love to Spain, Offers to*

Our Lord the Spanish Martyrs of 1936, a work which had been specifically commissioned by Cardinal Goma. In the painting the crucified Christ swoops down like a fighter pilot in a dizzying aerial display to meet St Teresa from whom he receives the souls of the stricken martyrs. At her feet are the bishops and below them their flock, a perfect expression of the hierarchy so blessed by Franco and Goma's Church. Sert had always been a brilliant practitioner of mural painting, mixing the influences of Piranesi, Tiepolo and Goya into an alluring modern cocktail of *trompe-l'œil* theatricality. Fashionable, wealthy and well-connected, Sert had become a close member of the Picasso circle while living in Paris. He also happened to be the uncle of Josep Lluís Sert. Like so many of his friends, José María had been a supporter of the Republic during its Golden Age, and in 1936 had even been commissioned to paint a mural for the Council Chamber of the League of Nations in Geneva. Allegedly, following Sert's arrest as a 'Red' in late autumn 1936, Franco's brother-in-law and *éminence grise*, Ramón Serrano Súñer, offered to commute his death sentence if he publicly switched sides. Sert did. It was a huge propaganda coup,

and a clear warning to any Spanish artist living in exile of what to expect if they were foolish, or unlucky, enough to face capture by Franco's troops. What is absolutely certain is that the burning of Sert's murals at Vic cathedral on 21 July 1936 by Republican sympathisers had a profound effect on his political outlook. In mid-1937 he presented himself at the Nationalist headquarters in Burgos and offered to help Franco's cause. It is no coincidence that the burning church depicted in *St Teresa* happens to be the cathedral at Vic.

Josep Lluís Sert, 1937.

In the shadow of Speer's massive statement lay Josep Lluís Sert and Lacasa's modest offering. The Nazi machine had already demonstrated at Gernika that in modern warfare there were no longer any taboos. The Republican government's only viable response was to use the pavilion as an opportunity to underpin its legitimacy, highlight its suffering and demonstrate its resilience. In terms of quality of art, after all, what were Arno Breker's superhuman Teutonic males in comparison to Picasso's *Guernica*?

The Spanish Pavilion, it was obvious, could only draw on a fraction of the budget of its imperious neighbour. And, with the Pontifical Pavilion sited immediately behind, it must have felt hemmed in. When Gaos replaced the previous commissar Carlos de Batlle, following Largo Caballero's appointment as Prime Minister in September 1936, his first choice for architect was Luis Lacasa. Lacasa was cosmopolitan; he had lived in Paris and also worked in Dresden's city planning department from where he had often visited the Bauhaus. Although he was an accomplished architect, his real strengths lay as a theorist. Lacasa was also an active member of the Spanish Communist Party. His credentials were perfect, but it was only when he teamed up with Josep Lluís Sert, and later on with Antoni Bonet, that the trio were able to produce the most emblematic and successful Spanish building in the rationalist idiom.

Early on in the planning stage the architects and potential exhibitors, including Picasso, Miró, González and the sculptor Alberto Sánchez, met at the Spanish Tourist Office in the Boulevard de La Madeleine, to hammer out their plans. On 27 February 1937 the first stone was laid. Lacasa hoped that when finished, it would sing out 'the glories of the *pueblos* of Spain' in all their diversity. The site, set amongst the mature trees of the Trocadéro gardens, permitted Sert and Lacasa to landscape their pavilion in a way that neither the Soviet nor the Nazi Pavilion had managed to do. In essence, the design was engagingly simple. The ground floor, sitting on a masonry base, was left open, with regularly spaced steel *pilotis*, functioning as stilts, supporting two further floors. The first impression was of lightness,

and of a space that was fluid and open. And, in contrast to the anchored colossus of Nazi Germany, it appeared to float. It had been Sert's inspired idea, faced with the impossible build schedule, to forget the more 'noble' use of stone and brick and go for prefabricated elements which put greater emphasis on the fenestration. The spartan application of colour, with the metal painted red or white, and the dull greyness of the corrugated fibre cement boards on sections of the second floor, reasserted once again the building's functionality and driving rationale.

Surprisingly, and completely out of tune with the Expo's theme, the Republic side-stepped the brief, to focus not on industrial design but on art and propaganda. On the first floor it was planned to exhibit documentary material, including maps and photographs, that would focus on and celebrate the Republic's real achievements in education, and particularly its successful provision of greater accessibility to the arts. The logic of how the pavilion worked as an exhibition space, however, was cleverly turned on its head. An exterior ramp delivered the visitor to an entrance on the second floor, providing access to the first floor only via an interior staircase.

The first approach towards the pavilion was marked by the imposing 12.5-metre-high sculpture by Alberto Sánchez. Alberto, one-time baker and trade union activist, and until recently, according to Juan Manuel Bonet, 'Spain's best kept secret', was the quintessential model of the proletariat artist ennobled by the arts. Profoundly inspired by nature, he had designed for the pavilion a giant cement totem pole that rose out of the desert like a cactus, and was placed on top of a miller's grinding stone. The telluric pull of his work was matched by his choice of a disarmingly literal, almost utopian title, *El Pueblo Español Tiene un Camino que Conduzca a una Estrella* (*The Spanish People Have a Path that Leads to a Star*). Alberto's romantic tendencies provided a perfect foil to Julio González' welded iron depiction of a Catalan mother-earth figure, *La Montserrat*. The most horrific photos reproduced in the press had been those of women fleeing the aerial bombardment at Gernika. And, while the traditional image of the long-suffering,

devout Spanish peasant housewife, dressed all in black, remained current, there was also the 'new' woman of the Republic. A woman like the famous Communist leader Dolores Ibárurri, 'La Pasionaria', who was ready to stand in the trenches shoulder to shoulder with her menfolk but who drew her inner strength from historical archetypes like *La Montserrat*. On the other side of the entrance area stood Picasso's *Woman's Head*, bringing together the modern and the archaic in a way that represented most poignantly the pavilion's unspoken theme.

Once past the three sculptures it was the exterior of the pavilion that immediately grabbed the visitor's attention, covered as it was with blown-up photomontages, accompanied by pertinent selections of statistics and quotes from the Republic's President Manuel Azaña. The visitor was then invited in under the building through a sheltered courtyard towards a theatre stage, from where at an angle to the left a concrete slope rose gently in a gracious arc. It was here, in passing, that visitors first came face to face with the shock of *Guernica*. Following the itinerary, and having scaled the ramp directly to the second floor, they were immediately introduced, through a selection of paintings, drawings, posters and photomontage, to the theme of the Civil War. José Renau was particularly powerful in his graphic, direct and punchy style. In one photomontage lorries transport El Greco's *Trinity* from the Prado to the safety of Valencia, in a fine piece of propaganda designed to highlight the fact that the 'Reds' were actually the saviours of culture, not its destroyers, as Franco would have the public believe. A collection of Spanish contemporary art was displayed on interior panels. If the public, prior to the visit, had been warned of Picasso's horrifying mural, it was abundantly clear that he didn't hold the copyright on depicting anguish and pain. Works by Arturo Souto, Rodriquez Luna, Miguel Prieto, Mateo, Puyol, Horacio Ferrer and Edouardo Vicente dealt almost exclusively with the horrors of the Civil War. Painting predominantly in a palette of black and brown, these artists scratched, and laid on with their palette knife their passionate records of what they had seen of the bombings, starvation, torture and destitution. The most disturbing of all, and already well known to the

The vitrine display in homage to Federico García Lorca in the Spanish Pavilion, 1937.

Parisian public, was the work of José Gutiérrez Solana, whose paintings focused on the rituals and superstitions of the old dark inquisitorial Spain and its obsession with death.

Another profoundly moving element of the exhibition was the homage paid to important cultural figures who had already become victims of the war. García Lorca was represented by a photo, and the two realist sculptors Emiliano Barral and Francisco Pérez Mateo were exhibited in a place of honour amongst the work of their peers, including Picasso's *Head of a Woman*, immortalised in the *Vollard Suite*, and the *Woman with Vase* that would later stand on Picasso's tomb. There were specific areas throughout the pavilion that made it feel less like an exhibition than an obituary. It illustrated perfectly Antonio Machado's sentiments expressed in his famous concluding stanza from the *Proverbs and Song Verse*:

> Think of it: a Spaniard
> wanting to live, starting in
> with a Spain on one side of him dying
> and a Spain all yawns on the other,
> may God preserve you.
> One of these two Spains
> will make your blood run cold.

Further along the large top-lit space a selection of the works from Bilbao's Museum of Fine Arts and a collection of Catalan work was

placed. Unfortunately, precise records of everything displayed have now disappeared, as did many of the works, following their return to Valencia and Franco's subsequent victory. To make the exhibition less overbearing and more overtly democratic, the applied arts were well represented, with pottery, textiles, tools, basketweaving, embroidery, jewellery and an impressive collection of traditional costumes, these last proving highly popular. From there the visitor took the stairs down to the first floor, passing Miró's *Catalan Peasant in Revolution*, a large-scale mural measuring 5.5 × 3.65 metres, painted directly on to panels of 'celotex'. It was a technique that Miró described as 'direct and brutal', and it is clear that the luminous paint was applied with a controlled fury. Twisted into a grotesque parody of a peasant carrying a scythe, a theme close to both Millet and van Gogh, Miró's peasant is placed dramatically against a black background and transformed into a symbol of human suffering. In its way it is almost as pessimistic as *Guernica*, transforming the nobility of the Catalan peasant into a lunatic carnival scene. As a companion piece to Miró's striking poster *Aidez l'Espagne* it demonstrated perfectly how even the most avant-garde style could be effectively harnassed in service of the greater cause.

Once on the first floor, the spectator was introduced to the finer detail of the Republic's programme of reforms. There were fascinating panels that dealt with the pioneering work of the Misiones Pedagógicas, the Catalan schools project, the planned agricultural reforms, the mercury mines at Almaden and Madrid's new university campus which had been partially destroyed during the siege. Considering the complexity of arranging a thematic exhibition with display material running from dry statistics through everyday artefacts, to propaganda posters, Social-Realist works and the most advanced examples of the avant-garde, Gaos and his design team had put together a convincing and absorbing narrative. Once outside, the real test of their curatorship skills came on the open ground floor. Supported by the slender *pilotis*, the two floors above cast the open loggia into shade. And it was here that *Guernica* covered the

entire end wall, with only Alexander Calder's *Mercury Fountain* placed directly in front of it to disturb the viewer's gaze.

What was immediately apparent was that whereas Picasso's initial idea of the *Artist in His Studio* echoed the expansive openness of the building, *Guernica*, with its claustrophobic structure, was in direct contrast to Sert's cool and rational space, creating a palpable tension that was strangely unnerving. The energy and focus of *Guernica* pulled the eye inwards to the centre of its chaos, towards a vacuum that Picasso had created between the sunburst light and the horse's wound. Lacasa's sensitivity to the site, where the large overhanging trees were used to filter the sunlight, and Sert's ingenious use of a retractable canopy over the adjacent theatre, potentially trans-formed the entire space into an area of quiet contemplation. It felt distinctly Mediterranean, like a modern-day version of a classical Greek setting where the arts, public debate and the tragedies of *Orestes* and the *Iliad* sat side by side with hellenistic mosaics and images of war that encircled a simple Attic vase. It also drew its inspiration, it has been suggested, from the typical Golden Age *corral de comedias*, the intimate neighbourhood theatres in old-town Madrid where works by Cervantes, Calderón and Lope de Vega had been performed.

Guernica had tapped into the ancient and epic rituals of death. But it was also a silent requiem. The contorted, grief-stricken faces of women, with their gaping cup-shaped mouths, seem to wail up to the heavens in despair. But there is no sound. The screaming horse, with its vocal chords cut – as was the practice before horses were supplied with padding during the *corrida* – also remains silent in its pain. *Guernica* symbolised a requiem for an entire generation. But how, considering the extraordinary power of the image, was *Guernica* received by the general audience that strolled through the pavilion every day?

On 11 July, one day before the official opening, the pavilion's construction workers gathered together in a simple ceremony to celebrate their achievement. Max Aub gave a short but moving address in French:

It seems almost impossible in the struggle that we are conducting, that the Spanish Republic has been able to construct this building. There is in it, as in everything of ours, something of a miracle. I am not speaking of the construction itself, the result of the work of our architects Lacasa and Sert, and of yourselves. Man has invented work and it in turn has shaped us. The rest is paralysis, putrefaction, and death.

At the entrance, on the right Picasso's great painting leaps into view. It will be spoken of for a long time. Picasso has represented here the tragedy of Gernika. It is possible that this art be accused of being too abstract or difficult for a pavilion like ours which seeks to be above all, and before everything else, popular manifestation. This is not the moment to justify ourselves, but I am certain that with a little good will, everybody will perceive the rage, the desperation, and the terrible protest that this canvas signifies . . . To those who protest saying that things are not thus, one must answer asking if they do not have two eyes to see the terrible reality of Spain. If the picture by Picasso has any defect it is that it is too real, too terribly true, atrociously true.

On the following day the official opening took place, attended by the new Spanish Ambassador Ángel Ossorio y Gallardo, just weeks into his new post, and the commissar of the entire Expo, Edmond Labbé, as well as José Gaos and many of the artists represented in the pavilion. If the audience had expected diplomacy to take the place of Aub's passionate address of the previous day, it was mistaken. There was talk of 'titanic labours' and of 'immortal and glorious Spain's struggle to defend the rights of intelligence'. It was a fine piece of propaganda. But what surely must have made Labbé shuffle uncomfortably in his shoes was the chilling observation that, 'We would have to be blind not to listen to this prediction. A Spain that is crushed, means a France surrounded.' The celebration ended with a performance by a Catalan *cobla* band, a delight for Picasso who decades before had crystallised the *cobla*'s music into the hermetic Cubist works he had produced in the Catalan village of Céret.

Surprisingly, considering the prestige of Picasso's *Guernica*, it

appears that the Basque government were not overly enamoured of the painting. Whether this was a hangover from two months before, when they felt they had been strong-armed into its commission, or because they simply failed to see anything in the painting that spoke of their appalling predicament, is hard to say. But it has been suggested that Picasso was understandably upset by the lack of enthusiasm shown by the Basque PNV (Nationalist Party) delegate Manuel de Irujo who failed to take up his invitation to see *Guernica* being painted. A far greater slight to Picasso was the less than enthusiastic response shown by President Aguirre. 'If President Aguirre asks for it, the painting is for the Basque people.' Picasso had offered. But Aguirre declined. Perhaps he shared the same kind of festering repulsion as Ucelay, who said, 'as a work of art, it's one of the poorest things ever produced in the world. It has no sense of composition, or for that matter anything . . . it's just 7 × 3 metres of pornography, shitting on Gernika, on Euskadi, on everything.'

Picasso hoped, as did friends like Louis Aragon, that *Guernica* would appeal to the workers. Edouard Pignon, son of a miner and member of a Communist trade union, wrote in *La Quête de la réalité* (*The Quest for Reality*), 'As for the working class, in fact, it never saw it.' Others like Paul Nizan, a close friend of Jean-Paul Sartre, argued that Picasso's art was both ivory tower and effete, and suggested that all attempts to bourgeoisify the workers with the art of their masters would fail. As criticism this must have hurt. More laughable, but still prickly enough for Picasso to keep it on file until his death, was German criticism of the work. Considering the subject matter, it was never likely that it was going to go down well in the corridors of the Reichs Chancellery in Berlin. In the German fair guide the Spanish Pavilion was criticised for its all-round poverty, and *Guernica* received the special opprobrium of being dismissed as a 'hodgepodge of body parts that any four-year-old could have painted'. In July the *Entartete Kunst* (*Degenerate Art*) show opened in Munich which gave the clearest signal of what the Germans thought of that type of expressive art.

Perhaps, the most famous response to the painting was that of Le

Interior of the Spanish Pavilion looking towards *Guernica* from the stage.
On the left, the tables of Rementaria's café-restaurant.

Corbusier who claimed that no one looked at *Guernica* because they
all had their backs to it. But his implied criticism was merely a
statement of fact. *Guernica* had been placed in the most public of all
the spaces, which explained in part its graphic immediacy and
power. Behind the theatre's stage was a small cinema which every
afternoon screened films like Carlos Velo's *El Escorial y Felipe II*,
and documentaries as diverse as *Almadrabas*, which focused on the
tuna fishery in Cadiz Bay, Luis Buñuel's *Las Hurdes*, Ernest Hemi-
ngway and Joris Ivens's film *Spanish Earth* and Nemesio M.
Sobrevila's film on the recent bombardment, entitled *Guernika*.
The films were screened in the gaps between plays. Occasionally
La Barraca performed works by Lope de Vega, Tirso de Molina and
Juan Encina, while other theatrical troupes brought to the stage
Golden Age classics like Calderón's *auto-sacramentales*. One of the
most gripping performances planned was La Barraca's performance
of Lope's *Fuenteovejuna*, a melodrama of lust and feudal politics,

with backdrops designed by Alberto. Without a doubt, the most popular entertainment were the daily folklore performances by the Segovian guitarist Agapito Marazuela who had dedicated his life to rescuing folksongs from obscurity and keeping antiquated instruments like the *dulzaina* in the repertory. Accompanied by female dance troupes from Castile dancing their *jotas*, with a performance every half-hour, concentration on *Guernica* was at times difficult. And, doubly so, considering that the last pair of tables of Antonio Rementaria's Basque-style café almost touched the painting.

In the twelfth issue of *Cahiers d'Art*, Ozenfant's Expo diary entry reads:

> SUNDAY: I am writing at a little table in the Spanish pavilion's Catalan tavern. Painful. A show of Spanish suffering . . . *Guernica* makes one *feel* the terrible drama of a great people abandoned to mediaeval tyrants, and makes one *think* about it.

Overhearing a mother describing to her daughter the effect of photographs of Civil War atrocities, Ozenfant was struck by her use of imagery. 'How dreadful all that is! It makes my back tickle, as if a spider had been put down my neck.' Then, looking at *Guernica*, she told her child: 'I don't know what that's meant to be, but it gives me a very queer feeling. Queer, it makes me, just as if somebody's cutting me in pieces.'

The renowned chemist Francisco Giral, who happened to be in Paris attending an international conference hosted by Frédéric and Irene Joliot-Curie, managed to slip away one afternoon to see the Spanish Pavilion which was inundated with a river of visitors. 'Le tout Paris' was there, according to Giral: 'it was the coming together of the world's intelligentsia, and the perfect marriage of reason, sensibility and thought'. Allowing for Giral's enthusiasm – he would later become President of Acción Republicana Democrática Española – the pavilion was just one part of a far larger programme celebrating Spanish culture. There was a homage to Federico García Lorca in the Salle Jena and Agapito Marazuela played to a full house

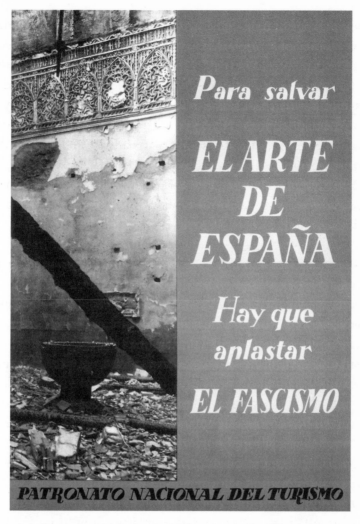

Para salvar el arte de espana Hay que aplastar el Fascismo
(To save art in Spain Fascism must be crushed) – republican propaganda poster, 1937.

in the Salle Pléyel. Picasso was one of ten artists showing in the Palais de Chaillot celebrating the pre-eminence of the School of Paris, while at the Maison Lafitte the Bilbao Museum of Fine Arts displayed its collection, and at the Jeu de Paume the world-famous collection of Catalan romanesque art also drew in the crowds. Here at least was concrete proof that Franco's propaganda, branding the Republicans a mob of crazed iconoclasts, was a hollow sham.

There was one criticism that stuck, and would continue to plague *Guernica*'s public reception for years. For many, *Guernica* was obscure, its Cubist style difficult, and its subject matter deliberately enigmatic. One of the first critics to pursue this line was Anthony Blunt. In the *Spectator* on 6 August 1937 he wrote:

> The painting is disillusioning. Fundamentally it is the same as Picasso's bull-fight scenes. It is not an act of public mourning, but the expression of a private brain-storm which gives no evidence that Picasso has realised the political significance of Guernica.

Blunt was wrong. In conversation with Brassaï on 9 April 1944, Picasso recalled:

> the Spanish like violence, cruelty, they like blood, like to see blood flow, stream – the blood of horses, the blood of bulls, the blood of men. Whether it's the 'Whites' or the 'Reds', whether they're flaying priests or communists, there's always the same pleasure in seeing blood flow. In that respect, they're unbeatable.

Picasso knew the horror of the situation perfectly well. Soon enough Blunt's doctrinaire beliefs gave rise to a heated exchange with Herbert Read in the letters page of the *Spectator*. On 8 October Blunt allowed for the fact that Picasso's feelings were genuine, but argued that he depicted 'useless horror' which 'cannot reach more than the limited coterie of aesthetes'. As a riposte, Read dismissed Blunt as just one of those 'middle-class doctrinaires who wished to use art for the propagation of their dull ideas'. And he reminded him pertinently on 15 October 1937 that: 'This painting is virtually in the marketplace, where Mr Blunt wishes to see all art, and hundreds of thousands of people have seen it and, as I can testify from personal observation, accepted it with the respect and wonder which all great works of art inspire.' The debate was only just warming up, and would reach a passionate climax in October the following year.

Across the Channel *Guernica* had also won other supporters. The

Penrose circle had been immediately impressed but so too had the less well-known art critic Myfanwy Evans. Along with her husband, the artist John Piper, she had co-edited the avant-garde magazine *Axis*. In her appreciation of *Guernica* she was extraordinarily perceptive. In a rather eccentric collection of essays discussing the works of Léger, Moore, Ernst, Picasso, Kandinsky and Ozenfant, entitled *The Painter's Object*, published by Curwen Press in 1937, Evans laid down her visceral response to Picasso's masterpiece. In two paragraphs Myfanwy Evans had managed to condense and predict accurately many of the arguments that would surround *Guernica* for the next few decades.

Picasso has done an enormous mural for the Spanish pavilion in the Paris exhibition. It is a terrible picture of atrocities that would turn one's hair white if one met them in real life. It is not gently composed to soften the blow, either; not a Laocoön picture. Nor is it the wild testament of a man distracted by the thought of his tortured country, and least of all is it a 'Red Government' poster screaming horrors to a panic-stricken intelligentsia. It is a passionate recognition of the facts, so purged as to become almost detached statement, and ultimately so unrealistic as to be almost as abstract as his most abstract painting. Yet only a Spaniard could have done it because only a Spaniard could have exploited in just that way with the present events in Spain. It is not *qua* Spaniard that he is able to do it, but as a member of a suffering race he is able to feel its sufferings and live them and use them entirely for his own ends. Picasso himself could never have a *Guernica* for France or Germany or England in the Great War – then he was exploiting his detachment. To-day he is exploiting his actual implication – but all the time towards purging, resolving. And all the time whether in war or out of war, implicated or not implicated, whether apparently abstract or apparently realistic, the detachment is in the painting and not in the feeling; that is what gives his abstract pictures life and makes *Guernica* a great painting and not just a piece of sentimental political propaganda. What happens when the picture is done, is, as Picasso points out, quite a different matter. As a picture

it is destroyed and becomes something else. It may be used as propaganda. If so, it is just luck for the propagandists that they find it suitable. It may be used as a scourge to whip other artists into paying more attention to the world's daily crises and less to the single purpose of their art; but they above all have to remember, that it was not as a fosterer of crises that Picasso painted *Guernica* any more than it was when he painted the still life at the beginning of this book.

Purging into formality: it is the old classical and romantic tale, and those who cannot see the table, wineglass and guitar, the bare bones, the abstract qualities beneath the shattered limbs and the blood of *Guernica*, will only be overcome by the sadistic horror of it, and indulge themselves to madness by continually resurrecting a half-understood nightmare, that is to some, in the first place, only half heard.

One cannot compare Picasso's way of keeping alive to-day, his way of turning his experience to account, his hilarious reply to the dreary charge of escapism, with the ways of other painters and sculptors without elaborate and yet groping qualifications and additions. The most surprising thing about his genius is the extraordinary rapidity with which the most raw and unselected experiences pass through his system (to use his own digestive metaphor). He takes in anything, denies nothing: he makes no pre-choice of meal, has no use for menus. He is the king of racketeers for quick turnover: he uses all materials and has a genius for by-products. It is not until he has swallowed them that they are submitted to his own special formula, that they are purged. And it is that that gives them their curious double and separate existence. At once classical and romantic, *but not fused*. If Picasso made an abstract sketch of his *Guernica* picture (as one might make an abstract sketch of a Poussin) putting in the most important lines and shapes formally and leaving out the detail, we should have, not a framework, without life and pointless, but a new picture, complete, and full of a special life of its own. But in Poussin the two pictures would be inseparable (the classical and the romantic one), and an abstract would only look like a student's blocked-in sketch for a museum copy. To-day, as a Spaniard, Picasso has the extra capacity for absorbing and the extra right to express the most

violent emotions, but his whole practice as an artist has been to make a formal virtue out of chaos, to exploit the incredible ruin and inconsequence and purposelessness of the world to-day by actually breaking things down and making a new order out of the bits (a cubist picture is the most obvious example of this, but it is true of his others too), formalising a figure or an object in chaos. And so a table, a wineglass and a guitar, which had no special significance in themselves, are in a picture, in their breaking down, charged with life and become almost formal symbols for *life* to-day. While *Guernica*, which was in fact charged with unbearably violent emotion, becomes in the picture a formal symbol for *art* to-day.

Evans had correctly concluded that long after the Expo gates had closed the painting would have an entire life of its own. She also observed that the battle between the classical and the romantic style trapped within the painting echoed the violent subject matter, lending it extra resonance and giving it an added depth of meaning.

In Paris, Picasso's friend Christian Zervos, the editor of *Cahiers d'Art*, had spent most of 1937 trying to make sense of the evolution of Picasso's work in direct response to the Spanish Civil War. Obsessed with Picasso's *oeuvre*, Zervos was brought to a feverish state of excitement by *Guernica*, as if his critical antennae and sensory organs had been set on fire:

In *Guernica*, expressed in the most striking manner, is a world of despair, where death is everywhere; everywhere is crime, chaos, and desolation; disaster more violent than lightning, flood, and hurricane, for everything there is hostile, uncontrollable, beyond understanding, whence rise the heart-rending cries of beings dying because of men's cruelty. From Picasso's paintbrush explode phantoms of distress, anguish, terror, insurmountable pain, massacres, and finally peace found in death.

Cahiers d'Art's support for Picasso was quickly transformed into a campaign. In the Spring issue the magazine had reproduced *Songe*

et Mensonge, an article by José Bergamin linking Picasso to Goya, and a powerful poem by Paul Eluard who had in effect become *Guernica*'s amanuensis. In *The Victory of Guernica*, translated by Roland Penrose, Eluard had written the following lines:

> The women the children have the same treasure
> In their eyes
> The men defend it as best they can
>
> The women the children have the same red roses
> In their eyes
> All show their blood
> The fear and the courage of living and of dying
> Death so hard and so easy
>
> Men for whom this treasure was extolled
> Men for whom this treasure was spoiled
> Real men for whom despair
>
> Feeds the devouring fire of hope
> Let us open together the last bud of the future
>
> Pariahs
> Death earth and the vileness of our enemies
> Have the monotonous colour of our night
> The day will be ours

In *Guernica* Eluard had discovered what is often so easily missed, the phantom presence of a flower at the warrior's right hand that seemed to promise rebirth. Both the poem and the painting enjoyed an almost symbiotic relationship, sharing many of the same ideas and imagery. And the text had been placed in a prominent position in the pavilion, near the photo of García Lorca. Josep Lluís Sert felt the kinship between painting and poem strongly: 'I think there is a lot of the poem in the picture and a lot of the picture in the poem.'

Bergamin, on the other hand, wrote of 'the struggle it cost the painter to press his poetry to the ultimate nakedness'. Each of the contributors to *Cahiers d'Art* had their individual take. In the Summer issue no. 12 Jean Cassou wrote evocatively of the almost umbilical link between Goya and Picasso:

> Goya is brought back to life as Picasso; but at the same time, Picasso has been reborn as Picasso. It had been the immense ambition of his genius to keep himself forever apart, denying his own being, making himself live and carry on outside his own realm – like a ghost frenzied to see his vacant home, his lost body. The home has been found again, both body and soul; everything that calls itself Goya, that calls itself Spain has been reintegrated. Picasso has been reunited with his homeland.

Michel Leiris was even more familiar and matter-of-fact, describing *Guernica* as merely 'the world transformed into a furnished room'. These 'black-and-white exhalations of a dying world' threatened, in the words of Leiris, to represent all our lives. For Bergamin the painting smacked of finality: 'It tells us the truth. Doubt is no longer possible.'

Nobody in the summer of 1937 could possibly have predicted how the war in Spain might end. And Picasso could never have known that he would never see his homeland again. In the pavilion, he had symbolically left his shoes outside the door, like a Muslim entering the mosque or a Jew treading on the sandy floor of the synagogue, to walk once again on the brown earth of Spain. *Guernica* was his homeland, his waste land, his burnt-out pile.

3

Homer at the Whitechapel

Who in Europe does not know that one more war in the west and the civilisation of the ages will fall with as great a shock as that of Rome?
Stanley Baldwin to the Classical Association (1927)

Victory finds a hundred fathers but defeat is always an orphan.
Count Ciano

For Picasso and the Republican government-in-exile it was important that other European countries should also 'see' the truth that *Guernica* had so passionately represented. As a propaganda exercise there was still plenty of mileage in alerting the wider public to both the tragedy of the Civil War and the illegitimacy of Franco's Nationalists. And hopefully a travelling exhibition might also raise money for Spanish refugees and encourage volunteers to join the International Brigade. The Summer issue of *Cahiers d'Art* had clearly demonstrated to Picasso, if he was ever in any doubt, that *Guernica* had achieved something extraordinary. To create a work that succeeded as propaganda, while still remaining original and true to the artist, was already a rare enough achievement. But Picasso had also cleverly managed to dramatise an actual historical event without his treatment becoming overly literal, clichéd or histrionic. It was this honesty that gave *Guernica* such a peculiar and special status. Painted on the scale of the nineteenth-century Salon *grandes machines* – those pompous history paintings that tended towards the maudlin – it maintained the freshness and immediacy of a large banner or a theatre backdrop.

In the immediate aftermath of the Expo there was no indication

that Picasso had become either precious or obsessively protective about the painting. It had a job to do. It was as simple as that. And like a theatre backdrop, it could be easily untacked and rolled round a tube ready for transport. In the spring of 1938 Paul Rosenberg, the dealer who had usurped D. H. Kahnweiler's role as the exclusive conduit for Picasso's work, had organised a four-man extravaganza comprising 118 works by Picasso, Matisse, Braque and Henri Laurens to tour around Scandinavia. The star exhibit was *Guernica*. From January to April the punishing schedule took in the Kunstnernes Hus in Oslo, the Statens Museum for Kunst in Copenhagen, the Liljevalchs Konsthall in Stockholm and terminated at the Konsthallen in Göteborg. On *Guernica*'s return it was stored safely back at rue des Grands-Augustins but it was already clear that Juan Larrea and Roland Penrose had been in correspondence discussing a possible exhibition in London. For Larrea this made clear tactical sense, as it remained absolutely imperative that Britain should rethink its stand on the Non-Intervention policy that had proved so damaging to the Republic's war effort. On 12 February 1938 Larrea wrote to Penrose:

We want the exhibition to happen with the maximum force and solemnity, both for Picasso himself since the more admired he is the more useful he will be to our cause, and for our cause itself since this is one of the rare means we have to reach that sector of the public for whom this kind of argument may prove convincing. The question of making money is only a secondary consideration.

Since that dinner the previous year, on 21 June 1937, when Penrose and Moore had seen *Guernica* at rue des Grands-Augustins, Penrose had worked hard to secure a London show. If confronted directly by the dramatic work, Penrose hoped, the British public might finally be allowed to judge for themselves whether Blunt's criticisms amounted to more than Marxist dogma.

By the summer of 1938 Britain's artists and intelligentsia had become increasingly obsessed with the idea that the Spanish Civil

War could only escalate into a broader European conflict. As in France, Britain had already lived for fifteen years with scaremongers fuelling pessimism and despair. As early as 1925 Liddell Hart had described in his book *Paris or the Future of War* a frightening scenario of what the future might bring:

> Imagine for a moment London, Manchester, Birmingham, and half a dozen other great centres simultaneously attacked, the business localities and Fleet Street wrecked, Whitehall a heap of ruins, the slum districts maddened into the impulse to break loose and maraud, the railways cut, factories destroyed. Would not the general will to resist vanish, and what use would be the still determined fractions of the nation, without organisation and central direction?

Popular war fiction went even further in dramatising the coming Armageddon. Titles like *The Black Death, Empty Victory, War upon Women, Menace, The Shape of Things to Come* and *What Happened to the Corbetts* did nothing to calm the nerves.

During the 1930s, despite economic depression and mass unemployment, the British art world remained remarkably vital, creative and politically engaged. With culture in crisis it was no longer viable to sit on the fence. There were too many battles to fight, not just against Fascism and the growing threat of Mosley's Blackshirts but also over questions of the artist's role in society. Spain had polarised politics. But it had also forced a rethink on artistic methods and ideology, and provoked a genuine attempt by artists to engage with their public while still retaining their artistic integrity. Myfanwy Evans's eight instalments of *Axis*, that ran from January 1935 until it folded in the winter of 1937, was a worthy attempt to internationalise the British art scene and provide a forum for debate. Just as important was the review *Circle*, the mouthpiece of the Constructivists, a group of exiles that included Walter Gropius, Naum Gabo and László Moholy-Nagy. Arguably, *Circle*'s most important convert, J. D. Bernal – a Marxist scientist and Cambridge crystallographer – had also, as it happened, accompanied Moore and

Penrose on the trip to Paris to see *Guernica*. For Bernal it was the intimate relationship between art and science that he found most inspiring. For Penrose, on the other hand, faced by what he saw as an increasingly absurd, cruel and chaotic world, it was Surrealism that signalled the way forward. In issue 1 of *Axis*, dated 1 January 1935, Geoffrey Grigson proposed a middle way and hoped that artists would have 'enough imaginative power to settle themselves actively between the new preraphaelites of *Minotaure* and the unconscious nihilists of extreme geometric abstraction'. It was not by chance that Grigson had picked on *Minotaure*, for increasingly in British art circles Picasso had become the new God; the one artist on whom almost everyone could agree.

Over the decade of the 1930s the galleries showing Picasso's work in London had rapidly expanded. Zwemmers had always been supporters, as had Alex Reid and Lefevre, but in 1933 Freddy Mayor and the irascible Douglas Cooper teamed up at the Mayor Gallery to provide another outlet. There was also the spacious New Burlington Gallery, in the heart of the West End, which was followed by the opening in summer 1938 of the London Gallery; an exciting new addition forged out of the partnership of Roland Penrose and the Belgian Surrealist E. L. T. Mesens. Picasso, in all those galleries, had become the touchstone. Leafing through the art reviews of the time in the *Listener*, the *Spectator*, Penrose's the *London Bulletin* and the *Left Review* reveals that hardly a single review failed to include Picasso as the reference mark against which to measure the show's success.

Battles over style were often bitter, but by 1937 these partisan interests appeared increasingly trivial when contrasted with the growing international crisis. For the Abstractionists, Surrealists and Realists there was now just one common enemy, Fascism. In 1933 the AIA, the Artists' International Association, was formed as an umbrella organisation united to fight the growing forces of Fascism. One of its prime objectives was to focus on propaganda by specialising initially in the manufacture of cartoons and posters. It must be admitted, however, that compared with the powerful

imagery produced by their Spanish colleagues, they were distinctly second rate. Despite their inexperience, the 1935 exhibition *Artist against Fascism*, in Soho Square, still managed to attract more than 6,000 visitors. One of the AIA's most important roles was to forge international links and it quickly set up contacts with the American Artists' Union and in Paris with Louis Aragon's Maison de la Culture and L'Association d'Ecrivains et d'Artistes Révolution-naires, which hosted a conference in Valencia the following summer, attended by the likes of Hemingway, Bergamin and Eluard.

By 1936 the AIA had mushroomed to 600 members that included artists as diverse as the old guard of Augustus John, Stanley Spencer, Vanessa Bell and Duncan Grant and the new wave of English Surrealists and the *Circle* group who buried their differences and brought in renowned artists such as Henry Moore, John Piper and Ben Nicholson. Other members included Roland Penrose, Eric Gill, Bill Coldstream, Claude Rogers and other artists of the nascent Euston Road Group. Fund-raising and awareness-raising exercises were at the heart of the AIA's programme and their central pre-occupation remained always Spain. In December 1936 the Artists Help Spain sale of donated works raised enough money for a field kitchen. Also of great symbolic importance was the AIA's donation of a handmade banner to the British battalion of the International Brigade to take into battle. But there were lighter manifestations of support as well, like an evening of cabaret in Marylebone's Seymour Hall, in March 1938, written by W. H. Auden and Benjamin Britten. As was to be expected, it was in the working-class areas of London, like Hammersmith, Whitechapel and the East End, where AIA supporters were often directly confronted by Mosley's mob, that the organisation was at its most dynamic. Working-class men like ambulance driver George Green, who had gone out to Spain emboldened by their idealism, wrote back from the front to explain why they had made the choice to go to war:

I've seen a few unemployed lads from the Clyde, and frightened clerks from Willesden stand up (without fortified positions) against an

artillery barrage that professional soldiers could not stand up to. And they did it because to hold the line here and now means that we can prevent this battle being fought again later on Hampstead Heath or the hills of Derbyshire . . .

Within a few months the AIA had paid for a field ambulance. To maximise its propaganda value it set off for Spain from Parliament Square. On 24 June 1937 the AIA co-sponsored a mass meeting at the Albert Hall in support of exiled Basque children with the National Joint Committee for Spanish Relief. Picasso had been invited but sent apologies – he could not attend because he was busy painting *Guernica*. Roland Penrose, Henry Moore and J. D. Bernal, who had been dining with him two nights earlier, rushed back to attend. And, when Paul Robeson finally appeared at the last minute the hall broke out in tumultuous applause.

The National Joint Committee for Spanish Relief had been set up in the autumn of 1936, and while the AIA had become increasingly less tolerant of the pacifist stance, it was one of the main reasons why Roland Penrose, a practising Quaker, readily accepted the post of Honorary Treasurer. Chaired by the formidable Duchess of Atholl, branded by Lord Rothermere's right-wing press the 'Red Duchess', the organisation immediately proved effective. Standing for the Conservative Party in the 1923 election, the Duchess of Atholl was the first woman in Scotland to be elected an MP. Her outward appearance bore resemblance to a highly principled 'humourless headmistress, slight, upright and uncompromising', and at first glance, she looked entirely conventional, a perfect product of her breeding. However, 'the fire which smouldered undetected in her small body had not', according to a contemporary observer, 'encountered the blast which was to fan it into a flame. When it did, the flame burned through party loyalties, social conventions, hereditary prejudices, and landed her in strange company.' Like George Steer she had been repelled by the Italian invasion of Ethiopia and the indiscriminate bombing of civilians. But it was the Spanish Civil War and the policy of Non-Intervention that disgusted her most. In

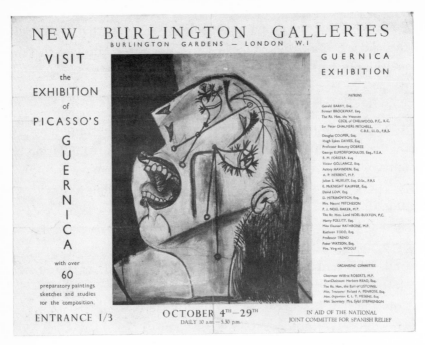

Programme for the New Burlington Gallery exhibition 1938, front.

April 1937 a fact-finding mission to Spain inspired her scathing book *Searchlight on Spain*, a worthy companion to Arthur Koestler's *Spanish Testament*. In the Duchess of Atholl, Penrose had found an able and vociferous supporter to aid him in his plans to bring *Guernica* to London.

It was also obvious that the AIA would give enthusiastic support to such a move. At the Paris Expo the AIA had sponsored four of their members, Misha Black, Betty Rea, Nan Youngman and James Holland, to decorate two rooms in the Peace Pavilion, just 100 metres from the Spanish Pavilion. Halfway through completing their series of murals they survived a suspected arson attack. This was just one more example to illustrate the fact that politics and art were now dangerously inseparable.

During the summer of 1938 Penrose and Mesens worked hard to locate the perfect space to display *Guernica* and, if possible, to arrange a tour. One of the most exciting spaces, and one which had built up a reputation for showing the avant-garde, was the spacious

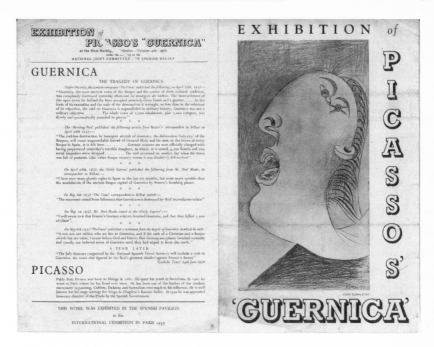

New Burlington Gallery programme, back.

New Burlington Gallery. In June 1936 Penrose, Herbert Read and the poet David Gascoyne had organised the hugely successful and provocative International Surrealist exhibition which, headlined in the newspapers as 'Marx Brothers of Art', attracted 20,000 spectators, many of whom left scandalised by Salvador Dalí walking around in a diving bell and Dylan Thomas generously offering a teacup spilling over with boiled string. Penrose and Mesens booked the space once again.

On 30 September, the day of the Munich Pact, *Guernica* arrived in London. The exhibition opening was planned for 4 October and scheduled to close on the 29th. Penrose was optimistic, as were the other members of the National Joint Committee for Spanish Relief who stood to benefit from the exhibition. Profits from the short catalogue, priced at 1s. 3d., went directly to them. The list of patrons and the organising committee was as impressive as it was long, including Herbert Read, Douglas Cooper, the Surrealist multi-millionaire Edward James, Virginia Woolf, with E. M. Forster

and Victor Gollancz offering 10s. and £5 respectively towards
the costs. The spacious top-lit gallery, with its elegant coffered
ceiling, was just high enough to squeeze *Guernica* in under the
dado rail.

The exhibition was a disappointment, however. Considering
Picasso's fame, and the favourable reviews by Herbert Read and
Myfanwy Evans the year before, the audience of 3,000 was much
less than Penrose had hoped. Picasso hadn't turned up, but was
represented instead by Paul and Nusch Eluard, just as had happened
at the Valencia meeting of L'Association d'Ecrivains et d'Artistes
Révolutionnaires and the International Surrealist exhibition. Pen-
rose could only conclude that the Munich crisis had dampened all
spirits, provoking a drained-out feeling of collective lethargy. The
exhibition did, however, offer Read and Blunt the chance to con-
tinue their feud. Perhaps, given time for reflection since their last
exchange, and considering the terrible events in Spain, it is reason-
able to assume that Blunt might have swung back round in *Guer-
nica*'s favour. But it was clear that the two critics' animosity went
back a long way.

Two years earlier, in the 19 June 1936 issue of the *Spectator*,
Blunt had delivered a scathing review of Read's International
Surrealist show. His style was witty, precise but above all acid:
'Take Blake's anti-rationalism,' Blunt suggested, 'add Lamartine's
belief in the individual, stir in some of Coleridge's faith in inspira-
tion, lard with Vigny's ivory tower doctrines, flavour with Rim-
baud's nostalgia, cover the whole with a thick Freudian sauce, serve
cold, stone cold.' The following year, he had become increasingly
Stalinist. On 8 October 1937 he focused, once again in the *Spectator*
on what he saw as the failings in *Songe et Mensonge*:

> The etchings cannot reach more than the limited coterie of aesthetes,
> who have given their lives so wholly to the cult of art that they have
> forgotten about everything else. The rest of the world may see and
> shudder and pass by. It is not surprising, as Picasso's life has been
> spent in the holy of holies of art.

A year later, seeing *Guernica* at the more rarefied space of the New Burlington Galleries, Blunt remained as convinced as ever. In 'Picasso Unfrocked' Blunt argued once again that *Guernica* was hopelessly obscure, its meaning elusive, and its Cubist style too elitist. It was a view that was shared by Kenneth Clark who dismissed the Penrose, Read, Mesens clique as a host of 'little dissenting sects'. In private, away from the public gaze, Read and Blunt could still share a gentlemanly exchange over lunch at the Reform Club, but in public there was too much at stake. Read replied in the October issue of the *London Bulletin*:

> It is not sufficient to compare the Picasso of this painting with the Goya of the *Desastres*. Goya, too, was a great artist, and a great humanist; but his reactions were individualistic – his instruments irony, satire, ridicule. Picasso is more universal: his symbols are banal, like the symbols of Homer, Dante, Cervantes. For it is only when the commonplace is inspired with the intensest passion that a great work of art, transcending all schools and categories, is born; and being born lives immortally.

It was a spirited defence and a message that Blunt finally understood, almost thirty years too late. By 1969 Blunt had swung around to Read's point of view, claiming for *Guernica* its unrivalled position as the last great painting in the European tradition.

Penrose and Mesens's *Guernica* tour was by necessity improvised. At the end of October the Oxford Peace Council sponsored an exhibition of all the preliminary works, excepting *Guernica* itself, in the lecture rooms of Oriel College. The same halls that during the nineteenth century had given birth to the Catholic Revival were now given over to what the *Oxford Times* described as a collection of 'horses with maddened expressions, small eyes and ears, and cavernous mouths with bared fangs'. The success of the exhibition's impact was significantly reduced by the fact that the students had all gone down for the Christmas 'vac'. (They would have to wait to see Picasso's work until the following year when Denis Healey and the

New Oxford Art Society appealed to Penrose to lend them works for another exhibition.)

On 9 December at the Leeds City Art Gallery the same selection of *Guernica*'s preparatory sketches as shown in Oxford was opened by the distinguished English scholar Professor Bonamy Dobrée. Although the masterpiece itself was missing, the exhibition still offered the chance to see the powerfully emotive *Weeping Woman*, where Dora's distracted features are broken up and rebuilt like splinters of broken glass.

On the same day as the Leeds opening, 9 December 1938, back at the New Burlington Galleries, the programme continued. In a repeat of the Paris Expo, where Sert had taken pride of place in the Pontifical Pavilion, a new show opened with an impressive display of the work of Ignacio Zuloaga, a Franco favourite. Instead of the Duchess of Atholl as apologist, Lady Ivy Chamberlain now took on the role of Zuloaga's British protector, declaring him 'perhaps the greatest of Spain's modern painters'. Lady Ivy's husband was Sir Austen, best known for describing Mussolini as 'a man with whom business could be done'. And in recognition of their burgeoning friendship, Lady Ivy had been awarded the Gold Medal of Merit of Italy by Mussolini himself.

In the catalogue essay Lady Ivy wrote: 'For many years generations of Spaniards have been struggling to rehabilitate their nation. Zuloaga portrays the spiritual aspect of that struggle; it is his part in the endeavour to recover the soul of Spain.'

Of the forty-five paintings on display most were *costumbrista* – folklore interpretations of the world of old Spain. As in *Guernica* there were bullfight scenes, and portraits of famous matadors like Juan Belmonte, but Zuloaga had drawn them in a seductive and readily accessible realist style. There were also portraits of key figures in Spain's pre-war intelligentsia like Vallé Inclan and Manuel de Falla, hanging alongside pictures of fiery flamenco dancers and a portrait of the actress Aga Lahowska in her acclaimed role as Carmen. But these romantic tourist views of the Spain of the castanets led the spectator inexorably back to the old order and

pre-war hierarchy with portraits of the aristocracy, flanked by cardinals and priests. One of the most imposing paintings on display was the academic *Landscape, Alcazar of Toledo*, painted since its partial destruction in the siege of 1937, and which for Franco's supporters had taken on mythic status. It was the *Guernica* of Franco's Nationalists. But, if there was still any doubt as to the political message, Count Ciano, Mussolini's son-in-law, had lent his sentimental portrait, *The Oldest Requeté in the War*. Ciano, like Marinetti, found war beautiful, and the bombing of a defenceless village gave him the aesthetic pleasure and excitement of an opening flower. Ciano understood only too well the power of art but for him it was nothing compared to the devastating power of war. What he wanted was the 'flags and guns captured from the Basques . . . A flag taken from the enemy is worth more than any picture.'

In case Zuloaga's paintings did not prove a large enough draw Lady Ivy had persuaded the artist to lend his greatest 'genuine' El Greco from his collection of fakes. And it was a supreme irony, and a perhaps not entirely innocent choice, that Zuloaga had lent from his home in Zumaya in the Basque country El Greco's stunning *Profane Love*, now in New York's Metropolitan Museum. Over the twentieth century it travelled through various titles from *Profane Love* to *The Opening of the Fifth Seal* until finally arriving at *Apocalyptic Vision*. Zuloaga, like Sert, had once been Picasso's close friend, but political realities had eventually driven a wedge between their friendship. *Apocalyptic Vision* was the painting that had marked the high point of that friendship back in Paris in their bohemian days when it had been centre-stage at sophisticated evening soirées in Zuloaga's studio at 54 rue Caulaincourt. More importantly, it was the very painting that Picasso had studied endlessly and reinterpteted in his seminal *Demoiselles d'Avignon*. The whole Zuloaga show had been a carefully orchestrated slight, designed to throw *Guernica* and the Republicans' message into the shade.

In the New Year, January 1939, the preparatory sketches re-turned from Leeds to the Whitechapel Art Gallery on the borders of

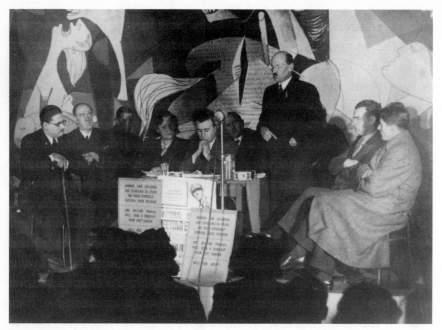

Opening of the Whitechapel Art Gallery *Guernica* exhibition, 1938,
with Major Attlee (*centre*) and Roland Penrose (*right*).

London's East End where they were reunited with *Guernica*. The purpose-built gallery, designed by C. Harrison Townsend in the Arts and Crafts 'Free Style', was far more sympathetic to the scale of the painting than the New Burlington Galleries had been. And in the East End, it was geographically closer to the working classes. In a letter addressed to Picasso, dated 21 January, Roland Penrose was more upbeat than he had been two months earlier. 'I want to give you some idea of the profound impression your works have made on these simple people.' The exhibition was opened by Major Clement Attlee, Leader of the Opposition Labour Party and a keen supporter of the International Brigade, and supported further by the Stepney Trades Council's foodship campaign that hoped to raise 'one million pennies'. In his passionate opening address Major Attlee warned: 'If once Fascism gets a hold, the people who will suffer most will be the young. Fascism tries to make the younger generation in its own image, to make every boy into the image of Hitler or Mussolini.' But more optimistically he continued, 'Today

Fascism is weak, far weaker than people think. For they cannot fool all of the people all of the time.'

The *Guernica* show was a great success, with more than 15,000 people passing through the doors in the first week alone, raising £250. Every evening 'talking films' were screened, on the subject of the Spanish Civil War, and in the entrance hall the visitor was met by the colourful banner of the 'Major Attlee Brigade'. Herbert Read, Eric Newton and Roland Penrose offered their services to explain to the general public the meaning of Picasso's work. But the most remarkable addition to the *Guernica* exhibit was the serried ranks of working men's boots that were left like *ex votos* at the painting's base: the price of admission was a pair of boots, in a fit state to be sent to the Spanish front, a generous gesture that considering Barcelona's imminent fall now seemed increasingly futile.

From the Whitechapel Art Gallery *Guernica* travelled to Manchester where it was to be exhibited from 1 to 15 February in the unusual space of a car showroom on the corner of Victoria Street and Cateaton Street. At the inauguration a local dignitary, A. P. Simon, spoke passionately of the painting as 'an expression of what happened in the minds of the people of Guernica when their town was bombed . . . and that something similar was happening at this moment on the snowbound roads leading from Catalonia into France. The need for help to the people of Government Spain was as great today as it had ever been.' This time it was planned that the exhibition proceeds would go towards supplying the Manchester Food Ship for Spain to bring relief to the growing humanitarian crisis. In an effort to attract working people on their way home, the exhibition stayed open until 8 p.m. 'DEATH COMES FROM THE AIR', read the headline in the *Manchester Evening News* on 31 January 1939. 'During the next fortnight, before the picture goes back to Paris, hundreds of Manchester people will see it and puzzle over its meaning.' But there was a guarded caveat. 'It is felt by some critics that the picture does not do justice to the studies, but no-one could fail to be impressed by a

tremendous work which, more than any words, condemns the crime of war.' After the exhibition had ended the works were transported back to London for safekeeping. In late March Picasso wrote to Penrose to request that *Guernica* and all the associated works be shipped back as soon as possible. There were plans, apparently, for the works to be shown in the United States.

Guernica's sojourn in Britain had not been the success that Juan Larrea and Roland Penrose had hoped for. True, it had received some wonderful reviews. But it had essentially changed nothing. President Roosevelt admitted to his Ambassador in Spain that Non-Intervention had been a terrible mistake. It was all too late, however. *Guernica*'s audience in Britain had never extended beyond those like the Duchess of Atholl and Clement Attlee who were already converts to the cause. For British artists it had been a privileged moment to see the great masterpiece of twentieth-century art, although many figures in the art scene, like Blunt, would only recognise the fact decades later. Only a few found it inspiring and sustaining in terms of their own art – its legacy would live on in the work of John Craxton and Francis Bacon.

Within two years of the Whitechapel show the reality depicted in *Guernica* arrived with the Blitz. Only then would those who had doubted the authenticity of Picasso's masterpiece experience the horror for themselves.

4

To the New World

I looked at Picasso until I could smell his armpits and the cigarette
smoke on his breath . . . Picasso had uncovered a feverishness in
himself and is painting it – a feverishness of death and beauty.

<div style="text-align: right;">William Baziotes</div>

By the end of January 1939 Republican resistance to the Franco
Nationalist onslaught was all but over. Worn down by persistent
bombing raids, Barcelona finally capitulated on 26 January, just
thirteen days after the death of Picasso's mother. In Catalonia, the
Nationalists completed their victory with a rapid sweep-up opera-
tion moving north to the Pyrenees. Just ahead of the Franco troops,
Republicans and their sympathisers fled into exile to await their
future in the disease-infested internment camps of Argelès-sur-Mer,
St-.Cyprien, Barcares, Le Vernet and the fortress of Collioure,
hastily set up by the French to receive the sudden and massive
immigration.

In the last Republican stronghold, Madrid, the future looked
almost as desperate. Within the Republican coalition, agreement
between the different factions slowly collapsed. President Azaña
went into exile on 6 February, followed rapidly by the Premier Dr
Juan Negrín. Negrín's alleged support for the Communists, and his
apparent willingness to continue the battle against Franco at all
odds, promised a bloodbath for the Madrileños and all those who
had taken shelter in the capital. Seizing the moment, Colonel
Segismundo Casado, a commander in the Republican army, effected
a coup against the absent Negrín. With what appeared to be a
greater grasp on reality, Casado tried to negotiate satisfactory terms

of surrender with the Franco regime in Burgos, but it proved impossible. Throughout the Civil War Franco had repeatedly chosen to prolong the carnage in order to cleanse Spain once and for all of the Liberal, Jewish, Freemasonic and Communist menace. With victory so close, Franco would not throw away this opportunity to crush all possible resistance and terrorise the survivors into submission or petrified inertia. On 28 March 1939, with the Republican defence of Madrid hopelessly split, the Spanish Civil War was finally over. Madrid fell.

With stark clarity, the final bulletin issued by Franco's headquarters on 1 April read dispassionately, 'Today, with the Red Army captive and disarmed, our victorious troops have achieved their objectives.' Dejected Republican troops, well aware of the promised threats against their safety, surrendered to Franco. Others made their way home to a life in hiding, while as many as possible fled to Mediterranean ports to get on the last available ships to take them into exile. The bloody Spanish Civil War had come to an end but the reprisals were about to begin.

Later that day, as a clear demonstration of Vatican policy, the recently elected Pope Pius XII sent a personal message of congratulation to El Caudillo, which was followed swiftly by the United States' official recognition of the Franco-led insurgents as the new legitimate government of Spain (Britain and France had recognised Franco two months earlier).

For almost the entire period of the Spanish Civil War, the United States had chosen to shelter behind its Neutrality Act of 1 May 1937 which prevented arms shipments to either side. The Act was, in effect, a replica of the Allies' apparently worthy, but impotent, system of arms embargoes set up by the Committee of Non-Intervention. Cynically involving almost no real compromise towards either party, the Neutrality Act prevented effective support for the Republicans while permitting American business to continue shipping lorries and oil to the Nationalist side. Serious attempts had been made by arms dealers, prior to 1 May, to beat the embargo and supply the Republic. As described in Gerald Howson's *Arms for*

Spain, a forensic dissection of the duplicitous arms trade, even President Roosevelt's brother-in-law, Hall Roosevelt, was deeply involved. But, despite attempts to use third-party 'neutral' countries, nothing materialised for the Republicans. The arms dealers, most of whom were corrupt or just blatantly criminal, practised extortion on the exchange rate, sold outmoded weaponry with limited ammunition, or waited well after their receipt of payment until the Republic's defeat was finally assured.

If all now seemed hopelessly lost, Picasso, in discussion with his friend Christian Zervos, had already reached the conclusion that *Guernica*, despite the US government's lack of official support for the beleaguered Republic, should be shipped to America to raise funds for refugee relief. Many Americans, after all, had expressed their personal sympathy for the Republican combatants and their outrage at the total disregard for the democratic process demonstrated by Franco's insurgents. A few had helped financially, while others like Ernest Hemingway had been instrumental in bringing the scale of the tragedy to the public's notice. Others still had risked their lives fighting alongside the Republicans with the legendary Lincoln Brigade. Many left wing – and Communist-sponsored associations in America, like the American Artists' Congress Against War and Fascism, under whose auspices the Spanish Refugee Relief Campaign functioned, had voiced their unwavering support for the Republic throughout the war.

The Spanish Refugee Relief Campaign was founded in autumn 1936 by the Protestant minister Herman Reissig, himself a committed Socialist. It tapped into a broad base of appeal from the American Communist Party right across to President Roosevelt's Secretary of the Interior, Harold Ickes, who agreed to become the Campaign's first honorary chairman. Indeed, the Campaign's list of sponsors reads like a catalogue of the biggest stars of the arts and sciences: Theodore Dreiser, the left-wing activist and author of the bestselling novel *An American Tragedy*, was a committed sponsor, as too were Ernest Hemingway and the poets Malcolm Cowley and Archibald MacLeish; the influential sociologist, critic and architec-

tural historian Lewis Mumford was an active supporter, as were the European exiles Thomas Mann and Albert Einstein, the acerbic *Vanity Fair* columnist Dorothy Parker and the renowned dramatist Lillian Hellman.

Unfortunately Picasso was too ill to pass on his message of gratitude and support personally in a telephone link-up with a large gathering of the American Artists' Congress at Carnegie Hall in December 1937. His message was phoned in from Switzerland, where he had been scouting for a suitable safe haven for the priceless Prado collection of hundreds of works by Titian, Velázquez, Goya and El Greco (a direct response to another of the scurrilous programmes of misinformation propagated by the right-wing press, namely, the accusation that the Republic was selling off all Spain's artistic assets). For the American Artists' Congress, the fact that a nurse had to read out Picasso's statement barely diminished the effect of immediacy and the very real feeling of brotherhood he shared with his supporters across the ocean.

I am sorry [he apologized] that I cannot speak to the American Artists' Congress in person, as was my wish, so that I might assure the artists of America, as Director of the Prado Museum, that the democratic government of the Spanish Republic has taken all the necessary measures to protect the artistic treasures of Spain during this cruel and unjust war. While the rebel planes have dropped incendiary bombs on our museums, the people and the militia, at the risk of their lives, have rescued the works of art and placed them in security. It is my wish at this time to remind you that I have always believed, and still believe, that artists who live and work with spiritual values cannot and should not remain indifferent to a conflict in which the highest values of humanity and civilization are at stake. No one can deny that this epic people's struggle for democracy will have enormous consequences for the vitality and strength of Spanish art. And this will be one of the greatest conquests of the Spanish people. Convinced of our triumph, I take pleasure in greeting the American Democracy, as well as those present at this congress. Salud – Picasso speaking.

Picasso had made many American friends, dating right back to his first days in Paris, thirty years before. The Cone sisters from Baltimore had acquired his work from early on in his career, when financially this had been essential to his artistic survival. So too had Gertrude Stein – that great overweight oracle of modernity – whose support and friendship meant a lot to Picasso. A pair of Philadelphian collectors, Earle Horter and the famously irascible Dr Barnes, had also built up astonishing collections, as had John Quinn and Chester Dale. What Picasso admired above all was the infectious energy, enthusiasm and deep commitment that many American collectors and museum officials had demonstrated towards his work; instinctively, it seemed, they had sympathised with his challenging modernity. Their deep pockets were also, without a doubt, appreciated by the artist and his dealer, Paul Rosenberg.

So keen had Picasso now become on the idea of the travelling exhibition around the United States planned for *Guernica* that he offered to pay for the painting's transport costs back to Paris from its London Whitechapel show so that it might arrive in New York on time. The move to the United States made both practical and tactical sense. America, during the 1930s, had become Picasso's largest market. With the precarious state of the French economy, especially in the latter part of the decade (the knock-on effect of the Great Depression), collectors had gradually melted away and the market had dried up. Even Switzerland was no longer safe: in Lausanne, G. F. Reber, one of the largest collectors of Picasso's work, with more than sixty paintings, had gone bankrupt midway through the decade. Picasso's market was now more than ever his coterie of avid collectors based in the United States. But at this moment, as far as *Guernica* was concerned, Picasso's only thought was the speed with which the Spanish Refugee Relief Campaign could start sending the funds raised by the tour back to his friend Juan Larrea, to alleviate the appalling conditions in the internment camps in the South of France.

Once again, just three weeks after the fall of Madrid, the unstretched *Guernica* canvas was packed up with the related sketches

and preparatory oils, awaiting transport to begin its tour around the United States. For the ninth time in twenty months the vast canvas was lowered gently face down on to the gallery floor, then painstakingly untacked, taken off the stretcher, rolled around a drum and crated up. On arrival at each new destination, the frame was reassembled and laid on to the painting placed face down; then the overlapping edges of the canvas were gradually pulled and stretched by hand into exactly the correct position. Working from the centre of each edge, professional gallery staff then slowly strained the canvas with stretcher pliers, as *Guernica* was carefully tacked back on to its support, each tack inevitably enlarging its hole as it pulled open the weave, and occasionally tearing the cloth around a previous perforation. Although dry to the touch, Picasso's masterpiece was still technically unstable and fragile, and would remain so for many months to come. Returning a canvas of this size to the correct tension required some sponging down on its unprimed reverse with a slightly damp cloth to bring it back taut and remove the sags. On each occasion, the painting suffered from immeasurably small but nevertheless accumulative wear and tear. Cracks from movement, over-zealous stretching, changes in temperature and humidity, would be the inevitable price the canvas had to pay for its very public role.

Delivered by train to the docks at Le Havre during the final week of April, *Guernica* was hoisted carefully on to the ocean liner *Normandie*, ready for its transatlantic voyage. The contrast between the tragic events memorialised in Picasso's painting and the *Normandie*'s luxurious decor, with its delicate Sèvres porcelain and rich Aubusson carpets, its Art Deco etched glass and polished stainless steel, was a dramatic indicator of how time and a new political reality, had in the eight years since the ocean liner slid down the slipway at the shipyards at Le Havre, made such luxury seem irrelevant. Nothing better demonstrated the growing irrelevance of the aesthetics of pleasure, and the total decadence of that bygone philosophy of 'art for art's sake'.

In order to highlight the diplomatic nature of *Guernica*'s journey,

and to stress its importance to the desperate Republican cause and the hundreds of thousands of refugees who had already made their way across the borders, the painting was accompanied on its journey by the Premier-in-exile, Dr Juan Negrín. As an internationally recognised physiologist, bon vivant and moderate Socialist, Negrín had quickly turned himself into President Azaña's favourite. During the internecine fighting between the Communists and other left-wing parties in Barcelona in May 1937, described so passionately in Orwell's *Homage to Catalonia*, Negrín had skilfully negotiated his way through the minefield of the battling rival factions of the Marxist POUM, the anarchists, the Communists, the Socialists and the destabilising force of Franco-supported *agents provocateurs*. Negrín had also been resolute in lobbying the League of Nations to kill off the policy of Non-Intervention, but in this he sadly failed. His reputation remained controversial. While some saw his closeness to the Communists as the desperate last-dice throw of *realpolitik*, others painted him as Stalin's patsy and poodle; the Republic's Trojan Horse.

In retrospect, it is hard to think of a single politician who might have saved the Republic without Allied financial help, arms and logistical support. Betrayed by its friends and the duplicity of British foreign policy, the Republic was in reality all but dead. Accompanying *Guernica* to America was, as it turned out, Negrín's last effective diplomatic role – his final moment on the world stage. When he disembarked on Manhattan Island he would arrive in the New World as yesterday's man.

Stored safely in the hold of the ship, *Guernica* would soon be viewed by its new American public. For the remaining months of 1939, and on into early January of the following year, when it was planned that the painting would return to Europe, *Guernica* would tour from city to city, educating and shocking the public in equal measure, as hopefully it collected the much needed funds. The climax of the tour was its final appearance as one of a trio of star exhibits in the long-awaited Picasso retrospective at New York's Museum of Modern Art (MOMA).

Just eighteen months before, in October 1937, Picasso's master-
piece the *Demoiselles d'Avignon* had made the same journey on the
Normandie to end up briefly at the New York office of the dealer
Jacques Seligmann and Co. By December, the young and dynamic
director of MOMA, Alfred H. Barr Jr, had persuaded his Acquisi-
tions Advisory Committee to secure Picasso's savage brothel scene
for his museum. It was a work that, more than any other picture
produced in the first half of the twentieth century, had heralded the
arrival of Cubism and the art of the modern age. Furthermore, in the
same month, December 1937, Mrs Simon Guggenheim had ac-
quired and generously gifted to MOMA Picasso's 1932 colourful,
zebra-striped *Girl Before a Mirror*; a work of astonishing vivacity.
Little could the art-loving public have known then that for the next
four decades these three avant-garde masterpieces would hang
together as companion pieces, transforming New York into the
greatest centre for the study of the radical new art.

By this time MOMA had moved into its new purpose-built
premises at 11 West 53rd Street and had matured into an institution
that was absolutely central to the understanding and interpretation
of modern art. Openings at the museum had become key dates on
New York's social calendar, and its trustees were carefully selected
from New York's most powerful billionaire clans. Modern art had
become wildly fashionable. In *The WPA Guide to New York City*,
published in 1939 to coincide with the World Fair, it stated that
modern art had become so popular that an exhibition could 'attract
as many people as a prize fight'. In its first decade MOMA had
held eighty-five exhibitions and one and a half million visitors had
passed through its doors. Through its programme of touring ex-
hibitions it had reached an even larger public than that afforded
by New York alone, and MOMA had become a truly national
institution.

The timing for *Guernica*'s arrival on American soil could hardly
have been more auspicious. Just a week later, on 8 May, the doors
opened to the 'new' MOMA's inaugural show, *Art in Our Time*.
Alfred H. Barr had approached Picasso for the loan of the historic

masterpiece for exactly that purpose, but it was the artist's commit-
ment to the Spanish Refugee Relief Campaign that had finally
persuaded him to exhibit the picture in America. It would tour
first: MOMA would have to wait until the full Picasso retrospective,
planned for later that year.

On 1 May 1939 the *Normandie* steamed slowly into New York
Harbour past Frédéric-Auguste Bartholdi's gigantic statue of *Lib-
erty Enlightening the World*, a gift from the French government in
1884. For many of the passengers, and certainly Dr Negrín, the
powerful symbolism could not have been missed. They had left
behind them a Europe on the verge of a catastrophic and probably
suicidal war; a continent hopelessly divided between the totalitarian
extremes of Communism and Fascism. Steaming past the stone
colossus proved a poignant moment and one that was also pecu-
liarly pertinent to the subject matter of *Guernica* itself. A smaller
version of Bartholdi's statue, that Picasso knew only too well from
his walks through Paris, stood on a plinth in the river Seine at the
foot of the Eiffel Tower. In *Guernica*, the raised arm of a woman
holding a candle tight in her grip pushes in dramatically from the
right-hand side of the canvas and helps to illuminate the scene.
Symbolic of liberty and truth, she enlightens the world while forcing
us to survey the tragic drama played out in front of our eyes.

Turning into the narrows of the Hudson estuary, the *Normandie*
edged slowly up along the Lower West Side to its midtown berth at
the 48th Street pier. Once lowered on to the quayside, *Guernica* was
immediately guarded by student volunteers and members of the
Spanish Refugee Relief Campaign in New York; for them it was a
talisman and a survivor from another world.

At the beginning of the Spanish Civil War, fortress America,
intent on maintaining its isolationist policy and sensitive as always
to the vociferous traditional Catholic lobby, had remained diplo-
matically distanced from the conflict abroad. But, significantly,
Hemingway had managed to persuade President Roosevelt to attend
a private viewing of his film *Spanish Earth* on 12 July 1937, the day
the Spanish Pavilion was officially opened in Paris. Roosevelt's

interest represented a subtle sea change in public sympathy for the Republic. By the end of 1938, as the Republic appeared increasingly in mortal danger, Gallup polls swung in its favour. Whereas the previous year 67 per cent of those asked had favoured neutrality, by the end of 1938 a majority now supported the Republican cause. There was a growing feeling within the United States that their lack of support had been a tragic miscalculation.

Guernica's arrival proved opportune in other ways, not just as a reminder of the threat to civilisation that Nazism posed, or to celebrate MOMA's first ten years, but also because it conveniently coincided with the opening of the New York World Fair. Ironically, the Fair's ambition was 'to pierce the fogs of ignorance, habit and prejudice'. Staged in Queens on the bank of the Flushing river, with its full-scale utopian city, *Democracity*, the World Fair was dedicated to the future: a bold and optimistic gesture in the face of profound European despair. There was no pavilion designed by Sert this time, just some simple murals by Luis Quintanilla. A memorial to the defeated Republic might have been more appropriate. But, in the Court of States, a large sculptural piece entitled *Don Quixote de la Mancha*, by Olympio Brindesi, reminded the viewer of another extraordinarily powerful and self-flagellatory work of Spanish art that, like *Guernica*, had killed the dreams of a fragile nation. The Italian Pavilion, escaping censorship, was furnished with a bullish bust, chiselled out of Carrara marble, of Il Duce, Benito Mussolini, staring manically into a future where, no doubt, all the trains ran on time. The historical blindness of France's contribution, however, would have been pathetic if it had not been so desperately sad. Overlooking the gently lapping water of the Lagoon of Nations (an obvious pun on another discredited institution), France's Pavilion housed its contribution, 'Art, Luxury, and Elegance', that provided a further insight into the French passion for designer *luxe*.

Escapist though it may have been, the World Fair attracted an estimated 60 million visitors, many of whom, out-of-towners or travelling in from other states, were visiting New York for the first time. Many were potential visitors to the other art venues in the city:

the Metropolitan Museum, the Whitney and the radical and up-to-the-minute MOMA. If only a tiny proportion of the sixty million took the chance to see *Guernica* over the following weeks, it would in no way detract from its impact.

For those who had seen *Guernica* in Paris or at its other European venues, or for those who had followed the passionate debate between Anthony Blunt and Herbert Read (the latter a favourite writer of the New York art world), its arrival on American soil had been long awaited. The critic Elizabeth McCausland, in an article published in the *Springfield Republican* on 18 July 1937, was one of the first to request that *Guernica* travel to the United States. Later on that month *Life* magazine illustrated the work for the first time for a mass audience. Meanwhile, Emily Genauer in the *New York World Telegram* in August 1937, somewhat subdued and measured in her praise, nevertheless drew attention to the fact that the success of the Spanish Republic Pavilion rested on the celebrity status of just one painting 'because it is by Picasso, and because it is in his typical abstract manner and therefore incomprehensible to most people who see it, the pavilion turns out to be one of the most crowded and provocative in the whole shebang'. What American artists and critics now wanted was a chance to make up their own minds.

Responsibility for the actual exhibiting of *Guernica* had been handed over by the American Artists' Congress to the chairman of the *Guernica* exhibition committee, the art dealer Sidney Janis. Janis quickly approached a fellow colleague, Valentine Dudensing, whose new premises, the Valentine Gallery at 16 East 57th Street, were spacious enough and advantageously well positioned close to the new MOMA. Valentine Dudensing was perhaps an obvious choice as he perhaps more than anyone in the United States, apart from Alfred H. Barr at MOMA and Chick Austin at the Wadsworth Atheneum in Hartford, Connecticut, had worked hard to promote Picasso. Almost every year since his 1931 pioneering *Picasso Abstractions* exhibit, Dudensing had brought to the increasingly sophisticated American public the very latest of Picasso's work.

The preview night at the Valentine Gallery on 4 May proved a

success. As a society fund-raising event it drew in the great and the good: representing the government, Eleanor Roosevelt arrived from Washington accompanied by Secretary of the Interior Harold Ickes; the monied Whitneys, Paleys, Rockefellers and Guggenheims turned up, as did the Chairman of the MOMA Trustees, Stephen C. Clark, and the powerful political mandarin and future Cold Warrior, W. Averell Harriman; also attending were some of the established avant-garde artists of a previous generation, like Georgia O'Keefe and Picasso's friend from past summers on the Côte d'Azur, the stylish and charming Gerald Murphy. Juan Negrín, as Premier-in-exile, accepted heartfelt commiserations from the assembled guests, while circulating, no doubt, with a certain satisfaction and quite justified pride that even in exile Picasso and his *Guernica* had brought out this distinguished crowd to witness the tragedy befallen his beloved land. Contributing $5 a head, the select 100-strong gathering had kicked off the fund-raising with a certain degree of success. Over the next three weeks, while *Guernica* was on view for the general public, a further 2,000 visitors would each donate a reduced contribution of 50 cents to see Picasso's much-talked-about work.

'It is a half-dollar well spent,' declared Elizabeth McCausland, once again in the *Springfield Republican* after a gap of two years, 'for it symbolises the passage from isolation to social identification of the most gifted painter of our era.'

For art lovers there was the added attraction that *Guernica* was exhibited alongside its intimate family – a selection of the sixty-two related preparatory sketches and drawings – that had fed and nurtured Picasso's imagination and the complex final image. For many it proved a revelation. Often the spontaneity, the graphic freedom, the sheer pace of the drawing proved a more accurate testament to the anger that Picasso had been forced to distil in the larger canvas. *Guernica*, in contrast, somehow looked more studied, laboured and worked at; which, of course, it was. The qualities of scratchiness, speed and urgency, and the concentrated isolation of a particular motif in a drawing, like the screaming horse, the

dismembered soldier or the inconsolable woman supporting her dead child, brought an added focus to the painting's record of pain. Curiously, the accumulative effect of the drawings, seen side by side with the final work, added a subtle sense of process and gradual progression. *Guernica*, almost magically, appeared more alive, as the viewers could witness and trace for themselves the changes, the cul-de-sacs, the mutations that had taken place before arriving at the final image. Paradoxically, echoing the creative process, it gave *Guernica* a sense of life while, by extension, drawing attention to its polar opposite, the imminence and tragedy of death.

Early on many American critics, just like Herbert Read and Myfanwy Evans before them, recognised in the painting this progression from the specific towards the universal. Picasso, McCausland continued, 'has found his soul not in the studio, not in the laboratory of plastic research, but in his union with the people of his native land, Spain. In the painting, *Guernica*, he functioned not only as a son of Spain but as a citizen of the democratic world'. As war in Europe loomed closer, the tragedy of Spain's recent history as highlighted in Picasso's painting, even in the celebratory mood surrounding the World Fair, appeared increasingly ominous. *Guernica* was both unrelenting and unforgiving. It was this appeal to higher values, clearly, that made it so poignant to the Americans who would increasingly see themselves as the final bastion of democracy and defenders of the faith.

The press and art critics did their best to draw the public's attention to the *Guernica* exhibit. But the American Artists' Congress also supported a more serious opportunity for debate in two symposia organised at the Valentine Gallery and later on at MOMA in front of the work. Chaired by Walter Pach, the symposia included the critics Malcolm Cowley, Leo Katz and Jerome Klein with more personal interpretations coming from the artists Peter Blume and the then relatively unknown Arshile Gorky. It was while out gallery-hopping that the artist Dorothea Tanning chanced upon the first symposium at the Valentine Gallery. Tanning (who became Max

Ernst's wife once she had wrestled the exhausted Surrealist free from the clutches of the sexually voracious Peggy Guggenheim) found the symposium profoundly moving.

> After closing time we edged into one of our favourite galleries, where there was already a little crowd of nobodies like us sitting on the floor before a large Picasso painting. We listened as a gaunt, intense, young man, with an enormous Nietzschean moustache, sitting opposite us talked about the picture. It was not his accent, which I couldn't place, that held me, but the controlled passion in his voice, at once gentle and ignited, that illumined the painting with a sustained flash of new light. I believe he talked about intentions and fury and tenderness and the suffering of the Spanish people. He would point out a strategic line, and follow it into battle, as it clashed on the far side of the picture with a spiky chaos. He did not, during the entire evening, smile. It was as if he could not.
>
> Only afterwards I was told that the man's name was Arshile Gorky.

For Gorky, *Guernica*'s apparently universal language had hit home in a very personal way and would act as a bridgehead between the traditions of America and Europe. In the painting, in direct opposition to the seductive skills of dexterity and easy facility, there was what the eighteenth-century philosopher, Edmund Burke, might have described as 'rudeness in the work'. Picasso had approached closer to Burke's notion of the sublime: a sublime that was awesome and terrifying, both brutal and powerful. Super-sensitive and passionately involved with the work of Picasso, almost to the point of slavish imitation, Gorky found that *Guernica*'s disturbing subject matter rang frighteningly true, as if dragged up from his very own past, or the depths of his subconscious. The picture seemed to depict the tragic events of Gorky's own life. During the First World War, he had witnessed the appalling genocide perpetrated by the Ottoman Turks near his birthplace at Van, in which more than a million fellow-Armenians were murdered or starved to death.

'How that painting could send him into a spiral of emotion!' Dorothea Tanning recalled.

Other American artists, distanced from the tragedy, would react to *Guernica* in very different ways. For not only was its subject matter a key to its reading, but so too was its style. It was convincing, honest, politically committed. It showed that it was possible to deal with the political realities of the present world without descending into kitsch, populist melodrama or plain bad taste. In America, *Guernica* had arrived exactly on cue, an icon that reflected accurately the spirit of the times.

Over the previous two decades the American art world had gone through a profound identity crisis. Regarded as producing nothing more than a poor imitation of European art, it seemed destined always to lag behind. Positive action had to be taken. The best way, according to Barr, was to show the home-grown artists the greatest European art, predominantly the Paris School. It should be studied, dissected, pulled to pieces, then assimilated before a response could be made. In the long term American artists might even surpass their Old World mentors.

Early attempts to force America out of its cultural isolation have become legendary. Just prior to the First World War, in spring 1913, the infamous 69th Regiment Armory Show had brought to New York some of the most radical European art. Picasso was represented by eight works that mapped out clearly his Cubist invention, but it was Marcel Duchamp's *Nude Descending a Staircase*, where multiple images of a nude were overlayered as in a superimposed set of movie stills, that scandalised the public. To maintain the momentum the photographer Alfred Stieglitz continued this involvement with the polemical European avant-garde at his New York gallery 291. But there were other brave attempts to introduce the very latest concepts and pictorial ideas. Marcel Duchamp, the skilled and by now infamous *agent provocateur*, teamed up with Man Ray and Katherine Dreier to set up the Société Anonyme to show predominantly Cubist work. Just as exciting, and far more encyclopaedic,

was Albert Gallatin's Museum of Living Art set up in the New York University Library in 1927. His unrivalled collection of modern European masters, which included works by Cézanne, Seurat, Picasso, de Stijl, Bauhaus and the Russian Constructivists, was used as a research tool for the latest artistic investigation. But, despite the generosity of patrons like Dreier and Gallatin, and the evangelical drive of Stieglitz, these ventures often highlighted the very problem they hoped to cure; the sheer parochialism of much of American art.

Like so many others, Marsden Hartley, the creator of exquisite water-colours, felt defeated by this cultural schizophrenia and the profound inferiority complex that the constant comparison with Europe produced. In 1919 Hartley wrote defiantly to his friend Carl Sprinchorn who was worshipping at the shrine of Cézanne in Aix-en-Provence.

> They want Americans to be *American* and yet they offer little or no spiritual sustenance for their growth and welfare. But apart from all that I refuse to accept any status as a Europeanised artist or person, for Europe culturally makes no difference in my life. I am as I always was and will remain to the end. America offers one thing, Europe another, and neither is either more remarkable than the other or preferable.

One day, it was hoped, America might break completely free from the shackles of European art and find its own 'true' character. As early as 1921, in the avant-garde magazine *291* (named after Stieglitz's gallery,) Marius de Zayas had written, 'America has the same complex mentality as the modern artist.' America's heterogeneous condition then, according to de Zayas, was peculiarly suited to understanding the modern age. Where it differed from Europe was in its raw vitality. It was a sentiment echoed later by Duchamp himself. 'If only America would realise that the art of Europe is finished, dead – and that America is the country of the art of the future, instead of trying to base everything she does on European traditions.'

Duchamp's exhortation against Europe would slowly become accepted wisdom; its acknowledgement self-fulfilling. The hangover after the Great Depression had, despite the fall-off of private collectors, proved a tonic to the art world: a clear case of triumph over adversity. Both government and private initiatives had been set up to ameliorate the worst effects of the Depression. In 1934 the American Artists' Union was formed as an experiment in self-help, followed quickly by the founding of the American Artists' Congress in 1935 (sponsored secretly by the American Communist Party), which absorbed many of the original Union members. What both associations brought to the art world was a chance for debate, companionship and solidarity; and, less frequently, commissions for work. In the short term it hoped to provide succour.

The almost total collapse of capitalism during the Depression, in a society that valued business above all, by default raised the value of the arts that had previously often been discounted as merely effete. With the American Dream finally proven bankrupt, it was time to replace it with another set of values. In 1935, in response to the devastated art market, President Roosevelt established the Works Progress Administration (WPA) and the Federal Arts Project (FAP), both extraordinary and enlightened examples of government pa-tronage. Employing at its zenith up to 5,000 artists, who in turn produced a total of 2,500 decorative murals to instruct the public in offices, schools, government buildings, factories, law courts and other public buildings around the country, the FAP provided relief to an art world previously in despair, coupled with the US Treasury Department, which commissioned a further 1,100 murals. Artists had plenty to keep themselves occupied, and in doing so were provided with a living wage.

Guernica's early acceptance amongst New York artists was dependent on that shared experience of the communal struggle through the Depression years. For those artists who were accus-tomed to producing wall-size murals, the scale of Picasso's canvas came as no real surprise. It was clearly not a polite easel painting for a bourgeois drawing room. More importantly still, it was a painting

that was both highly politicised and deliberately partisan, and produced by the artist who was almost universally recognised as the only one to aspire to. Consequently *Guernica* legitimised a socially and politically conscious art. For an art world, therefore, intent on creating a sense of community and collective responsibility, and infused with new ideologies, *Guernica*'s powerful message inevitably proved seductive.

The American art community had, as Irving Sandler observed, in its ideological naiveté 'lent itself to manipulation by the Communist Party, which was the mainspring of radical activities, and which attracted intellectuals because it presumed to have explanations for the existing crisis and offered plans to rid society of poverty, injustice, and war'. In many ways the Communist Party was speaking the same language as Picasso's painting. Both the Communists and Picasso's *Guernica* argued strongly for the validity of art as propaganda. But the Communist Party insisted on Social Realism as the right style and dismissed Modernism as a decadent, bourgeois manifestation, and an essentially escapist art. *Guernica* was a curious hybrid that almost, but never quite, managed to satisfy the two extremes. For some it appeared too abstract while for others it was not challenging enough.

In its obsessive search for its true identity the American art world had made it obvious that it had become radically polarised. What was it to be an American artist, after all? The American Social Realists were caught between the two extremes of a back-woodsy Regionalist style – all rodeos, hominy grits, mid-West baptisms and *Grapes of Wrath* – or the even grittier struggle of the downtrodden urban proletariat against the Robber Barons. Was that perhaps truly American? Or did the future lie in those anecdotal-historical murals produced by artists like Thomas Hart Benton, that today hold the charm and appeal of social documents, but then seemed to catalogue American life in all its variety, from the buzz and energy of the city to the vast emptiness of the prairie and the corn belt? In Benton's work, cliché was stacked upon cliché. It was simple, populist, direct and naive. Essentially romantic,

it overplayed its feeling with about as much subtlety as 'soap-box' oratory.

Somewhere, many argued, between all these possibilities, or perhaps somewhere beyond, lay the key to an imminent renaissance in American art. In the studios, bars and coffee shops of Greenwich Village, the debating, the drinking and the brawling went on. At venues like the legendary Cedar, or George's on the corner of 7th Avenue and Bleecker Street, or the Waldorf Cafeteria on 6th Avenue, the small community of radical artists, as yet almost completely unrecognised, discussed what it was they needed to do if they hoped to make their mark. The mood swung violently from messianic optimism to despair. Barnett Newman remembered it clearly. 'In 1940 some of us woke up to find ourselves without hope – to find that painting did not really exist . . . It was that naked revolutionary movement that made painters out of painters.'

At the debating clubs, like the Art Students' League, the subject always eventually returned to how to defeat Europe. Heated, and often vicious, debate continued in the 'small magazines' that had mushroomed in the 1930s and continued to be published throughout the Second World War. Between the covers of *VVV, Dyn*, Jolas's *Transition, The Tiger's Eye, Partisan Review, Commentary, Nation, View* and the single issue of Robert Motherwell's *Possibilities*, the future of American art was slowly shaped and hammered out.

Next on the menu was how to deal with the unassailable talent and the volcanic energy of Picasso himself. He had opened up so many possibilities. He was so prolific, and he left most of the artists gazing in a hopeless mixture of disbelief, impotence and awe. Of all his works, *Guernica* came to represent to many American artists the apotheosis of an ambition fulfilled.

But the weight of European art was still too heavy. There was still too much to learn. The Marxist art historian Meyer Schapiro, like so many of the artists, was continually bowled over by the quality of art imported from abroad. 'For years surprising Picassos, Braques and Mirós turned up on 57th Street or at the Museum of Modern Art and in books and magazines, as Roman statuary had emerged from

the ground in the fifteenth century to join the standing objects in the ruins. Until one day, Europe was itself exiled to America.'

It was true. *Guernica* was not the only exile. Threatened by the growth of Nazism, members of the Bauhaus and Neue Sachlichkeit artists, like George Grosz, found refuge in New York. The influx of these cultural refugees increased rapidly after *Kristallnacht* and Hitler's degenerate art show *Entartete Kunst*, which made creative life in Germany dangerous and eventually impossible. Most impor-tant, in terms of their future influence, was the arrival of key figures in the Surrealist movement to whom Picasso had been loosely allied. The hard core of the Surrealists, André Masson and Yves Tanguy, settled in Connecticut. Breton, the Pope of Surrealism, stayed predominantly in New York but never learnt English, making personal contact with American artists almost impossible. Wolfgang Paalen and Matta Echaurren did most to pass on the ideas of the Surrealists – ideas for which the American art world had been prepared by MOMA's groundbreaking exhibition, *Fantastic Art, Dada and Surrealism*, another triumph in its cultural programme to educate and sensitise the public to the latest tendencies from the other side of the Atlantic

With his hollowed-out cheeks and ascetic spectacles, Alfred H. Barr, MOMA's inspired director, had the diffident appearance of a trusted family lawyer or a young partner in a prestigious Wall Street firm, not yet entirely comfortable with his own success. In keeping with the safe image, he was measured and temperate in all things. And, in truth, there was certainly something of the pernickity administrator in him. His wife Margaret observed that 'in all things of the mind he wanted discipline and neatness'. It was this intellec-tual rigour that he brought to focus on his analysis of modern art and to the effective running of the museum.

Barr's apparently cold and urbane exterior, however, hid a passionate nature that fuelled a powerful missionary zeal, a legacy of his Scottish Presbyterian background. On the one hand, his encyclopaedic knowledge of modern art was accompanied by a tendency to create lists and chart out the countless 'isms' of the early

Alfred H. Barr in MOMA (Museum of Modern Art), New York, c. 1930.

twentieth century. On the other hand, much to his credit, he remained flexible and open to the latest trends. His gift, almost bordering on genius, was his ability to popularise modern art and make the complex seem simple, without patronising his audience or trivialising the work. It was a subtle skill that balanced the discipline of scholarship with a deeply held belief that modern art was absolutely central to an understanding of modern life.

One of the most revolutionary aspects of Barr's approach was precisely this inclusive view of what comprised modern art. 'Modern art is almost as varied and complex as modern life,' he argued. It cut across all disciplines, from the applied arts through architecture, music, industrial design to the rapidly evolving world of film and photography. His concept of what constituted culture, in terms of a museum, was therefore unusually broad.

This was a result, no doubt, of his travels during the 1920s to the Bauhaus, the Soviet Union and to the Netherlands to see the works of de Stijl artists. The Russian trip had proved revelatory. Having witnessed the pressures that totalitarian regimes brought to bear on the individual artist, Barr became passionately committed to the pursuit of artistic freedoms and human rights. Individuality, he insisted, however difficult, must always be allowed to stray its bounds. This would prove prescient for *Guernica*. After all, Barr argued, art is 'often hard to understand at first but, like our minds and muscles, our artistic sensibilities are strengthened by exercise and hard work. I have never thought of art as something primarily pleasant.' *Guernica* was a difficult painting, but it was also the paradigm of the modern.

MOMA's role was, as Barr saw it, to be a cultural beacon, its duty to counter, for instance, the parochial Whitney Museum: three quaint townhouses in Greenwich Village on 8th Street, hung with paintings by Homer, Eakin, Whistler and Thomas Hart Benton. MOMA's rich holdings of Cézanne, van Gogh and all the international modern masters ensured that under Barr's stewardship, it would rapidly become the foremost museum of modern and contemporary art in the world.

Despite his aversion to dogma, Barr was nevertheless absolutely certain of one thing: Picasso was the most important artist the century had produced – perhaps the greatest artist of all time. Barr had studied Picasso, had courted and wooed him in France, and had made him the central figure in the 1936 blockbuster shows *Cubism and Abstract Art* and *Fantastic Art, Dada and Surrealism*. A Picasso retrospective had been one of Barr's earliest dreams. But the first attempt had foundered in 1931 when Picasso, following advice from his Paris dealer Paul Rosenberg and a misunderstanding with Barr, withdrew his support at the last minute. Barr had become so distressed, exhausted and ill that he was given a year's leave by the trustees to avert a complete nervous collapse. Three years later the first full Picasso retrospective was stolen from under Barr's nose by Chick Austin at the Wadsworth Atheneum. Ever the gracious professional, Barr generously lent one of MOMA's Picassos to Austin's widely acclaimed show.

In 1935, however, Barr's luck with Picasso had begun to change. Walter Chrysler donated to the museum *The Studio* (1927–8), a beautifully restrained Cubist meditation on the artist's own creative space. But more astonishing still, in 1937, the *Demoiselles d'Avignon* was offered up for sale. MOMA had by now become a revered institution on both sides of the Atlantic, and its own Picasso collection the best in any public museum. As always, Barr fought off any possible opposition to the purchase of the *Demoiselles* from the Acquisitions Committee with cold-headed logic. 'If fifty years from now our errors should seem egregious, perhaps a hundred years hence some of our judgements may be justified. In any case, it is already clear that errors of omission are by far the most serious for they are usually irrevocable.'

Meanwhile, in those first few weeks in May 1939, with *Guernica* on show at the Valentine Gallery, the critics now had their first chance to make an appraisal. Over the next few months they staked out their positions. Royal Cortissoz, art critic of the *New York Herald Tribune*, complained angrily of a 'campaign' on Picasso's behalf. In his opinion Picasso and *Guernica* were already well

overhyped. Edwin Alden Jewell, writing for the *New York Times*, was far more specific in his criticism, lamenting the painting's crude energy and its 'grotesque shapes, human and animal, flung into a sort of flat maelstrom'. This critical view, that highlighted *Guernica*'s foreignness and its brutal ugliness, was returned to often over the next few years. In 1942 Wendell Hazen, art critic of the *Boston Post*, feeling somehow duped, suggested that Picasso offered up only 'chicanery', and added that it was difficult to decipher where 'it begins and ends'. It was the age-old argument of the Emperor's new clothes, trotted out by others as well. 'For the average gallery-goer *Guernica* must remain unpleasantly incomprehensible, and the purpose of the present editorial is merely to deplore the dishonesty of the American art public when confronted with work which it can neither understand nor appreciate but which it feels nevertheless obligated to accept,' admonished Virginia Whitehill.

Even a potential ally, George L. K. Morris, painter, collector of Picasso's work and art critic for the left-wing *Partisan Review*, was measured in his praise. Admitting initially that 'the mood of horror and despair, carry realism to its highest pitch', he was also quick to point out that the picture still caused him a problem. '*Guernica* remains the final attempt at synthesis. Picasso has gone back to the grisaille of Cubism . . . There are striking passages, and the emotion fits the form completely, but unity of spirit cannot conceal disunity of structure. The picture shows obvious results of careful planning, yet the sections split awkwardly apart.'

It was a pictorial problem that hardly bothered Elizabeth McCausland, who was now seeing the painting for the second time. And at Valentine's, free from the distractions of the Spanish Pavilion with the tinkle and splatter of Calder's rolling mercury tears, the distraction of the emotive photograph of García Lorca and the sounds of the bar, it sharpened her focus.

The result is a canvas of amazing plastic complexity, imbued with esthetic ideas and concepts from cubism, abstractionism, neoclassicism and the psychological period. But all these attributes are only

means to an end. Picasso has used the skill and dexterity of his method to convey a message. He wants to speak to all those who see his work. And what does he want to say?

He wants to cry out in horror and anguish against the invasion and destruction of the Spain of his love. He wants to protest with his art against the betrayal accomplished by Franco and his fascist allies. He wants to wake in the breasts of all who see *Guernica* an inner and emotional understanding of the fate of Spain. He wants simple and well-meaning citizens everywhere to live through the tragedy of bombardment, physical mutilation, and death, so that they in turn will raise their voices in a passionate cry for justice and peace.

Henry McBride in *The New York Sun* touched on another area of potential weakness, the fact that *Guernica* might be dismissed as mere 'propaganda'. But, for those who saw that as a failure, McBride undermined potential critics by arguing that 'the picture was intended to be such, but it ended in being something vastly more important – a work of art'. On the subject of its qualities McBride was absolutely unequivocal. Picasso was 'prodigal', 'unerring', 'amazing in force'. And, where George L. K. Morris had divined 'disunity of structure', McBride saw instead 'the unity of the design and its tremendous and dramatic thrust'. McBride had no doubts: *Guernica* was 'an extraordinary achievement and destined without doubt to be regarded as Picasso's masterpiece'.

On 27 May the *Guernica* exhibit at the Valentine Gallery closed its doors. Alfred Barr, anxious to see the new Picassos hanging together, would have to wait impatiently until mid-November for the experience of viewing the *Demoiselles, Girl before a Mirror* and *Guernica* in the new MOMA space. As previously arranged, *Guernica* was about to go on tour.

On 10 August the *Guernica* exhibition opened at the Stendhal Art Galleries on Wilshire Boulevard in Los Angeles. Sponsored by the Motion Picture Artists' Committee for Spanish Orphans, the opening attracted some of Hollywood's greatest stars such as Edward G. Robinson, Bette Davis and the director George Cukor. From the

press and literary world Walter Arensberg, Dashiell Hammett, Dorothy Parker and Nathanael West also showed their support, as did fellow-exiles George Balanchine, Ernst Lubitsch, Fritz Lang and the Viennese architect Richard Neutra. It seemed that the poet Delmore Schwartz was right when he figured that 'Europe is still the biggest thing in North America'.

The sponsors' loyalty proved a brave gesture. Arranged at short notice, the exhibition lacked some of the impact of the New York show. Only 735 gallery-goers took the chance to see Picasso's work, and more disappointing still, it only raised $240. What it did achieve was a *succès de scandale*. West Coast lack of sophistication was immediately reflected by the press's response. The *Herald Express* was quick to draw attention to the public's vote of no confidence, dismissing *Guernica* as 'CUCKOO' art. Worse was to come with the *Los Angeles Examiner* which lambasted the masterpiece as 'revolting', 'ugly' and just plain 'bunk'. More dangerous, however, was the paper's reassertion of the erroneous accusation that Picasso was a card-carrying member of the Communist Party. In May Henry McBride had announced in *The New York Sun*, 'Picasso is an ardent communist and in painting *Guernica* he was attacking Franco with might and main.' There was clearly no hint of criticism, it was just that McBride was in detail completely wrong. Back in 1932 Picasso had announced, 'I will never make art with the preconceived idea of serving the interests of the political, religious or military art of a country. I will never fit in with the followers of the prophets of Nietzsche's superman.' And we should also remember that even while trying to coax Picasso to produce *Guernica*, Sert had struggled hard to persuade him to declare his political commitment.

It was certainly true that many of Picasso's closest friends, Louis Aragon, Paul Eluard and André Breton included, had been Communist Party members. (Most had left when the Party tried to impose on them its Social Realist style, while others were publicly expelled for their decadent Surrealist ways.) But Picasso was still four years away from membership. The repeated accusation of

Picasso's Communist links by the *Los Angeles Examiner* was either misinformed or vindictive, and doubly dangerous as in the same month as the Los Angeles exhibition Hitler and Stalin signed the Soviet–Nazi Non-Aggression Pact, transforming Communists from former allies into the enemy.

One of the most vociferous groups to attack *Guernica* was the extreme right-wing Regionalist collective Sanity in Art, which called on fellow-artists to stand up and be counted, and to 'Fight Foreign Influence'. By the time *Guernica* arrived for the opening on 29 August at the San Francisco Museum of Art the Sanity group were in full cry, preparing their anti-Modernist vitriol to follow the tour. Neither the work's quality nor its genuine abhorrence of war interested them; they were not about to engage with foreign, left-wing junk.

Exhibited for the first time alongside the *Songe et Mensonge*, and corruscating works by Goya and Daumier and the contemporary artists Otto Dix, George Grosz, Kathe Kollwitz and Orozco, *Guernica* was placed in a thematic and historical context decrying war as never before. As international events unravelled, the prophetic qualities of the painting became increasingly clear. Three days after the San Francisco opening Germany invaded Poland.

In the gallery, alongside *Guernica*, the Curator, Charles Lindstrom, had pinned up a passionate statement for the public to consider.

'It is no part of wisdom to slay the bearer of ill tidings – the horrid facts remain, and it is they, not the report of them, which deserve abhorrence . . . This is the *Last Judgement* of our age, with a damnation of human manufacture, and nowhere the promise of a paradise.'

The desperate nobility of Lindstrom's statement made sober reading in contrast to the reviews *Guernica* would receive at its exhibition at the Arts Club of Chicago in October. The *Chicago Herald and Examiner* dismissed it with the headline 'BOLSHEVIST ART CONTROLLED BY THE HAND OF MOSCOW'. Ironically, the last time that Picasso's art had been so consistently insulted

(apart from by Hitler, and the French critics Camille Mauclair and Lucien Rebatat, who had all labelled Picasso either a madman, a Mason, a Jew, a half-Jew, a Red or a decadent) was during the First World War, when, partly due to his affiliation with his dealers Kahnweiler and Thannhauser, he was branded a *Boche*. On 18 May 1917, during the opening performance of the ballet *Parade*, a collaboration with Diaghilev's Ballet Russe, he had been heckled by the *claque* as a filthy German. It was clear that *Guernica*'s status as propaganda would often mitigate against a calmer appraisal of its qualities as a work of art.

And it was also obvious, by the end of the tour, that *Guernica* was still only appreciated by a small minority led by a select group of passionate museum professionals. In a modest way it had done what it was supposed to do by alerting people to the real and actual dangers of a World War instigated by an axis of Fascist and Communist totalitarian regimes. It had also provoked passionate debate. The sum of money raised to send to Juan Larrea's Junta de Cultura Española, however, was disappointing; just $700. In New York, in November, all that would change. On 15 November 1939 the long-awaited Picasso retrospective opened at MOMA, entitled *Picasso: Forty Years of His Art*. Overtaken by the declarations of war by France and Britain, and increasingly unwilling to travel, Picasso declined Nelson Rockefeller's invitation to attend.

For the first time *Guernica* could now be appreciated not just on its own merits but also as the latest chapter in a continually evolving body of work. To get this far, yet again, Barr had had to fight hard against Rosenberg and Picasso to get the exhibition that he wanted and had so meticulously planned. He was only in part successful. Forced to accept some Picasso loans he hadn't requested, he remained ever fearful that Picasso might pull out at the last minute as had happened before. Writing to a trusted ally, it is clear that Barr had come in the intervening years to understand Picasso's machinations better, and 'the rather complex problem of manoeuvering through the devious intrigues which surround Picasso . . . Picasso's own good will I think we have, but he is capricious and irresponsible.'

Barr knew full well that retrospectives always bring with them the danger that they might show up the glaring inconsistencies and the endless repetitions of an artist's recipe in style. Often these niggling weaknesses cast a long shadow over the artist's remaining strengths, and the retrospective can represent the kiss of death. But according to George L. K. Morris, Picasso had passed the test with plenty to spare.

Often artists make better critics than their professional *bêtes noires*. William Baziotes was one of those artists who had carefully stalked the exhibition like a lion its prey. 'Picasso had uncovered a feverishness in himself and is painting it – a feverishness of death and beauty.' Everywhere in MOMA there were new routes to take, new discoveries to see. 'I looked at Picasso until I could smell his armpits and the cigarette smoke on his breath.' As for many other artists, Baziotes' encounter with Picasso proved an epiphany. Critics like Royal Cortissoz could still dismiss Picasso as 'groping in the void', or describe his recent work as 'rubbish', as did Edward Alden Jewell, but a growing group of artists were closer to James Thrall Soby who declared *Guernica* nothing less than the 'the most forceful achievement of our century'. New York had gone Picasso mad. No fewer than 60,000 visitors attended the show and the department stores Bonwit Teller and Bergdorf Goodman dressed their windows with clothes inspired by the world's greatest living artist.

At last in America *Guernica* had come out into the public domain. And, even more to Barr's liking, the vicissitudes of war had ensured that, with Picasso's full agreement, his institution was now the painting's guardian until, if ever, it was deemed safe for it to return to Europe. The years of often frustrating negotiations with Picasso had finally paid off. *Guernica*'s future in America was now relatively secure. The luxurious *Normandie*, in contrast, would be stripped out completely as a troop ship for the Atlantic crossing the following year.

The Death of Paris

How sad we aren't around a table that we love. But there are only half-tables now.

André Breton to Dora Maar

Light the lanterns. Throw flights of doves with all our strength against the bullets and lock securely the houses demolished by the bombs.

Pablo Picasso, from *Desire Caught by the Tail*

For Picasso, the two years after completing *Guernica* that led up to the Second World War had been the most troubled and, by his own admission, probably the worst in his life. Normally healthy and enormously vital, he had been driven to bed by painful and recurring bouts of sciatica. These were the lows, accompanied as they were by the increasingly sad news coming out of Spain, culminating in the death of his mother, Maria Picasso y López, on 13 January 1939, at the age of eighty-two. Throughout the war he had also been preoccupied with the safety of other family members, particularly his nephews Fin and Javier Vilato who had both been fighting on the Republican side. But there were moments of escapism too; stolen weeks of hedonistic pleasure with Dora. While staying with the Eluards, Nusch and Paul, in Mougins' Hôtel Vaste Horizon on the Côte d'Azur, there was time to paint and play, away from the imminent threat of war. To accompany the word-games, the joking and general high spirits, there was also the erotic tension of long lazy lunches shaded from the hot Mediterranean sun with wives and girlfriends lounging around topless, and the frequent swapping of

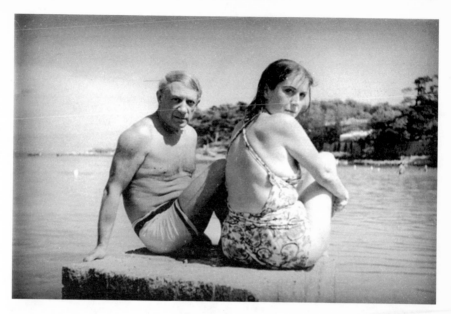

Picasso and Dora Maar on the beach, Mougins, 1937.

sexual partners for the siesta. The steady stream of visitors that made up the *bande à* Picasso (apart from the Afghan hound Kazbek and a new pet monkey) included André Breton with his partner Jacqueline Lamba, Man Ray with his young lover Ady, from Martinique, Roland Penrose and Lee Miller, and Picasso's most loyal supporters, Christian and Yvonne Zervos.

But the snapshots of the sensual retreat serve to obscure Picasso's other lives, with all their inevitable complications. The rejected Olga was like a shadow, somewhere in the background, constantly threatening divorce and a subsequent division of Picasso's assets: his properties, the châteaux at Boisgeloup and the flat in Paris, but also, far more damagingly, his holdings of his own art – his personal research laboratory. Marie-Thérèse Walter, more easily mollified, had been packed off with their young daughter Maya to the Atlantic coast near Royan.

Recollections of those two apparently idyllic summers etched themselves deeply into the collective memory of the *bande à* Picasso. Two years later, in a letter dated 13 September 1941, Jacqueline

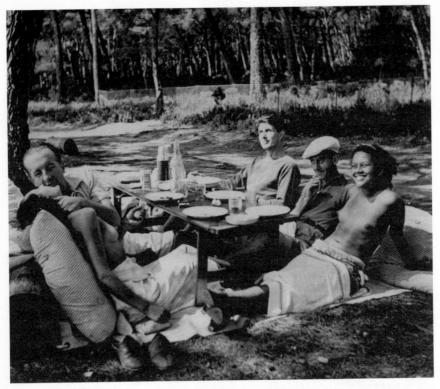

'Picnic at Mougins, 1937; *from left to right*:
Nusch Eluard, Paul Eluard, Roland Penrose, Man Ray and Ady.

Lamba, writing to Dora from her exile in New York, lamented her
sense of loss and isolation, separated as she was from her closest
friends in the Picasso coterie. Strolling through the Museum of
Modern Art, she observed poignantly, 'From the *Moulin de la
Galette* to *Guernica* – you appear very often, I've spilled some
bitter tears.'

 Most of Picasso's *bande* knew of the master's whereabouts and of
his relative safety during the early days of the Occupation. Order in
the rue des Grands-Augustins studio had been re-established at last,
with the arrival of an old friend.

 Jaime Sabartés had finally come back from years of self-imposed
exile in Guatamala, where he had worked in the textile business El
Sol, for his uncle Francisco Gual, a failed one-eyed bullfighter. From
its backroom, he played a central role as a journalist in his adopted

country's artistic and poetic avant-garde. On his arrival in Paris in November 1935, he would come to serve Picasso as his secretary, friend, general factotum and whipping boy; he would be 'the seismograph that recorded all the quakes and tremors'. The miopic Sabartés was a childhood friend of Picasso's from Barcelona and the legendary Els Quatre Gats, where they had collaborated on short-lived magazines like *Pel y Ploma* and *Joventut*. Dressed in his habitual black beret and crumpled raincoat, Sabartés quickly brought stability to the day-to-day running of studio life. There was another advantage, that would always prove invaluable: Sabartés was 'as discreet as the tomb'.

He was a curious companion. Obsessively loyal, his relationship with Picasso bordered at times on masochistic self-negation. In his own words, he 'fell like a fly into the trap of Picasso's stare'.[164] Françoise Gilot recorded that Sabartés' devotion to Picasso was exactly the same as 'a Trappist has for his God'. Picasso painted him various times over their sixty-year friendship, just as Sabartés would record his life with the master in numerous books. While Sabartés

'Déjeuner sur l'herbe', Mougins, 1937. *From left to right*: Nusch Eluard, Paul Eluard, Lee Miller, unknown, Man Ray and Ady.

remained always reverential, Picasso portrayed his friend variously
as a lecherous gibbon, a lovesick poet and a Cubist sixteenth-century
hidalgo with the trademark *golilla* ruff collar of the court of Philip II,
complete with floppy velvet hat. Along with his wife Mercedes,
Sabartés moved into a small cold-water attic flat at 88 rue Con-
vention, in the working-class 15th *arrondissement*, where in com-
pensation for his trifling pay he formed one of the finest Picasso
print collections in the world. If he apparently suffered, Picasso's art
was worth suffering for. In 1946 in his book *Picasso, Portraits, and
Souvenirs*, Sabartés wrote,

> He believes (Picasso) that art is the daughter of sadness and pain (and
> I agree). He believes that sadness forces meditation and that pain is
> the very essence of life. We've reached that point in life where all is to
> play for, that period of uncertainty where each person has to
> reconsider life from the basis of their own misery. That our lives
> with all its torments has to go through similar experiences of pain,
> sadness and misery – that is what constitutes the groundrock of his
> theory on artistic expression.

Written at the far end of the war, it was an accurate depiction of the
depression that Picasso and Sabartés had suffered from while living
in Occupied France. But back in New York, the general art-going
public knew very little of Picasso's everyday life.

Guernica's presence in New York acted, in some ways at least, to
scotch some of the wilder rumours that circled around the growing
Picasso myth. Frequently insulted as a Communist in the yellow
press, there were now malicious rumours that he had bought his
safety, and time to paint, by collaborating with the Nazis. Jerome
Seckler, a US soldier, fortunate enough to secure an interview with
Picasso for the Communist publication *New Masses*, in November
1944 after the armistice, remembered the surrounding confusion.

> Nasty stories circulated about Picasso. That he was living well in
> Paris under the Germans; that he played ball with the Gestapo, which

Picasso and Sabartés, Villa La Californie, Cannes, 1956.

in return permitted him to paint unmolested. That he was selling the Nazis fakes – works he signed, but which were actually painted by his students. Still another that he was dead. From 1940 until the liberation of Paris, Picasso remained a figure completely surrounded by mystery and obscurity.

Life in Paris had already begun to change months before war finally broke out. Looking back, there were symbolic moments and sudden ruptures that clearly marked the after from what had gone before. For Picasso and the Paris art world, there was a key event that proved to be their last reunion before war finally forced each of them to negotiate their own survival under the shadow of Nazi rule. On 22 July 1939 Ambroise Vollard, one of Picasso's earliest dealers, who had become a close friend, mentor and the artist's guide through the snakepit of art dealing, had died in an extraordinary car crash. Swerving off the road, he was crushed by the arm of a Maillol sculpture that had broken free from its anchor points in the

back of his car. Normally superstitious to the point of panic by anything associated with death, Picasso made an exception for Vollard and returned to Paris to honour the friend he had immortalised years earlier in a group of 100 etchings, the famous *Vollard Suite*.

These were moments for both private and collective grief: a time to recognise that nothing would ever be the same again. Returning to the Côte d'Azur almost immediately, Picasso started to paint a strangely hypnotic canvas, *Night Fishing at Antibes*, whose motif he discovered on his evening strolls along the beach with Dora Maar. Painted in a jarring cacophony of acid yellows, aquamarine and penitential purple, the image depicts Dora and Jacqueline Lamba looking out from the harbour towards a pair of fishermen spearing their catch, magnetised by the light of their acetylene lamps. It is a disturbing image. Coloured like the vision of a fractured stained-glass window, it is eerily hypnotic. Dora, bicycle in one hand, with a double ice-cream cone in the other, stares on transfixed. It suggests an uncomfortable study of human appetite under the increasing glare of a fireball moon. The echoes from *Guernica* can still be faintly heard. Soon after *Night Fishing* was completed the beaches along the Côte were made ready for war, transformed from pleasure grounds into no-go zones by the emplacement of guns.

Picasso's immediate response to the disturbance was once again to rearrange his living situation and find, if possible, peace to paint. In early September 1939, as both Britain and France declared war on Germany, Picasso left Paris for Royan where Marie-Thérèse and Maya were staying at the villa Gerbier des Joncs. He was accompanied by Dora, and under suspicion by the authorities as a potentially dangerous alien – living arrangements that produced, understandably, an unusual level of stress. For the next few months Picasso's pattern of living fluctuated between the ménage in Royan and visits to Paris to secure the safety of his paintings in his private bank vaults at the BNCI on the Boulevard des Italiens. Brief moments of conviviality were captured in Paris during those limbo months of the Phoney War, as they awaited the inevitable, with old

friends like the photographers Brassaï and Man Ray, and the Zervoses. But increasingly, Paris was emptying as many of Picasso's closest friends, including Paul Eluard, André Breton and Louis Aragon, were called up to enlist. Joan Miró took the risky gamble of returning to Barcelona on his way to Mallorca where he went underground to avoid arrest by Franco supporters. More ominous, however, was the policy of rounding up artists and intellectuals, whose countries were now technically at war with France, and forcing them into internment camps. Walter Benjamin was taken to the isolated Clos St-Joseph near Nevers. Otto Freundlich was arrested, as too were Max Ernst and Hans Bellmer who ended up in a disused brick factory with its ovens hastily reconditioned into cramped living quarters.

In France, the opening of MOMA's exhibition *Picasso: Forty Years of His Art* went almost completely unnoticed. Barr had sent an effusive telegram of congratulations, and Nelson Rockefeller had pushed for Picasso to attend, but both were left unanswered. External events were rapidly pulling France into the maelstrom. With growing anxiety the press reported the invasion of Belgium on 10 May. Within hours the impenetrable Maginot Line, France's gigantic defence project, was rendered useless as tanks rolled in a sidesweep action through the wooded Ardennes. The fall of Paris was only weeks away.

On his last visit to Paris before the Occupation, Picasso bumped into Matisse on the way to the tailor to get measured up for a suit. Bemused by *maître* Matisse's sang-froid, Picasso warned his rival of the speed of the German advance. Matisse turned to Picasso: 'But what about our generals, what are they doing?' Picasso's response was immediate: 'Oh, they're from the Ecole des Beaux Arts.'

On 12 June, just two days before the German tanks rolled down the Champs-Elysées, Daniel-Henry Kahnweiler made his escape, taking the precautionary measure of signing over his gallery to his non-Jewish sister-in-law, Louise Leiris. Ten days later, on 22 June 1940, the armistice with Maréchal Pétain was signed. Only three days later France was divided into the Occupied and Free Zones.

Royan, because of the Nazis' strategic need to control the Atlantic coastline, fell into the Occupied Zone.

Had Picasso chosen, he could have managed to escape. Offers of asylum had been made, most notably from Alfred Barr through the Emergency Rescue Committee. Many of Picasso's friends, including Breton and Lamba, had fled to Marseille to the Villa Air Bel, run by Varian Fry of the Rescue Committee, and from where eventually they would find passage to the United States. The Mexican muralists José Clemente Orozco and Diego Rivera had also organised an entry visa for Picasso to Mexico, a country which under the Presidency of Lázaro Cárdenas had maintained an open-door policy for Republican exiles throughout the Spanish Civil War. Later Picasso would claim that his decision to stay was based on nothing more heroic than inertia. But the ramifications of that choice determined for him a period in his creativity that by necessity became increasingly introverted. Not since the epic days back in the first decade of the century when he and Braque, 'like two mountaineers roped together', nurtured the birth of Cubism, had Picasso become so isolated. In many ways it suited him. Later on in the same year Paul Rosenberg admonished him: 'You never change your habits, you never respond to letters and telegrams, even from your most loyal friend.'

Slowly, as *Guernica* toured around the United States – from the Chicago Art Institute to the Fogg at Harvard, the City Art Museum of St Louis, the Museum of Fine Arts, Boston, San Francisco Museum of Fine Art, Cincinatti Art Museum, Cleveland Museum of Art, Isaac Delgado Museum of Art, New Orleans, Minneapolis Institute of Arts, the Carnegie Institute, Pittsburgh and finally the Columbus (Ohio) Gallery of Fine Arts before returning to MOMA – to the outside world at least Picasso had become invisible. As the months dragged into years he disappeared increasingly behind the smoke-screen of myth. To some, he was already dead.

For the first time in Picasso's career Zervos's faithful *catalogue raisonné* shows that his output had slowed down to a trickle. It is

clear that Picasso was profoundly affected and threatened by the war. From the window of his Royan studio he had seen the lines of German soldiers parading, ready to impose their new regime. The dust, the lorries, the shouted orders and smell of gasoline transformed the normally peaceful town. Suspect foreigners were continually questioned and kept under strict observation. If papers were not in order and completely up to date it could mean prison, followed by transportation. Picasso was no exception. Despite his unique position and his worldwide fame he could easily have perished, as had García Lorca, or died dispirited as had Walter Benjamin and Antonio Machado, within a few miles of each other, on the border at Port Bou.

For Picasso the threats to both his work and his safety were ever present and real. Royan was now dangerously small, and he was too conspicuous in such a small provincial town. At the end of August 1940, accompanied by Sabartés, he returned to Paris by car. Dora followed by train while Marie-Thérèse and Maya stayed on. Within weeks the structure of the Picasso household was rearranged yet again. The flat in rue la Boëtie was closed up. The studio in rue des Grands-Augustins, still with its ghostly aura of *Guernica*, was made habitable by the illusory comfort of a gigantic wood burning stove, ready for hibernation.

If life in the privacy of the studio, allowing for the inevitable deprivations, remained almost as before the war, outside its protective walls there were dramatic changes in the Paris art world. Picasso had never been sympathetic to the official Salons, the numerous official Sociétés, the establishment Academy, the stuffy Beaux Arts or the gilded Prix de Rome. And now, under Nazi influence, it was to be once again their day. Picasso's power base and sphere of influence were immediately swept away. Zervos's *Cahiers d'Art* folded, as did *Minotaure*, to be replaced by a virulent form of criticism that was anti-Semitic and almost apocalyptic in tone, matured during the late 1930s and carefully honed to provoke maximum effect by Waldemar George, Camille Mauclair and the insidious Lucien Rebatat in their populist *Je Suis Partout* with its

readership of 200,000. Picasso's dealers, Rosenberg and Kahnwei-
ler, could no longer remain active. In fact, Rosenberg's collection of
Picassos had been expropriated and placed in store in the Palais de
Tokyo, ready for Nazi aesthetes like Göring to take their first pick.
As before, when Kahnweiler's Picassos had been offloaded on to the
market after the First World War, there was the real likelihood that
the market would be flooded, possibly forcing a collapse in prices.
'Aryanisation' was a favourite euphemism for the confiscation of
property, and Picasso's stock was still high enough to appeal to the
base instinct of greed. A specialist in this sordid trade was Alfred
Rosenberg (no relation to Picasso's dealer), whose department, the
Einsatzstab-Reichsleiter Rosenberg, specialised in looting Jewish
collections.

For Franco, despite his victory, *Guernica* remained a blatant
provocation. Working through Embassy channels, the Franco re-
gime quickly organised the posting of notices on the flat in rue la
Boëtie and the studio in rue des Grands-Augustins that works were
to be confiscated in lieu of payment of Spanish tax. There was,
however, no legal foundation to the claim, despite Picasso's Spanish
nationality. Perhaps a more crippling policy was to deny the artist
his audience. Although there was never a wholesale blanket on
showing Picasso's work – occasionally single works appeared in
group shows – the general prohibition proved effective.

The special relationship between Maréchal Philippe Pétain and
Franco, while the former was in post as Ambassador in Madrid, had
been somewhat marred by Franco's diplomatic clumsiness, never-
theless they still shared a dislike of avant-garde art. In the 1939
Salon in Paris an insipid marble bust of Franco by the sculptor
Maxime Real de Sarte had taken pride of place. Real de Sarte, a
right-wing activist and a confidant of the great Maréchal, could only
add venom to a policy that was soon put in place. Through Embassy
channels it took little effort to persuade the German Propaganda-
Abteilung on the Avenue des Champs-Elysées, the office responsible
for censorship, that Picasso's deranged and deformed pictures were
not for public viewing. To console Brassaï, to whom permission to

take photos had also been denied, Picasso told him with resignation: 'We're in the same boat. I don't have the right to exhibit or publish either. All my books are banned. Even reproducing my works is prohibited.'

The few moments of *copinage* stolen in the bars, or the visits to the studio by admiring friends, could not in any way diminish the potential dangers. Max Jacob, one of Picasso's oldest friends, arrested as a Jew, would later die in Drancy. Dora, who was half Jewish, was equally in danger once the German bureaucracy and Vichy collaborators had started to filter out their prey. If fame gave Picasso a certain level of immunity, he was never totally secure. Indeed, under the foreigners' law passed on 4 October 1940 the local prefect could have Picasso placed under house arrest – the *résidence surveillée*. More dangerously still, Franco, who was easily stirred up by toadying subordinates, might follow the example of the Italian Fascists who had assassination squads working in Paris tracking down traitors and liquidating them. Less dramatically, Franco might quite logically have taken the decision to order Picasso's immediate arrest. One solution was for Picasso to take on French nationality, which as a proud Spaniard was anathema but perhaps the only logical course. In October 2003 Pierre Daix and Armand Israël published the revelation that Picasso had indeed attempted to change his nationality. On 26 April 1940 his application to the *Commissariat de police* was received favourably.

On 25 May, however, a second report dismissed the appeal on the grounds of Picasso's anarchist youth, his failure to serve during World War I, his insulting of French institutions, and the fact that apparently on his death his collection was bequeathed to the Soviet State. That Picasso had reasons to fear for his own security is supported by the facts. In October 1940 a whole register of prominent Republicans, including the Catalan President Lluis Companys, had been extradited, tried and summarily executed. Paul Preston has described Franco's mentality: 'Not afflicted by doubts about the guilt of his enemies, Franco did not pay much attention to the sheaves of death sentences put before him for signature.' The

following year a confidential intelligence report stated that Serrano
Súñer had come to an agreement to ship Spanish refugees to Africa
to build a railway in the Sahara Desert. To help track down
'subversive' elements, thirty inspectors of the Spanish political police
had crossed into France. It also stated that 'the Weisbader Armistice
Commission occasionally makes requests to the police commis-
sioners for lists on foreign nationals whose applications for visas
are pending.' With Picasso the acting Republican Director of the
Prado, and therefore responsible in Franco's eyes for the theft of the
nation's masterpieces, he had already committed a crime against the
state. Add to that his further offences as the decadent Marxist
scribbler of *Songe et Mensonge de Franco*, the pamphleteer and
purveyor of the *Guernica* lie, the money launderer for the Republic,
the provider of haven for subversives, and the catalogue of sins
committed (if the legal niceties were ever needed) could go on and
on. The most simple method of execution was what was euphemis-
tically described as the *paseo*: a quiet walk into oblivion or an
unexplained disappearance. There were always third parties, the
Gestapo and the Italians, to do the dirty work.

At lunch with Jacques Prévert at Les Vieilles on 12 October 1943,
Brassaï suddenly launched into a heated discourse on Picasso's
dangerous predicament. It was impossible to predict the outcome
of the war, where the bombs might fall, or who might be 'burned at
the stake'. 'No one in the world, not the pope or the Holy Ghost,
could prevent such an auto-da-fé. And the more desperate Hitler and
his acolytes become, the more dangerous, deadly, and destructive
their rage may be. Can Picasso guess how they might react? He has
assumed the risk. He has come back to occupied France. He is with
us. Picasso is a great guy.'

One possible response to the increasingly difficult situation for
Picasso was to capitulate and start collaborating, as so many like Coco
Chanel, Sacha Guitry and the actress Arletty in fact did. He would not
have been the first artist under a totalitarian regime to denounce the
errors of his ways and elect for 're-education'. But Picasso was no
Gertrude Stein, who through her naiveté or fear, or both, had had her

offer accepted to start translating Pétain's speeches for an audience abroad. As the creator of *Guernica*, Picasso had become the lightning conductor for all the artists living under the Occupation. Even a silent dignity would leave this previous work unspoiled.

Visited frequently by German soldiers, under the pretext of admiring his work, Picasso had acquired a protective skin, deflecting false praise with his satirical wit and wounding sarcasm. Rooting around his studio for evidence of his links to the Resistance, the Gestapo visited frequently to see if he had also made illegal sales. Apocryphal anecdotes of Picasso's encounter with Ambassador Otto Abetz or other Gestapo officials abound. In *Les Lettres françaises* of 24 March 1945, in an interview with Simone Téry, Picasso responded to the accusations of collaboration.

'Tell me, Picasso, is that story true which is making the rounds all over the world? One day a Gestapo officer brandishing a reproduction of your *Guernica* asked you: "You did that, didn't you?" And you are supposed to have answered: "No, you did."'

'Yes,' Picasso laughs, 'that's true, that's more or less true. Sometimes the Boches would come to visit me, pretending to admire my paintings. I gave them postcards of my *Guernica* picture saying: "Take them along, souvenirs! Souvenirs!"'

Jerome Seckler was right. The rumours around Picasso's whereabouts and lifestyle had spread far and wide. The reality was often harder to bear. On one occasion Picasso fell victim to a sick practical joke, when an official letter arrived saying that he had to report for medical inspection prior to deportation to Essen to enter a labour camp. But wry wit and a sense of resignation were often the only way through.

'What's this, Picasso, you are in Paris? All the papers reported that you were at the front!' questioned Simone Téry in the interview for her article 'Picasso n'est pas officier dans l'armée française'.

'Yes,' Picasso answered, 'the newspapers made me an officer, but nobody said anything to me. Nobody knows anything about it at the

War Ministry. All I know is that one day they asked me, "Picasso, how would you like to go to the front as a war correspondent? You sure could paint some Guernicas out there! And you know, a war correspondent has officer rank." "Officer rank?" I said, "That's something!"'

'You like that gold braid so much, Picasso?'

'It's not so much the braid,' said Picasso modestly, 'but you know, if I were an officer, I could get a hold of cigarettes. And perhaps they'd give me a bit of butter and some meat. And who knows, I might also be eligible for some coal.'

For visitors to the studio the first obstacle was Sabartés who furtively opened the door with 'his head sticking outside like a little sand fox'. Once having negotiated their way past Sabartés and Marcel the chauffeur, the string of callers had to thread their way under low-slung washing lines on which the trusty secretary had pinned up Picasso's correspondence, ready for reply in strict order of urgency. Some days visitors calling on Picasso would find him in the bathroom, which had been transformed into a makeshift studio, with its electric bar heater the only source of warmth. Picasso talked dismissively of rue des Grands-Augustins as the 'great barracks'. On a cold winter's afternoon it was a forbidding place. Cold winds blew a clinging rheumatic damp up the street directly from the river Seine, while the building's large iron entrance gates gave on to a cobbled courtyard entirely devoid of charm. The overall first impression was of a dull, dispiriting greyness. In free-flowing poetry Picasso had written poignantly on 13 May 1941: 'Chasuble of blood cast over the bare shoulders of the green wheat trembling between the dampened sheets symphony orchestra of strips of flesh hanging from the flowering trees of the ochre-painted wall flapping its great wings apple green and mauve white tearing its beak open against the windowpanes architectures of suet . . .' It was significant that in one of the few views that Picasso painted from the windows looking out of rue des Grands-Augustins the radiator in the foreground took pride of place.

Occasionally Picasso had been offered a supply of wood or coal to fire up the gigantic stove by a friendly German soldier trying to ingratiate himself. But accustomed from his youth in the Bateau Lavoir – where he and Ferdinand had cuddled up to an unlit stove – to the power of illusion over reality, he politely declined: 'We Spaniards never feel the cold.'

Another visitor who called on Picasso found him rather less proud, even openly apologetic about being found huddled in his bedroom. 'I've had to organise myself in this little room with my dog, my papers, my drawings, my bed, because I was freezing downstairs,' said Picasso. Seckler observed: 'For a small room, it certainly was crammed full. The unmade bed, several bureaus, a slanting drawing table and a large gently-eyed dog all revolved about a little coal stove, capped by a pot of water. Scattered on the bed and table were seven or eight large etchings in color which he had just finished – with bright reds, blues, and yellows laid down in mass. On the bed also were five or six newspapers, including *L'Humanité.*'

It was during this period that Picasso wrote a farce entitled *Désir attrapé par la queue* (*Desire Caught by the Tail*), completed in three days in January 1941. Three years later, with a growing feeling that the worst was over, the play was performed in private under the direction of Albert Camus, with a cast that included Simone de Beauvoir, Dora Maar, Michel Leiris, Georges Hugnet and Jean-Paul Sartre. Enacted as part of a larger fiesta in which Dora Maar staged a pantomime bullfight, the night of *Desire* was remembered as a legendary event. Roland Penrose highlighted a strong element of the play's appeal: 'It savoured of a clandestine orgy, an insult to the preposterous invaders who had imagined that they could govern Paris.' In a thinly disguised portrait of Picasso's studio life the Surrealist farce unravels a Rabelaisian drama that hinges on the trio of wartime obsessions, hunger, the biting cold and the numerous pathetic attempts to find and capture love. Familiar with the tradition given birth to in the thirteenth-century text *The Book of Good Love*, in which Carnival and Lent invoke vegetarian and carnivore

warfare, Picasso created a battlefield for the hero Big Foot, his rival Onion, the heroine Tart and the secondary characters Fat and Thin Anguish, Cousin, Roundpiece and the Two Bow-Wows. Big Foot's seduction of Tart is all lascivious lust. He adores 'the sweet stink of her tresses', 'the melted butter of her dubious gestures' and longs to grasp her 'buttocks a dish of cassoulet'. He is enraptured by her 'osseous cavities', transported by her 'lips twisted from honey and marshmallow', and driven to madness by her 'gall' and her inviting 'mauve gums'. There was just enough detail in the characterisation for friends to recognise their portraits and the whole event to become energised by their shared hilarity. Dora, aka Tart, who in real life was as far as you get from an image of stinking tresses draped with greasy chipolatas, is also described more poetically as an artist: 'the roses of her fingers smell of turpentine'. More prosaically, however, on climbing nude out of the bath, Tart unequivocally makes her case: 'I have six hundred litres of milk in my sow's tits. Ham. Tripe. Sausage. Entrails. Blood sausage . . . I wear the ridiculous outfits I am given with elegance. I am a mother and a perfect whore, and I know how to dance the rumba.'

For warmth and comfort there was still the life of the bars around Saint-Germain-des-Prés. There had been a deliberate policy by the Nazis to maintain at least the surface appearance of everyday life. There was rationing, of course, and the sordid world of informers, followed quickly by the sound of jackboots on cobbles in the middle of the night; there was the inevitable 'Aryanisation' of friends' and neighbours' houses and flats; but there was also the opera, cabaret, and the odd stylish *vernissage* and cocktail reception for society painters and Academicians: if you wanted to see Picassos they could be seen in the backroom of Louise Leiris's gallery, as a clandestine pleasure stolen from under the Wehrmacht's eye.

Although generally hidden from the public gaze, Picasso's art still drew bitter criticism. On 6 June 1942 in the journal *Comoedia* Maurice de Vlaminck issued a virulent attack on Picasso's art that he saw as primarily responsible for leading the gullible into a stylistic cul-de-sac and 'indescribable confusion'. Vlaminck had

only recently returned from *le voyage*, the famous trip around Germany organised by the German Ministry of Propaganda and accompanied by Kees van Dongen, Dunoyer de Segonzac and André Derain, and there was clearly a political angle to his hostility, which only added to the gnawing envy and bitterness he felt at having been bypassed by Picasso's success. In the following week's issue of *Comoedia* André Lhote put up a spirited reply. But for Picasso, the warfare on paper was perhaps a mere prelude and an omen of what was still to come.

Picasso was fortunate. There were friends and insiders who would come to his support. Although it has never been conclusively proven, Arno Breker, Hitler's favourite sculptor, whose recent exhibition in Paris had been an enormous, though carefully orchestrated, success, claimed to have helped Picasso when he was threatened with deportation for sending money to Spain. There have even been suggestions that Breker helped Picasso to find bronze to cast his plaster maquettes. Jean Cocteau also trod the fine line between courting German friendship while remaining 'patriotic' and close to the avant-garde. André-Louis Dubois, a Parisian policeman who was sympathetic to Picasso, to the point of compromising himself, was to act as a protective barrier between the artist and the Gestapo with his daily visits at 11 a.m. to rue des Grands-Augustins. One day, responding to an anxious phone call from Dora Maar, Dubois arrived at the studio to find Picasso seated amongst slashed canvases, stony-faced and numbed by what had just occurred. Turning to Dubois, Picasso said, 'They insulted me, called me a degenerate, a communist, a Jew. They kicked the canvases. They told me, "We'll be back." That's all . . .'

If there was no manifest reaction against such humiliation in Picasso's art of the time, and nothing as overtly belligerent as *Guernica*, this mortification had nevertheless been absorbed. 'I have not painted the war . . . But I have no doubt that the war is in these paintings I have done,' Picasso told Peter Whitney soon after the Liberation.

By the beginning of 1942 Picasso's production had once again

begun to pick up its pre-war rhythm. Literally hundreds of canvases, prints and sculptures were produced before the Liberation of Paris in 1944. Picasso's gift for ingenuity meant earlier works were recycled, antique dealers were alerted to find old canvases for over-painting, paper supplies were found, and anything from matchboxes to cigarette packets, hatpins to torn newspapers, twisted bottle tops and pieces of bone, could be transformed and used resourcefully as material for another work of art. Many of these smaller intimate pieces were jealously guarded as talismans or votive objects by Dora Maar who saw them as her last link to Picasso once he abandoned her for Françoise Gilot. Little love tokens to Dora were produced by the dozen: torn cardboard hearts with the face of the bull. The most iconic image of this period was without a doubt the *Head of a Bull*, fashioned from bicycle handlebars and an unadorned leather saddle. For more traditional works, sculpted first in plaster, it was Sabartés who persuaded Picasso that for posterity they should be cast in bronze. It was a dangerous process; in fact, completely illegal as all bronze was requisitioned for melting down. 'A few devoted friends transported the plaster casts at night in lorries to the foundries,' Picasso recalled in conversation with Brassaï.

Unable to travel out of Paris, Picasso was encouraged to roam the streets of Montparnasse and stroll with Kazbek, his Afghan Hound, along the banks of the Seine. As he settled into work again, life in the cafés brought back a sense of community. Dora and the Zervoses accompanied him to the Café de Flore, with Kazbek always in tow. The Braques and Eluards might meet them there for dinner. Simone de Beauvoir and Jean-Paul Sartre were often found at Les Deux Magots or the Brasserie Lipp. Brassaï, the poets Robert Desnos, Raymond Queneau, Léon-Paul Fargue and Georges Hugnet would often call in, while Jean Cocteau, butterfly and dandy, flitted energetically from theatre to bar, from café to artist's studio. Just down from the studio gates on rue des Grands-Augustins, Arnau, the owner of the restaurant Le Catalan, catered to the Picasso *ménage* with the few resources he had managed to scrounge on the black market. For the shrinking *bande* of friends

Le Catalan increasingly became a second home. By stocking up on
ration cards, swapping art for food, relying on the good nature of
the *patron* or just straight cash, the odd treat could be found. But
on return to the studio hunger returned. Food and its scarcity
were always at the forefront of everyone's mind. It was a hunger
both spiritual and physical, that Picasso reflected upon in still life
after still life. In a whole gallery of images, depicting winding
tomato plants shooting out their ravenous tendrils, a woman with
a hat shaped like a fish, empty plates licked clean and solitary
kitchen implements, Picasso paid witness to the longing that
everyone shared. 'Even a casserole can scream,' Picasso allegedly
said. And surely, in those steely anorexic still lifes, what is
important is exactly what is *not* there, rather than what we
can see. It was here that the *vanitas* tradition of still lifes that
contemplate unblinkingly on our mortality was transformed into
the French genre of the *nature morte* – nature dead. Death was
everywhere in Picasso's work and in his life – in the portrayal of a
desiccated skull, in the death of Julio Gonzales on 27 March
1942.

There was still the rare feast day, however, as in November 1943
when the Picasso group were caught eating Chateaubriand steak on
a 'meatless day', causing the closure of Le Catalan for a month, to
the despair of Arnau. Picasso was also fined. For Picasso an
imminent change to his life was announced by the appearance at
Le Catalan of the art student Françoise Gilot. For Dora in particular,
it spelt the beginning of her long season in hell. If there had been
happiness with Picasso she would soon collapse back towards her
representation, frozen for ever, in the various states of the *Weeping
Woman*. Of all the motifs developed in *Guernica*, it was the
Weeping Woman that Picasso returned to again and again, as if
somehow trying to exorcise his feelings of guilt. Although most
often depicting Dora, there were times when Olga reappeared
wailing on canvas, as did Marie-Thérèse whimpering quietly in a
monochrome sketch. Twenty-six times Picasso returned to the
depiction of a woman in despair; for the last time in October

1939. Grief, war and Picasso's women had slowly blended into one. Picasso explained to Gilot the persistence of this contemporary *mater dolorosa* motif.

> An artist isn't as free as he somehow appears. It's the same way with the portraits I've done of Dora Maar. I couldn't make a portrait of her laughing. For me she's the weeping woman. For years I've painted her in torture forms, not through sadism, and not with pleasure either; just obeying a vision that forced itself on me. It was a deep reality, not the superficial one.

Gilot was now about to take Dora's mantle and partner Picasso, her protean mentor and friend. 'You've never loved anyone in your life. You don't know how to love,' Dora remonstrated bitterly.

Gilot remembered that first encounter with Picasso and Dora clearly. Elegant Dora, with her long trumpet-shaped cigarette holder, so poised and other-wordly, who 'carried herself like the holy sacrament'. Picasso with 'his greying hair and absent look – either distracted or bored – [which] gave him a withdrawn, Oriental appearance that reminded me of the statue of the Egyptian scribe in the Louvre. There was nothing sculptural or fixed in his manner of moving, however: he gesticulated, he twisted and turned, he got up, he moved rapidly back and forth.' As so often before, Picasso's *modus vivendi* was to prefigure in his paintings the future passions and events in his life. Dora would now have to witness on canvas the arrival of Françoise. 'Better tears and tragedy than a modest veil thrown over the name and face of the woman he loves,' observed Brassaï, who had also witnessed at first hand the final throes of Dora's affair. As always with Picasso, hurt and the very last ounce of love still had to be wrung out. In the shadow of *Guernica* Dora and Marie-Thérèse, just a few years earlier, had been goaded into a fight. But this time neither Dora nor Françoise was ready to battle it out. Dora was left hanging anxiously at the end of the phone in her flat in rue de Savoie, refusing all other invitations on the off-chance that Picasso might call. The dependency and intrigue, and the catalogue

of broken promises that threw Dora off balance, were still powerful weapons.

But Françoise was far from convinced. Picasso's seduction techniques, offering to have her 'locked up in the attic', cocooned from the world, frightened her off. She was not yet ready to submerge herself in Picasso's all-absorbing world. Years later Gilot described Picasso's treatment of his many 'wives':

> He had a kind of Bluebeard complex that made him want to cut off all the heads of all the women he had collected in his little private museum. He preferred to have life go on and to have all those women who shared his life at one moment or another still letting out little peeps and cries of joy or pain and making a few gestures like disjointed dolls.

For Picasso the break between partners was often complete. Sabartés observed: 'Every time he starts over, it's for good, irremediably. That's his strength! The key to his youth. Like a molting snake, he leaves his old skin behind him and begins a new existence elsewhere. After a clean break, he would never turn back. His ability to forget is even more phenomenal than his memory.' It was those left behind, like Dora, who were drowned by the weight of the memories. Dora still had the fragile drawings, the tissue-thin tokens of love, the doodles of spiders on the kitchen wall and her scorpion-infested house in Ménerbes. She also kept her place in history as part inspiration and recorder of *Guernica*'s troubled birth. But Dora was forced to recognise that she was now firmly in the past. Instinctively Françoise knew that to give in immediately to Picasso and his pattern of humiliation was to risk her identity. She was still too cautious to take that risk.

The winter of 1943 was the coldest in years. At −15°C, Brassaï's goldfish froze to death in its tank, and Picasso's large studio, where *Guernica* had been painted, became almost unusable, iced over like the Siberian steppes. From winter into spring Françoise increasingly became an integral part of Picasso's life. The streams of visitors to

the studio still continued, but were kept at bay by Sabartés while work continued. In the last week of February 1944 Picasso received the terrible news that Max Jacob and Robert Desnos had both been interned in Nazi camps.

Over the whole of the previous year, Picasso had worked fitfully on a series of drawings that would eventually find their plastic incarnation in the monumental plaster sculpture *L'Homme au Mouton* (*Man with a Sheep*). Described by André Malraux as a pendant to *Guernica*, the 7-foot plaster represents almost all the values of human compassion that the painting rejects. Just as with *Guernica*, the sculpture of *Man with a Sheep*, with its intimations of the Good Shepherd, remains deliberately Manichaean as Picasso leads the viewer through a confusing moral maze. Is the Man the sheep's protector and saviour, or is perhaps the slaughter of the innocent about to take place? Having witnessed the sculpture's rapid construction from its mountains of clay, Paul Eluard wrote soon afterwards to a friend, 'Picasso paints more and more like God or the Devil' (an observation that applied equally to his sculpture).

By mid-August 1944, with the Allies at the gates of Paris, dreams of imminent liberation were now at the forefront of everyone's mind. Sporadic street fighting between an emboldened Resistance and the remaining German troops around rue des Grands-Augustins persuaded Picasso to move in with Marie-Thérèse and Maya on Boulevard Henry IV. But immediately after the Liberation, on 25 August 1944, Picasso moved back to rue des Grands-Augustins. The first Allied soldier to run up the steps to see Picasso was his old friend Lee Miller, last seen on the beach on the Côte d'Azur. As Penrose recorded, 'The excitement was so great at finding what seemed to be a miracle – Picasso not only alive but unimpaired in his vigour – that the number of the visitors who pressed around him became almost overwhelming.' A euphoric Paris immediately transformed Picasso into '*le symbole de la liberté retrouvée*'. After the Eiffel Tower, Picasso had become the largest tourist attraction in town. Everyone wanted to shake hands with the prophet of *Guernica*, and witness his survival. Cartons of cigarettes, bars of soap, canned food and boxes of

Picasso and Lee Miller at rue des Grands-Augustins, 1944,
with plaster of *Man with a Sheep* in background.

chocolates lay piled up on Sabartés' desk. The studio came to resemble
a railway station. 'PICASSO IS SAFE – the artist was neither a traitor
to his painting nor his country', ran the headline in the *San Francisco
Chronicle* on 3 September 1944. At first, as relieved and excited as the
rest, Picasso indulged the swarming hordes of visitors. But soon
normal life and all attempts to work proved impossible. One visitor
recorded seeing over twenty sleeping GIs strewn around the studio.
'Paris was liberated,' Picasso later said to his friend Brassaï, 'but I was
besieged.' Slowly Sabartés and Marcel the chauffeur started to weed

out those who were just a distraction. The welcome sign '*Ici*' on the gate disappeared overnight.

The jubilant celebrations were quickly poisoned, however, by the setting up of Collaboration committees and the subsequent settling of scores; the purges that went by the name of *épuration*. For Picasso, there was no forgiving Derain and Vlaminck who had personally insulted him and 'accommodated' Nazi rule. *Liberté*, however, meant a chance for Picasso to show his work once again. Proposed by the Communist artist André Fougeron, he was offered an '*hommage*' for his first showing ever at the Salon d'Automne. As an opportunity to show the previous four years' work it was planned to open as the Salon de la Libération on 6 October. Two days prior to the inauguration Picasso made an announcement that would dramatically alter his position as a post-war cultural icon.

On 4 October in the offices of *L'Humanité*, Picasso formally announced his allegiance to the Communist Party. Witnessed by Marcel Cachin, *L'Humanité*'s director, and Jacques Duclos, the Communist Party secretary, Picasso's friends Louis Aragon and Paul Eluard were also invited as sponsors to this historic event. For Picasso, joining the Communist Party represented the logical conclusion of his life and work. In an interview on 24 October with the American Communist broadsheet *New Masses* Picasso explained further:

> I have always been an exile, now I no longer am; until the day when Spain can welcome me back, the French Communist Party opened its arms to me, and I have found in it those that I most value, the greatest scientists, the greatest poets, all those beautiful faces of Parisian insurgents that I saw during the August days; I am once more among my brothers.

It was perhaps a strangely naive decision to make on the eve of the peace, particularly following damning proof of Stalin's duplicity during the Moscow show trials of the late 1930s. But the horrors of Stalingrad had created a wave of sympathy. No other nation had lost so many lives fighting the Nazi menace.

For Picasso, there were good reasons to formalise a relationship that was already deep in his blood. As a young man in Barcelona he had displayed definite anarchist sympathies. But it was during the Civil War that the Soviet support of the Spanish Republic confirmed its position as the only reliable champion of democracy. Subsequent history has clearly demonstrated the fallacy of this view. For Picasso, who was never an orthodox Marxist, there were personal reasons too for joining the Party. His relationship with Paul Eluard was so close it was almost symbiotic. Friendship and *copinage* almost certainly played their role. How best could Picasso honour his Communist friends and the 60,000 exiled Republicans who had fought alongside the French Resistance? And then there were the thousands more who had fought for the Free French army, and a further quarter of a million Spaniards conscripted into the forced labour corps of the Vichy government's Travailleurs Etrangers. Picasso was, in the eyes of one commentator, 'above all loyal to loyalty'. (Which is perhaps more than can be said for the Allied governments who after the war left the Republicans high and dry, victims to Franco's brutal repression.) For the Communist Party, whether Picasso's reasons for joining were nostalgic or sentimental, it still remained a huge publicity coup. Along with the Nobel prize-winning physicist Frédéric Joliot-Curie and Louis Aragon, Picasso became one of the Three Musketeers – Moscow's most valuable trio in the battle to win over the post-war intelligentsia.

There were still close friends, like D. H. Kahnweiler and Roland Penrose, who would testify to Picasso's almost total lack of political commitment, but their judgement clearly belies the facts.

While some questioned Picasso's integrity, for many observers the existence of *Guernica* proved his commitment beyond any doubt. On 28 March 1945 Christian Zervos wrote to Alfred H. Barr: 'The participation of Picasso in the Resistance is false. Picasso simply kept his dignity during the Occupation the way millions of people did here . . . Realise that his work itself is the greatest form of resistance, not only against an enemy but against millions of pretentious imbeciles.' After the Liberation Picasso's role during the Occupation

took on a new importance. To discredit him for having survived would be to challenge the honesty of his whole *oeuvre*, and cast doubt over the sincerity of the moral outrage portrayed in *Guernica*. In spring 1943 he had reasoned with Françoise Gilot:

> in a sort of passive way I don't care to yield to either force or terror. I want to stay here because I'm here. The only kind of force that could make me leave would be the desire to leave. Staying on isn't really a manifestation of courage; it's just a form of inertia. I suppose it's simply that I prefer to be here. So I'll stay, whatever the cost.

But this pose of impassive fatalism disguised an involvement that went far deeper than has previously been thought. According to Juan Larrea, Picasso's support included donating the funds of *Songe et Mensonge* to the Republic, buying milk for Barcelona's needy children, a gift of FF550,000 to help exiled intellectuals, Republican refugees and other *personae non gratae* like Communist Party members and anarchists. Gilot remembers the potentially dangerous visits to the studio of Resistance fighters like André Malraux and Laurent Casanova. But far more compromising were Picasso's sending of money to Spain, his help in securing green cards for Spanish exiles, his sponsorship of a hospital for injured Republicans in Toulouse, financial help offered to Jewish painters like Otto Freundlich, and his attendance at Max Jacob's memorial service.

That Picasso cared deeply was reinforced once again in his art. In the beginning of 1945 he embarked on another large canvas with the dreadful aftermath of war as its central theme. *Le Charnier* (*The Charnel House*) was yet another meditation on hopelessness and despair. Employing many of the devices used in *Guernica*, notably dramatic distortion and the ghostly *grisaille*, photographs were taken of the canvas as it slowly evolved. Strangely prophetic of the death camps, before the sheer scale of the Holocaust was known, the piled-up mangled bodies lying under a kitchen table were derived, according to Dora Maar, from the graphic scene in a Republican film of a peasant family burnt to death in their home.

Picasso, intimated Penrose, 'had been led by his daemon through dark channels'.

With the capitulation of Germany in the first days of May 1945, the war in Europe had come to an end. Paris could return to a semblance of normality, but something was broken. The spirit had cracked. At the Salon de la Libération, far from winning unanimous approval, Picasso's stark war images were openly threatened and mocked. What was clear to many was that Paris as the art centre of the world was finished. The balance had shifted. Now New York, which had provided a haven for so many exiles, would become the new world centre for the production and consumption of art.

Guernica had been prophetic in more ways than one. If it had alerted the world to the catastrophic war, it also rang the death knell on a hopelessly exhausted European art. Its showing in New York was in effect a memorial service to a dying continent; its tragic subject matter a eulogy to a vanishing world. There was now a very real sense in which the baton had been passed on. If the 1930s had been the preparation for America's muscling in on European cultural hegemony, by 1940, as Clement Greenberg observed, 'New York had caught up with Paris as Paris had not yet caught up with herself, and a group of relatively obscure American artists (Pollock, Gorky and Rothko) already possessed the fullest painting culture of their time.' If Hollywood and Jazz had seduced Europe before the war it was now America's turn to play for the highest of stakes. 'The main premises of Western art have at last migrated to the United States,' pronounced Greenberg, 'along with the center of gravity of industrial production and political power.' It was the death of Paris.

6

The Big Bang

Picasso is a genius, that's obvious, but his 'monsters' no longer trouble us. We're looking for different monsters and by different paths. The question of 'succession' may come up, but in a different way.

Henri Michaux in conversation with Brassaï (October 1943)

One must change the Furies into beneficent powers.

Martha Graham

Art must contact with mystery – of life, of men, of nature, of the hard, black chaos that is death, or the greyer, softer chaos that is tragedy.

Barnett Newman, *The Ideographic Picture* (1947)

Despite the pain of separation from Europe, and the obvious anxiety over the survival of family and friends, from New York Jacqueline Lamba was still able to write back to her friends the occasional upbeat letter, flashed through with a newly found sense of optimism. Inebriated with the joy of survival, her mounting hysteria leaps out from the written page. 'America is the Christmas tree of the world,' she eulogised. New York had survived with its fabric entirely intact and effused an extraordinary raw and vital energy. 'New York was triumphant, glossy, more disorderly than ever,' recalled Alfred Kazin in his intellectual autobiography *New York Jew*. But it was also, according to Kazin, 'more "artistic", the capital of the world, of the old European intellect, of action painting, action feeling, action totally liberated, personal and explosive . . . Its beauty rested on nothing but power, was dramatic, unashamed,

flinging against the sky, like a circus act, one crazy "death-defying" show after another.'

Following its tour of the United States *Guernica* had finally settled at MOMA for the New York art world to reassess it calmly as an image of a catastrophic world war that had finally been survived. It slowly moved from the condition of witness and prophecy back into the safer realm of artefact and history. Strangely, no longer harnessed to a single historical event, *Guernica* was finally released from its role as war reporter and propaganda machine. The period of its most enduring legacy was about to begin.

Many American artists who had seen the painting on its travels had been shocked and overwhelmed by *Guernica*'s power. Many felt themselves impotent in the face of its audacity and expressive potential. Willem de Kooning, a Rotterdammer whose city had been destroyed by aerial attack at the beginning of the war, had been living in New York for just over a decade. For him, his encounter with *Guernica* had been quite literally 'staggering'. Others grew drunk on the image. The artists who would soon triumph as the Abstract Expressionists found nourishing meat in *Guernica*'s dramatic energy and theatrical scale. It was European. It was cosmopolitan. It was politically committed, and both flayed and raw enough to appeal to the gutsiness of New York. Most importantly, it had arrived bang on time. Kazin portrayed the setting well:

New York in 1943 was the beacon, the world city of freedom, openness, hope . . . full of famous conductors who had no orchestra, great pianists who could not get a hearing, German, French, and Italian intellectuals broadcasting to their old homelands for the Office of War Information. My 'world city' was never more full of talent, brains, buried treasure. Delmore Schwartz was right. Europe was still the biggest thing in North America.

For those cultural and art historians fixed on trying to understand the zeitgeist, *Guernica* made its dramatic entrance as the key player in what Robert Rosenblum has jokingly called the Big Bang theory

of American art – in which a single cultural 'event' like *Guernica* kickstarts a whole renaissance. Centre-stage on MOMA's wall, *Guernica* arrived in New York at the very moment when American art was changing from the ideological, utopian and regional to the romantic, interior, epic and mythological. Initially blasted by Picasso's creative power, a whole school of artists would deconstruct his lessons and slowly rebuild their art from the rubble up. Jerome Seckler in his 1945 interview with Picasso for *New Masses* remembered the seriousness of that exploratory environment well.

> For the past ten years my friends and I had discussed, analyzed and rehashed Picasso to the point of exasperation. I say exasperation because very simply it was just that. The only conclusion we could arrive at was that Picasso, in his various so-called 'periods', quite accurately reflected the very hectic contradictions of the times, but only reflected them, never painting anything to increase one's understanding of these times. Various artists and critics who make their living by putting labels on people identified him with a wide variety of schools – surrealist, classicist, abstractionist, exhibitionist and even contortionist. But beyond this lot of fancy nonsense, these people never did explain Picasso. He remained an enigma. Then came the bombshell. In the midst of the last agonised hours of Loyalist Spain, Picasso painted his *Guernica* mural, and with this mural emerged as a powerful and penetrating painter of social protest.

Every artist naturally read *Guernica* in an entirely different way. For some it was its political message that was important, for others it was its style. The artist who had lived with Picasso's art longest was Arshile Gorky. Nicknamed the 'Picasso of Washington Square', Gorky had slowly worked his way through Picasso in his every manifestation: first, the Picasso of the synthetic Cubist style, then the classical artist of the 1920s at home in the *haut monde*, followed by the Surrealist of the early 1930s, and finally culminating in the tortured period of the Minotaure that led on towards the etchings of *Songe et Mensonge*. Like a snake sloughing off its skin, Gorky, via

his *alter ego* Picasso, renewed himself again and again. Faithful to the point of mimesis, he absorbed and ingested Picasso until his own character seemed to disappear almost completely; the camouflage bought him time. Harold Rosenberg, the art critic famous for coining the epithet 'Action Painting', remembered the pride that Gorky took in his apparently self-effacing style. 'When, in '37, some important paintings arrived in New York in which the Spaniard had allowed the paint to drip, artists at the exhibition found a chance for their usual game of kidding Gorky. "Just when you've gotten Picasso's clean edge," one said in mock sympathy, "he starts to run over." "If he drips, I drip," replied Gorky proudly.'

Of singular importance to Gorky, and extremely helpful in unravelling the mysteries of the Picassian style, was the eccentric figure of John Graham, an aristocratic and enigmatic Pole who claimed connections to the Tsar. The chameleon-like Graham would become for many New York artists what Guillaume Apollinaire had been to Picasso; a fount of inspiration and ideas. Claiming familiarity with every European artist of import, Graham attached himself to modern art with a missionary zeal. His *Primitive Art and Picasso* (1937) proved highly influential. For the first time Graham introduced the momentous convergence of ideas in the writings of Jung, the art of primitivism and the protean outpourings of Pablo Picasso. It represented the cultural matrix of its time. But equally important was Graham's curatorship in 1942 of an exhibition at McMillen, Inc where he selected the work of Pollock and de Kooning to sit side by side with Picasso, Braque and Matisse. Graham brought together the two energy forces that would come to shape the visual world – Paris and New York.

Amongst American artists there had been a real feeling during the late 1930s and the war years that culture was in mortal danger. Exacerbated by the realisation that as artists they were not yet up to their European peers, it is not surprising that a millennial sense of desperation set in. In the late 1930s Gorky had opened an artists' meeting with the then common defeatist mantra 'We are failed.' Re-energised by this cathartic moment, however, he immediately

retracted and suggested they collaborate on a painting. What was
needed was an image or a form of expression that could do what
Guernica had done. What was required was authenticity and a
breadth of voice. *Guernica* was universal. It portrayed man's
instinctual animal nature, the history of human and inner conflict,
the battleground of desires, the spirit and the potential for brutality.
It depicted the origins of human behaviour, the eternal and the
recurring, death and rebirth, seasons in hell, the dark nights of the
soul, human discord, tragedy and waste. For American artists like
Gorky and critics like Graham there was a profound interest in the
archaic, the ritualistic, rites of passage, the tragic, the sublime, the
transcendent, sacrifice, and the synthesis of pantheism, shamanism,
Christianity, Eastern philosophies, religious belief systems and
Freudian and Jungian analysis. All this, mixed up together in a
pot-pourri of convergent and overlaying ideas, represented the
nervy, jangled portrait of the New York mind at work, and the
simultaneity of modern consciousness. 'The Americans drew on
what was lacking for those in the First War, a sophisticated culture
of waste, horror, fear and anger.' Their mental habitat included
Frazer's *The Golden Bough*, T. S. Eliot's *The Waste Land*, Melville's
Moby Dick, the Grail myth, the legend of the Fisher King and
pictorially, of course, *Guernica*. Through its use of archetypes
Guernica had simultaneously depicted the arrival of modern war-
fare and the breakdown of the modern psyche – it was a common
theme that ran like a thread through so many of these works.

For Gorky, however, the encounter with Picasso and *Guernica*
was more immediate and more personal. For him to be 'with'
someone signified the most intense partnership; a welding together
of identities. 'I was "with" Cézanne for a long time, and then
naturally I was "with" Picasso,' Gorky explained with a sense of
historical inevitability, as if there was nothing more logical in the
world. In an interview with the artist Milton Resnick, Gorky
explained the depth of his reverence for his master: because art
was his father, Gorky could not kill what he loved. 'Since I, as a son,'
he said, 'cannot kill my father – that is, my past, the past of art – then

Arshile Gorky, *Study for 'They Will Take My Island'*, 1944.

I have to die because I am born to art and cannot deny my father and cannot murder him.' The question of Picasso's succession as discussed earlier by Michaux and Brassaï was still clearly up for grabs. What Gorky had provided in a late flowering of works was a pure meditation on the armature of *Guernica* fired up with intense and hovering colour. In the evocatively and beguilingly titled *Apple Orchard, Making the Calendar, One Year the Milkweed, How My Mother's Embroidered Apron Unfolds in My Life, Landscape Table*, and most obviously in the 1944 *Study for 'They Will Take My Island'* Gorky married his refined sensibility to *Guernica*'s shattered planes and nostalgia for his Armenian past. In the floating penumbra he suspended the viewer's attention but it was not yet enough to break entirely free.

'We want', declared the co-signatories Gottlieb, Rothko and Newman in a letter to the *New York Times* in June 1943, 'an art that is tragic and timeless.' With their colleague Gorky they had begun to approach it. They too revered Picasso. In a radio inter-

view in October 1943 for WNYC, Gottlieb and Rothko furthered
their case: 'All primitive expression reveals the constant awareness
of powerful forces, the immediate presence of terror and fear, a
recognition and acceptance of the brutality of the natural world as
well as the eternal insecurity of life.' It was the same language that
Guernica had held up to them in broad strokes of black and
scumbled paint. The painting fitted in perfectly with Harold
Rosenberg's concept of Action Painting, which romanticised the
artists as 'anti-intellectual, naive, emotionally tortured, but honest
noble savages'. Rothko, Gottlieb and Newman were after the
elusive sublime – a concept proposed by Edmund Burke in his
*Philosophical Enquiry into the Origin of Our Ideas of the Sublime
and Beautiful* (1757). Burke wrote that 'dark, confused, uncertain
images have a greater power on the fancy to form the grander
passions than those which are clear and determinate'. It was an
interpretation of the sublime that inspired the Romantic movement
and came across to post-war America almost unchanged. *Guernica*
was a totem to the idea of the sublime. Through its use of *grisaille*
it created an all-enveloping mood; through its use of scale some-
thing akin to the quality of the 'cinematic', as suggested by the
Catalan critic Lluís Permanyer. A large canvas forced human
contact and a more actual, physical encounter. *Guernica* was a
wrap-around picture, a total environment, on a larger than human
scale. It was a scale which forced the viewer to measure up to the
painting. *Guernica* was perhaps the first step for Rothko through
his 'doorways to hell' – those large, radically simplified walls of
colour that would become his signature style. The European
urbanity of the Andalucian patio or the small whitewashed plaza
in *Guernica* – within whose claustrophobic walls the tragedy is
acted out – is transformed by the Abstract Expressionists, Newman
and Rothko, into the open expanse of the prairie – a new sublime –
shimmering while it simultaneously denies and invites the eye to
read through the surface of the paint, to encounter both nothing-
ness and the absolute.

There were many ways to come at *Guernica*; some head-on and

others more oblique. For American artists Picasso was the legitimate path to follow precisely because he had kept his distance from the Surrealists who had become increasingly narcissistic, and who seemed intent on leading artists down blind alleys and into labyrinths from which there was no escape. They had created what Barnett Newman criticised as mere 'phantasmagoria'. *Guernica* had a seriousness, an epic, universal, historical and social appeal, as opposed to the Surrealist internal life of fantasy and the unconscious. Even in its nihilism it spoke of community, and of trying to depict the human historical tragedy.

What appealed then in *Guernica* was its capacity to modernise myth and recycle the ancient world. The painting's importance as a fund of sources and ideas was hinted at only in titles like Mark Rothko's *The Syrian Bull*, for instance. There was also, however, a deeper engagement with the lessons of *Guernica*. In *Guernica* Picasso had conflated the myth of the Minotaur, the Crucifixion and the *corrida*. That was his 'universal' tradition. What was a similar tradition bank for a first-generation American like Adolph Gottlieb, one might ask. In series after series of what Gottlieb described as his

pictographs, he divided up the canvas into discrete rectangular shapes, akin to comic strips, and filled the boxes with images that are reminiscent of North American Indian blankets, Egyptian hieroglyphs or the carefully carved walls depicting the victories of the Assyrian kings. The viewer's eye is teased back and forth to accommodate the accumulation of detail and the apparent confusion in scale. Threatening eyes, a chopped-off hand, a gaping mouth, a foot, a fish, a sperm, sit myster-

Adolph Gottlieb, *Black Silhouette*, 1949.

William Baziotes, *Untitled*, 1939.

iously next to one another. It is like seeing arbitrary selections of celluloid film strip, each telling a different story and each in a different time. As in *Guernica*, time and logic are broken on the wheel of a barbaric world.

Other artists like William Baziotes, of Greek origin, were immediately seduced and bowled over by the epic potential of *Guernica* and its 'feverishness of death and beauty'. In an interview, years later in 1963, Baziotes elaborated his philosophy:

> It is the greatness of spirit in painting that compels us to return to it, time after time. We go back . . . not for new discoveries but for the renewal of a great experience . . . Some mysterious force, some strange energy occurs as soon as brush touches canvas . . . Therefore, when I look at contemporary painting, I must judge it by the one criteria I have. It is a level of painting where the interest is not only in the physical aspect of paint, but also in the drama and poetry of the soul of man.

In *Guernica* there was certainly drama. Baziotes had felt the wind of the apocalypse blow through the room. But where Rothko's sharing of an interest in myth had been implicit and internalised, Baziotes was frighteningly explicit. All of *Guernica* was too much to deal with. So he took it apart, broke it into fragments and started again. There are wounded souls, dwarfs and the dreaded Cyclops. There is a contorted sadism in his work. Animals and unknown beasts released from some private or prehistoric bestiary are twisted and pulled, their gaping mouths metamorphose into other

monsters. Sometimes the contours of one freakish creation is shared with another, as one image voraciously consumes the other: an ancient coelacanth swallows a bird, teeth eat each other, forms lie side by side swelling like microbes in suspension on a Petri dish. Everywhere there are themes of dismemberment. In one moving image a sad-faced boy, no more than a torso with a head, is placed on a chair, signalling to us 'who knows what?' with his two bandaged stumps cut off above the elbow. He is as anonymous, mute and pathetic as a tailor's dummy. He is a resurrection of Picasso's self-portrait lying broken in the plaza, trampled by the dying horse; put together, but as pathologically broken in spirit as he ever was before.

One of the most original and sophisticated responses to *Guernica*'s style was to be found in the work of Willem de Kooning in the second half of the 1940s. Unlike many of the other Abstract Expressionists, who were autodidacts or who had been physically divorced from the European grand tradition, de Kooning's visual education sat on a solid bedrock of academic training, formed after eight years of study at the Rotterdam Academy of Fine Arts and Techniques. Staggered by Picasso's bravura and the fractured space in *Guernica*, de Kooning slowly worked his way through the pictorial implications. Early in the 1940s, not unlike Baziotes, he created a series of Manikins and Standing Men, with features reminiscent of many of the preparatory drawings for *Guernica* in their expressive contortions. Not drawing from life, that is, not employing a model, de Kooning had instead dressed up a tailor's mannequin and hardened his own trousers in glue to create these 'hollow men' with their mournful, vacant gaze. Slowly the figures disappeared and were submerged in broad sweeps of paint – thrashed over in pinks, carmines, brash lipstick-reds, custard-yellows and suffocated under plates of powder-white – which inevitably set up a tension between figuration and abstraction, a dialectic that would for ever remain the subject of de Kooning's work. Influenced by his friendship with and admiration for Arshile Gorky, whose work was always more lyrical, de Kooning drew

Willem de Kooning, *Attic*, 1949.

closer and closer to the visual violence essayed in Picasso's work. For him it was always Picasso who was the one to beat. His greatest homage was *Judgement Day (Labyrinth)* (1946) in which critics have found figures wrested from *Guernica* and mutated in a tighter, flatter space. Again and again, we find 'glimpses' of subject, as de Kooning liked to describe it; those squints, fleeting shots and momentary reflections that make up the jarring dissonance of city life. In *Mailbox* (1948) and *Town Square* (1949) the eye is led on a visual assault course, dipping in and out from the surface, teased and dislocated as the picture once again slowly begins to rebuild. Like sitting on the Coney Island helter-skelter, we are treated to vertiginous swoops and sudden surprises as we just as quickly hit the ground. In the late 1940s it was de Kooning's use of *grisaille* that was perhaps most evocative of *Guernica*. Just as Picasso had done so often before during any of the pictorial crises in his life, de Kooning went back to the basics of black and white to discover

where it was he needed to go to next. Configurations of shapes were repeatedly overlaid. A whole series of masterpieces including *Attic, Black Friday, Zot, Asheville, Excavation* and the melancholy *Dark Pond* describe the new language of dislocation that de Kooning had learnt; a style where the direct influence of Picasso meets the frenetic pace of New York life. Gone is the pastoral; this is gritty, urban, sexy modern life. But it was in the private research laboratory of lightning sketches and drawings that de Kooning revealed himself most. One after the other of what might be easily dismissed as mere abstract doodles return to the world of that bombed-out Spanish square. Nothing quite so literal as Picasso, but all the same, in sapolin enamel on graph paper, the grid is washed over and dripped with the medium, leading to images as free and liberated as almost anything ever seen before. It is game-playing of a very high order.

A similar game, but on a far grander scale often bordering on the

Robert Motherwell, *At Five in the Afternoon*, 1949.

melodramatic, was played out by Robert Motherwell in his attention-grabbing series *Elegies to the Spanish Republic*. Started in 1948, these meditations on a lost republic would continue to engage Motherwell for a further thirty years. Motherwell has often fallen foul of the critics, possibly, according to one, because he stood 'out from his artistic peers like the preppie in the Gashouse Gang'. Or, perhaps, according to another, because he dressed down deliberately with the tell-tale holes in his clothes to put his more proletarian peers at ease. Setting these affectations aside, Motherwell was certainly different. Of all the artists so far mentioned he was arguably the most 'refined'. Having studied philosophy at Stanford, followed by aesthetics at Harvard, he would become the Abstract Expressionists' only Ivy Leaguer. Just prior to the Second World War he spent two years in Europe, mostly in France working on a thesis on Eugène Delacroix. After post-graduate studies at Columbia University, he was finally persuaded by Meyer Schapiro to take up the brush. In many ways he enjoyed a privileged position, able to discourse with the Surrealist exiles in their mother-tongue. And it was their work – the automatic writing of André Masson and Matta, and its opening up to the subconscious – along with the example of Picasso's collage and his use of fractured planes, that interested him most. As co-editor of *Possibilities*, and from 1944 as editor of the ground-breaking *The Documents of Modern Art*, he became Abstract Expressionism's most partisan voice; the movement's self-appointed spokesman, a one-man think-tank. But where he differed most from Gorky, de Kooning, Rothko and Pollock, the standard-bearers of the emerging style, was that as a relative newcomer he hadn't cut his teeth in the bitter political battles of the 1930s. In short, he hadn't suffered. This would always set him apart, allowing him to be on the one hand more cerebral and detached, on the other, more openly hedonistic. Of all the Abstract Expressionists his work was the most celebratory but also the most prone to slipping deceptively into the realms of decoration. With Motherwell, a penchant for 'tastefulness' and cultural tourism was never far away. Even as a relative novice his delicate collages, with their inclusion of torn fragments of French cultural paraphernalia, from wrapping paper and cigarette boxes to obscure

literary magazines, had the bewitching charm of *nostalgie* comfortably controlled. Nevertheless, and perhaps unexpectedly, it was to *Guernica* and the Spanish Civil War that he would turn for the most abiding imagery of his prolonged career.

In 1941 his *Little Spanish Prison* was the first indication that he would adopt Iberia as an ongoing theme. We must never underestimate the idealism of many of those who had gone to Spain to fight, or the pain of the dislocated exiles who were never again to return. But Motherwell's involvement is of another order. He joined the long tradition of the romantic travellers of the nineteenth century who acquired foreign exotic cultures, with all their associated clichés, essentially at second hand. The strategy he would adopt to deal with *Guernica*, and all that it represented, was to come at it obliquely, to deal with it side-on. With a taste for musing on James Joyce, Stephane Mallarmé, or Proust's *A la Recherche du temps perdu (Remembrance of Things Past)*, it was to poetry that Motherwell would turn for his inspiration. And nothing less than Federico García Lorca's 'At Five in the Afternoon', from the *Lament for Ignacio Sanchez Mejias*, would do. It was a cunning way in to the painting.

Deceptively simple, measuring a mere 37.5 × 45 centimetres, three ovoid shapes in black are bound by columns and a thin black line on a white background. At the top right border, what appears to be the bottom ledge of a window opens up the flattened space, offering escape. But already from the titles *Little Spanish Prison* and *At Five in the Afternoon* we are aware that there is little room for manoeuvre; Ignacio Sanchez Meijas, like Lorca himself, has got what is coming to him. It is a discreet, private meditation on human tragedy and death. Little could anyone predict that soon Motherwell would dramatically enlarge the image to foster many other versions on the scale of *Guernica* itself. Some are magnificent, although with Motherwell there always lingers the suspicion that he is more than susceptible to forcing feeling, and that tragedy is on the verge of becoming sentimentalised.

In the 27 November 1948 issue of *The Nation*, Clement Greenberg took on Motherwell to good effect. He accused him of falling prey to 'an archness like that of an interior decorator who stakes

everything on a happy placing to the neglect of everything else',
adding, for further measure, that he suffered from 'felicity' and a
'syrupy grace'. It is certainly true that with the *Elegies* Motherwell
came dangerously close to transforming tragedy into good taste. The
dark soul of Goya is replaced by the stylish black of Coco Chanel.
They feel suspiciously resolved.

Midway through the series in 1957 Motherwell stated his purpose
in the catalogue for the MOMA exhibition *The New American
Painting*: 'I believe that painters' judgements of painting are first
ethical, then aesthetic, the aesthetic judgements flowing from an
ethical context . . . Without the ethical consciousness, a painter is
only a decorator. Without ethical consciousness, the audience is
only sensual, one of aesthetes.' He had neatly described his own
Achilles heel. Appropriating the look of tragedy, the black colour of
the *cante jondo*, the deep song of Andalucia, particularly with a

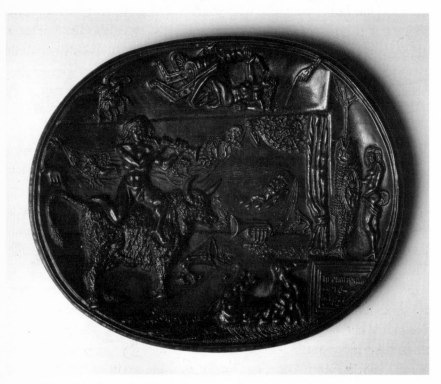

David Smith, *Medals for Dishonour: Propaganda for War*, 1939–40.

predominantly abstract style, the authenticity of Motherwell's *Elegies* might have slipped by many critics, but not Greenberg.

Another response to *Guernica* was to be found in the sculpture of David Smith, who would later develop into one of the most important abstract sculptors of the twentieth century. In his *Medals for Dishonour: Propaganda for War* (1939–40) shallow relief is used to create medallions obviously inspired by the painting. The result is sometimes comic, sometimes sad, but as with *Guernica* the viewer is left with a residue of feeling that Smith has created an epic of which the key stages of narrative have been unfortunataly lost. The debate as to whether *Guernica* might have been more successful as a sculptural ensemble was partly fuelled by Smith's response to Picasso's work. Yet none of these reinterpretations of *Guernica* radically challenged the primacy of Picasso's original work. None single-handedly put the juggernaut of modern art on to a new set of tracks. That honour fell to Jackson Pollock. It is to him that we have to look if there is any credibility to the theory of the Big Bang.

Jackson Pollock's marriage to Lee Krasner was famously difficult. How could it not have been? He a chronic alcoholic who disappeared on violent benders for days at a time, haunted by inner daemons that only his psychoanalysts rarely saw, and she, also a painter trying to fight her corner and no doubt out of necessity relying on equally destructive self-defence mechanisms. But there was one place where they met and agreed an amnesty – standing, absorbed, in front of *Guernica*. Lee Krasner remembered her first encounter: 'Picasso's *Guernica* floored me. When I saw it first at the Dudensing Gallery, I rushed out, walked about the block three times before coming back to look it. And then later I used to go to the Modern every day to see it.'

For Pollock his first sight of *Guernica* would prove revelatory. It is no exaggeration to call it an epiphany. Prior to the encounter, Pollock's early enthusiasm for Picasso had been tempered and muted by his mentor Thomas Hart Benton who reviled the Spaniard's work. But on entering Valentine Dudensing's on 57th Street Jackson was for ever changed. One of the best descriptions of that

moment falls to his biographers Steven Naifeh and Gregory White Smith: 'Sometimes Jackson came alone, sometimes with others, to make sketches, to exchange hushed comments, or just to stand and be overwhelmed by the great, gray monolith of it. Eleven feet high and twenty five feet long, it loomed in the modest gallery space like a ship run aground, its images enlarged to supernatural proportions.' He became extraordinarily proprietorial about the work, on one occasion inviting an art critic who he saw as wanting in enthusiasm to 'step outside and fight it out'. It had got right under his skin. Even more than Arshile Gorky, Jackson Pollock was to take on *Guernica*, perform a visual autopsy, and over a period of two years eventually move beyond it.

The starting point for the dialogue followed a period in which Pollock had been hospitalised after a particularly heavy period of alcoholic dependency, followed by a profound nervous collapse. Entering into analysis with Dr Joseph Henderson, a Jungian member of the Analytical Psychology Club of New York, and with John Graham occasionally footing the bills, Pollock took his first steps on the painful road to recovery. Henderson suggested he bring in some drawings from which they might work. Over the next two years (which included Pollock's referral by Henderson to Dr Violet Staub de Laszlo) the artist produced eighty-three drawings that give an extraordinary insight into the workings of his inner mind, and his visual dependency on the *Guernica* theme. When Henderson suggested Pollock might turn to other visual sources, including primitive American Indian art, he came head to head with the strength of his resistance and the power of his self-projection on to *Guernica*'s themes. 'As a true son of Picasso, Pollock felt bound to uphold the dogma of the contemporary art world of his time . . . He fought me tooth and nail,' remembered Henderson.

Almost more important to Pollock than Picasso's large painting were the looser associated sketches and preparatory paintings and the prints *Songe et Mensonge*. Where Picasso had struggled to find a universal language, Pollock appropriated it and made it all his own. Public tragedy was now inverted to map out the evolution of a

private pain. Public images were recycled and passed through the crucible of Pollock's subconscious to reappear energised and subtly transformed as they came out the other side. Henderson's approach to the material was matter of fact: 'I received [his drawings] and reacted to them as art, examples of his work-in-progress as a painter. I felt this to be his most reliable form of identity and I encouraged him to develop this talent.' Violet Staub de Laszlo, whom Pollock perhaps associated more closely with the powerful and calming presence of his own mother, could push him and direct him more. 'Often we looked at them in silence, with only a few interpretative remarks on my part, some allusions from various mythologies; I did speak of archetypes. Jackson was very intelligent and I felt that he made himself receptive.' She tiptoed slowly through her patient's wounded heart, leading him eventually to the concept of rebirth, 'to give him hope and confidence'. Both analysts had been extraordinarily receptive and wise, realising early on that although they might never heal the person, they might leave the artist intact.

Two months before he died in 1956, in a tragic car accident, Pollock gave a valuable insight into his working methods in an interview with Selden Rodman: 'I'm very representational some of the time, and a little all of the time. But when you're painting out of your unconscious figures are bound to emerge. We're all of us influenced by Freud, I guess, I've been a Jungian for a long time.' What Picasso had done for Pollock, was to give him fast-track access to the language of the collective unconscious, primitive archetypes and myth.

In the eighty-three drawings, which as 'working' therapy studies have a complicated status, Pollock doodled frenetically, scribbling full pages that have a gut, visceral authenticity about them. Individual passages, even on the small scale of 10 × 10 centimetres, have a rightness and a feeling of unbrooked power. In one untitled CR 521 the *Guernica* horse appears caricatured with clearly no attempt to hide its source. In another, CR 531, a Spanish *corrida* is mockingly acted out with figures constructed from the childhood game of 'Pin the Tail on the Donkey'. Shaman drawings come mixed up with pre-Columbian imagery as Pollock struggles on paper to

Jackson Pollock, *untitled*, CR 521, 1939–40. Jackson Pollock, *untitled*, CR 531, 1939–40.

find his essential self. What Pollock learnt from *Guernica* and its family of associated works was the value of 'unedited' ritualistic game-playing; of the value of taking a symbolic image and making it jump through the hoops. This 'deep' play, or what Rudolf Arnheim has described as 'visual thinking', was second nature to Picasso; everything from symbol to myth was legitimate material. No image *per se*, in the whole history of image-making from cave drawings to the present day, was therefore somehow magically taboo. Feeding on the expressive power of American Indian art, from the bark paintings, ceramics and feather pieces on through to the ephemeral Navaho sand paintings, and from African carving to the work of the Mexican muralists (he had worked with David Siquieros on the WPA) and poring over diagrams from Jungian texts, Pollock had come up with a personal cocktail of forms to help him react to *Guernica* and gradually subvert it to make it his own.

In Jerome Seckler's much-quoted interview with Picasso he unpredictably brought the sixty-three-year-old artist around to thinking about American art.

'In the United States,' I said, 'we don't have as many artists as France, but on the whole our artists are more vigorous, more vital, more concerned with people than the French painters. France has had the same big names in art for the past forty or more years. From what I observed in the exhibition at the Salon d'Automne, the younger artists were mostly introspective, concerned mainly with technique and hardly at all with living reality. French art is still concerned with the same techniques and still lifes.'

'Yes,' Picasso said, 'but the Americans are in the stage of the general sense. In France, that is past for us and we are now at the stage of individuality.'

Picasso clearly knew little of Pollock's work. For one American, on a purely psychic level it had been a brave, almost heroic gamble to take on Picasso's monsters and look them directly in the eye. Pollock's battle with Picasso would now be elevated to an almost mythic scale. During 1943 in canvas after canvas Pollock would hack through the undergrowth and dredge up images from his unconscious world. *Moon Woman Cuts the Circle, The She-Wolf, Male and Female* and *Guardians of the Secret* are all, as the titles suggest, records of a personal odyssey to find psychic balance and break free from the past, to find, as de Lazslo hoped for, the grace of rebirth. The collective unconscious was now harnessed to cure the wounded present. One final image was still waiting before he could finally fly free. In 1943 he had also painted *Pasiphaë*. In one complex image Pollock announces the battle between two worlds: the Old and the New. Pasiphaë, the wife of Minos, King of Crete, forms an uncontrollable passion for a bull. To consummate her desire she has to resolve to subterfuge, and requests Daedalus to fashion a life-size model of a cow into which she eagerly climbs. She fulfils her unnatural lust and the Minotaur is born of the union, later to be killed by the Athenian King Theseus. It is only a short journey before we are forced to recognise Pollock's oedipal desires; *Guernica* as mentor has finally been surpassed. But there is a curious rider to the story. Pollock empathised so strongly with Melville's *Moby Dick*

that his favourite dog had been named Ahab. Prior to *Pasiphaë*, the painting was titled *Moby Dick*. By changing the title, Pollock had symbolically placed the battle back on European soil.

By the early summer of 1943 Peggy Guggenheim had finally been persuaded by her trusted advisers Matta, Piet Mondrian and Marcel Duchamp to show Pollock's recent work at her New York gallery, Art of This Century. Once she was convinced, Peggy's hot-headed nature usually encouraged her to go the whole hog. Along with the promise of the exhibition, she commissioned a mural from Pollock to decorate the entrance hall to her spacious new apartment. It was a troubled period for Pollock. 'There's me and there's Picasso,' he bawled out in a bar, 'the rest of you are whores!' For months Pollock stared at the enormous empty canvas, just as Picasso had prevaricated with his commission for the Spanish Pavilion before the bombing of Gernika had finally taken place. Finally, in November, the night before the delivery deadline, he locked himself in the studio with a bottle of bourbon and began to fill the 15 square metres of canvas with a riot of battling forms. It was heroic, unprecedented, extraordinary, something that even Picasso would have been hard-pressed to achieve.

For Pollock the themes of psychic, mythological and particularly ritual regeneration sat at the heart of his work. He had taken the struggling plant with its tender leaves from *Guernica* and transplanted it in the open prairie. The ritual of the bullfight and the Crucifixion had been transformed into the frenetic blending of the pagan ritual of American Indian dance, the rodeo, the buffalo hunt and the livestock stampede. Amongst the dust, the tumbleweed and the lunging steers, recognisable forms are swallowed up and covered by layer after layer of manically applied paint. Adjectives trip over one another in the rush to describe Pollock's *Mural* of 1943: it is olympian, bacchanalian, extravagant, wild, wilful, dionysiac, dramatic, driven, dissonant and dazzling . . . The mural is nothing less, according to David Anfam, than America's *Rite of Spring*; a riotous cacophony of colour and sweeping forms. *Guernica*'s visual vocabulary and syntax had, in the words of another critic, become in 'Pollock's hands thoroughly depoliticised and transferred to a cosmic frame'. He had, according

Jackson Pollock, *Mural*, 1943.

to Irving Sandler, 'pulverised' Picasso's 'closed forms and scattered them over the surface in curvilinear rhythms'.

The *Mural* was what the art world had been waiting for. For Pollock it opened the door. Over the next four years he produced some of the brashest, wildest, most elegant ballets in skeins of dancing paint ever seen. *One, Autumn Rhythm, Lavender Mist, Eyes in the Heat, Sounds in the Grass: Shimmering Substance, Reflection of the Big Dipper*, sing harmoniously of a soul in full flight. They are passionate abstract celebrations of pleasure for pure pleasure's sake. 'Picasso is a genius, that's obvious, but his "monsters" no longer trouble us,' Michaux suggested to Brassaï. And he continued prophetically, 'We're looking for different monsters and by different paths. The question of "succession" may come up, but in a different way.' With a personality as complex as Pollock's it is not entirely surprising that we can find a hidden, carefully coded subtext that undermines almost everything that has previously been argued. Picasso also loved this unsettling type of paradox. In conversation with Françoise Gilot, he carefully tutored her: 'Every positive value has its price in negative terms and you never see anything very great which is not, at the same time, horrible in some respect. The genius of Einstein leads to Hiroshima.'

Serge Guilbaut, in *How New York Stole the Idea of Modern Art*, has suggested that both *Sounds in the Grass* and *Eyes in the Heat* are Pollock's response to atomic tests in 1946 carried out by the Americans on the Bikini atoll. Described in the same year in *Fortune* magazine, the test reports were placed side by side with abstract paintings by Ralston Crawford. Is this just coincidence? Or are we seeing a serendipitous bringing together of all the different manifestations of modernity? There can be no conclusive evidence. But Guilbaut argues his case persuasively: 'What Pollock depicts is a source of energy that is not merely powerful but also destructive. What is shown, in short, is not the sun but its equivalent, the atomic bomb, transformed into myth.'

By 1947 MOMA had started to invest in its home-grown modernity. Pollock, Rothko, Newman, Gorky and many others were now represented in the collection. But *Guernica* was still the star exhibit. In a 1947 photo of its installation, the painting is flanked on

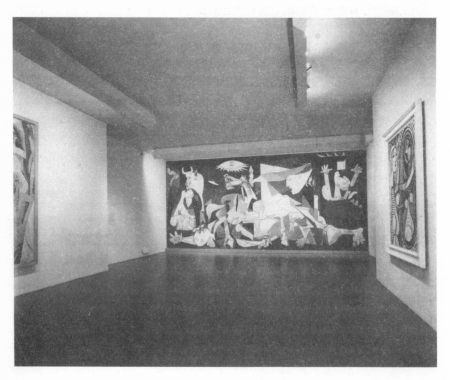

Guernica in MOMA, 1947.

either side by the *Demoiselles d'Avignon* and *Girl before a Mirror*. *Guernica* appears squashed, jammed into an end space almost exactly as high and as wide as the painting itself. Lit dramatically from above with a bank of floodlights, the effect is distinctly claustrophobic. Despite its sublime grandeur, from a distance it looks too keyed-up and intense, lending it a cartoon quality that appears almost as radically simplified as a theatre set. The photograph of *Guernica in situ*, through its lack of subtlety (perhaps a condition of the contrasty print), gives it a powerful, rude energy that borders on clumsiness. It is almost as if Picasso had reworked El Greco's masterpiece *The Burial of Count of Orgaz* in a contemporary vein and popped it with a balloon. From the central apex of the painting, body parts tumble down to the bottom corners, as if pulled from a sheet. The added drama of the artificial light has robbed *Guernica* of Picasso's carefully modulated lighting effects, of 'the greyer, softer chaos that is tragedy'. It has become at once an epic, a work of mythic proportions, and a convincing partner piece to Melville's *Moby Dick*. Jackson Pollock would have to wait a full thirty-five years before he could 'officially' take Picasso's place. When *Guernica* finally left MOMA in 1981 it would be Pollock's painting *One* that would hang in its place.

7

Reds under the Beds

Art is something subversive. It's something that should not be free. Art and liberty, like the fire of Prometheus, are things one must steal, to be used against the established order . . . If art is ever given the keys to the city, it will be because it's been so watered down, rendered so impotent, that it's not worth fighting for.

Picasso to D. H. Kahnweiler

The truth of the matter is that by means of *Guernica* I have the pleasure of making a political statement every day in the middle of New York City.

Picasso to Rafael Alberti

The next war will be between the Communists and the ex-Communists.

Ignazio Silone

After fourteen years serving as Director of the Museum of Modern Art, Alfred H. Barr's unrivalled position as America's most influential tastemaker was swiftly brought to an end in a bitter in-house coup. In 1943 the Museum's President and Chairman of the Trustees, Stephen Clark, moved to have Barr suspended from his post. There was no suggestion of wrongdoing or financial irregularity, but over the previous two years it had become increasingly clear that there was a growing, and unbridgeable, personality difference between the two men, only partially camouflaged behind highminded and ever more heated debates over Museum policy. Barr had always fought for a holistic, inclusive approach to

museology. The more patrician Clark felt that this policy was in danger of dragging MOMA too far down the road to populism and would eventually, if not stopped, damage the Museum's authority. For Barr it was a matter of principle. For Clark it was the ultimate test of his power and authority. In MOMA's boardroom, where Nelson Rockefeller later claimed to have honed all his political skills en route to the post of Mayor of New York, the full weight of politics was brought to bear on the founding Director. Barr was ungraciously ousted, and it says a great deal about his character and his devotion to the institution that four years later, in 1947, he accepted without rancour the position as MOMA's Director of Museum Collections.

The hard lesson in politics was not lost on Barr, and prepared him over the forthcoming years when the Museum's very existence and *raison d'être* were endlessly questioned by Washington politicians. No clearer voice than Barr's would be heard over the growing clamour of the philistines and the yellow press. And, when American cultural life finally succumbed to the hysterical paranoia and pressures of the Cold War, Barr was one of the few who upheld the authority and integrity of the creative and intellectual life. In accepting Barr as *Guernica*'s guardian, Picasso had been fortunate. Picasso's increasingly prominent status as the world's most famous Communist ensured that his work and life remained in the public eye. Following Franco's rehabilitation within the international community in the early 1950s, *Guernica*'s guardians – both Barr and the Museum – would come under increasing attack. The earliest battles fought over *Guernica*, however, did not target its political content but were focused primarily on its apparent problems of style.

In a 1957 review of Picasso's seventy-fifth birthday exhibition, entitled *Picasso at Seventy-Five*, the hugely influential art critic Clement Greenberg, who could claim pre-eminence as the most articulate and impassioned interpreter of the modernist aesthetic, articulated publicly for the first time what had been worrying him privately for decades. It is almost certain that his coterie of artists,

Pollock, Rothko, Newman and the next generation, the colour-field artists of the Washington School, Kenneth Noland, Helen Frankenthaler, Morris Louis and Jules Olitski, got to hear this at first hand. But in *Picasso at Seventy-Five* Greenberg's careful dismantling of the Picasso myth was for the first time coherently and patiently drawn out for a wider public. Always confident in the power of his critical eye, Greenberg rapidly surveyed Picasso's entire career, only to pronounce unequivocally that his art had never quite recovered from a crisis that had begun as early as 1929. 'Once a master, always – to some extent – a master. Almost everything Picasso does has a certain pungency or, at worst, piquancy,' he allowed. But the genius of Cubism, mused Greenberg, had been gradually running out of steam. *Guernica*, under this type of partisan analysis, was never going to fare well. What Greenberg was carefully constructing was an essentially rigid rationale that argued for the primacy of abstraction, with American artists, in particular, as the new vanguard pushing back the boundaries towards a heady new style. His formal analysis fingered Picasso's weak points, his 'innate lack of capacity for *terribilità*', for one, and the fact that as '*Guernica* had previously shown: he could not make a success of a large canvas with cubistically flattened forms'. Back in 1948 Greenberg had written that 'great art' is impossible without 'truth of feeling'. And this made *Guernica*, with all its drama and tragedy, suspect, for Greenberg.

In *Picasso at Seventy-Five* he proceeded to elaborate: '*Guernica* is the last major turning point in the evolution of Picasso's art. Bulging and buckling as it does, this huge painting reminds one of a battle scene from a pediment that has been flattened under a defective steam-roller.' From here on, following the logic of Greenberg's argument, decadence inevitably set in, particularly in a whole group of series where Picasso retreated from the possibility of total abstraction and locked horns with the Old Masters, from Cranach the Elder through Delacroix and Courbet, on to Manet and Velázquez, producing through the confrontations a visual gymnastics that bounced all of Picasso's many styles against the weight of their tradition. Greenberg suggested that 'Perhaps Picasso has succumbed

to the myth of himself that too many of his admirers have propa-
gated: that he is a demi-god who can do anything and therefore is
not entitled to weaknesses.' He was right in part, but he was by no
means *Guernica*'s only critic. The yellow press had lined up against
Guernica, as, of course, had the old Regionalist rearguard of artists.
But the main danger of *Guernica* lay not in its apparent failings, but
rather in its overwhelming power to seduce. As Thomas Hess
observed so well: 'Even if *Guernica* was sneered at, it stuck in
the back of the mind . . . the image of those big, torn black shapes
must have lived in every artist's subconscious.' It wasn't just Pollock
who had been haunted by its forms. So too had many others.
Perhaps even Greenberg.

What Greenberg protected from the power of Picasso's painting
was his stable of artists, and his abstract vision for the future. So he
was tough on his pupils, and even tougher on his artistic gods.
Famously belligerent, Greenberg saw his main job as cutting Picasso
back down to size. It was precisely Greenberg's obsession with the
all-over, decorative, flat picture that proved him both temperamen-
tally and historically ill-suited to searching out *Guernica*'s meaning.
It was just too dramatic. Greenberg was, in the opinion of Lawrence
Alloway, an 'aestheticist' set on divorcing art from life and culture,
and it was precisely that connection that was now being 'flattened
under a defective steam-roller'. The criticism that was beginning to
collect around *Guernica* was increasingly symptomatic of a growing
debate in society as a whole. Once again, *Guernica* would be at the
eye of the storm, witnessing the critical, ideological and political
battle for the post-war American soul.

The new American political landscape, with victory in the Second
World War finally secured, had become a confusing waste land,
littered with broken ideologies, making for an 'unreality created by
the shuffling of abstract theories', according to William Phillips, co-
editor of *Partisan Review*. Fascism – Franco aside – had been all but
defeated, at exactly the same time as Communism had lost its
utopian appeal. The Moscow show trials, Leon Trotsky's highly
publicised treason trial, not to mention his assassination in Mexico

in 1940, the Nazi-Soviet Non-Aggression Pact, the invasion of Finland and the Baltic States, the mutation of Communism into Stalinism, the imprisonment of academics, the humiliation of high-profile intellectuals, and all attempts by Moscow apparatchiks to force upon American artists the cliché-ridden Social Realist style, functioned as a wake-up call. With Communism as an ideology increasingly bankrupt, the pre-war Communists and their sympathisers had to rethink their positions. For many of the artists and intellectuals who had earlier found succour in Marxist doctrine, the new political reality forced some deep soul-searching. If Fascism had been the enemy that the Allies had to vanquish during the war, Communism now replaced it as the main threat to world peace. Growing and increasingly virulent anti-Communist rhetoric signalled the arrival of this new orthodoxy. The new political consensus, though apparently united behind this one big idea, was actually a loose coalition of warring groups. There were the 'hard anti-Communists', whose bible was *The Origins of Totalitarianism* by Hannah Arendt, who believed that America was the only barrier to the Soviet Union's dream of world domination. But there were also ex-Marxists who, while agreeing on the common enemy, namely Soviet Stalinist Russia, could never agree on the method to counter the growing menace or, for that matter, the reduction of civil liberties that this new war might entail.

The clearest warning of a new direction in US foreign policy came in March 1947 with the elaboration of the Truman Doctrine, in which President Truman heralded a new interventionist *pax americana* – arguably already a complete contradiction in terms: 'I believe that it must be the policy of the US to support free people who are resisting attempted subjection by armed minorities or by outside pressure,' pronounced Truman. 'I believe', he continued more prophetically, 'that we must assist free peoples to work out their own destinies in their own way.' Coupled with the Marshall Plan, announced two months later on 5 June 1947, in which a programme of loans to save a bankrupt Europe was promised, it was still just possible to celebrate Truman's altruism. Within more enlightened

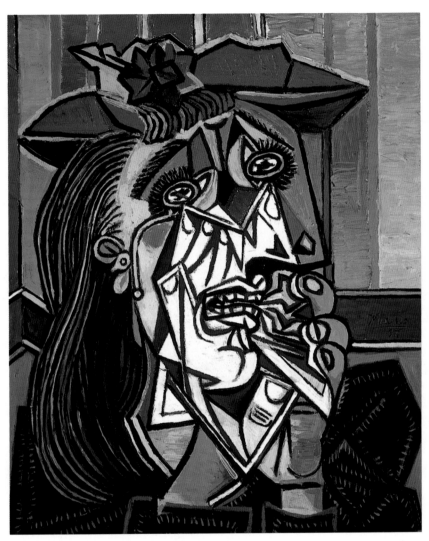

Weeping Woman, Paris, 26 October 1937

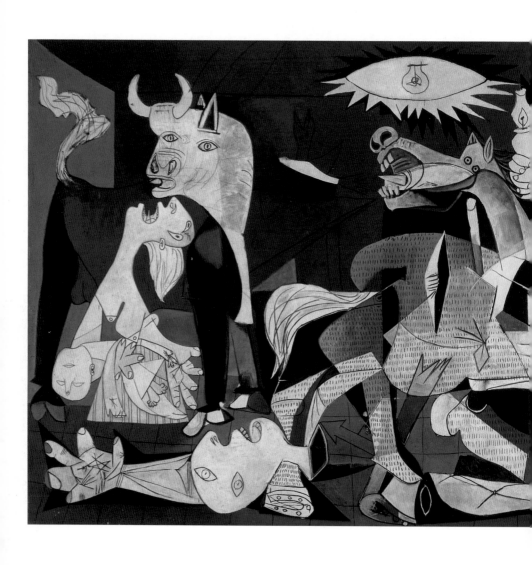

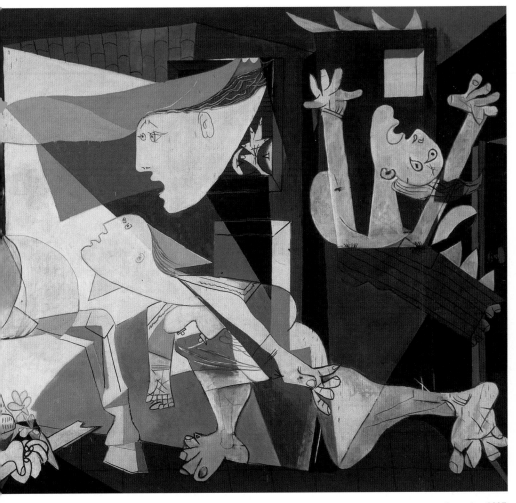

Guernica, 1937

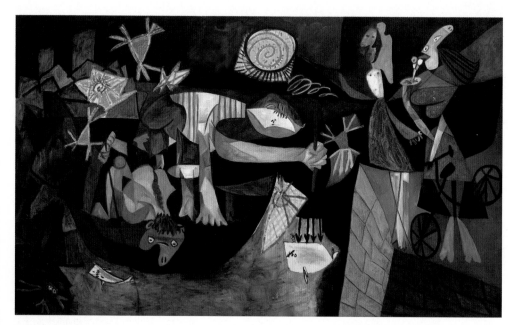

Night Fishing at Antibes, August 1939

government circles, however, there was a growing realisation that crude dollar diplomacy, however well-meaning, would never be enough. What was needed was a cultural policy to match.

A broad view of the new post-war power balance suggested that the Cold War was just a continuation of the 'hot' Second World War. During the Cold War, new weapons would be employed: propaganda, psychological warfare, sabotage, subversion, all of which were elements of a much wider cultural struggle – fought in the shadows, where nothing was quite what it seemed. It was an ideological battle, nicely described as 'waging peace'. In a war fought under these rules, where inquisitorial tactics, threats and a reliance on fear became the norm, it was not unusual for labyrinthine intrigues to unravel and lead to the discovery that you were sometimes fighting your own friend. And so it was in the United States. Under Truman's Presidency a united front against Communism quickly broke down to reveal beneath the surface large divisions. On the one side there was the paranoid J. Edgar Hoover and his loyal FBI foot-soldiers, who garnered further support from the bullying Senator McCarthy. On the other side was the increasingly powerful CIA, supported by a rather more sophisticated coalescence of powerful clans that included the Rockefellers, Whitneys, Morgans, Vanderbilts, DuPonts, Mellons and Dulleses, who saw themselves as the 'patricians of the modern age, the paladins of democracy'.

Within this internal war it was the Hoover–McCarthy alliance that was initially favoured by events wholly outside its control. In China the failure of Chiang Kai-Shek to hold off the invasion of Mao Zedong in 1949 led to a treaty between China and the Soviet Union. This forced the United States to the realisation that Communism was not a diminishing but a growing threat. It also damaged the United States' sense of invincibility. Democrats were seen by the electorate as responsible for failure in foreign policy, a view McCarthy encouraged by declaring that there was a conspiracy within the government, and that the public should be extra vigilant against the enemies within. On 25 June 1950 the United States

entered the Korean war with General MacArthur's crossing of the
38th parallel, arguing that non-intervention was unthinkable and
would result automatically in a domino effect, with Malaysia and
Indonesia falling next. Closer to home, the Communists had come to
power in Poland, Romania, Bulgaria and in Tito's Yugoslavia.
Czechoslovakia had fallen, as Jan Masaryk was crushed. In Italy,
Greece and France the electorate threatened to move to the left into
the open arms of their Communist masters. And, if the electorate
were not obliging, there were rumours of possible coup d'états.

The CIA – liberal axis, less bellicose, yet still mindful of the
threats to long-term American interests – was, on the other hand,
just as fearful of McCarthy as of the Communists themselves.
Under the auspices of the American Committee for Cultural Free-
dom, founded in 1949, there had been a fragile unanimity amongst
the anti-Communist factions. But the rise of McCarthyism with its
witch-hunts and blacklistings acted as a corrosive poison in public
life. The loose anti-Communist group split into a further sub-
group, who became known as the anti-anti-Communists, and who
furthermore saw McCarthy as a dangerous threat to the enduring
American values of liberty and freedom of expression; the very
essence of what it was to be American. McCarthy countered this
by suggesting that the anti-anti-Communists – who in his opinion
were no more than a bunch of effete, Ivy League liberals and
Harvard 'pinkos' – were soft on Communism, and by dint of not
screaming loud enough, were its apologists. Sophistry and subtlety
of argument were viewed with suspicion, and seen by many as
diluting the message that Communism was the new evil that had to
be contained.

Against this deeply unpleasant backdrop of suspicion and accusa-
tion, culture became increasingly threatened. The philistines and
iconoclasts were waiting impatiently at the swing-doors of the
Museum of Modern Art to root out, and ridicule, the Communist
junk hanging on its walls.

Modern art was an easy target, after all, and Picasso as its
apotheosis was hunted down especially. In a memo dated 16

January 1945, Hoover wrote personally to the US Embassy in Paris: 'In the event information concerning Picasso comes to your attention, it should be furnished to the Bureau in view of the possibility that he may attempt to come to the United States.' The FBI machine had started to keep tabs. So much so, that when on 11 November 1990 Herbert Mitgang, the first journalist under the Freedom of Information Act to get access to Picasso's file, published a précis of his findings in the *New York Times*, the file numbered a full 187 pages. Considering that as a foreigner, Picasso was technically outside the FBI's remit, this demonstrates poignantly the depths of Hoover's growing paranoia. In Mitgang's revelatory piece, entitled 'When Picasso Spooked the FBI', Picasso is listed in the files kept by the State Department and the FBI as a 'subversive'. Much of the sensitive information held on 'subject Pablo Picasso: security matter C; file: 100–337396' was still blacked out forty years later. However, there were also wholly unsubstantiated accusations, that Picasso was a Russian spy, for instance, which despite their foundation in fantasy were nevertheless kept on file. His friendly relationship with Charlie Chaplin was deemed compromising, although it seemed only to have endangered Chaplin, who it was suggested should be extradited as a subversive alien. Also mentioned was a letter of thanks sent by Picasso to a reunion of Veterans of the Abraham Lincoln Brigade, the idealistic few who had stood shoulder to shoulder with the Republic. Details were given as to the exact breed of bird employed as a model for his famous Peace Dove – a Russian Trumpeter, no less!

Picasso, it was clear from the files, was not in danger. But those who had assisted the progress of *Guernica* across the United States back in 1939, the members of the American Artists' Congress and the Motion Picture Artists' Committee for Spanish Orphans, would find their names at the top of fresh, newly opened FBI files. It was not long before the information would be shared with Senator McCarthy and his two young stooges, Roy Cohn and David Schine. Nor would it be long before Picasso's well-meaning supporters would find themselves up in front of the House Un-American

Activities Committee, hectored and bullied, and outed as unpatriotic
Commie decadents.

In an article written in 1944 and published in *New Masses*,
entitled 'Why I Became a Communist,' Picasso had written:

> My joining the Communist Party is a logical step in my life, my work
> and gives them meaning. Through design and colour, I have tried to
> penetrate deeper into a knowledge of the world and of men so that
> this knowledge might free us. In my own way I have always said what
> I considered most true, most just and best, and therefore, most
> beautiful. But during the oppression and the insurrection I felt that
> that was not enough, that I had to fight not only with painting but
> with my whole being.

It was clear that in the increasingly ugly political atmosphere
Guernica might prove a lightning conductor to men like McCarthy,
Cohn and Schine, none of whom were ever frightened by taking on a
big name. Barr's problem then was to neutralise the image without
losing face. While *Guernica* was on exhibit at MOMA all references
to Franco and the Spanish Civil War on the painting's explanatory
label were discreetly lost. On a first step to universality, it was
merely pointed out to the interested and innocent spectator that 'the
mural expresses his abhorrence of war and brutality'. Deliberately
playing down the specific political content was a fine piece of
casuistry that only partially neutered the work. On the white walls
of the modernist temple, *Guernica* could now become first and
foremost a painting. No longer would it be a powerful *banderole* or
battle flag leading its supporters out to war. Still right in the centre of
the spotlight, its meaning had subtly changed. This was now the age
of the art superstar, and Picasso's star shone brightest of all. In the
United States, with the power of the press and the explosion of the
glossies, he would become the perfect story. From *Guernica*'s arrival
in 1939 to its departure in 1981 Picasso was on the cover of *Time*,
Newsweek, *Atlantic* and *Life* more than ten times. Being contra-
dictory and capricious, as Duchamp had also discovered, made one

all the more famous. An artist multi-millionaire, Communist, wo-manising genius, whose dramatic painting *Guernica* remained like the veritable fifth column right in Manhattan's heart, made for irresistible press. Copied and reinterpreted again and again, *Guernica* was in danger of being commodified. Pollock's Guggenheim mural had become the backdrop for *Vogue* fashion shoots. Would *Guernica*'s power also be weakened by marketing? It seemed possible. But then Pollock's mural had never demanded the con-centrated engagement that *Guernica* required.

Picasso's relationship to politics as a whole, and to the Commu-nist Party in particular, had always been complicated. It was quixotic, idealistic, anarchic, contrary, personal, at times almost innocent. Though involved with the Communist Party, Picasso knew just as well that he obeyed few rules. 'Picasso is more important than Communism. He knows it, and they know it. His magic is greater than theirs,' Dora Maar told her close friend James Lord. (For Dora, Picasso's conversion to the faith had been so important that the newspaper reports were on the table beside her deathbed more than fifty years later.) It was impossible to rein in Picasso. Back in the 1920s André Breton had tried to seduce him into committing himself publicly as a Surrealist, but in the end was forced to give up. In the 15 July 1925 fourth issue of *La Révolution Surréaliste*, Breton could only indulge Picasso and hope that some of the magic would rub off on the art movement he so relentlessly promoted:

> We claim him as one of ours, even though it is impossible – and would be impudent, furthermore – to apply to his means the rigorous critique that elsewhere we propose to institute. Surrealism, if one must assign it a line of moral conduct, has but to pass where Picasso has already passed, and where he will pass in the future.

His genius bought him dispensation. Where other artists would be crushed, Picasso was treated with tolerance and indulged. A loyal Communist Party member, he was nevertheless contemptuous of the

Socialist Realism forced so ruthlessly on his Russian colleagues by Stalin's cultural commissar Andrei Zhdanov. In many ways Picasso epitomised the very essence of what Zhdanov inveighed against at home. In his post-war onslaught on decadent Western art Zhdanov was, however, wise enough to recognise Picasso's propaganda value regardless of style. For Picasso there were no rules.

In spring 1957 Picasso was visited in his new villa, La Californie, by Carlton Lake, the Paris art critic for the *Christian Science Monitor* who later, much to Picasso's disgust, would ghost Françoise Gilot's *Life with Picasso*. In the July 1957 issue of *Atlantic Monthly*, Lake recorded Picasso's thoughts:

> 'I'm no politician. I'm not technically proficient in such matters. But Communism stands for certain ideals I believe in.' So what about Stalin? [asked Lake] 'Well, what about him? You would have said he was no good – but you didn't know that; you only thought it. Well, I thought he was. It turned out that I was wrong. But is that any reason why I should renounce the ideals I believe in?'

With a healthy sense of pragmatism, Picasso explained patiently to Lake:

> 'Let's say I were a Catholic and I met a priest who was no good – a worthless type in every sense of the word. He's all the bad things you can think of. Is that any reason why I should give up believing in Christianity? There were all kinds of perfectly authentic stories about the sins of the Church in the Middle Ages. Some of the Popes were horrible creatures. But should I – as a Christian – in view of that, give up my adherence to the ideals I believe in? *Eh bien, non!*'

Becoming increasingly frustrated, Picasso continued: 'I don't understand why Americans are so concerned about Communism, anyway. Especially, about whether some individual is a Communist or not.' It echoed almost precisely the opinions of his friend André Malraux, who argued 'Just as the Inquisition did not affect the

fundamental dignity of Christianity, so the Moscow trials have not diminished the fundamental dignity of Communism.'

With hindsight, Picasso and Malraux were both wrong and right. Wrong to think that Communism posed no danger, but right about the exaggerated American mass hysteria over Communism and the neurotic fear of Reds under every bed. No Western country had a smaller Communist Party – so insubstantial, in fact, that it was probably kept alive by FBI infiltrators paying their dues as they spied on the apparent Red menace from within, effectively transforming the Party, according to Stonor Saunders, into just another State department.

By the end of the 1940s anti-Communist hysteria in the United States had become so alarmingly virulent that it drew in, and impacted on, almost everyone involved in the arts. Within the art profession there had always been criticism of MOMA's promotion of 'international' art, mainly from parochial critics who saw their fragile outdated positions eroded by the day. That was to be expected. But the attacks were now becoming horribly personal. In 1948 Thomas Craven took on MOMA with a hard-hitting title that certainly didn't disappoint: *The Degradation of Art in America*. 'Its top intellectual, Alfred Barr, master of a style that is one part mock-erudition and nine parts pure drivel, writes books on Picasso, the Red idol deified by the Parisian Bohemia which he rules, and on other such deadly phenomena.' Craven's thesis would be merely laughable if it did not represent the coming of a larger storm. It was true that many, even within the arts, were beginning to feel isolated, excluded and bewildered by the new art that MOMA, amongst the other avant-garde institutions and commercial galleries, had been busy promoting: the work of Pollock, de Kooning, Gottlieb and Rothko. There was a feeling, which now, of course, we recognise as the perennial condition of contemporary art, that art had become a private language for initiates. It was secret, obscure, self-referential, self-obsessed, and worst of all promoted as the American style, in what some cynically saw as no more than a cleverly manufactured and seductively packaged American renaissance. More galling,

perhaps, particularly to populist politicians who felt they could read the public's pulse, was that it was precisely this art that was being collected by those rich 'mushy eggheads', the scions of the East Coast elites, who as always felt they knew best. In the *Atlantic Monthly*, Francis Henry Taylor, director of the Metropolitan Museum, described what he saw as the real predicament for those artists infected, as Thomas Craven would have it, by this new call to modernity:

> Instead of soaring like an eagle through the heavens as did his ancestors and looking down triumphantly upon the world beneath, the contemporary artist has been reduced to the status of a flat-chested pelican, strutting upon the intellectual wastelands and beaches, content to take whatever nourishment he can from his own too meager breast.

Despite this, Barr's missionary zeal was still to shine through. James Plaut, the distinguished Director of the Boston Institute of Contemporary Art, accused Barr of perverting the 'true' course of art by means of his power base at MOMA. In 1949 the more conservative elements of the Boston Brahmin found themselves in a holy alliance with a waning group of Regionalist cowboy artists whose growing impotence and failure only increased their ire.

Barr would have none of it. He'd seen enough of this type of double-think from both ends of the scale: from those apologists in academia who as card-carrying Communists argued for freedom of speech, something denied to their colleagues in the USSR, across to those right-wing rednecks who screamed the loudest in support of their homespun 'authentic' style. In a 1949 statement, Plaut was forced to eat humble pie and become co-signatory to the principle, penned adroitly by Barr, that: 'We believe that it is not a museum's function to try to control the course of art or to tell the artist what he shall or shall not do; or to impose its tastes dogmatically upon the public.' There was still steel in Barr, and a touch of the Jesuit. There would have to be.

In 1950 Francis Henry Taylor compared *Gvernica* unfavourably to *The Charge of the Light Brigade*, remarking that Picasso had 'only substituted Gertrude Stein for Florence Nightingale'. Barr saw these defamations on modern art by his colleagues as spineless and reactionary. According to Irving Sandler, Barr 'resisted any attempt to fetter artistic freedom whether by acts of censorship or the imposition of any preconceived or deterministic ideology – Marxist, nationalist, or avant-gardist. The only arbiter that Barr would accept was the self-determining individual genius and his or her creation. This he considered central to modernism – and possibly only in a democracy.' In the long battles ahead, and in his subtle attempts to 'persuade' European intelligentsia of the value of American art, Barr would become one of the leading 'cultural' Cold War warriors. He profoundly believed, as did so many others, in the key theme that had run like a thread through *Partisan Review*'s 1952 symposium, entitled *Our Country and Our Culture*, namely that, 'Politically, there is recognition that the kind of democracy which exists in America has an intrinsic and positive value: it is not merely a capitalist myth but a reality which must be defended against Russian totalitarianism.'

That culture was becoming increasingly politicised was obvious to all. Even President Truman joined the debate. He liked his art. He knew what he liked. Traditionalist in his tastes, he enjoyed strolling through Washington's recently opened National Gallery of Art, eyeing up the Botticellis, the El Grecos, the Raphaels, the Reynoldses, all so carefully collected by Mellon and then donated to reflect the cultural power of the nation's capital. His approach to modern art displayed his fundamentalism more accurately than politics ever could. It was perfectly in line with Vatican policy. In September 1950 Pope Pius XII condemned all abstract art. For Truman, abstract art, dammit, was plain 'Communistic'. It was just hucksterism, fobbed off on a gullible public by 'modern day daubers and frustrated ham and egg men'. Face to face with a Kuniyoshi, his conclusions were entrancingly brief: 'If that's art, I'm a Hottentot.' For Pollock and Newman, and all the other con-artists hitched up to

the Abstract Expressionist circus, he reserved his special oppro-
brium, dismissing their hackwork as 'the vaporings of half-baked
lazy people'. It was an honest philistinism that no doubt won him
popular support. But it hid uglier people, and uglier thoughts.

The most vituperative and dogged of all the modern art baiters was
the Congressman from Michigan state, George A. Dondero, who in
a speech to the House of Representatives on 16 August 1949 listed
Picasso and Duchamp as dangerous subversives. What Dondero
saw as dangerous was that Picasso's Modernism was highly con-
tagious and had already spread like a virus to Motherwell and
Pollock, who had become willing participants in this pernicious
Communist conspiracy. *Guernica* was part of a subtle, subliminal
brainwashing programme that could only result in a spreading
plague. Building up a good head of steam, Dondero reserved his
special rage for Picasso, by now a familiar target. 'Picasso, who is
also a dadaist, an abstractionist, or a surrealist, as unstable fancy
dictates, is the hero of all the crackpots in so-called modern art . . .'
Appearing often on the radio, and with the ever-receptive ear of the
Hearst- and McCormick-owned newspaper groups, Dondero
ranted on about the proliferation of the rabid Communist cells
fronting as avant-garde artists' collectives, and threatened openly,
like some Lower East Side hood, that 'the critics who support
modern art should be attended to'. Dondero played cleverly to
the crowd – to the excluded majority, to the redneck backwoods'
mentality that felt it was being duped and made a monkey of by
some smart-arse East Coast artist. Their drippings, pourings, scum-
bles, stainings and gestural gymnastics mocked the healthy society
of the rugged Wild West, and were only fit for consumption by the
effete urban elite. If these were just the manic outpourings of some
disaffected crank, it wouldn't have mattered. But they impacted on
government policy, dovetailing all too neatly with McCarthy and
Hoover's innermost thoughts. It hardly mattered that artists like the
radically abstract Barnett Newman were vehement anti-Marxists
and anti-Communists. In that poisoned climate of accusation and

counter-accusation, most artists were now tarred with the same brush. Within a few years the Picassos in Dallas Public Library were unceremoniously removed. Dondero had come to represent an increasingly powerful philistine faction within the establishment, so much so that in 1957 he was awarded the Gold Medal of Honor from the American Artists' Professional League for his tireless exposure of Communism in art.

With Dondero paranoia had reached new heights. What did Pollock's work actually mean? Those endless square metres of abstract doodles that had won him the half-mocking sobriquet Jack the Dripper. With Picasso it was of course easy; he was up-front. He was a Communist whose *Guernica* declared his position unequivocally. With Pollock it was different; he didn't oblige the viewer with ready ideas. What was it that was hiding so tantalisingly behind Pollock's fraudulent facade; lurking like a stowaway amongst those haphazard splatters of paint? There were those who divined behind Pollock's whiplash tracery secret messages that only the enemy had been trained to understand. Pollock's skeins of paint, that had danced on to the canvas with dionysiac abandon, might even reveal coordinate points to aid the Kremlin in targeting its bombs, it was suggested. Such was the paranoia that contemporary art and its failings were openly, and often, discussed up on Capitol Hill on the Congress floor.

At MOMA, Alfred Barr, supported by his colleagues, the new Museum Director René d'Harnoncourt and the Curator James Thrall Soby, fought hard to neutralise Dondero's poisonous slurs. It was not enough to 'point out that the modern art which people such as Dondero call Communist and want suppressed is hated and actually suppressed in the USSR'. At first, Barr would try to fight them with cold logic by pointing out that their hugely insensitive policy exacerbated exactly what they argued against; artists were now becoming even more marginalised. Time and again the so called anti-Communist groups like the American Legion or the Dallas County Patriotic Council would train their sights on the artists. When they weren't being attacked in the press, the FBI was busy snooping and digging through their past.

Barr's support for the artists was, of course, roundly ignored. Few of the reactionary patriot groups were ever likely to open the *Princeton Alumni Weekly*, where Barr, in a letter to the editor, demonstrated that he understood the complexities of the issue better than most. 'Nothing is more nauseating than an American Communist appealing to "academic freedom" when he – and we – know what has happened to professors and liberal intellectuals generally in the USSR.' In the *New York Times Magazine* in December 1952, in an article entitled 'Is Modern Art Communistic?', Barr was prepared at last to take off his gloves. The philistines who didn't like or understand modern art just demonstrated the depth of their insecurity, argued Barr, by merely dismissing it as Communistic and subversive. With a hint of desperation he tried pointing out to all those fundamentalist patriots ranged up against him (who had a less solid grip on foreign policy than they had on a bag of French fries) that in the Soviet Union it was precisely these artists who were hounded out of teaching positions, refused commissions and villified as decadent bourgeois artists. It was *Pravda* that dismissed with particular venom both Picasso and Matisse as the producers of 'bourgeois decaying art'. Indeed, quite correctly, Barr stated bluntly: 'Those who assert or imply that modern art is a subversive instrument of the Kremlin are guilty of fantastic falsehood.'

Already the philistines had enjoyed a modicum of success. Bending to the prevailing wind, the United States Information Agency (USIA), whose job it was to act as ambassador for the arts, was absolutely unequivocal in its clearly stated policy. It would on no account help promote or display 'works of avowed Communists, persons convicted of crimes involving a threat to the security of the Unites States, or persons who publicly refuse to answer questions of congressional committees regarding connection with the Communist movement'. For Barr it was becoming difficult to navigate what George F. Kennan described as these 'malodorous waters'. And for Picasso too. Françoise Gilot recalled that 'Many American collectors were still being put off by Pablo's having joined the Communist Party and Kahnweiler told Picasso that he was having enough

difficulty selling Picassos at the old price without worrying about trying to sell them at the price Pablo was suggesting.'

Another major achievement of the anti-modern alliance was forcing the State Department to withdraw a carefully curated exhibition entitled *Advancing American Art*, in which the challenging works of Gottlieb and Gorky, amongst others, were scheduled to tour Europe and Latin America. The nascent Abstract Expressionist style was a perfect reminder, when contrasted with the 'deadly procession of overdrawn generals and over-idealised proletarians' of Zhdanov's Social Realist production line, that art in America was individualistic, free, energetic and, most importantly, could stand on its own. The philistines would have none of it; despite successes with the exhibition in both Paris and Prague, the tour was cancelled. Senator Brown, a reluctant student of the modern style, went down on the House Congressional Record for 14 May 1947 with a spirited interjection. 'If there is a single individual in this Congress who believes this kind of tripe is . . . bringing a better understanding of American life, then he should be sent to the same nut house from which the people who drew this stuff originally came.' The paintings were subsequently sold off at a 95 per cent discount as surplus government stock. The inquisitorial atmosphere was highly corrosive and dangerous. Mud-slinging, envy, loose tittle-tattle and idle and unconfounded gossip brought misery to many a creative life. William Zorach was denounced by an academic rival as a member of the Communist John Reed Club back in the 1930s, and summarily dismissed from his teaching post. Ben Shahn's sin had been to donate a drawing for auction to the Communist paper *New Masses*, at a time when the Soviet Union had actually been an ally. It is to Barr's credit that he reversed the disgrace by inviting Shahn in 1954 to represent the United States with a one-man show at the Venice Biennale.

It was during this heated period that Picasso received an urgent telegram from MOMA signed by Stuart Davis, the sculptor Lipchitz, and the in-house curator James Johnson Sweeney, pleading for his support:

SERIOUS WAVE OF ANIMOSITY TOWARD FREE EXPRESSION
PAINTING SCULPTURE MOUNTING IN AMERICAN PRESS
AND MUSEUMS STOP GRAVE RENEWED PRESSURE FA-
VOURING MEDIOCRE AND UTILITARIAN STOP ARTISTS
WRITERS REAFFIRMING RIGHTS HOLD MEETING MUSEUM
MODERN ART MAY FIFTH STOP YOUR SUPPORT WOULD
MEAN MUCH TO ISSUE COULD YOU CABLE STATEMENT
EMPHASISING NECESSITY FOR TOLERATION OF INNOVA-
TION IN ART TO SWEENEY 1775 BROADWAY

It was a chance, perhaps, for Picasso to stand by his peers. But after
discussing it with Kahnweiler, he threw it dismissively into the bin,
commenting: 'Art is something subversive. It's something that
should not be free. Art and liberty, like the fire of Prometheus,
are things one must steal, to be used against the established order . . .
If art is ever given the keys to the city, it will be because it's been so
watered down, rendered so impotent, that it's not worth fighting
for.' Picasso had always been reluctant to be pushed into a corner,
and loathed to be paraded in the front of the world as a mascot for
some political ideal. Remember his initial rejection of Sert for the
Guernica commission. Or how long, in comparison to so many of
his Parisian friends, it had taken him to join the Communist Party.
The question is how, despite the evidence of history, Picasso actually
continued to remain loyal to the Communists and to donate money,
art and time to the Party. On a mere human level, however, it is fair
to suggest that Picasso was often far better served by MOMA than
he perhaps deserved. In an in-house memo, written a few years later
on 8 October 1955, Barr gave voice to his misgivings: 'Picasso is
politically naive and foolish, but the Soviet authorities have not
accepted his art.'

Perhaps Picasso's apparently callous reaction to Sweeney's call
for help was because he was still smarting at the United States'
treatment of his visa application for a visit he had recently planned.
In 1950, along with twelve other delegates from the Congrés
Mondial des Partisans de la Paix (the World Congress of Peace

REDS UNDER THE BEDS

Partisans), Picasso requested permission to travel to Washington. However well-meaning the Congress appeared (which of course in propaganda terms was precisely the point), it was actually no more than a Communist front hoping to persuade President Truman to ban the atomic bomb. From Picasso's FBI file note it is patently clear that the request went right to the top. The American Ambassador in Paris, David K. Bruce, in a confidential memo dated 23 February 1950, directed to the Secretary of State Dean Acheson, puzzled long and hard over the effect the denial of a visa might have:

> In view of his worldwide reputation, refusal of visa to Picasso would certainly cause unfavourable comment here, particularly in intellectual and 'liberal' circles. It would also tend to suggest that we have something to fear from Communist 'peace' propaganda. However, if decision is negative, we believe that Departmental spokesman and VOA [Voice of America] should point out that proposed visit is a brazen propaganda stunt for purely political motives which have no connection with professional activities of applicants . . . In either event, we would urge that decision be made as rapidly as possible, since the longer it is postponed, the easier it will be for the Communist Party to exploit its nuisance value, which of course is their essential objective.

Picasso's petition was blankly refused. Working on the principle that you can never overdo vigilance, it was exactly for cases like this that the McCarran Internal Security Act, which banned entry to the United States of anyone who had been a member of a totalitarian organisation, was passed through Congress. Denied entry into the United States, Picasso travelled to the hastily arranged Sheffield World Peace Conference in October 1950. Arriving at the Sheffield Midland railway station, just ahead of Hewlett Johnson, the Red Dean of Canterbury, Picasso was greeted by Communist Party members Bill Ronksley and Chris Law, the latter putting his false teeth in to celebrate the occasion. Looked after with true Sheffield

hospitality, the man of the people was taken to Peckitt's barbers for a quick trim, followed by a sausage sandwich at Thorpe's café in Sheffield's Fargate.

Over the previous two years Picasso had become increasingly political and politicised. In August 1948, alongside Paul Eluard, he attended the Congress of Intellectuals for Peace in Wroclaw, Poland where he gave an address in support of the poet Pablo Neruda who was then being persecuted in Chile. Unexpectedly, the Soviet writer Alexander Fadeyev, the President of the Union of Soviet Writers, turned on Picasso. When he had finished insulting the Americans as 'beasts', and their intellectuals as 'jackals who learned to use the typewriter' and 'hyenas who mastered the fountain pen', he treated the artist to a diatribe on his decadent style, which according to one witness almost reduced Picasso to tears.

His ensuing trip to Birkenau, Auschwitz and the Warsaw ghetto quickly put the diatribe back into perspective. On his return to Françoise Gilot he was still resolutely upbeat. She recalled: 'In Russia, they hated his work but liked his politics. In America, they hated his politics but liked his work. When he came back from the Wroclaw conference, he said, "I'm hated everywhere, I like it that way."'

Still not put off, in April 1949 he attended the Peace Congress at the Salle Pleyel in Paris, which marked the appearance of the famous poster design with a dove of peace – actually a Milanese pigeon. He would name his daughter Paloma, born that month, after the bird. It was a benign creature, and Picasso would later make a joke about the Americans' ridiculous fears of such a forlorn, feathered little thing. Actually chosen by Louis Aragon from a folder of drawings, the dove represents what some saw as Picasso finally selling out. 'Hundreds of millions of people know and love Picasso only through the doves,' his friend Ilya Ehrenburg observed. 'The snobs sneer at those people. Picasso's detractors accuse him of having sought an easy success.' It didn't worry Picasso. Even the US press's jokes

about 'fat little pigeons' were easily laughed off. What hurt more was Breton's blistering attack on Picasso's attachment to the Party, come what may: 'he has . . . yielded to their entreaties and peopled their atomic skies with so many fallacious, anemic doves'.

In September Picasso gave a speech at the International Youth Congress for Peace and in the same year started to live in Vallauris. His move there was undoubtedly a reflection of his burgeoning interest in ceramics, and its possibilities as a plastic medium, but it was not mere coincidence that this town built on handicraft was also run by a Communist mayor. Gradually Picasso's closest circle of friends had become almost indistinguishable from the Communist Party in France. Ehrenburg, a Soviet writer with boundless charm, was highly effective in persuading Picasso that, while certainly not perfect, life in the Soviet Union was well on the way towards the socialist dream. (It was Ehrenburg, incidentally, who would be instrumental in the award to Picasso of the Lenin Prize in April 1962.) Laurent Casanova, another activist who had befriended Picasso during the Occupation, had after June 1947 become responsible for the FCP, the French Communist Party. Picasso admired his charm and intelligence, and the sang-froid he displayed during the Occupation when he slipped past Gestapo observers to visit him in rue des Grands-Augustins. Little encouragement was required, but it was Casanova who strengthened Picasso's belief, discreetly hidden whenever amongst American guests, in 'le complot de l'impérialisme américain'.

In view of President Eisenhower's gradual rehabilitation of Franco, coupled with the acceptance of American bases on Spanish soil, it is perhaps not surprising that Picasso would be sympathetic to the sentiment expressed by his friend, the poet Louis Aragon, that 'In the field of literature as elsewhere we must not let the Coca-Cola triumph over the wine.' Many of Picasso's friends, like Jean Cassou, were fervently anti-American, seeing the United States as mere colonialists. It was a popular thesis in the French Communist Party, which developed along the lines that the United States was a Fascist state convinced of its own racial superiority and relying as a last

recourse on the force of arms. Dolores Ibárurri, 'La Pasionaria', whom Picasso was to meet again in 1948, was quick to remind her audience that American foreign policy hadn't changed since the Spanish-American war of 1898. In 1949, along with Aragon, Picasso marched proudly down the Paris boulevards at the head of the May Day parade under banners declaiming 'French blood is not for sale for dollars.' 'Picasso', in the words of Gertje Utley, who in her study *Picasso: The Communist Years* has done so much to advance our understanding of this period in the artists's life, had become 'the target of a heightened nationalism, a focusing on the core of what it meant to be French, and a reaffirmation of the enduring values of the so-called *grande tradition française*'. Denounced by Waldemar George as both 'inhuman' and 'oriental' – the two seemingly interchangeable terms displaying neatly George's innate racism – Picasso was also apparently 'barbaric', to boot. In George's twisted canon of beliefs, the celebrated Spanish genius, whom it now suited the FCP to pass off as French, was nothing less than 'the evil spirit of Western art'. Cultural life had become hopelessly polarised. European culture as a whole, and French culture in particular, had become sandwiched between two super-powers who had already set out their stalls for the battle ahead.

If the battle over art was just a reflection of the world in microcosm, few would ever go as far as Senator Robert A. Taft, who announced with imminent foreboding: 'Let us face the facts, we are already in World War Three.' Soon enough, though, McCarthyism would test America's democratic life and ways. It was an ugly phenomenon, described by V. S. Pritchett in his engagingly provocative essay 'The Americans in My Mind' (1963). Pritchett remembered American friends trying to play down 'the significance of McCarthyism, that it was just one more circus, one more saturnalia'. But he was less than convinced by their making light of something that struck so deeply at the core of American identity. 'I cannot regard the Ku Klux Klan, the John Birch Society or McCarthyism as circuses . . . they strike me as being illnesses.' Elliot Cohen,

the editor of *Commentary*, dismissed the alarming phenomenon: 'McCarthy remains in the popular mind an unreliable, second-string blow-hard; his only support as a great national figure is from the fascinated fears of the intelligentsia.' For those being investigated, however, sitting at a desk facing Cohn or Schine, it was anything but entertainment and the fear was real enough.

'The American inquisitors had many an ex-Communist in a vice; he was guilty if he affirmed Socialist ideals that were now totally unreal, guilty in his own mind if he "named names", guilty about the divided, secret, hesitant figure he publicly presented before a triumphant prosperous postwar America to which he was more reconciled than he could admit,' recalled Alfred Kazin about one of the most unedifying chapters in American life. McCarthyism's real appeal lay in its brutal simplicity. It was a highly effective cocktail of fear and accusation, with informers and forced confessions, all set in a politically and morally confused landscape. Although crude and often disgusting, McCarthy was far from dumb. He was one of the first politicians to understand the power of the media, and that the higher profile the victim, the more coverage you got. As in the Inquisition, fear arose from the knowledge that you might be next. From his power base as Chairman of the Committee on Government Operations of the United States Senate, McCarthy knew perfectly how to manipulate all the powers of the numerous government sub-committees, how to subpoena witnesses, and interrogate them by sidestepping the strict codes of procedure of courts of law. All the committees – the House Committee on Un-American Activities, Senator McCarthy's Permanent Investigations Subcommittee, the Tenney Committee on Un-American Activities in California, School Boards Committees, Library Committees – in every corner of academia and the arts, the Communists, the fellow-travellers and ex-Communists were rooted out, forced to confess, and pressured to inform on their friends. Charlie Chaplin was denied a visa, as was the black singer Paul Robeson. The playwright Arthur Miller was threatened with jail and then had his visa

removed. Dashiell Hammett was jailed and Lillian Hellmann denied work. Hundreds of people were hounded out of their jobs and blacklisted, for no better reason than that once in their youth they had displayed Communist sympathies.

One of the most notorious cases of all was the Hollywood Ten in which film stars, directors, producers and screenwriters were publicly humiliated, and some of them jailed, to discover on release that calls to their agents to offer them work had evaporated into thin air. Alvah Bessie, a screenwriter for Warner Brothers, who had fought with the Lincoln Brigade, was given a one-year jail sentence and a $1,000 fine. Some film directors like Elia Kazan turned over their evidence to the committee and snitched on their friends. It was a dirty propaganda war, going for celebrities and household names to create maximum fear. Alfred Kazin remembered the nightmarish apparition:

> There on the screen, enveloped in a mist of smoke and beer, was the Grand Inquisitor of Un-American thoughts, smiling, grimacing, talking, fast, fast, fast ... The strangest thing about McCarthy was how distracted he looked for all his belligerence. His mind was clearly not on the immediate suspect. There was that solid block of face, that balding face that looked as if he were trying to keep his features in line, and there were those roaming, spent, madly shifting eyes.

In the Senate there was only embarrassed wriggling. Only three Senators, William Benton of Connecticut, Ralph Flanders of Vermont and Margaret Chase Smith of Maine, had the courage to challenge McCarthy's increasingly reckless claims – one, in particular, where he said he knew of more than 200 card-carrying Communists in the State Department alone.

In the 1952 Presidential election campaign the McCarthy circus played a leading role. It was fortunate for McCarthy's ongoing credibility that they actually found some genuine spies. Or almost. As far as many of the general public were concerned, innocence

didn't carry much weight, it was the strength of the accusation that mattered most. In January 1950 there was the controversial case of Alger Hiss, a diplomat in the State Department and suspected Communist spy, who was tracked down by his seedy tormentor Whittaker Chambers, and then convicted on two counts of perjury and sentenced to five years in prison. There was the case of Klaus Fuchs, a British scientist who had leaked atomic information to the Soviets. Most notorious of all were the Rosenbergs, Julius and Ethel, sentenced to execution, and whose pathetic correspondence in Sing Sing was pored over in public with almost ghoulish glee. With Truman gone, it was President Eisenhower who inherited McCarthy. Eisenhower later admitted that he rode the McCarthy poison for two years because he was unwilling to 'get in the gutter with that guy'.

In France, the FCP looked on these events with growing dismay. The formation of NATO in 1949 had been, in their eyes, just another provocative example of creeping Americanisation. Picasso had also, on a personal level, become more involved, signing petitions for the release of American Communists from jail, supporting the Hollywood Ten, and fined *in absentia* $1,500,000 in 1952 by the State of New York for misuse of funds in his role as Honorary President of the Anti-Fascist Refugee Committee. His most dramatic critique of American foreign policy came in January 1951 with his painting *Massacre in Korea*. Exhibited that spring in Paris in the Salon de Mai, it provoked heated debate. As a painting it was a complete failure. Inspired by Goya's etching *No se puede mirar (They could not look)* and thought of as a pendant piece to *Guernica*, its high aspirations remain completely unfulfilled. It is trite, wooden, almost a caricature. It is a cross between Jacques-Louis David's classical response to the French Revolution and a *Star Wars* film. Picasso himself was at a loss as to why it met with so little critical success. Comforting himself, he told Pierre Cabanne: 'That picture threw people, and did not appeal. But I myself have begun to see it for what it is, and I know why it met with surprise: I had not done *Guernica* over again – which was what people were

Massacre in Korea, 18 January 1951.

expecting.' It is the one canvas that you wish Picasso had never painted.

Guernica's power ultimately rests on Picasso's genuine engagement with the horrific event. It is personal and deeply felt, it uses a language that has surfaced from deep down in his subconscious. One feels that the entire history of art has been trawled, as the layers of symbolism are applied, one on top of the other. If it weren't for Dora's famous photos of the work in progress, you sense . . . take a knife, scrape off a layer . . . there's still a lot more to learn. With *Massacre in Korea* you get what you see, hackneyed Communist propaganda. Far more genuine was Picasso's willingness to join the demonstration, on 28 May 1952, against the imprisonment of André Stil, editor of *Humanité*, who had helped organise a march in Paris against the nomination of General Matthew Ridgway, Commander-in-Chief in Korea, as head of NATO.

Fired up with indignation at US foreign policy in the Far East, and with rumours spreading of the employment of bacteriological warfare by the Americans, Picasso decided upon a more ambitious response. His plan was to transform a deconsecrated gothic chapel in Vallauris into a temple of peace by means of two large murals, depicting war and peace. Picasso was careful, specifically with *La*

Guerre, to avoid admitting any direct relationship with American barbarians running amok in Korea: 'To call up the face of war I have never thought of any particular trait, only that of monstrosity. Still less of the helmet or uniform of the American or any other army. I have nothing against the Americans. I am on the side of men, of all men,' he explained six years later, in 1958. It was a guarded response, but perhaps in the wake of Khrushchev's revelations of Stalin's extraordinary litany of crimes against humanity at the twentieth Party congress in Moscow, followed in November 1956 by the tanks rolling into Budapest, it had to be. Hungarian exiles implored him, 'Do for Budapest what you have done for Guernica and Korea – support us – relinquish your restraint.' In a private correspondence with Penrose, Barr admitted 'a certain sense of disgust'. Perhaps Picasso was still reliant on Louis Aragon's advice: 'It is preferable to be wrong on the side of the party than to be right in opposition to it.' Unwilling to criticise the party he may have been, but it was obvious that his heart had gone out of it.

Throughout this whole harrowing period the 'real' culture war had been going on behind the scenes. It had to be covert, because anything that sponsored the avant-garde, or cosied up to the left, was immediately jumped on by McCarthy. It was the CIA, and the powerful East Coast elite, many of whom had connections to the Board of Trustees at MOMA, that saw the value of a more pro-active role in cultural matters. If the face of America was McCarthy, it played straight into the hands of the Communist propagandists. In Barr's essay of 1954, entitled 'Artistic Freedom', he warned, somewhat belatedly, 'let us keep our eyes on the the two chief enemies of American Freedom, the Communists and the fanatical pressure groups working under the banner of anti-communism . . . It is hard to say which faction is actually the more subversive of our civilisation and culture.'

There was a certain irony that just as the New York School was replacing Paris as the vanguard, the attacks had grown in their animosity. The moment at which the CIA axis was finally galvanised

into action was on 25 March 1949, at the now famous Waldorf
Conference in New York. The main event was the 'Cultural and
Scientific Conference for World Peace', a propaganda stunt orga-
nised by the Soviets, led by Alexander Fadeyev – Picasso's *bête noire*
– and the composer Dmitri Shostakovich, strong-armed by the
Soviets, and utterly humiliated. Supported by Arthur Miller, Lang-
ston Hughes, F. O. Mathiessen, Lillian Hellman, Clifford Odets,
Leonard Bernstein and Dashiell Hammett, it was, according to
Frances Stonor Saunders – whose extraordinary history, *Who Paid
the Piper: The CIA and the Cultural Cold War*, is a Machiavellian
textbook of our times – a sensational *coup de théâtre*. 'The Reds
weren't just under the beds, they were in them,' she writes drama-
tically. While the conference was being kicked off in the Waldorf
Astoria's wonderful Art Deco ballroom, the real action was going on
upstairs in one of the suites. Crammed into every available space
were the 'intellectual gladiators' Sidney Hook, Elizabeth Hardwick,
Robert Lowell, Arthur Schlesinger, Dwight MacDonald, the *Parti-
san Review* editors Phillips and Rahv, Mary McCarthy and Nicho-
las Nabokov. The suite was paid for, unknown to many of them, by
Frank Wisner from the Office of Policy Coordination at the CIA. It
was here that the culture war in Europe could be said to have been
born.

The CIA's primary weapon was the Congress for Cultural Free-
dom, based in Paris and manned by Nicholas Nabokov, Melvin
Lasky and 'the Diaghilev of America's counter-Soviet cultural
propaganda campaign', Michael Josselson. Its strategy was to
counter the Soviet propaganda so effectively used by the tireless
Willi Munzenberg. The CCF would have to be at least as effective.
According to Saunders: 'At its peak the Congress had offices in 35
countries, employed dozens of personnel, published over 20 prestige
magazines, held art exhibitions, owned a news and feature service,
organised high-profile international conferences, and rewarded mu-
sicians and artists with prizes and public performances.' Funded
with the crumbs that fell off the Marshall Plan's table, the annual
budget crept up to hundreds of millions of dollars. Financial

transparency was to be avoided at all costs, so circuitous routes were set up using 'Junkie' Julius Fleischmann's Farfield Foundation, the Ford Foundation, Rothschilds in London, the Sonnabend and Sunnen Foundations, as well as numerous Rockefeller institutions, amongst a whole host of others, so that money could arrive at the relevant magazine clean. Conor Cruise O'Brien was the first to blow the whistle in the 1960s with revelations about *Encounter*. But until then the energies of the Congress for Cultural Freedom were effectively directed at two targets, the Communists abroad and McCarthy at home.

By the mid-1950s, with McCarthy's witch-hunt focused almost entirely on the powerful military establishment, it was inevitable that poisonous Senator Joe, the self-styled guardian of public morals, would be finally defeated. In 1957 he died a dejected drunk. Despite this personal defeat, McCarthyism as an ideology still maintained a strong appeal in middle America. It was fortunate then that during the height of the McCarthy hysteria, and the period of the battle with the US army that had led to his final disgrace, *Guernica* once again travelled abroad. During the summer of 1953 the painting returned to Europe for the first time in almost fifteen years. In October in the Palazzo Reale in Milan, the gigantic canvas became the star exhibit in the first Picasso retrospective on Italian soil. It was an extraordinary and unique moment, the first and only time that *Guernica* was shown in the same space as *Massacre in Korea* and the two mural panels *La Guerre et la Paix* before they were finally installed in the chapel in Vallauris. The message that this trio of works transmitted to an Italian audience – made up of Communists and ex-Fascists – must have been confusing and provocative, offering simultaneously an indictment of their involvement in Spain, while criticising US foreign policy from behind a smoke-screen of universal disgust at the brutality of man.

For Picasso, any pleasure derived from seeing *Guernica*'s safe return to Europe had been completely overshadowed by more pressing problems at home. At the end of September, Françoise

Gilot, who had been relentlessly taunted and goaded by Picasso's continued philandering and deliberate provocations, finally acted on her threat to leave him, taking the two children Claude and Paloma with her. It was the first and only time that a woman had stood up to Picasso and dictated terms.

Just two months later, *Guernica* was once again taken off its stretcher, rolled carefully over its drum, and transported to Milan airport to join a transatlantic flight direct to Brazil for exhibition at the increasingly prestigious São Paulo Biennale staged at the Museu de Arte Moderna. It was a profoundly symbolic gesture, uniting as it did, for however short a time, the diaspora of Spanish exiles that had fled the Franco regime to find safe haven and a community of shared values in Latin America. From June to October 1955 *Guernica* was once again back in Europe, for exhibition at Paris's Musée des Arts Décoratifs. By now, already well on the way to becoming the most influential cultural icon of the twentieth century, it pulled in the Parisian crowds. At the end of October, with Germany still struggling to come to terms with its apocalyptic recent history, *Guernica* was exhibited at Munich's Haus der Kunst. With a poignancy not lost on the German audience, it proved an uncomfortable reminder of a history that was still far from being assimilated; commemorating an event in which many Germans could not yet admit their involvement, and even less their guilt.

From Munich the busy exhibition schedule continued through 1956, moving on to the Picasso retrospective at the Rheinisches Museum in Cologne, there to be viewed by a population who knew only too well that it was not just the Germans who had learnt the tactical efficacy of a devastating aerial attack on a civilian target. And, from there *Guernica* went on to the Kunsthalle in Hamburg, then to the Palais des Beaux Arts in Brussels, to Amsterdam's Stedelijk Museum, finally ending its punishing European tour in December 1956 at Stockholm's National Museum. By summer 1957 it was safely back in the United States again for MOMA's Picasso's seventy-fifth birthday retrospective, from New York it travelled on with the exhibition

to the Chicago Art Institute, ending in 1958 at the Philadelphia Museum of Art. Once again Picasso was being watched closely by the FBI, to the point at which Alfred Barr found it necessary to note down MOMA's diplomatic response. Remembering what had occurred seven years before with the aborted World Congress of Peace Partisans, Barr wrote: 'We do not want to put Picasso in an embarrassing position by inviting him, only to have his entry questioned by our government.'

Guernica's European sojourn had been a calculated gamble on the part of the MOMA trustees. Would Picasso's reacquaintance with his masterpiece change his plans for the painting's future? With Picasso's capricious temperament, who could accurately predict what he might do next? Would Franco's rehabilitation into the international community perhaps soften Picasso's abhorrence of the regime? Or might a request by the artist for the return of his property save MOMA's directors continuing embarrassment? None of these possible scenarios in fact played out. For Picasso, *Guernica* still functioned as a symbolic and ongoing rejection of the Franco regime, however much that reactionary government now tried to disguise its totalitarian and barbaric past behind a more modern and tolerant outward façade. Both parties shared a pigheadedness and an unwillingness to give in, and both guarded long memories. *Guernica*, as far as Picasso was concerned, was best served by its safekeeping in New York, with the added advantage, as he told his friend Rafael Alberti, 'that by means of *Guernica* I have the pleasure of making a political statement every day in the middle of New York City'. Safekeeping, however, had proven a rather more relative concept. On its return to MOMA the painting passed, as always, through the rigorous inspection of the Museum's conservation staff. The news was not good.

Over its four years of continual travel *Guernica* had finally begun to show its fragility and age. During its first fund-raising tour across the United States in the late 1930s the paint still maintained a certain degree of elasticity. By the early 1950s, in contrast, the paint had dried out completely and crystallised, and had consequently lost all

its flexibility. Bending it round a drum, ready for transport, there-
fore, however large the drum and gradual the pressure applied,
forced a flat surface into a gentle curve, causing unnecessary stress.
The painting had always created conservation problems due pri-
marily to its size and unwieldiness, increasing the chances during
handling of the occasional accident. But size brought with it other
problems. A larger canvas was often placed under greater tension to
avoid the inevitable tendency to sag, putting increased strain on the
borders, which were further damaged by the considerable weight of
the canvas, impregnated as it was with size, a white ground priming
coat and the paint itself. Increased tension, coupled with the can-
vas's size, also meant that any jolts or vibrations suffered during the
hanging process were amplified as the shock waves spread out
across the surface. Apart from the damage on the back of the
canvas edges, received during the tacking process, the surface of
the painting had suffered a deterioration that was obvious now even
to the naked eye. In some parts flakes of paint had fallen off. In other
areas the surface of the paint was splitting away from the canvas
support. Under the microscope it was obvious that different appli-
cations of paint, the result of Picasso's many reworkings, were
behaving in a subtly different way; swelling and contracting at
different speeds as the medium had dried. This was perfectly normal
and to be expected. But again, the stress of travel could only
exaggerate the effects. Most worrying, however, was the appearance
of tears, clumsy dents that reflected the light awkwardly, a 5-
millimetre hole punctured the eye of the smashed bust – Picasso's
self-portrait – and long surface cracks: one in particular ran cross-
ways through the neck of the bull. All across the surface there were
hair-line cracks, webs of microscopic craquelure, that continued to
absorb surface dirt. Painstaking cleaning with distilled water and
cotton wool only revealed further the extent of the damage which
had occurred with accidental handling, cracking during rolling, and
changes in temperature and humidity. Nothing but careful restora-
tion could cover up the proliferation of missing areas of paint. In
1957, using a technique that is still occasionally used today, the

conservation department decided to reintegrate the paint and canvas by employing wax resin. Today conservation departments might opt for fish glue or other natural organic adhesives, but MOMA's restorers stuck with a technique that was then known to work. There was only one problem, and it is a legacy that all subsequent interventions have had to deal with – the wax-resin process is irreversible.

First, *Guernica* was placed carefully, unstretched, face down on a plastic sheet. Where tears had occurred, and around all the weakened edges, strips of a cotton/linen-mix lining canvas were attached under gentle heat with wax resin acting as adhesive to the back of the canvas. More radically still, the whole surface of the back of the painting, divided into sections for ease of application, was painted over with wax resin, turned over on to a hot bed and pressure applied by creating a vacuum that pulled canvas, paint and wax resin together to give greater rigidity. Effectively, the three elements had been transformed into one. Loose flakes of paint were unlikely to move. Tears could now be dealt with more easily – with a solid backing, missing areas could be expertly disguised and carefully painted in. When the wax resin returned to room temperature, however, it lost all its flexibility and any other further movement inevitably increased the potential for damage, resulting in open cracks and clean breaks. Another problem, which took a while to appear, was the tendency for the wax resin, with its yellowish tobacco tinge, to migrate to the surface through any holes, or to collect at the edges in gently swelling pools.

First, and most importantly, MOMA's conservation team had secured *Guernica*'s future. This was relayed to Picasso, who took the decision that the painting should never leave the Museum again until its final transport to a Republican Spain. After another surface clean in 1962 it was decided to cover the entire surface with a protective matt varnish, Paraloid (Acryloid) B-72. A consequence of this process was to exaggerate the contrasts of black and whites and to subtly key-up the image to make it even more dramatic. Only once more was it deemed necessary to move the canvas, purely for

museological reasons, when it was taken up to MOMA's third floor in 1964.

For American artists *Guernica* never really lost its strength, but it did lose its immediacy and its ability to shock. Even for the next generation of artists, after the Abstract Expressionists, and well into the 1960s, Picasso would always remain, in the words of Chuck Close, 'a much respected but extremely domineering father'. 'Even people who are desperately trying to get away from him were influenced,' recalled the Pop artist Roy Lichtenstein. For Kenneth Noland, Picasso's 'work, for artists, is as important as the theory of relativity to scientists'. *Guernica* had bled its way into the American artists' psyche, and now, it seemed, patched-up and repaired, it was there to stay. Manifestations, reproductions and reinterpretations of *Guernica* would appear frequently, and still do to the present day. Nelson Rockefeller, most notably, denied the possibility of ever owning *Guernica*, requested Picasso's permission to have an exact tapestry copy made for his private collection at Pocantico, in upstate New York, which was duly given. On Rockefeller's death, his widow donated it to the United Nations Security Council where it still hangs today.

There were those who loved *Guernica* as a work of art, and those who hated the politics that it purveyed. There were those eternal optimists who, despite everything, still saw the painting as representing a drama of resurrection. By the late 1960s Walter Darby Bannard, a painter and formalist critic of refined sensibility, was one of the first to break the taboo and describe *Guernica*'s failure as a work of art. In a profound and convincing analysis he claimed that Picasso's gift for touch was crippled by trying to work on such a gigantic scale. The mechanics of Cubist structure just didn't seem to work. Shouted down on occasions in American art schools for delivering these heretical views, Bannard concluded, '*Guernica* remains a pathetic monument, impressive for its huge size and for the "human content" which flickers through the desperate overstatement.' Whether in favour of *Guernica*, or not, at least in the United States, you were at liberty to speak your mind. In

Franco's Spain, critique of the artist had to be carefully measured to remain within the censorship laws. Any mention of Picasso, who was often dismissed merely as 'the artist from Malaga', was hedged in ambiguity. To understand the true meaning you had to learn to read carefully between the lines.

The Silent Resistance

I want my paintings to be able to defend themselves, to resist the invader, just as though there were razor blades on all surfaces so no one could touch them without cutting his hands.

Pablo Picasso

For some living is stepping on shattered glass with naked feet; for others it is looking at the sun face to face.

Luis Cernuda

On 28 March 1939 the bloody Spanish Civil War ended. The date remains deeply imprinted on the Spanish psyche – the before and the after. The War and the Peace. The War and the non-War – that long-drawn-out period of numbed, exhausted limbo. For many, the worst was about to begin. Each family had lost someone, but for the vanquished, punishment for supporting the Republic was to continue for decades. More than 100,000 Republicans were summarily killed. Many more, over a quarter of a million, were jailed or bought remission from their sentence, in exchange for backbreaking work in forced labour camps on projects as diverse as the Guadalquivir Canal, the Asturian mines, electricity dams, iron foundries in the Basque country, the restoration of destroyed monuments like Toledo's Alcazar, or just scrabbling around in the rubble and dust of the destroyed infrastructure in almost every Spanish village and town. The most powerfully symbolic construction project was Franco's grim mausoleum, Cuelgamuros, known as the Valle de los Caidos (the Valley of the Fallen) close to El Escorial. Rehabilitation for those unfortunate enough to experience the work camps

came only after correction. 'We cannot return damaged elements to society, perverts who are morally and politically poisoned', explained Franco, harbouring his plans for an extended revenge. According to the historian José Luis Gutierrez, 'The Spanish civil war did not end in 1939. The regime never talked about peace; it talked of "the first year of victory, the second year of victory", and so on. Spain became an immense jail, in which the vanquished were put at the service of the victors.' Those who escaped death, jail or forced labour, particularly if they were professionals, continued to be humiliated by working in jobs for which they were massively overqualified – a chief surgeon might be forced to work as a stretcher-bearer for years, to learn proper humility. The families of the vanquished were continually spied on, in case they ran an escape network for fellow-'Reds', or were hiding a threatened relative with a death sentence hanging over their head somewhere in an attic, a cellar, or out in the fields. There was also a whole generation of exiles who had fled across the border, draining the country of much needed talent.

By 1940 Spain had changed dramatically from that volatile period of heady optimism still associated with the Republic. Its populace under Franco had been effectively subdued. It lived in a permanent state of fear: fear of discovery, fear of punishment, fear of being denounced, fear of being caught speaking Catalan, Gallego or Basque, fear of not giving active support to the regime, fear of forgetting to salute, and fear of receiving compromising letters from relatives in exile. It was a fear that quickly turned into crippling inertia.

For a long time after the Civil War, until relatively recently, there has been an almost Pavlovian instinct among historians to argue that Spain started its history again, from point zero, on that historic day, 28 March 1939. In a brave and brilliant effort to explain that Francoism was more than just a dark tunnel of terror, the historians Jordi Gracia García and Miguel Ángel Ruiz Carnicer have dug out the subtleties of changing culture and everyday life under the Franco regime. If the predominant smell in the first Franco years was that of

burning chicory, the *ersatz* coffee substitute, then its distinguishing colour was a muddy brown. Not the brown of military uniforms but the dun brown of sacking material, of collapsed adobe buildings, of poor-quality wrapping paper, of recycled scrap wood. It was the brown of scorched earth.

The first clear indication of a return to everyday life was the development of a culture of survival. And within that culture, it was important to observe silence and learn to speak without being overheard. People who were always guarded and deeply suspicious of one another learnt to communicate in signs, to lip-read, and develop their own guarded semiotics of survival. A selective amnesia was also necessary. According to Gracia García and Ruiz Carnicer, 'the most important thing was to learn to forget the smell of the dust and the vision of the ruins'. If the idea of a complete rupture between the pre-war culture and culture under Franco has perhaps been somewhat overplayed, there is no doubting that there was a profound crisis. It had been a deep and wounding trauma. But, there was also, it must be recognised, a certain sense of continuity. This is not to deny the often brutal and crippling nature of Franco's repressive regime. But, culture, despite everything, proved surprisingly resilient.

Not all discourse referred to the Holy Crusade, or for that matter, aped the anti-Semitic, anti-Masonic, anti-Communist rantings of most of Franco's endless monologues. Despite the power of the Catholic Church and the growing centralisation around the Movimiento, the wholesale imposition of an official culture was never achieved as it had been under Stalin or Hitler. There just wasn't the money or the messianic will. There were more important things to think about, namely life's basics – followed, quite naturally, by a desperate desire for the return to normal everyday life.

Culture under Franco, it must be remembered, was never homogenous. It was complex, many-layered, evolving sometimes quite dramatically over a period of almost forty years. One of the best indicators of growing tolerance was the change in perception of Picasso and *Guernica*. Immediately after the Civil War, Picasso had

been an artist reviled by the Franco regime. But attitudes gradually changed. By the late 1960s *Guernica* had somehow become transformed into a painting desired by some of Franco's most powerful ministers. It was an unlikely transition, and one that needs to be explained.

Guernica could never have been popular in the immediate aftermath of the war, portraying as it did the horrors of what still had to be painfully assimilated and gradually overcome. Only in Gernika and the Basque country might its presence have proved a cathartic salve; where it might even have functioned as an official recognition of the tragedy, and would have countered the anti-Republican propaganda and the growing mountain of official lies. For the rest of Spain, amnesia and psychosomatic blindness were sometimes the only effective ways of suppressing the terrors of the past. Despite the enduring cliché about Spain as a land of contrasts, *Guernica* had never offered a moral landscape neatly divided between the extremes of black and white, or good and bad. It was *grisaille* – a painful litany composed out of black and white, with all the grey areas in between. It represented the shadowland where everyone in Spain now had to live – a psychological space of suppressed violence, of carefully orchestrated repression, and clandestine longings for a different world.

Despite all his best efforts, Franco never managed to impose a completely monolithic culture, directed wholly from above. There were many different cultures that often crossed one another's paths. There were cultures that were bound by class. At the most simple level, for instance, a love of classical music denoted the sophisticated tastes of the well to do. The *pueblo*, on the other hand, enjoyed the folkloric tradition and the sentimental *coplas*. There was of course, overriding all of this, the official Franco culture of hierarchy, paternalism and faith, that created a nationalist liturgy of marches, masses and memorials to the dead. But, to counter the claustrophobic weight of authority, there was also a stolen 'underground' culture that had been imported and carefully hidden – a vestige remaining from a democratic past: the poems of García Lorca and

Antonio Machado, the essays of Unamuno and Ortega y Gasset and Miguel Hernandez's heart rending 'Lullaby to an Onion', written from jail. After the failed autarky of the 1940s, where Franco's costly experiment in self-sufficiency collapsed into black-market racketeering, there was another culture brought home in the 1950s by the emigrant guestworkers, the *Gastarbeiter*, on their yearly pilgrimage back home from Germany, Switzerland or England.

Despite an almost phobic hatred of the intelligentsia, Franco still permitted culture. There was even 'dialogue and debate'. But it was a negative culture that through the imposition of the censorship law, passed on 22 April 1938, crushed the liberal heritage of the famous generations of 1898 and 1927, and attempted to send the inspirational example of writers like Rafael Alberti, Juan Ramón Jiménez, Giner de los Ríos, Luis Cernuda, María Zambrano and Jorge Guillén into eternal oblivion. For those wishing to maintain intellectual integrity it was wise to pick your audience carefully, and stifle any overt displays of rebellious thought. The authority of the regime and the official censor was not to be questioned. It demanded cunning, foolhardiness and bravery to stretch the guidelines and push the barriers further back. It was possible, but it had to be done with subtlety. Any criticism was heavily coded; hedged in irony, camouflaged in metaphor, sheltered in subterfuge; employing essentially a symbolism that was only understood by an initiated few. The real discourse, then, lay hidden deep between the lines, and in paintings, just below the surface.

To caricature Franco simply as a brutish philistine is an over-simplification that goes a long way to obscuring the truth. We can scoff at his obsession with the National Lottery (which, incidentally, he won twice), or his addiction to cowboy films, both hobbies of his late in life. But he scripted the film *Raza* and was an amateur water-colourist. Nevertheless, what Franco understood instinctively, like Mussolini and Hitler, was that art invokes power. From early on he used art deliberately to underpin his nationalist rhetoric. It was something he had learnt from the Republicans who, right from the

beginning of the Civil War, had accused the Nationalists of being nothing better than a group of savage barbarians, insensitive to both culture and life; this had, after all, been the *leitmotif* of the Spanish Pavilion. In *Songe et Mensonge* and *Guernica* the attack had become more personalised, with Franco lampooned as the gross beast that smashes classical sculpture and desecrates the past. What Franco desperately needed was the creation of his own rhetoric and aesthetic by attaching himself to images and objects that could overpower *Guernica* – which, in any case, had already been censored and rendered completely invisible within the borders of Spain. With Cardinal Goma's help, it should be remembered, José Maria Sert had sent work to the Pontifical Pavilion at the 1937 Expo in Paris. Less well known is the official Nationalist selection of artists sent to the 21st Venice Biennale in 1938, which included socialite portraitists like Ignacio Zuloaga and Álvarez de Sotomayor, accompanied by the more spiritual and blatantly imperialist outpourings of Gustavo de Maeztu, José de Togores, Pedro Pruna, Lino Antonio, and the sculptors Enrique Pérez Comendador, Pablo Mañé and Quintin de Torre. In keeping with Franco's ambition, a whole host of grandiose and perfectly asinine busts, as well as a huge number of highly polished nudes and equestrian statues, fresh from the hands of sculptors like Juan de Ávalos, Josep Clarà and Fructuoso Orduna, invaded the public space. Carlos Sáenz de Tejada, who perhaps more than any other artist came to represent the idealism of the Franco style, provided in his canvases acres of slick and sentimental romance. Alongside his portraits of Franco these were only rivalled by the work of Ignacio Zuloaga and José Aguilar.

It was in the large-scale monuments and mass public events, however, as well as in the mass-produced area of posters, with cartoon series like *Flecha*, the graphic covers of the Falange magazine *Vertice*, and in the cinema with its state-controlled news service No-Do, that a recognisable Franco aesthetic was essentially born. Like his Fascist and Nazi allies, who had been expert in group psychology, Franco saw the large orchestrated public event as powerfully ritualistic, overwhelming and bonding. None more so

than the victory parade or the celebratory mass. At the end of 1939's victorious procession around Spain, the final mass in Madrid was lent additional resonance by the presence of Don Juan of Austria's pennant taken from his flagship at the battle of Lepanto, the famous victory of the Holy League over the Saracans where Cervantes had lost an arm. Accompanying this poignant reminder of Spain's glorious past was the Lepanto Christ (a sculpture expropriated briefly from the vanquished Catalans), as well as the standard belonging to the Moorish Prince Mamolin, allegedly taken as a trophy during the *reconquista* after the Christian victory at the decisive battle of Las Navas de Tolosa, right back in 1212. As the *Te Deum Laudamus* sounded through the Madrid church, it was suggested therefore, by association, that Franco's Christian crusade was the modern-day equivalent of the glorious achievement of the Catholic monarchs Ferdinand and Isabel who had ousted the Moors; or, perhaps, the equal of the powerful thirteenth-century alliance between Alfonso VIII of Castile, Pope Innocent III and Rodrigo Ximénez de Rada, the Archbishop of Toledo, that had made victory at Las Navas de Tolosa possible. Just as Picasso had trawled the history of art to memorialise an inglorious episode, Franco in turn had ransacked Spain's supply of historical relics and artefacts to crown his final victory. Soon enough, art would offer Franco another opportunity for a resounding propaganda coup.

One of the great myths propagated by Franco's Nationalists throughout the Civil War was the accusation that the Republicans had been selling off Spain's heritage to buy arms and finance the war. Why else send the Prado to Switzerland, or the work of the Catalan primitives to France? Coupled with the Republicans' profound hatred of the Church, the murder of priests and the burning of churches – and a very careful and select rewriting of history – it was entirely plausible. After all, where were all the gold reserves that had sat in the basement of the Bank of Spain? Gone to Moscow, and never likely to return. In 1940 Franco started secret negotiations with Maréchal Pétain for the return of many of the art treasures the Republicans had taken to safety. With the official recognition of

Franco as the legitimate government came a further corollary, namely, a recognition that the artistic treasures belonged to his Spanish state.

Franco delivered a masterstroke. Not only would he succeed in liberating the objects from the greedy hands of devious Republican exiles, still working in France to divest Spain of its greatest treasures – in league as always with the international Judaeo-Masonic conspiracy – but he would bring back Spain's greatest treasure of all, lost for generations, namely, *La Dama de Elche*. Excavated in 1897 in Elche, close to Alicante, this extraordinary hieratic bust of what surely must have been an early Iberian Queen or powerful noblewoman was sold to France and displayed prominently in the Louvre. Its sheer antiquity, dating to around 500 BC and therefore pre-Roman, coupled with its sophistication and its perfect state of preservation, made it an unrivalled cultural artefact. Going back through the genealogy of the Spanish kings, the image suggested that it derived from the Ur-culture of Spain, before Iberia had become infected by foreign interference, namely the Romans, the Arian Visigoths, the Islamic hordes, and finally the Hapsburg and Bourbon kings. One can see how with her enigmatic gaze and resolute stoicism *La Dama de Elche* might have appealed to Franco, who always prided himself on his ability to hide his feelings behind a cold, impassive mask. She is imperious and quietly resolute. There was no better image, apart perhaps from the portraits of the fifteenth-century Catholic monarchs Ferdinand and Isabel flanked by their symbols of the yoke and arrows, to bolster Franco's historical vision that the greatness of Imperial Spain had a long and noble tradition; a tradition which had been sold shamelessly down the river by the liberal politicians of nineteenth-century Spain and its pathetic gallery of corrupt and decadent kings and queens.

With regard to *La Dama de Elche*, Franco was of course very careful to avoid mentioning that she had come at a price. On 7 December 1940 Franco received Pétain's new Vichy Ambassador, François Piétri. He responded to Piétri's courtesies with cold disdain: 'Friendship cannot exist without justice, and there are all too many

injustices to repair for this friendship to become real.' What Franco
was alluding to was his belief that as a friend of the Axis powers it
was about time he was rewarded with the Rock of Gibraltar. The
return of *La Dama de Elche* along with other treasures was a deal
cut to distract attention from the fact that Hitler wasn't about to give
anything away.

Throughout the whole period of the Franco dictatorship it was
obvious that critical reaction to Picasso had to be tailored to what
the censor allowed. In the immediate aftermath of the Civil War,
with the memory of Picasso's involvement still fresh in the public
mind, it is not surprising that there was little, if any, positive
response to his work. It goes without saying that there was almost
no opportunity to see any of it in Spain. The first post-war review of
Picasso's work, by the London correspondent of *Jornada*, for the 5
January 1946 issue, gave a good indication of the tone future
criticism might take. The *Jornada* journalist picked up quickly on
any anecdotal evidence that ridiculed Picasso's work at the Picasso
and Matisse exhibition at the Victoria and Albert Museum. Mrs
Michael Joseph, the daughter of the famous Pre-Raphaelite Holman
Hunt, opined: 'Art is inspired by the imagination. But how can
anyone find inspiration in contemplating a grotesque nude or a
woman with three eyes?' Delighted, the *Jornada* journalist further
reported a six-year-old's uninhibited reactions on seeing one of
Picasso's reclining nudes: 'A hippopotamus in bed,' she apparently
squealed with pleasure. Trawling through the letters page in *The
Times*, there was every opportunity to give fair wind to Angry of
Tunbridge Wells. 'Fortunately, in nature there are few figures with
half a head or three eyes, if we want to see such monsters we should
go to the circus . . . they say we are seeing the end of painting. I
sincerely hope so.' Norman Wilkinson, President of the deeply
conservative Royal Society of Watercolourists, called it an insult
to the public's intelligence. The Countess of Shaftesbury went one
step further and declared it a danger to British youth. Sir John
Coldstream, a retired Indian Civil Servant remained eminently
practical. It might, he hoped, work as an emetic. With a strong

enough dose, Britain's vulnerable youth might yet be saved. The exhibition did have its defenders, reported *Jornada*, but they only defended Matisse. 'Picasso doesn't nurture us with milk,' observed Mr Dunlop, 'but gives us tea with a strong shot of vodka.' The strongest criticism of all was found in the *Daily Telegraph*. 'When one thinks that many a modern celebrity has died mad, I would like to warn our children that imitating this art might have the same pernicious effect as Hitler had on the German youth.'

Two years later, in the 12 September 1948 issue of *!Arriba!*, the mouthpiece of the Falange in which Franco contributed his most inflammatory anti-Masonic articles under the pseudonym of Jakim Boor, Picasso was again held up for public ridicule. Illustrated prominently with the portrait of Sabartés as a sixteenth-century *hidalgo*, the article was entitled 'Picasso tiene este amigo' (*'Picasso has got this friend'*). 'This egg with glasses and sombrero, with a collar and two noses, is the portrait of Don Jaimé Sabartés.' Poor Sabartés, sympathises the writer, it wasn't really his fault, his only mistake was to strike up a friendship with Pablo Picasso, the 'great enemy of Spain'. Quoting the poet Damaso Alonso, *!Arriba!* described Picasso as an elitist enemy of the people. Attacking his apparent hermeticism, the reviewer writes, 'It is sterile and ego-centric to keep writing lyrics that only a privileged few can decipher, while millions and millions are excluded.' Echoing the tenor of much of the criticism received by Picasso at the time in the United States, the reviewer continues, 'This painter, a quasi Communist, in the service of the red intelligentsia, makes paintings exclusively for the Communists who also find it incomprehensible.' Picasso is dismissed as a hopeless schizophrenic. His art is both 'infantile and elephantine'. As the insults rain down, the reviewer offers Picasso some advice. 'Has Picasso forgotten that, for the Spanish, even madness is a way of moving closer to God?'

The critical debate, however, was not always reduced to the level of swapping insults. Occasionally, a light would shine through. In the 1 June 1956 issue of the traditionalist right-wing newspaper *ABC* – part of Torcuato Luca de Tena's media empire – space was

given over to the distinguished art historian José Camon Aznar, editor of the high-class art magazine *Goya,* and author of the first serious study of Cubism in Spanish. It is an object lesson in how to write an entire article about *Guernica* without once mentioning the painting's name. In his piece, entitled 'El Maniqueismo Iberico de Picasso' ('Picasso's Iberian Manichaeism'), Camon Aznar skilfully runs with the bulls. Illustrating the article prominently with the *Guernica* study of the screaming horse, he deciphers the duality and moral ambiguity that are the essence of much of Picasso's work. 'It is since 1935 that the artist has started to produce these enormous hallucinatory works,' writes Camon Aznar. (And we, the initiated, know exactly to which painting he is obviously referring.) It is on these canvases that the battle between the bull, with its 'instinct for butchery', comes head to head with the horse. And it is precisely here that we see Picasso's Manichaean mind-set working at its best, suggests Camon Aznar. These animals slowly metamorphose as their expressions take on a gruesome human aspect. The Horse, in its terrible pain, is, according to Camon Aznar, an animal version of the classical sculpture *Laocoön*. And it is the brutality of the Bull, without exception, that always wins. 'What fiery Malagan blood is awakened in Picasso that he returns so obsessively to the bull?' the writer asks. 'What powerful instincts control his brushes and dip them into the paroxysms of the *corrida*? The Iberian cycle is closed: the bull as religion, the bull as fiesta, the bull as condemnation. This has been the essence of Spain since prehistory.' It was a brave and cunning dissection that somehow made it past the censor. But the fact that it was published makes clear that Spain, after fifteen years of Franco's dictatorship, was slowly changing.

With the war finally ended, Franco rapidly sought a legitimacy above and beyond his role as mere military dictator. Divine Providence had assisted him in the crusade for God and Spain, but now in peace he had to pull the threads of support together into a one-party state; from the hierachy of the Catholic Church to the Monarchists he sought out their support; from the radical Fascist extremes of the Falange and the military to the old reactionary Carlists, he promised

each increased power in the future, without ever clearly setting a date. In a pact of blood, these victorious elements were brought together under a leadership that closely resembled Napoleon Bonaparte's hold on France: with a similar lack of humility, Franco regarded himself answerable only to God and History.

In 1964, after a quarter of a century in power, he read out his end-of-year message which amounted to his own self-congratulatory school report. 'Throughout this long period of time we have governed adapting our ideas to the time we live in.' And he was right – pragmatism had always been one of the defining characteristics of the Franco regime. Playing one group of supporters off against the other, Franco had skilfully positioned himself as the ultimate mediator; accepting all the praise when things went well, and quick to blame his ministers when things went wrong. After the Second World War, during which, much to Hitler's disgust, Franco had managed to keep Spain neutral, the country had passed into a period described by historians as National-Catholicism, in which economic and cultural autarky were the driving ideologies. But autarky, an attempt at economic and cultural self-sufficiency driven by fear and insecurity in relation to the outside world, had proved disastrous. Where the average wage had been $789 in 1930, by 1950 it was still only a lamentable $694 per head. In agriculture there was a fall-off in production, compounded by a concomitant collapse in industrial production, which also only recovered to pre-war levels by 1950. The result was appalling levels of malnutrition and an abject poverty more extreme than in many Latin American countries. Behind the carefully stage-managed façade of a totalitarian state there was growing disquiet. Among Franco's own supporters there was a growing realisation that El Caudillo was falling increasingly out of touch. Some echoed General Kindelán, who saw him as driven mad by power, and who described Franco in a letter to the king-in-exile as 'sick with his rapid rise to such dizzying heights, compounded by a lack of culture'.

By the early 1950s, however, things were about to improve. One

of the main motors for change was the gradual reintegration of Spain into the international community that culminated in membership of the United Nations in 1956, leading to cheap loans from the United States and a growth in inward investment. In return for the acceptance of US bases at Torrejon, El Copero, Morón de la Frontera, Sanjurjo, Reus and Rota, and an agreement on support in the Cold War, Spain received $465 million between 1953 and 1957; a substantial amount, but noticeably less than that received by Turkey, Greece, Yugoslavia and Brazil. Significantly, 1956 also witnessed the first overt signs of internal rebellion. The first battles were fought between the old guard of the reactionary Falange and the liberalising tendencies of the new Opus Dei ministers – a secretive organisation that found no contradiction between deep religiosity and worldly success.

Following the death of the brilliant critic José Ortega y Gasset, Madrid's university campus became the stage on which the forces of reason and reaction fought for Spain's future. On 9 February 1956, following riots and the shooting of the student Miguel Álvarez, emergency powers were introduced. The university was closed, suspect students were arrested, and the following day the Minister for Education, the 'liberal' Ruiz-Giménez, 'resigned'. In a knee-jerk reaction he was replaced by the loyal Falangist Jesús Rubio in Education and José Luis de Arrese as Minister-Secretary General for the Movimiento. The crisis, with its short-term solution and swing to the right, represented, however, the death throes of the reactionary Falange. Almost immediately the Opus Dei technocrats persuaded Franco that modernisation was now absolutely essential if the regime was to survive. In February 1957, in a cabinet reshuffle, the Falange was considerably weakened. In came the new blood of the Opus Dei economists – the *aperturistas* (those who wanted openness) – Mariano Navarro Rubio, Alberto Ullastres and Laureano López Rodo, a trio set on administrative reform and modernisation. For the anti-Franco lobby, both within and outside Spain, the years in the wilderness were slowly coming to an end.

Bending to the wishes of his new ministers, Franco was grudgingly

forced to accept an uncomfortable austerity package, with its humiliating, but necessary, devaluation of the peseta accompanied by an unpopular wage freeze, a radical reduction in debt and an opening up of the markets to competition. Despite these moves towards European integration, Franco remained belligerently ana-chronistic, painting himself now as 'the Sentinel of the West' – as the last protector of freedom against the creeping poison of Commun-ism. At the long-awaited inauguration of the Valle de los Caidos in 1959, he delivered a speech that made it obvious that reconciliation with the enemy was still the last thing on his mind. 'Anti-Spain was beaten and defeated, but it is not dead. Every so often we see it raise its head abroad.' But the bull in *Guernica* was not about to bow its head. 'What', asked Franco rhetorically, 'are the enemies of Spain?' Framing his answer in almost biblical terms, he answered, 'The enemies of Spain are seven: liberalism, democracy, judaism, the Masons, capitalism, Marxism and separatism.' It was probable that Franco included Picasso in every category cited in his rousing speech. But it was also obvious that Franco was beginning to delegate more. As a figurehead and father of his people he could leave the everyday management to his ministers. And one of the immediate effects of the Opus Dei-led reforms was a rapid growth in the economy throughout the 1960s at an annual rate of 7 per cent, second only to Japan.

The Spanish economic miracle had at last arrived. For those who warned against excessive liberalisation, economic well-being had come at too high a price. Tourism had brought in new ideas. Spanish society, according to the reactionary right, was rapidly losing its Catholic crusading zeal, and would fall prey, sooner or later, to the seven enemies of Spain. Once again, one of the most accurate yardsticks of increasing tolerance in Spain was the press and the public's reaction to Picasso.

In 1960 a Picasso exhibition opened at Barcelona's Sala Gaspar to considerable media attention. Since 1956 the Gaspar brothers, Joan and Miquel, along with the publisher Gustavo Gili, had been at the forefront of promoting Picasso's work. In 1956 they had shown

lithographs; in 1957 a collection of drawings, paintings and prints; in 1958 the tauromaquia series based on the feats of the remarkable *torero* Pepe Illo; and, in 1959, fifty-nine of Picasso's deceptively simple linocuts. Each time, however, the exhibitions were passed over by the press and almost entirely ignored. On 23 July 1960, however, Maria Dolors Orriols, reviewing the latest Gaspar show of forty-five Picasso linocuts for the magazine *Gran Via*, was given freedom by the censor to point out that 'In France, in England and other countries, the work of Picasso is frequently shown, and not just the engravings. These cultural events get the attention they deserve, and the critics don't just remain silent or ignore them.' On the same day, in *Destino*, Tristán La Rosa, reporting from London on the resounding success of the Picasso exhibition at the Tate Gallery, was amused by the flamenco and *tapas* on offer on the banks of the river Thames. Running through Picasso's chronology, La Rosa reported only fleetingly on the 1930s as the period of *Minotauromachia*, ignoring completely the existence of *Guernica*-related works.

In the same issue Jorge Marín applauded Roland Penrose's magnificent organisation of the exhibition, and took the opportunity to invite the reader to stop and admire a masterpiece of the '*epoca cruel*', the painting inspired by the death camps, *Charnel House*. According to Marín, it represents the pictorial equivalent of what Lorca was looking for in '*la raiz del grito*' – the root of the indignant scream. Between the lines it was obvious that what Marín was arguing for was greater recognition for Spain's most prodigious and prodigal son. For one of the first times Barcelona's ambitions and aspirations had become inseparably linked to Picasso: 'Barcelona is a city that constantly dreams. Apart from its fame as a materialistic city, it needs always to maintain and feed its illusions, and one of these illusions is Picasso.' Any self-respecting Catalan, crushed under the yoke of Franco, would know exactly what other illusions Marín was alluding to in his passionate text: freedom to speak Catalan, a working democracy, protection for Catalan industry, control over budgets, a larger slice of the Spanish cake, and

even, perhaps, a separate Catalonia . . . but none of these wishes could ever be publicly voiced.

In the August 1960 issue of *Gran Via*, Sempronio continued with a topographical survey of Picasso's affection for the Barcelona of his youth, picking out his studios and pointing out his numerous flats. None of his early anarchist connections are mentioned, of course, or the bohemian times at Els Quatre Gats, or for that matter the horseplay and debauchery in the calle d'Avinyon. But, Sempronio does alert the reader, for the first time, to the plans for Sabartés' Picasso Museum in the calle Montcada.

In 1953 Barcelona City Council acquired the dilapidated fifteenth-century merchant palace, the Palacio Aguilar, in the calle Montcada. Sited in the heart of the mediaeval Ribera quarter, which over the years had fallen into an appalling state of disrepair, the vociferous Amigos de la calle Montcada lobbied the council to protect the fabric of this unique historic area. The Mayor of Barcelona, José María de Porcioles, a passionate promoter of the city as a tourist attraction, and with a strong belief in the power of culture to effect change, felt the most viable future for the calle Montcada was as a street of museums. Introduced by the Gaspar brothers to Jaime Sabartés, Porcioles quickly recognised the unique opportunity on offer; to regenerate the Ribera *barrio* with the finest of contemporary art. Porcioles was a remarkable man in many ways. Jailed for being active in the Catalan Lliga Party, and for his involvement on the Republican side during the Civil War, he mixed a profound love of Catalonia with the pragmatic realisation that, under Franco, Catalonia would always be part of Spain. As an active mayor he had been instrumental in starting works on the metro, the restoration of the 1929 Feria de Muestras, the elegant exhibition centre below the palace on Mon-tjuic, large housing projects to absorb the huge migration from other parts of Spain, the promotion of tourism, and a rationalisation of the city's water supplies. Porcioles was so energetic, and often so impatient for change, that two egg-shaped water towers, set above the city in the Colserolla hills, were nicknamed the '*cojones de Porcioles*' in recognition of his ballsy, no-nonsense approach. Talking to Picasso

on the phone in Catalan, Porcioles immediately struck up a good working relationship with the artist whom he teased and seduced with elaborate plans, photos and a maquette of the museum that would eventually bear his name.

Having manoeuvred the sitting tenants out of the Palacio Aguilar, the project to provide an adequate setting for Picasso's work could effectively begin. It was not just the Sabartés collection that would be housed at the palace, with its signed proofs of every Picasso print, but also other works that had gradually accumulated in Barcelona's public collections since the donation of *The Harlequin* in 1917. Barcelona, more than any other Spanish city, had always maintained a discreet representation of Picasso's work. Mayor Porcioles was completely convinced that now was the time to strike. There were still dissenting voices on the extreme right, particularly in the newspaper *El Cruzado Español*, who were disgusted that a notorious Communist and corrupter of souls should be honoured with a museum. But Porcioles discounted *El Cruzado* as outdated and marginal, with absolutely nothing constructive to say.

By December 1960 Barcelona had caught Picasso fever. In the 1 December 1960 issue of *La Vanguardia*, the new Picasso exhibition at the Sala Gaspar, with thirty previously unseen works released from the artist's studio at La Californie, was afforded an entire page. A week later, *Gran Via* proclaimed that such was the enthusiasm for Picasso that Barcelona had become '*sur Picasso*'; as strongly associated in the public mind as Shakespeare with Stratford-upon-Avon, or as indivisible as Cervantes and Alcalá de Henares. Across a two-page spread key members of the Catalan art world were given the opportunity to voice their admiration for Picasso. Juan Vidal Ventosa, addicted to Picasso's art, claimed that he went every day to see the exhibition, like a lover calling on the woman he loves. Queues to get into the Sala Gaspar went the whole way round the block. Will Faber, an English art lover, apparently unaware of Picasso's strong opposition to the Franco regime, innocently requested that Picasso come to Barcelona for Christmas, where he would be received with a royal procession. They should name streets

and squares after Picasso, in order to speed up the opening of the museum, enthused Faber, and if that wasn't enough, December should be renamed Picasso month.

Noticeably more measured and sober, the Director of Museums, Juan Ainaud de Lasarte, also thought it time that they open the Picasso Museum. On the other hand, Subirachs, the sculptor later charged with finishing off one of Gaudí's façades at the Sagrada Familia, offered Picasso a double-edged compliment, suggesting that the reason his work was so popular was that it already smelled of the museum. Others felt he should be awarded the Gold Medal of the City of Barcelona, and adopted by the city as an honorary son. Oriol Bohigas, an architect who was later to be so instrumental in the renovation of Barcelona's infrastructure for the celebration of the Olympic Games in 1992, observed that 'the large queues in front of the Sala Gaspar are the first examples of civilised behaviour that we have seen here in years'. The artist Modesto Cuixart used *Gran Via*'s invitation as an opportunity to criticise previous apathy: 'If someone has missed the train, then they've missed it. For dignity's sake I won't say any more . . . the Picasso room in Barcelona's Museum of Modern Art is a complete disgrace.'

In another article, in *Gran Via*, Cesareo Rodriguez-Aguilera attacked the art critic Eugenio d'Ors for his failure to recognise the true significance of Picasso. D'Ors, the founder of the influential Noucentista movement, that returned to a Mediterranean Classicism, had found new accommodation under the Franco regime. In 1930 he had published his study *Pablo Picasso* in French and English. It was the fruit of a long friendship. D'Ors, however, would end up disappointed. Picasso couldn't be persuaded to spearhead the Noucentista movement that so revered the Mediterranean classical world. In 1936, with the war under way, D'Ors addressed his farewell to Picasso in the 'Epístola a Picasso' and his 'Adiós, Pablo Picasso!', both bitter recriminations against an artist by whom he felt deceived.

Rodriguez-Aguilera's article was more notable, however, for acknowledging *Guernica* in public for the very first time. In the

same month, in *Destino*, Juan Perucho echoed Rodriguez-Aguilera's theme: 'I suppose there will be people who only see monsters in this exhibition, and they are right because these are the monsters of life, and life is essentially monstrous. Picasso has made the most terrifyingly alive paintings of our age.'

A week later, *La Vanguardia* gave a progress report on the new Picasso Museum. Juan Cortes, the newspaper's in-house critic, was quick to stress the wonderful elegance of the Palacio Aguilera, with its flamboyant gothic style and perfectly proportioned patio that reflected Catalonia's greatness during a period when it held dominion over the Mediterranean trade. The municipal architect, Joaquin de Ros y de Ramis, in charge of the restoration, was praised for his sensitivity. Midway through January 1961, José María de Segarra reported again in *La Vanguardia* on a phenomenon that was entirely new. In the annexe of Madrid's Museo de Arte Contemporáneo at the imposing Biblioteca Nacional an exhibition of Picasso's graphic works was enjoying enormous success, despite the 5-peseta entrance fee. Segarra was surprised because there was nothing dramatic or shocking in either scale or content to explain what he described as the 'enormous and heterogeneous queue'. He could understand Picasso's appeal in Barcelona because of his attachment to the city and his Catalan friends. But Madrid, the seat of the Franco government, had always had a complicated relationship with anything Catalan. 'Picasso's voice had always been heard in Madrid,' explained Segarra, 'amongst the street sounds – like the clarion call of a confused and distant trumpet.' Segarra's article was particularly fascinating not for what it said about Picasso but rather for what it said about the audience. In the recent Velázquez show the queues had been nothing like this, Segarra pointed out. And although the Dalí show had been popular, it was merely the result, according to Segarra, of snobbism and propaganda. 'We must accept that what is happening in Madrid with Picasso's lithograph exhibition is one of those unexpected signs that is produced in these confused and ebullient times.' What surprised him most was the fantastic number of

young people walking round, catalogue in hand, studying the works with an almost 'addicted devotion'. On seeing a particular print one spectator was forced to breathe in deeply, as if reaching the summit of the Himalaya. Segarra noted the overbearing, almost reverential silence: 'a great silence, as if the Holy Spirit had passed silently amongst Picasso's lithographs'. Picasso's appeal, he argued, came from the fact that instead of being a slave to art, he had succeeded in making art his slave.

But there was still something else about the public's response that continued to puzzle Segarra. 'In Spain there is a great nostalgia and a growing desire for Picasso. And it is quite possible that in old age Picasso has also developed a growing desire for Spain. It's all very mysterious; in all of this there are elements which aren't purely dependent on art. There is something very dramatic and human about this devotion for Picasso. What I saw last Sunday within the walls of the Biblioteca Nacional was far closer to what we describe as a demonstration.' It had become increasingly obvious that admiration for Picasso and for *Guernica* had become an effective method by which to signal an attachment to a whole host of anti-establishment ideas.

That summer, in *La Vanguardia*, Pedro Voltes pointed out the symbolic relationship linking the restoration of the Palacio Aguilar with Catalonia's growing self-confidence. In the restoration works, the architect de Ros y de Ramis had uncovered superb examples of carved plasterwork and perfectly preserved romanesque murals. Progress on the Picasso Museum, in Voltes's opinion, was emblematic of Barcelona's troubled history. First, during the early Middle Ages, there had been growth accompanied by ever-increasing wealth. But by the early eighteenth century fortunes had dramatically changed, as the Palacio Aguilar slipped into decadence and abandonment. Finally, with the Civil War now becoming an increasingly distant memory, the city had once again risen like the phoenix from the flames.

All that winter, facing the steps of Barcelona's Gothic cathedral, the Norwegian Carl Nesjar had been working in secret on the façade

of the new Colegio de Arquitectos de Barcelona. Overlooked by the *sardana* dancers on a Sunday morning, and in full view of the Cathedral chapter's processions to the Bishop's Palace, it would have been difficult to find a more polemical site. Picasso, who had recently worked on large-scale commissions for the United Nations in New York and the SAS airline's head office in Copenhagen, readily accepted the opportunity to revive the ancient tradition of the *esgrafiado* technique, where decorative elements were carved directly into plaster. So secretive was Nesjar's transcription of Picasso's designs that there were reports in the newspapers of violence perpetrated on photographers who had been caught secretly taking snaps. It is difficult to see how Picasso's almost childlike illustrations of the Catalan traditions of building human towers, the famous Xiquets de Valls, or the procession of the *gegants* – the papier mâché giants – the Palm Sunday processions, or cartoon-like depictions of *sardana* dancers, might cause upset. But they did. Some felt insulted by their childish simplicity. Others, again in *El Cruzado Español*, were outraged that in full view of the Cathedral hierarchy the work of the infamous Communist would look down on the churchmen's *birretas* every day. Juan Cortes in *La Vanguardia* was considerably more upbeat, and was absolutely sure that every other European city would be envious of what the Catalans had achieved.

With images as charming and innocently beguiling as those prepared by Picasso for Nesjar's transcription on to the wall of the Colegio de Arquitectos de Barcelona it is hard to see how the official censor could find reason to complain. And, in general, the decorative project met only with praise. Censorship under Franco, however, proved a system of cultural control that was all too human and often flawed.

In keeping with the policy of increased openness, promoted by the *aperturistas*, Luis Buñuel, the *enfant terrible* of Spanish cinema, was permitted back to Spain in 1961, with the full knowledge of the Franco regime, after more than twenty-five years in exile. It was hard to imagine how the author of the two Surrealist masterpieces

Un Chien Andalou and *L'Age d'Or* might be used to advantage, if at all. Or, perhaps, it was that the ageing Republican spy and Spain's most infamous atheist, denounced by the La Coruña Police Chief as a depraved morphine addict and alcoholic, had been forgiven. Finally, it seemed, Buñuel's *moriña* – his homesickness – could be indulged. Radically anti-bourgeois and anti-clerical, Buñuel had close friends and associates who had also played central roles in the Republic: Juan Negrín had been his physiology teacher; García Lorca and Dalí had briefly been intimate friends; and he knew Luis Araquistain, the Spanish ambassador in France who had been so instrumental in commissioning *Guernica*, from his student days in Madrid. His other great pre-Spanish Civil War film *Las Hurdes* (*Land Without Bread*) was a lacerating social documentary that concentrated on a totally deprived and abandoned part of Spain, close to the Portuguese border, where in-breeding, malnutrition and all its associated diseases had brought an almost Stone Age culture to the point of collapse. Buñuel described it as the closest thing to hell on earth. What the landscape and local populace didn't provide in terms of *tremendismo* – exaggerated shock value – he added with his characteristic Surrealist flair. This was to be an unrelentingly pessimistic image of the 'real' Spain, the Black Spain, the Spain of superstition and often self-inflicted suffering. The Franco regime's only hope, it is safe to presume, was that Buñuel had mellowed in the intervening years.

In 1961 Buñuel was called by the beautiful Mexican film star Silvia Pinal whose ageing husband, the businessman Gustavo Alatriste, thought he might buy her into a film to keep her sweet. Seduced by this bold and honest approach, Buñuel quickly accepted. The resulting film, *Viridiana*, according to his biographer John Baxter, 'swelled with Buñuel's imagination into a raunchy and gaudily decorated fable, ripe with fetish and sacrilege'. Perhaps, it was Franco's vanity, that he as the screenwriter of *Raza* could extend his largesse to Buñuel, or, regardless of the result, that his pragmatic policy of maintaining two clearly divided worlds, inside and outside Spain, could only reflect well on a regime that had the

appearance of being more modern than it actually was. It is hard to say. But Franco should perhaps have remembered another dictator's flirtation with film, namely, Stalin's fated sponsorship of Sergei Eisenstein's *Ivan the Terrible*. There were, of course, safety nets to avoid exactly that kind of thing happening again. Buñuel's script still had to be passed to the censor before shooting could begin. The Under-Secretary of Cinema, José Muñoz-Fontan, who was probably intimidated by Buñuel's reputation, and his apparent politeness and suitably penitent air, made only a few suggestions, which included the cutting of the rape of Viridiana by a beggar. Otherwise all was well. Buñuel had gone to great lengths to get exactly the right effect by hiring an alcoholic tramp whose first contribution was to fuse the entire set by peeing on the electrics.

In six weeks the filming was finished. Although denying that he ever thought the film might cause a scandal, Buñuel took the precaution of having a copy smuggled out of Spain, hidden under the capes of a bullfighter's *cuadrilla*. Having returned to Paris, Buñuel awaited news of *Viridiana's* last-minute presentation at Cannes where it won the Palme d'Or and a secondary prize for black humour. Never having seen the film, not even at Cannes, Muñoz-Fontan walked proudly on to the stage to collect the prize for Buñuel and for Spain. Buñuel was at once shocked and delighted by Muñoz-Fontan's startling ineptitude. A film in which Buñuel had given free rein to his shoe-fetishism, and his obvious pleasure in Pinal's removal of her stockings, made for heightened eroticism when contrasted with Fernando Rey's suave, detached urbanity. The central scene was a beautifully staged burlesque of Leonardo's *Last Supper*, a veritable beggars' feast – it was perhaps not the Madrid that the regime had wanted to show the outside world. The following day the scandal broke as the Vatican took exception to the 'sacrilegious and blasphemous' content. When Muñoz-Fontan finally saw the film he realised that Buñuel had not heeded a single one of his suggestions. It was the last film he saw as Under-Secretary of Cinema. *Viridiana* was banned in Spain, and Buñuel's reputation as *agent provocateur* had never been as high.

To make the pilgrimage across the border into France to see *Viridiana*, and to own a poster-sized reproduction of *Guernica*, had become highly symbolic gestures. In the years of 'silent resistance' both were transformed into powerful cultural icons that spoke in code of their owners' rejection of the increasingly outdated values of the Franco regime. The fact that in Italy Buñuel had been sentenced to a year in prison *in absentia*, and that Belgium and Switzerland remained scandalised, only enhanced the director's kudos, and quite naturally the frisson to be enjoyed. Later, *Viridiana* and *Guernica* would be joined by other cultural artefacts: Bertolucci's *Last Tango in Paris* (1972); the iconic red and black poster of Che Guevara, a photo of Joan Baez, a copy of *Playboy* and Hugh Thomas's *History of the Spanish Civil War*, all wrapped in brown paper and accompanied by other more practical symbols of rebellion; a Beatles haircut, a miniskirt, and a packet of prophylactics – all representing freedom and openness to the outside world. Coach companies in Barcelona offered day trips to Perpignan, Biarritz and Bayonne, which included an afternoon viewing of those banned films. *Time* magazine marvelled that *Last Tango in Paris* was seen in Perpignan by 110,000 viewers, while the town's population numbered only 100,000.

Overnight the interiors of many Spanish houses changed. Franco's hold over that sacred space where the woman reigned supreme was inevitably relaxed. Off came the tin *estampas*, images of the Virgin Mary or a patron saint, tacked to the back of the front door just above the circular grille that acted as an air-vent and delivered the pungent smells of the neighbour's food. Down came the framed photographs of Franco and Primo de Rivera and the reproductions of Ignacio Zuloaga's dynamic and ever-youthful Generalissimo draped in a flag. Leonardo da Vinci's *Last Supper*, always placed above the table, was unceremoniously removed: Buñuel's revisiting the image in *Viridiana* had now changed it for good. In its place came *Guernica*, a symbol of the past that now spoke of hope in the future and the freedoms to come; a silent reminder that history was not yet entirely dead. For Juan Cruz, arts editor of *El País*, it was

'an appropriation of time lost'. Those few starved leaves, almost crushed under foot at the bottom of the painting, were, it seemed, just beginning to sprout. For many people, seeing *Guernica* in reproduction and in the privacy of a home was their first viewing of the legendary painting that had been so heavily censored and so successfully kept from the public gaze. But it was not just outside Spain – in London's Swinging Sixties or the America of Elvis and Hollywood, for instance, or within the vital culture of the Spanish exiles – that inspiration might be found. It was now available at home.

On Wednesday 6 March 1963, with just three days to go before the long-awaited opening of the Picasso Museum, Juan Cortes celebrated Picasso in *La Vanguardia* as the greatest talent of the age. It was a measure of the apparent relaxation of censorship that Cortes could celebrate the artist with such an exclamatory eulogy. The orgy of Picasso's forms, Cortes impressed, was just breathtaking. Without Picasso it was impossible to understand the twentieth century. He was the universal genius.

But Cortes and *La Vanguardia* had misread the signals. Just as the censors appeared finally to relax, the regime's capricious and spiteful nature came back into play. Years later, Mayor Porcioles denied that the minister Camilo Alonso Vega had leant heavily on the Barcelona authorities in a last-minute volte-face, preventing the use of the description Museo Picasso for Sabartés' generous gift. But evidence in *La Vanguardia* suggests otherwise, and points to the fact that the Franco regime had finally registered the effect a Picasso Museum might have. On the day of the opening of the Picasso Museum *La Vanguardia* failed to give a report or was prevented from doing so. The following day, Sunday, 10 March 1963, a mere quarter-page was given over to reporting on the previous day's opening. From Cortes's glorious eulogy of the previous week, everything now appeared to go dead. The culture page and space for the national news had been hijacked by the censors to report on other more pressing issues. The report on an unknown painter from Murcia who had left some of his work on a train was deemed

worthy of space. Work on the archive in the small Catalan town of Montblanch was reported on. So, too, was the triumphal return from Madrid of the Orfeó Català, the Catalan opera company. The rehabilitation and honouring of ninety-four-year-old Don Ramón Menéndez Pidal, the distinguished historian and Presidente de la Real Academia Española de la Lengua, previously humiliated by the Franco regime despite his celebrated and almost single-handed reconstruction of the myth of El Cid, was justly given coverage. And Don Manuel Aznar, one-time journalist and ambassador to Morocco, was also paid homage on a daily basis, often with full-page coverage. What was important for Franco and the controlling power of his regime was the cynical recognition that there was a huge difference between what could be said, seen or celebrated inside and outside of Spain. There was often no apparent logic or discernible reason as to why one book might be published while another banned. Camon Aznar's study of Picasso's Cubism could be readily bought in Spain, while Gaya Nuno's far less controversial *Bibliografía Crítica y Antológica de Picasso* could only find a publisher with the University of Puerto Rico Press. Julián Gállego's enthusiastic references to Picasso in his 1955 article 'Paris y Picasso' for the seventh edition of *Goya* were cut out, much to his disgust. In 1959 Roland Penrose's Spanish edition of his Picasso biography, to his embarrassment, was published by Edíciones Cid in Madrid with all references to Franco and the Spanish Civil War excised. Surprisingly, *Songe et Mesonge* was still illustrated. On 7 December 1959, he wrote to Picasso to apologise. Often more subtle games were played. The result of the almost Surrealist machinations and Jesuitical dealings of the regime's censor was that Picasso and his museum had once again become invisible, suffocated under a blanket of censorship. Forty years later, the art critic Lluís Permanyer still remembered with bitterness the effect of the censor on one of his earliest journalistic coups. Having travelled to Provence, Permanyer had managed to negotiate a rare interview with Picasso, which was scheduled for publication to coincide with the opening of the Picasso Museum. Having sent his piece to the censor for

overnight approval, he was left waiting for a response for more than a month, his article fortuitously lost in the censor's machine.

On 19 March 1963 *La Vanguardia* reported on the visit to Zamora of Don Manuel Fraga Iribarne, the Minister of Tourism and Propaganda, in which he pointed out the importance of tourism for Spain in terms of its economy. But equally important, observed Fraga Iribarne, was tourism's importance in promoting mutual understanding and also as a prime weapon in the battle against foreign propaganda: 'importancia para la defensa de España ante la propaganda exterior'. There appeared to be no contradiction that on the same day the Picasso Museum reappeared for the first time, in tiny print, at the bottom of the museums listings page, entitled the 'Donación Sabartés de Picasso', with no more information than just its opening times and address. *Guernica*, however, was now hanging in an increasing number of Spain's offices and homes.

9

Operación Retorno

My real, tyrannical father was Franco. My mother was killed by his bombs, my family destroyed, and he forced me to become an exile. Everything I created was a result of the Civil War.

<div align="right">Juan Goytisolo</div>

Six years prior to the opening of the Donación Sabartés de Picasso in Barcelona Picasso had set upon an extraordinary rapprochement with his Spanish heritage and his own complex past. On 17 August 1957 he had scaled the stairs to the deserted top floor of the Villa La Californie in Cannes to start painting, over a period of four months, a series of forty-five paintings and some dozen related works that reworked completely Velázquez's masterpiece, *Las Meninas*. None of Picasso's works were attempts at copies but were in essence appropriations and dissections of Velázquez's enigmatic painting. The explosion of creative energy and the focus on a single work can only be made sense of if related to Picasso's earlier struggles with the *Guernica* theme. Behind *Guernica* lay Picasso's first essays on the artist's studio theme, of which *Las Meninas* was the perfect exemplum. As Director of the Prado for the Republican government-in-exile, a post incidentally he never relinquished, Picasso was also in a sense just like Velázquez, and Goya before him, keeper of the royal collection and the nation's visual heritage. But here in the South of France in the summer of 1957, he embarked on a visual adventure that went far deeper than mere picture-making and the redoing and undoing of an earlier image. His forty-five variations, while paradoxically leaning so heavily on Velázquez as his primary source, were a bold assertion

of his own identity. 'In his variations,' writes Susan Grace Galassi, 'the creative and the historical processes meet, and Picasso makes history as he makes art.'

There is more to it than that, however. Nothing, in essence, could be more powerfully symbolic of Picasso's attachment to Spain and his powerful reassertion that the country and its soul were the very essence of his being. At seventy-five, the same age at which his father died, Picasso's deeply superstitious nature reflected back on a painting he had first seen as a teenager at his father's side. The torrent of his subsequent images, whose production left him completely wrung out and exhausted, represented nothing less than a homecoming and a taking of stock. The *Las Meninas* variations were a way of writing himself back into his own nation's history and stating unequivocally that despite his twenty-one years in exile he still stood as the beacon of the true Spanish state. Back in 1946, in a heated argument with Monsieur Cuttoli over gifting work to the Musée d'Antibes and a possible change to French citizenship, Picasso had been unequivocal and fired back angrily at what he saw as Cuttoli's impertinent suggestion: 'As for your idea about changing my nationality, I represent Spain in exile. I'm sure Françoise wouldn't approve of my changing that any more than I do. I think she understands that she and our son come after Republican Spain in my scale of values.' Guilt over his failed application for French citizenship in 1940 seemed only to add to his vehemence. He also refused to obtain a Spanish passport as it meant dealing directly with Franco's Spain, a decision which brought with it the further inconvenience of having to travel on a mere visa as a 'privileged resident', which in reality had no more status than a *carte de séjour*.

By the late 1950s, as he approached his eighties, the pattern of Picasso's daily life had become increasingly sedate, private and iso-lated, trapped as some of his older friends and his grandchildren would later conjecture by both Jacqueline and the impossible weight of his fame. It was Marina who felt most keenly the suffocating, vicarious and sometimes downright vicious treatment of her immediate family

by her own grandfather and would make public her heartrending feelings of shame and rejection in *My Grandfather* in 2001.

By focusing exclusively on her family's pain, Marina deflected attention from a gradual change that had been taking place in Picasso's personal life. Picasso, as the *Las Meninas* suite so poignantly illuminated, was once again looking towards his homeland, and like so many octogenarians he was both anxious for the future and nostalgic for the past. If Spain was his homeland, it was both *Guernica* and Franco that ensured he could never go back. In the 1950s Picasso's biographer and friend John Richardson recalled a drive to the border town of Cerbère where Picasso had strolled quietly away from the group to the end of the café terrace to stare at his homeland for ten minutes before returning to the company both angry and colder, and visibly aged.

What Picasso now looked for was to re-establish a Spanish enclave and form a miniature *mundillo español*, to create what Roberto Otero has described as 'La Última Tertulia'. Picasso's *mundillo* – his Spanish community-in-exile – echoed Goya's group of like-minded *afrancasados* – frenchified – *ilustrados* who, 130 years earlier, had settled in Bordeaux to escape from the intellectual tyranny of the Inquisition and the degenerate court of Fernando VII. Throughout his life Picasso, like his father Don José before him, who had frequented the Café de Chinitas in Malaga, had enjoyed the almost exclusively male atmosphere of the *tertulia*, a peculiarly Spanish and often bohemian meeting of like-minded people in cafés and bars. It had been the legendary Els Quatre Gats in Barcelona where Picasso had found his second home as a seventeen-year-old; in his twenties it would be the bars of Montmartre and later still the more select venues in Montparnasse. But the Second World War had changed everything. So too had the balance in Picasso's personal life: as Marie-Thérèse followed Olga; as Françoise followed Dora; and finally as Jacqueline, who would be his final wife, became the focus and guardian of his life.

Of all Picasso's wives and lovers only Dora could speak to him in Spanish, but even she was left excluded when he slipped into his

heavily accented Catalan to dredge up memories from the previous century. It is certainly true that Picasso had always encouraged and needed the presence of Spanish friends in his life, but they had almost always been kept separate from the sophisticated world of Paris's *demi-monde* so favoured by Olga: the world of Diaghilev, Etienne de Beaumont, the Viscount de Noailles and the poet Cocteau. But in that group were also South Americans like the painter Manolo Ortiz de Zárate, the poet Vicente Huidobro and the influential Chilean collector Eugenia Errázuriz who had taken over from where Gertrude Stein had left off, and had managed to pacify Olga while also keeping Picasso in touch with the surrealist gymnastics of his mother-tongue. Picasso had learnt over the years to run a double life where the intellectual universes of Spain and France were kept discreetly apart. In rue la Boëtie Olga inhabited the elegant apartment while upstairs in the studio Picasso entertained his Spanish friends: Joan Miró, Pere Pruna, a Catalan artist and opera set-designer who would later exhibit in Eugenio d'Ors's Franco Pavilion at the 1938 Venice Biennale; as well as the unlikely coupling of the sculptors Julio González and Apelles Fenosa, and many other *picasseños* (a term coined by Alejo Carpentier in 1931) like Luis Fernández, Joaquín Peinado, García Lorca's friend and collaborator Manuel Ángeles Ortiz and the Madrileño painter Francisco Bores, amongst many others. In almost everything Picasso and Olga were divided by their different and radically opposing tastes. Olga loved caviar spooned delicately on to melba toast, while Picasso adored a simple earthenware crock of chorizo and beans. On his studio door, according to his biographer John Richardson, he pinned a warning sign to any intruders from a different world: '*Je ne suis pas un gentleman*'.

It was in the late 1950s and the early 1960s, once again, in the Villa La Californie and subsequently at Notre-Dame-de-Vie, that the old worlds of Picasso's various Spanish friends came back together. There was Sabartés, naturally, but also some of the exiles from the war, like the poet Rafael Alberti who had moved back from Buenos Aires to Rome, and his childhood friend from Horta de Ebro,

Manuel Pallarès. Often present was Eugenio Arias, his hairdresser and fellow-Communist, whose Museo Picasso in the small crusader town of Buitrago de Lozoya, just north of Madrid, gives such a charming insight into their hermetic world. From Catalonia the publisher Gustavo Gili was always welcome, as were the Gaspar brothers, Joan and Miquel, and Picasso's biographer Josep Palau I Fabre. José Ortega, a painter from La Mancha, a member of the Central Committee of the Communist Party of Spain and twice imprisoned by the Franco regime, appeared frequently, disguised behind his clandestine *nom de guerre* 'Juan'. Of the younger generation welcome visitors were Picasso's beloved nephew Javier Vilato and the young avant-gardist Antoni Tàpies. Often present and ready to provide entertainment was the flamenco guitarist 'Silverhands', Manitas de Plata. Slowly the *última tertulia* took on a taurine flavour centred on the bullfighting impresario Paco Muñoz, the bullfighting Brothers Minuni and the celebrated *torero* Curro Girón.

It was not entirely by chance that in the early 1960s, in order to promote tourism, the Minister for Tourism and Propaganda, Manuel Fraga Iribarne, had coined the phrase *España es diferente*, an advertising spin that stressed Spain's exotic otherness. It was perhaps ironic that this clichéd image of Carmen and castanets so beloved of the macho Hemingway, which he would write up in *A Dangerous Summer* in 1959 and serialise in *Life* magazine, was in fact so close to the world promoted by Franco's minister and, furthermore, almost indivisible from Picasso's *tertulia* at the Villa La Californie. At the centre of this *corrida*, with its image of blood and gore used so effectively in *Guernica*, towered the two matadors Antonio Ordóñez and Luis Miguel Dominguín. The competitiveness of these two matadors, who were related by marriage, was immortalised for ever in Hemingway's *A Dangerous Summer* which transformed Pamplona and the Côte d'Azur fiestas into Hollywood occasions for the likes of Ava Gardner and Orson Welles. But at La Californie and the nearby Château de Castille, shared by the collector Douglas Cooper and John Richardson, the

tertulia could relax from the imminent danger immortalised in García Lorca's lament, '*A las cínco de la tarde*', and start to clap hands and dance flamenco. Richardson recalled a special occasion that was almost as baroque as it was burlesque. Picasso, who was visited frequently at La Californie by the dancer Antonio and his guitarist Manuel Moreno 'El Morao', one of the purest and most rigidly formal guitarists of his generation, had heard true flamenco almost from birth. At the Château de Castilla he was treated, to his obvious delight, to the uncontrolled fireworks of the Camargue master Manitas de Plata, a hilarious travesty of flamenco only made more comic by the seriousness with which 'Silverhands' practised his art. It was pure Spanish black humour. Dominguín's *cuadrilla* included a dwarf who performed the dance of the handkerchiefs with a woman three times his size; it was a cross between Velázquez and the Easter Sunday mock bullfight, Torero Bombero, in which padded dwarfs get knocked off chairs by baby fighting cows to hoots of pleasure from the howling infant throng.

But away from the hilarity and the energy of the crazy set pieces were also more tender moments that spoke just as strongly of Picasso's love for Spain. In June 1961, on the eve of his eightieth birthday, Picasso made a series of farewell drawings as an adieu to La Californie. That summer he and Jacqueline, who increasingly styled herself as a chic Iberian aristocratic beauty, moved into their new villa, Notre-Dame-de-Vie, in the hills above Cannes, near Mougins. Dominguín's wife, the Italian film star Lucia Bosé, recalled how on leaving Notre-Dame-de-Vie after every holiday Picasso would always steal an item of clothing from his godson, her baby boy Miguel. It was a talisman that he imagined would keep him forever young, but surely too it was because it held the perfume of Spain. There were more collaborations with his fellow-Andalucian, the poet Rafael Alberti, on books with such telluric power as *El Entierro del Conde de Orgaz* (*The Burial at the Count of Orgaz*) and Alberti's homage to his friend, *Los Ojos de Picasso* (*The Eyes of Picasso*), as well as his catalogue essay for

Picasso's penultimate exhibition at Clement VI's Great Chapel in Avignon's Palace of the Popes. With increasing frequency Picasso would order his chauffeur to drive him to the French–Spanish border from where he could see the Spanish side of the mountain Pic Canigou.

There was both longing and anger. 'Why', questioned Alberti in his catalogue essay 'Picasso at the Front', 'is it that Picasso now, at the very highest peak years of his life, feels the need to surround himself with Spaniards, to create a people, a rare world of age-old, Grecoish, Velázquez-like, Semitic, bitter, ferocious, ironic, tragic, funny, laughing, sobbing Spaniards, beings from the saddest and yet the bravest Spain, the finest and most surprising Spain, his Spain?' What was it that he saw as he looked at a Pic Canigou forcibly wrested from his Republican country by Franco? Alberti continued his essay on Picasso's personages. 'They are like the portrait of the history of Spain over the centuries, full of scares, blood-spattered jolts and mumps. But they certainly do not re-present the shadows, the Spain of mourning, cobwebs and slow torture. They are, on the contrary, protest, anger, fury, subversion, the spearhead of freedom.'

For fellow-artists in exile, not immediately threatened by the Franco censorship machine, it was easy to understand how *Guernica* could prove such a powerful source of inspiration. The painting represented and symbolised, and often directly inspired, the culture of exile. For those Spanish artists in Paris unable to return home, *Guernica* had become a powerful talisman. Julio González, who had formed an almost symbiotic relationship with Picasso in the 1930s, would continue to draw direct inspiration from the painting. And immediately after the Civil War and well into the late 1940s it was Luis Fernández and the violent Oscar Dominguez – sometimes better remembered for putting out the eye of his fellow-painter Victor Brauner in a drunken brawl and falling out of favour with Picasso for faking his work – who would create a whole family of austere Cubist still lifes, predominantly in *grisaille*, depicting bulls, skulls and revolvers. Maintaining the aridity and the dried-out lifelessness

of the *vanitas* tradition, Fernández and Dominguez responded to that quality in *Guernica* that Francisco Calvo Serraller likens to the French still-life genre. Along with the Italian Communist Renato Guttuso, whose series *The Triumph of War* came so close to pastiche, Fernández and Dominguez created what might be almost described as a *Guernica* school.

If *Guernica* had been an overt call to protest and revolution, by necessity it was quietly and silently finding a foot across the border in Spain as it entered people's psyche through the power of reproduction. Just as Picasso had discovered the source for *Guernica*'s graphic power in the newsreel and newspaper print, so too the original image came back to its Spanish audience with the immediacy and clarity of reproduction.

The avant-garde that had remained in Spain during the 1940s and early 1950s achieved little success at home and remained almost invisible abroad. This was still the moment of maximum glory for Franco's court painters, Ignacio Zuloaga and Carlos Sáenz de Tejada. At times it seemed almost impossible for artists not in tune with the regime to overcome the terrible past of the Civil War and the long-term effects of the dispersal of fellow-artists into exile. The backbone of the pre-Civil War art world had been broken, and the critical mass of avant-garde artists able to exercise creative choice had been dramatically depleted. Slowly, however, there were signs of recovery and the growth of an authentic group of artists whose work, though often carefully constructed to bypass the censor, was genuine, honest and ambitious, carefully balancing artistic integrity against the weight of the state.

In the late 1940s the Escuela de Vallecas, a group of landscape painters based around Benjamin Palencia, slowly pushed forward a realism that took account of the world as it stood: a world of *chabolas* – shanty towns, poverty and failing crops. They were soon joined by other artist collectives, the Salones de los Once and the Escuela de Altamira, the latter numbering amongst its members Ángel Ferrant and, more unusually, on an itinerant basis, the celebrated Joan Miró. On escaping from the Nazis, Miró had made

the potentially fatal miscalculation of fleeing to Normandy where he was caught between two fronts. He decided rather recklessly to return quickly to Spain where he lived an undercover existence in Palma de Mallorca until 1942. As an ex-exhibitor in the Republican Pavilion at the Paris Expo in 1937 it was a high-risk strategy, but after a few years in Barcelona he returned safely to Paris in 1947. Perhaps his predominantly organic abstract style with all its whimsy and Surrealist energy proved too obscure for the Franco censors to divine anything revolutionary hidden in the work. Miró, despite everything, had proved that it was still possible in barbaric times to hold on to a vestige of culture. It was a valuable lesson and one appreciated in Spain.

By the mid-1950s, despite the Francoist repression and censorship, the artists from the Escuelas de Vallecas, Altamira and the Salones de los Once had opened up enough possibilities to allow certain other artists to reach their 'maturity'. In a modest and a necessarily discreet way they had maintained the link with all that had gone before. Almost exclusively, the young artists of the next generation employed a palette of poverty. But their economic use of colour, nearly always reduced to a dramatic play between black and white, never lost its expressive potential. Abstract shapes formed themselves readily on the canvases of Antonio Saura, Rafael Canogar, Luis Feito and Manuel Millares, a group of artists who came together in 1957 in Madrid as the key members of the El Paso group. Charred blocks of wood bandaged in canvas were mounted with deliberate clumsiness on stitched and torn canvas. Gobbets of black paint soaked slowly into the canvas until the surface could absorb no more. Frames were broken and twisted, suffocated under wrappings of material, set fire to, and reworked heavily. On the face of it, the calculated aggression that shocked the viewer before it seduced was reminiscent of almost nothing that had gone before in the history of Spanish art. This new brutalism and honesty to material was the hallmark style of Manuel Millares and Lucio Muñoz. Initially this new expressive explosion leant heavily on the black and white reproductions of the pioneering

Antonio Saura, *El Gran Muchedumbre*, 1963.

American works of Pollock, Clyfford Still and Robert Motherwell
in international art magazines. It was Saura, in particular, who
reached out to meet halfway the American artists who had 'felt'
Guernica most deeply, and some of his finest works were reinter-
pretations and reappropriations of the works most profoundly
inspired by Picasso's masterpiece. With his great Hispano-Amer-
icano work, *La Gran Muchedumbre* of 1963, which today hangs
two floors above *Guernica* in Madrid's Centro de Arte Reina Sofia,
Saura successfully reappropriated the ambitious scale and language
of *Guernica*. In essence, his ambitious masterpiece reworked in a
Spanish vein Pollock's landmark mural for Peggy Guggenheim – a
work which we have already seen drew its chaotic, almost apoc-
alyptic energy from Picasso's previous example. By coming at it
secondhand, Saura was instrumental in bringing the spirit of
Guernica home, heavily disguised but refreshed for a new post-
war audience.

It was one of the quirks of Franco's censorship that it permitted,
and even went to great lengths actively to promote, the new Spanish
abstract style. Internationally renowned artists like Antoni Tàpies
and Modesto Cuixart who had founded in 1948 the Barcelona-
based Dau al Set group, and abstract sculptors like the Basque
Eduardo Chillida, without necessarily being compromised, won
increasing support from critics and philosophers allied to the

Falange and Franco's ministers, who felt that the seemingly innoc-
uous content of abstract art could never harbour dissent. The
highpoint of this apparent tolerance came at the 1957 São Paulo
Biennial and the nineteenth Venice Biennale when Spanish artists
living under the dictatorship exploded on to the international art
scene. This time Franco's pragmatic policy of 'openness' failed to
backfire on him, as it would a few years later with Buñuel, and at the
end of the 1960s, most notably with *Guernica* itself. By allowing a
pictorial expression however violent and wild, these artists had
helped to create an illusion of a regime that was relaxing its hold
faster than was actually the case; a regime that permitted indivi-
duality and celebrated self-expression.

For an audience ignorant of Spain's long tradition of counter-
classicism there was no suggestion that the abstract language these
artists employed disguised anything vaguely critical of the Franco
regime. On first viewing, the impassive mask of abstraction gave
almost nothing away. But deep under the surface, embedded in
the choice of materials, the violent expression, the slashings and
burning, lay camouflaged a rebellion that was not immediately
recognised or understood.

In their choice of humble materials, and the radical reduction to
an almost exclusive reliance on black and white, there appeared a
general consensus of style and taste; what the critics Tomas
Llorens and Francisco Calvo Serraller have described as an '*aire
de familia*'. Translated loosely as 'a family of values', or just 'a
feel', this could be described as a love of materiality, a gift for the
gestural, an employment of the full range of *grisaille*, and a violent
expressionism. The Spanish word most often used in connection
with this work is *áspera*, which in this instance has connotations of
'bitter', 'brittle', 'dried-out' and 'burnt'. But from behind the bold
gesture, the sweeping black forms and the tortured and strangled
material appear the ghosts and memories of another family,
namely the extended Spanish family of artists that throughout
history had found their identity in rejecting the canons of classical
art.

A twisted body of black swirls, trawled almost haphazardly over a blank canvas by Antonio Saura, seems to say so little at first. Precariously anchored to the top borders of the canvas there is an elastic stretched-out ball of gestures, that appears slowly to collapse and deflate under the force of nothing more than gravity. As a picture it looks defeated, with all its energy spilled. But it sets the alarm bells ringing. Crucifixions had been seen before; in fact Picasso loved them precisely because there were so many millions of them about. But in this case it was Velázquez's *Crucified Christ*, with its lean tonality and spotlight focus on the main event, that lay somewhere behind Saura's image. So too did the exaggerated distortions of El Greco. Perhaps the existentialist despair of Goya's strange portrait of a dog trapped up to its neck in a swamp while barking at the moon also found echo in Saura's troubled space. The introduction of Goya immediately throws up other images: the anti-clerical *Caprichos*, etched in acid; his *Cain and Abel, Saturn Devouring his Child*, the *Disasters of War*, and last but not least, the twin paintings, the *Second* and *Third of May*, hung up for the first time on a triumphal arch at the entrance to Madrid as a bold piece of propaganda to welcome home the exiled King Ferdinand VII at the end of the Peninsular War. All these images had also sat behind *Guernica* and it was, of course, to that painting that all these artists of the late 1950's looked and acknowledged when choosing a palette that was so pared down and so heavily reliant on black: the black of Spain, the black of the Hapsburgs, the black of despair, the black of the coffin and the black of St John of the Cross's 'Dark nights of the soul'.

Under Franco, life had become increasingly confused and complex. Despite the strict censorship policy and the rule of fear that suffocated creativity, and despite the displacement of talented exiles, a distinct and often critical culture continued to exist. Even in literature, which could never rely on the subterfuge of an abstract style, this was also the case. Works like Camilo José Cela's *La Familia Pascual Duarte* (1942) and Carmen Laforet's *Nada* (1944) could hardly be accused of underpinning the image of the ideal

family so actively promoted by Franco and the Movimiento. These are not pictures of the cosy, obedient world of the nurturing mother and the God-fearing patriarch. Here instead there is murder, prostitution, black-marketeering and petty crime. It is a bleak existential moral vacuum.

After the Spanish Civil War no space remained for moral clarity and the luxury of absolutes. Culture was as complex as the society it portrayed. Forgiveness was often impossible but, despite that, there had to be an uncomfortable *convivencia*, a cohabitation, which had been a central trait of Spanish life dating right back to the Moorish invasion of 711. Culture would have to be made by Civil War combatants like Dionisio Ridruejo, an early Franco supporter who would later bravely recant, and Berlanga the film-maker. The critic Eugenio d'Ors and the writers Camilo José Cela and Torrente Ballester, who had all been compromised by association with the right, continued to produce powerful work.

In film the Spanish cinema industry was finding a way through the impasse. *Viridiana* proved a watershed in more ways than one. In 1962 José María García Escudero was appointed Director-General of Cinematography for the second time. Having been ignominiously sacked in the 1950s for his support of José Antonio Nieves Conde's neo-realist film *Surcos*, awarding it status of 'National Interest', despite the Catholic Church qualifying it as 'extremely dangerous', Escudero was now given a second chance. In some ways *Viridiana*'s background of beggars, with its rape scene of Silvia Pinal, was merely a Surrealist reworking of the urban despair and rural desolation of the 'hunger years' portrayed in *Surcos* and other films in the same genre. The *'affaire Viridiana'* and Escudero's second term in office coincided, not by chance, with the birth of the Nuevo Cine Español.

The first Spanish film to make a recognised break with the past was directed by Antonio Saura's brother Carlos Saura. *La Caza* (1965) won the Golden Bear at the Berlin Film Festival that year. In the words of the historian of Spanish film, John Hopewell, 'Post-Franco cinema started while the dictator was still alive.' There was a

certain synchronicity with *La Caza* and Spain's petition to enter the European Community. It also coincided with the birth of the new novel (which, north of the border in France became the *nouveau roman*) and the publication of Luis Martín's linguistically baroque *Tiempo de Silencio*. A similar rebirth, or perhaps rebellion is a better word, also occurred in the world of popular music. The sentimental *coplas* of the 1950s that were mostly nostalgic for a world that there was little to be nostalgic about were replaced by the more intelligent *canción protesta*; singer-songwriters whose views of Franco's politics were diametrically opposed. Amongst these were to be found Joan Manuel Serrat, Lluís Llach, Paco Ibáñez, Raimón, Amancio Prada, María del Mar Bonet, Patxi Andión, Victor Manuel, Mari Trini and the gorgeous Ana Belén, some of whom had been members of the legendary Setze Jutges collective. Many were Catalan and Basque, which added a further nationalist flavour to much of their work, not least because the mere act of singing in their own tongue was regarded by many as a provocation in itself.

During the early 1960s came a growing sense of liberation and freedom. And with the growth in tourism came an opening up to new ideas. The 1966 press laws introduced by Fraga Iribarne offered an illusory relaxation. Any self-respecting journalist intent on policing the erosion of freedoms, the endemic corruption, political scandals, incompetent business practice and administrative failings, was now saved the humiliation of having to pass everything through the censor before publication. The onus was put on the journalists to censor themselves. However, if they published sensitive material, or a critique of the regime, they would automatically be prosecuted. According to Miguel Delibes, writing in *Tele/Expres* on 28 February 1968, the new laws were mere window-dressing:

> Recently the students at Valladolid and Bilbao, who know my work as a journalist, asked me about the effects on journalists of the recent Press Law. In both cases, I replied: 'The press, whose job it is to mediate between the rulers and the ruled, is still unable to do so in Spain. The press is still unable to facilitate a proper dialogue. Before

the new Press law journalists were not allowed to ask questions; after the law, we are allowed to ask the questions, that's true, but they don't answer . . . liberty, in this case, shows signs of progressing, but like the crab, backwards.

Franco's machines of state were still firmly in place. Despite the increasingly bitter struggles between the Opus Dei and the Falange, attention continued to be focused on capturing and reintegrating exiles as a valuable publicity stunt. Buñuel's attempted rehabilitation was just one of a few failed seductions. The philosopher José Ortega y Gasset had returned to Spain in 1945, chastened but never compromised and refusing to accept his salary as a professor, only to leave again for Munich in 1953. For every Picasso and *Guernica* who had survived in exile there were a thousand more names: the poets Salinas, Cernuda and María Zambrano; Juan Larrea, poet and critic, who lived in Argentina most of his life and would only return to Madrid in 1977 after forty years of exile to present his polished study *Guernica*; Max Aub, so close to Picasso during the painting of *Guernica* and its installation in the Republican Pavilion; Rafael Alberti, exiled in Argentina and Rome, whose 1956 play *Noche de Guerrra en el Museo del Prado* (*Night of War in the Prado Museum*) so accurately portrayed the tragedy and loss of innocence of a whole generation; Severo Ochoa, assistant professor to Juan Negrín, sometime lover of the Hollywood star Sara Montiel, biochemist and winner in 1959 of the Nobel Prize for Physiology or Medicine; Juan Ramón Jimenez, poet, Republican, author of *Platero y Yo* and Nobel prize-winner, who would only return to Spain in June 1958 in a coffin, to be buried alongside his wife Zenobia in the Cementario de Jesús at his birthplace, Moguer, in the province of Huelva; Vicente Aleixandre, Nobel prize-winner for Literature in 1977, who remained living in 'interior exile' under Franco although his house had been destroyed and his books banned; Esteban Vícente, Spain's only Abstract Expressionist who, promoted by Elvira González, would only return in glory in the 1990s; historians of the calibre of América Castro and Claudio Sanchez Albornoz who fought

for their versions of Spanish history from the safety of their chairs in the Ivy League; Ramón Sender, whose *Requiem por un campesino español* was written from the distance of the United States – these and many more were observed or followed. And often there would be hints from officials or mutual 'friends' that all was forgiven if they would only come home. It was a tempting offer: of those who remained in exile, Pedro Garfias, Guillermo de Torre, Ferrater Mora, Paulino Masip and Luis de Oteyza lost their reputations and sank into oblivion, only to be rediscovered decades after their death. As Carlos Fuentes wrote of Swift and Joyce, they were 'exiles condemned to live with the language of their oppressors', and then, broken by indifference, they became dispersed around the globe.

In strong contrast, Picasso was now unrivalled as the world's greatest-living artist superstar. It is impossible to imagine that the Franco regime, considering the success it had had with Salvador Dalí, had not considered the possibility of seducing him home. Feelers had been put out to many eminent exiles who, like their fellow *Gastarbeiter* living abroad, shared the same complicated relationship with their homeland, suffering from *morriña* – home- sickness – while enjoying the freedoms of their host country. It is almost certain that Franco received information on Picasso's day-to- day life from visitors to Vauvenargues, Notre-Dame-de-Vie or La Californie, and also that the FBI shared many of its findings with his regime. Lucía Bosé remembered quite clearly that it was her husband Luis Miguel Dominguin who had personally begged Franco on a hunting party to allow Picasso to return to Malaga and to name a plaza after him. According to Bosé, Franco said he would welcome the artist whenever he wanted, but Dominguin replied perhaps rather rashly, 'Yes, but then you'll never let him leave.'

By the late 1960s both Franco and Picasso were growing tired and old. Picasso was still capable of bouts of energy, especially extra- ordinary for a man deep into his eighties, but each year announced the death of yet another friend: in 1966 André Breton; in 1968 Sabartés; in 1970 Christian and Yvonne Zervos. Franco was now suffering from Parkinson's disease and showed less and less interest

in affairs of state. Increasingly he would spend hours morosely watching TV. By 1969 there was much discussion amongst Franco's ministers of a transferral of powers. It was the beginning of what Paul Preston has described as 'The Long Goodbye'.

For Picasso, however, the long goodbye had started two years earlier. On 20 January 1967 in the streets of Barcelona, homage was paid to him by hundreds of Catalan intellectuals and students, many of whom had employed the visual shorthand of a *Guernica* print. But more important matters of state had finally, after years of painful negotiation and indecision, drawn to another conclusion of sorts. Franco's most loyal supporter, Admiral Luis Carrero Blanco, had taken over the everyday running of government and become President in everything but name. And on 12 July 1969 Franco finally pronounced Juan Carlos as his successor.

If there appeared to be a certain sense of resolution and order it was quickly shattered by the making public of the Matesa scandal. In August Franco, who was resting as usual at his Galician estate, the Pazo de Meirás, received news of the imminent collapse of the Navarrese textile machinery plant Matesa – the Maquinaria Textil del Norte de España Sociedad Anónima. Its director, Juan Vilá Reyes, a slick businessman whose persuasive powers over Franco were considerably stronger than his order sheet was long, had managed – by milking government subsidies to Latin American countries who had allegedly put in orders for his shuttleless loom – momentarily to plug the gap between reality and desperate hope. Vilá Reyes's fragile edifice, despite his close relationship with Opus Dei technocrats who had earned Franco's absolute trust, had come tumbling down. But what was arguably more significant was that the whole sad structure, built entirely on greed, had become the theatre on which the Opus Dei technocrats and the Falange were to fight over the succession and their respective futures in post-Franco Spain. José Solís Ruiz as Ministro-Secretario del Movimiento (the Falange machinery of power) and Manuel Fraga at the Ministry of Information lined up the Falange power-base to discredit the Opus Dei who they felt had led Spain's finances to the border of

catastrophe. Carrero Blanco, less impressed with Solís and Fraga, denounced them to Franco for their 'scandalous politicisation'. Somewhere, and it is impossible to say exactly where and how, the story of *Guernica*'s return to Spain was dragged in.

In late 1968 the Director of Fine Arts, Florentino Pérez Embid, had managed to persuade Luis Carrero Blanco that to bolster the image of the newly planned Museum of Contemporary Art, in the bombed-out zone of Madrid's Cuidad Universitaria, it was imperative that Picasso should be well represented. The star painting would be *Guernica*. On 6 December 1968 Pérez Embid received a letter from Carrero Blanco stating that his consultations with El Caudillo had been positive, and stressing the matter-of-fact legal procedures that now needed sorting out. 'We will have to obtain information about the actual condition of this painting, and once this documentation has been completed and it becomes clear that the Spanish State holds title, your ministry should forward this documentation to the Foreign Ministry, so they can take proper action through diplomatic sources.' Whether the seasoned politicos were merely stringing along an overkeen art professional is difficult to say. But at a press luncheon in Paris in October 1969, insisting on the gravity of his plea and his official support, Pérez Embid announced that 'General Franco deems Madrid to be the place for *Guernica*, Picasso's masterpiece.' In private Franco had been far less generous, dismissing Picasso's scribblings as an embarrassment, but the public façade was a fine piece of *galleguismo* – a term that describes the surrealist twist of the Galician mind. But later in the ultra-right-wing journal *El Alcázar* portions of Embid's speech were reproduced alongside an image of *Guernica* the painting. '*Guernica* (given by Picasso to the Spanish people) is part of the cultural patrimony of this people and should be on exhibition in Spain as proof of the definitive end of the contrasts and differences aroused by the last civil conflict.' It was deeply ironic that *Guernica*'s first official reproduction should be in *El Alcázar*, but it was just as puzzling to figure out what the regime actually wanted to do. Was this just another chapter in the psychological warfare that had been played

out on the eminent band of exiles? If Franco had been serious, why had early secret negotiations with Picasso not been embarked upon? Or was this perhaps an attempt by either Opus or the Falange to appear as the leading *aperturistas* – men of the future, open to any change. If Picasso was prepared to capitulate to Franco's request, might the painting hang in the Prado one day? Or might it die under a cack-handed restorer's knife or moulder away in some dark basement in a national museum that would never open its doors?

The puzzling episode (it is still impossible to discover whether it was just for foreign consumption) nevertheless gave rise to one of the

Equipo Cronica, *La Visita*, 1969.

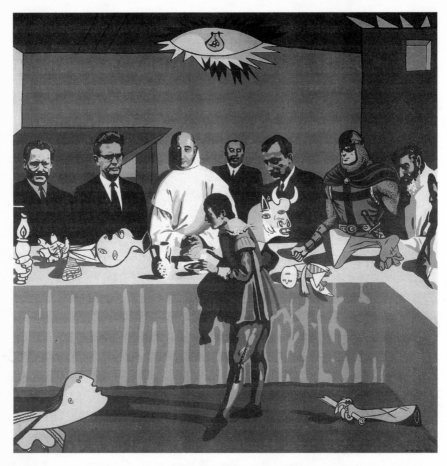

Equipo Cronica, *El Banquete*, 1969.

most extraordinary responses to a single work of art ever produced. In December 1969 in the Galería Grises in Bilbao, the capital of the Basque province of Vizcaya, Equipo Cronica, an art collective based in Valencia, displayed their series entitled *Guernica*. The team captains of Equipo Cronica, Rafael Solbes and Manuel Valdés, inspired by both the American and British Pop Art scene, brought to their painting a frightening edge that recalls the late Manuel Vazquez Montalban's wry observation that 'we lived better *against* Franco than we did after him'. Of the *Guernica* series only *La Visita* has come forward into the spotlight of international fame. Their life's work had focussed on a complete re-reading of the classics of

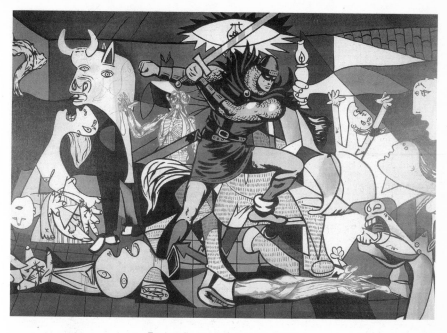

Equipo Cronica, *El Intruso*, 1969.

Spanish art, and the *Guernica* trio of images worked as a devastatingly effective critique of the Franco regime. There is *El Banquete*, a reworking of Zurbarán's Carthusian masterpiece *St Hugo in the Refectory*, where a comic-book caped crusader beats anxiously on the table to get his just deserts. This time round the monks aren't serving bread and wine but instead the meat of *Guernica*, Picasso's severed head, a clumsy foot and the rag-doll child. There is *El Intruso*, where the same high-toned crusader strikes out to cut away at Picasso's original work. But the most disturbing of all is *La Visita* where Picasso's *Guernica* hangs in a sterile gallery reminiscent of the Prado. In the distance the skylight opens out on to a cartoon version of a loose-clouded sunny Madrid day. Below, through the imperial-sized doorway, appear the grey men, the ambassadors, the army, the navy, the powers and the institutions, while on the right-hand side *Guernica*'s protagonists leap off the canvas in a desperate attempt to flee.

Guernica would continue to haunt Equipo Cronica's work for years, with snatched details creeping into their images or sometimes

even decorating the frame. But the most terrifyingly shocking of Equipo Cronica's *Guernica*-inspired series was produced the following year, 1970, after the Bilbao show had been finally taken down. *Juegos Peligrosos (Dangerous Games)* returns to the world of Velázquez and depicts the Infante Don Carlos, Philip IV's brother, dressed in traditional seventeenth-century costume, posed arrogantly against a grey marble backdrop. He shares none of the intelligence, refinement or diplomatic skills of his elder brother, but just personifies utter disdain. The viewer's eye registers details like the starched *golilla* collar, the cynical stare, the lantern jaw of the Hapsburgs, and the heavy gold chain. But in his hands, instead of holding the limp glove and soft felt hat of Velázquez's original, the *hidalgo* grips an open cut throat, dripping with blood, and a severed *Guernica* head – Picasso's self-portrait. It is disturbing, almost vicariously sadistic, recalling other earlier works by the Equipo Cronica such as *La Antesala* (The Waiting Room) where an impassive El Greco *caballero* sits behind a modern formica desk clutching a brushed-steel knuckle-duster, threatening anyone who has something or even nothing to say.

The Homecoming

There must be greatness in a painting that so effectively subsumes the past in the service of the future.

Joseph Mascheck

We meet not to weep like the daughters of Jerusalem over our long exile, nor to stir the ashes of fratricidal hatreds, nor to raise like a flag of battle the shroud of our dead.

Dolores Ibárruri, 'La Pasionaria' (June 1971)

Pérez Embid, monarchist, conservative and, in the opinion of the historian Javier Tusell, 'a brilliant administrator', had been highly diplomatic in the phrasing of his appeal to Franco through Admiral Carrero Blanco for the return of *Guernica*. Sticking initially to the relatively safe field of art history, he explained that Picasso was now regarded as the greatest painter since Goya. This was indisputable. Continuing his discourse, Pérez Embid tackled the rather thornier subject of Picasso's politics. Making excuses on the artist's behalf, Pérez Embid echoed Alfred Barr and much of the American press when he dismissed Picasso's political beliefs as 'childish' and as an unnecessary diversion hardly worth taking seriously. 'As is often the case with artists,' he warned, 'they adopt eccentric political views at times, which are neither coherent nor sustainable over time.' Judging his audience well, Pérez Embid went on to play down *Guernica*'s political importance, stating that 'the anti-Spanish propaganda of the Civil War years had exaggerated the significance of the painting, which has inflated our measure of its true political weight.' Having received an affirmative response from Franco, Pérez Embid delegated

the next stage to Joaquín de la Puente, the Assistant Director of the Museo de Arte Contemporáneo. Once again the *torero* Dominguín was used as a go-between to broker *Guernica*'s possible move to Madrid. The Director General of Fine Arts was thinking of honouring Picasso with the Gold Medal. The Prado would house the painting until the new contemporary art museum was ready. Homages were being rumoured in the press. *El Alcázar* had been positive. But there was a clear case of cultural schizophrenia. The Catalan artist Josep Guinovart responded to Franco's appeal for *Guernica* with a biting critique of the regime's cynical attempt to hijack the Civil War's most powerful icon. In his mixed-media work entitled *Operación Retorno* of 1970, all the protagonists in *Guernica* come tumbling down like dislodged pieces from an up-ended puzzle board. Only the bull finds its feet as it stands on the horizon like the ubiquitous advertising hoarding for the brandy house Osborne (its stark wooden silhouette still punctuates Spain's motorways today), a clichéd reminder of the enduring values of the 'real Spain'.

It had, it must be remembered, only been a few years since the Basque writer Xabier Gereño had been jailed for committing the crime of receiving a postcard commemorating *Guernica*. In some sections of society nothing had changed. From behind the disguise of reason right-wing journals still spat out their bile. It was a guarded warning that the return to Madrid of *Guernica*, or for that matter of any of Picasso's works, might prove inflammatory.

> To imagine that this painting can come to Spain is an insult to patriotism. Although it is increasingly unfashionable, it is deep in our hearts, and this act shows a total lack of respect to those who died in order that the nation could continue ... without *Guernica*, and without Picasso, we have lived quietly and we aren't homesick for either of them.

Perhaps Sabartés was right when he had told a diplomat in Paris that it was unwise to push Picasso on *Guernica*. 'Don't do anything,' he had warned. 'I know him and it would just be counter-productive.'

In order to scotch the growing rumours surrounding *Guernica*'s possible repatriation, Picasso responded to Franco's impertinent request via his Paris-based lawyer Roland Dumas. Picasso had come to trust Dumas: the lawyer had warned him back in 1964 that he would fail completely in preventing the publication of Françoise Gilot's revealing memoir, *Life with Picasso*; a decision that caused a permanent rift between Picasso and his illegitimate children, Claude and Paloma. Maître de Sariac, Picasso's erstwhile lawyer, was quickly replaced by the ambitious younger man. On 14 November 1970 Picasso and Dumas released a succinct statement of *Guernica*'s position with relation to the Spanish state:

> You have agreed to return the painting, the studies, and the drawings to the qualified representatives of the Spanish government when public liberties are re-established in Spain. You understand that my wish has always been to see this work and its accompanying pieces return to the Spanish people.
>
> To take into account your intention, as well as my wish, I ask you to consider carefully my instructions on this subject. The request concerning the return of the painting can be formulated by the Spanish authorities. But it is the duty of the museum to relinquish *Guernica* and the studies and drawings that accompany it. The sole condition imposed by me on the return concerns the advice of an attorney. The museum must therefore, prior to any initiative, request the advice of Maître Roland Dumas ... and the museum must comply with the advice he gives.

Alert to the possibility that their wishes might be misunderstood, Picasso and Dumas added a rider on 4 April 1971 stating: 'I confirm anew that since 1939 I have entrusted *Guernica* and the studies that accompany it to the Museum of Modern Art in New York for safekeeping and that they are intended for the government of the Spanish Republic.' If greater clarity was intended by the later addition it had quite the opposite effect, acting instead to cloud the issue when formal discussions between Dumas, MOMA, the

Picasso heirs and the Spanish state finally took place. What was abundantly clear was that Roland Dumas was being given the last say as to when *Guernica* might travel to Spain. For some it rankled that the man described in the French press as the 'prince of intrigue' was deemed fit to pass judgement on the health of the Spanish body politic. Dumas' subsequent rise to President of the Constitutional Court and his appointment as France's Foreign Minister under President Mitterand was spectacular. His less edifying moments, captured for posterity in his mistress Catherine Deverie-Joncours' kiss-and-tell exposé, *The Whore of the Republic*, have proved equally entertaining. In 2001 Dumas was sentenced to six months in prison for his part in the oil giant Elf Aquitaine scandal in which he was dragged in alongside other notable protagonists, Françoise Sagan, author of *Bonjour Tristesse*, and 'Dédé the Sardine'. Dumas, it appeared, was also in control of the Matisse estate – another important chunk of France's patrimony – and the sculptor Alberto Giacometti's estate. Sections of the French press were outraged in January 2003 when Dumas was finally acquitted for his role in the Elf Aquitaine affair, with his honour completely restored. There is a certain irony that Dumas argued the case for his innocence using a language reminiscent of Picasso's *grisaille* masterpiece: 'I'm being made a scapegoat. It's easier to crush me than to investigate the role of France itself, which benefited enormously from this subtle game of shadows and light.' What Spanish negotiators would soon be forced to recognise was that Dumas was a complex and skilled performer.

As Picasso's ninetieth birthday on 25 October 1971 drew close, plans for a celebration in Spain were of necessity subdued. There would be no official government recognition. No retrospective, no gold medal, no invitation to visit his home town, Malaga. No homecoming to Barcelona, and no invitation to view the Prado's pictures for the very last time. In contrast, in *El Noticiero* on 19 October Enrique Badosa highlighted the celebration in London of Picasso's ninetieth birthday with the revival of his 1949 play *Quatro*

Muchachas (*Four Girls*), organised by the theatre director Marowitz
and Roland Penrose. Less than gracious, Badosa suggested that
Picasso who, in his own opinion was one of art's great kleptoma-
niacs, had leant rather heavily for his dramatic inspiration on the
work of J. V. Foix. In France there were no such reservations. Under
the banner of 'Picasso, Our Contemporary' every museum in France
with a Picasso in its collection would open its doors to the French
public so that all might appreciate the work of this universal genius,
for free for ten days. In another tribute, to be opened personally by
President Pompidou, the Louvre's Grand Gallery was lined with
eight of Picasso's finest works in the 'Tribune' area, where the *Mona
Lisa* had previously hung. It was the first time that a living artist had
been honoured in such a way.

Shying away from all the distractions, Picasso stayed at home in
Mougins with Jacqueline, she content as always to be by the side of
the man whom she introduced proudly to visitors as '*le roi
d'Espagne*'.

In Spain, there were numerous newspaper articles congratulating
the Iberian genius's achievements, but the most touching gestures
were of a private nature and on a human scale. In Barcelona, on the
eve of Picasso's birthday, Andreu, the owner of the restaurant El
Canario de la Garriga, had set out a table with roses, bread and a full
jug of the house red wine. At the end of the table he had placed a
framed reproduction of the early portrait of Picasso by Ramón
Casas, whose graphic directness evoked perfectly the energy and
idealism of the bohemian days of Pablo's youth. It was here, at El
Canario de la Garriga, one of Picasso's favourite watering-holes,
that he had shared a table, *en tertulia*, with an extraordinary galaxy
of writers, painters and musicians, from Pio Baroja, Vallé Inclan,
García Lorca, Isidre Nonell, Casas and the irreverent Santiago
Rusiñol, through to the world-famous cellist Pablo Casals. As
was his custom, he ordered his favourite dish, *butifarra amb
mongetes*, an explosive marriage of haricot beans steeped and
sweated in garlic with rustic Catalan sausage. With a dish-cloth
draped over his arm, Andreu waited symbolically for Picasso to

cross the French–Spanish border and take up the seat he had vacated a lifetime ago. Under the Picasso relief on the façade of the Colegio de Arquitectos flowers had been placed but were almost immediately swept up and thrown away. In homes across Spain, but particularly in Catalonia and the Basque country, glasses were raised to the *Guernica* reproduction in the dining room, saluting the universal genius of Picasso and his unwavering rejection of the Franco regime. In secret meetings of the Spanish Communist Party messages of congratulations to Comrade Picasso were shared, hoping that, with Franco's failing health, time would not steal from Picasso his ultimate prize, a glorious return to a Republican Spain.

In Madrid other celebrations were planned. One of the most carefully thought-out homages to Picasso had been organised by the dynamic avant-garde art dealer Elvira Gonzales, at Galería Theo in the smart Santa Bárbara district, tucked away behind the neo-classical royal church of Las Salesas. On commission from the Knoedler Gallery, she had chosen to display for the first time to the Madrid public a full set of the legendary *Vollard Suite*. As a series it celebrated the erotic charge of Picasso's *amour fou* with Marie-Thérèse, while exploring many of the themes that would later be exorcised in *Minotauromachy*, *Songe et Mensonge* and *Guernica*. Depicting scenes that range from rape to tender reconciliation, the *Vollard Suite* is a master class in the art of printing – a celebration of an artist at the height of his creative powers, threatened only by the gradual realisation that he may never reach such heights again. The extraordinary suite reaches its climax in the deeply moving aquatint *Blind Minotaur Guided by a Little Girl in the Night*, a heartrending meditation on the fear of impotence, ageing and death.

On 5 November 1971 at five in the afternoon, with the siesta hour just over, the Galería Theo reopened its doors to a group of eight men who had phoned earlier to announce their visit. Storming in, the gang systematically set about smashing up the *Vollard Suite* exhibit; shattering the frames and glass, tearing the pictures and pouring acid over the prints. '*Soy beata de Picasso*' – 'I am a Picasso disciple,' Elvira Gonzáles pronounced in a recent interview, with

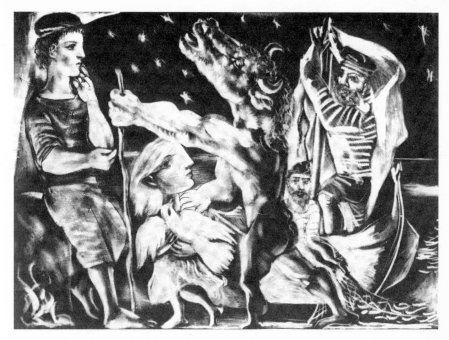

Blind Minotaur Guided by a Little Girl in the Night, Paris, November 1934.

only the slightest hint of ironic resignation. It is an episode in her life that only now seems fully absorbed. 'For days afterwards when taking my daughters to school I was frightened,' she recalled. Conscious of the fact that her only concrete evidence were the vandalised prints themselves, she had the presence of mind to photograph all of them – bar one which had been stolen – in case of legal action and an inevitable insurance claim. On the floor the group had left their calling card – the Guerrilleros del Cristo Rey (Warriors of Christ the King), an ultra-right-wing terrorist group. They shared an extraordinary cocktail of grievances that accurately reflected the explosive potential of the fragile status quo held on to so desperately by Carrero Blanco. From the Matesa scandal on, where he had worked hard to discredit the reformer Manuel Fraga as a sponsor of growing permissiveness and pornography, it had become increasingly obvious that the Franco regime was crumbling through inertia, a lack of ideas and a loss of control. Rebellion from both the right and the left was more radicalised and vocal. But the

most unexpected source of discontent came from the growing liberalisation and opposition to the Franco regime led by Pope Paul VI and the Catholic Church. The Church had begun to make serious efforts to listen and respond to the needs of its parishioners. By trying to befriend the trade unions, with their aspirations for regional equality and political freedom, the Church had set itself on a direct collision course with the Franco regime. In fact, it was increasingly apparent that in the eyes of the regime some of the pioneering churchmen were so radical that it was deemed necessary in the summer of 1968 to set up a prison in Zamora for the clergy where, to the embarrassment of both Church and state, no fewer than fifty priests were incarcerated. It was against this backdrop that Blas Piñar, the leader of the ultra-right *Fuerza Nueva*, formed his terror squads, the Guerrilleros del Cristo Rey, a rag-bag of neo-Nazis. To them it seemed that Franco and Pérez Embid's flirtation with repatriating *Guernica*, and consequent rehabilitation of Picasso's reputation, symbolised the regime's decadence and loss of direction. The hordes of upbeat Picassophiles who in the early 1960s had openly queued up to see the exhibition at Madrid's Biblioteca Nacional and the Gaspar brothers' show in Barcelona had melted away. At both extremes of the political spectrum a new intolerence rapidly spilt over into violence.

In the autumn of 1970 the Franco regime made one of its biggest mistakes. One of the greatest problems it faced was the growing effectiveness and belligerence of the Basque revolutionary separatist organisation ETA, Euzkadi ta Askatasuna (Basque Homeland and Liberty). Franco, who was more morose than ever – he slept with the holy relics of the Virgin of Pilar's shawl and St Teresa of Avila's preserved arm – had finally given in to the advice of a clique of right-wing generals to embark on the Burgos show trials of sixteen Basque prisoners, including two priests. From abroad came almost unanimous condemnation. But none of this was as poignant as what was about to happen at home. On 18 September 1970, as Franco presided over the world *jai-alai* championships in San Sebastián, Joseba Elósegi, a survivor of Gernika who had been commander of

the only Republican unit on the tragic day of 26 April 1937, set himself alight and launched himself as a human torch in front of El Caudillo, screaming for Basque independence. An active member of Partido Nacionalista Vasco, Elósegi, who survived this attempted martyrdom, wrote four months later, 'I do not intend to eliminate Franco, I want only for him to feel on his own flesh the fire that destroyed Gernika.' It was abundantly clear to all Basque nationalists, however radical, that Franco's cynical attempt to expropriate the symbol of their history, Picasso's *Guernica*, was just one more attempt in his regime's concerted policy to rewrite history and deny the Basques their dignity and freedom.

For Elvira González, sweeping up the glass in her gallery in Madrid left her only the briefest time for reflection and thoughts of what to do next. Her gallery had not been the first victim of the terror squads. According to the historian Enrique Moradiellos, the forces of law and order had systematically turned a blind eye towards the Guerrilleros del Cristo Rey who were being encouraged to become increasingly bold. In the opinion of Carrero Blanco, noted down in a private memorandum, it was the universities of Spain who should be held responsible for breeding homosexuals, Marxists, Masons and other such degenerates, and it was the virile ultra-right who were merely acting as a corrective force.

Prior to the shameful Galería Theo incident there had been a series of concerted attacks on bookshops that either had an association with, or promoted, the works of Republican exiles. In Madrid *Rafael Alberti* had been burnt out, and *Antonio Machado*, *Cultart* and *Visor* were attacked for no other reason than sometimes displaying a book on Picasso in the window. In Barcelona, despite the existence of the Donación Sabartés de Picasso and the Catalans' deep sympathy for Picasso's work, there followed an attack on the bookshop *Cinq d'Oros*. In *La Vanguardia* on 27 November 1971 the Guild of Booksellers, supported by the Asociación Española de Criticos de Arte and the Real Circulo Artistico-Instituto Barcelonés de Arte, publicly expressed their disgust, demanding from the authorities more proactive support

and protection. Considering that none of these bookshops brea-
ched Fragas's *Ley de Prensa* (Press Law), or dealt in censored texts,
they demanded that the law and freedom to trade be upheld. The
following month, again in *La Vanguardia*, a long list of official
associations demanded in an open letter to Barcelona's Mayor, in
the light of 'recent incidents which we don't need to go into, or
elaborate upon', a proper and decent homage to Picasso on his
ninetieth birthday, preferably before the year was out. Considering
Picasso's extraordinary generosity to his adopted city, the profes-
sional bodies of lawyers, architects, industrial engineers, designers,
'Friends of the City', 'Friends of the United Nations' and university
rectors – in short, the whole of the Catalan establishment – pleaded
for official recognition. It had always been Sabartés' dream that his
personal gift would spur Picasso on to continue his good works,
and so it proved. In 1968 Picasso had donated the Picasso–Sabartés
correspondence to the museum in Barcelona (with the condition
that it be frozen for fifty years) while also promising to send an
artist's proof of every future print. In February 1970 there was a
further gift of a collection of new works. On 24 April 1970 *La
Prensa* reported the astonishing gift of Pablo and Lola Vilató,
Picasso's nephew and niece, who donated 1,700 works from their
flat on the Passeig de Gracía. Lolita Vilató was subsequently
crowned the high priestess of the Picasso cult.

In Madrid, more than a year later, Elvira González was still
coming to terms with the senseless brutality and utter nihilism of
the recent attack on her gallery. Behind her passionate intelligence
and seductive charm lay a steely will. As a Spaniard she felt a
profound shame; a shame that drove her to reject offers to publicise
the incident in the German press. However, supported by expres-
sions of sympathy and offers of help, she was the first establishment
figure to lodge an official denunciation of the terror tactics.
Worried that there might be repurcussions, she passed a copy of
all relevant documents for safekeeping to the French embassy in
Madrid. The perpetrators were brought to court and tried, but
their plea justifying their actions as part of an anti-Marxist war

allowed Galería Theo's insurers to escape compensation on the grounds of it being a politically motivated act. For González this proved costly, as her future reputation as a dealer rested on her ability to compensate Knoedler for the damaged *Vollard Suite*, which she immediately did.

But it was not just in Spain that Picasso and *Guernica* had proved powerful magnets, attracting the growing forces of the counter-culture and the liberal conscience. By the late 1960s, particularly across university campuses in the United States, *Guernica* had become a ready, and easily understood, form of visual shorthand denouncing the cruelty and wanton destruction of entire communities in Vietnam. The social protest artist Rudolf Baranik produced a series of anti-Vietnam posters that were hard-hitting in their graphic directness. It is perhaps true, as one commentator observed, that in a period of growing scepticism *Guernica* is 'replacing the Crucifixion as an icon of cruelty and inhumanity for our secular age'. Protest groups like Angry Arts Against the War in Vietnam debated and argued the effectiveness of using *Guernica* as an image. The most memorable exchange was between the artists Jeanne Siegel, Ad Reinhardt and Leon Golub. In the 1967 debate entitled 'How Effective Is Social Protest Art?' it was Golub who warned against the painting's over-exposure. Although bowled over by *Guernica* in the late 1930s, when he saw it for the first time as an art student in Chicago, Golub explained his growing reservations:

> It was made to dramatise Picasso's anger and denunciation of Fascism, of great countries attacking small countries or attacking villages. Since then this particular painting has become an object of holy veneration and it's become a mystical thing but it's lost its effectiveness. People come and look at it and they don't even know what they're looking at in a certain sense.

In the Pop Art age, where consumerism and the power of the mass media were celebrated above all, *Guernica*'s power to affect the

audience was in real danger of evaporating by becoming over-exposed.

Once again external events would give *Guernica* a recharge of meaning. On 16 March 1968 in the small Vietnamese village of Mylai one of the most notorious massacres of the war led to the eventual court-martialling of Lieutenant William Calley. Despised by almost everyone unlucky enough to work with him, Calley led 11th Brigade's Charlie Company into Mylai, to slaughter indiscriminately 500 unarmed men, women and children, in an orgy of blood. The collectives of the Guerrilla Art Action Group, the Art Worker's Coalition and the Artists' and Writers' Protest penned an open letter to Picasso in Mougins requesting he withdraw *Guernica* from MOMA, arguing that the United States had lost any moral or ethical credibility, and now had collective blood on its hands. In their fiery plea to Picasso the cosignatories attested: 'What the US Government is doing in Vietnam far exceeds Guernica, Oradour and Lidice. The continuous housing of *Guernica* in the Museum of Modern Art, New York, implies that our establishment has the moral right to be indignant about the crimes of others – and ignore our own crimes.' Picasso discussed the matter with Kahnweiler, concluding correctly that the painting was best left where it was, an ever-present thorn in the American establishment's side. In this decision he found support from the art historian Meyer Schapiro who point by point demolished the logic of the group collectives' argument, while still remaining totally opposed to US involvement in South-East Asia. 'In hanging *Guernica*,' argued Schapiro, 'the Museum no more protests against the crime of Guernica than the Metropolitan Museum protests against the crucifixion of Christ in hanging a painting of that subject.' Once again *Guernica* revealed its flexibility as an image whose iconic status could be read and manipulated by interest groups to suit their own ends.

On 8 April 1973 Pablo Picasso died at Mougins. He was buried two days later at Vauvenargues, in the shadow of Mont St-Victoire, with the bronze *Woman with Vase* placed like a sentinel over his grave.

In terms of longevity Franco had beaten his adversary and had succeeded in keeping the world's most famous Communist out of Spain. But it was a pyrrhic victory that brought to mind Miguel de Unamuno's famous prediction on 12 October 1936, while celebrating the Day of the Race in Salamanca, the anniversary of Columbus's discovery of America. 'Vencer no es convencer,' the seventy-two-year-old philosopher and Rector of Salamanca had warned ominously. 'To win is not the same as to convince.'

On 20 December 1973, as Spain sank ever deeper into recession and was increasingly plagued by industrial unrest, ETA chose a spectacularly audacious response to the increasing repression by assassinating Admiral Carrero Blanco with a car bomb in Madrid, while he was on the way home from morning mass. It was precisely because they recognised that Carrero Blanco would provide continuity with the regime after Franco's death that he had been targeted. Franco's response was to withdraw into himself in disbelief. The following day at the funeral mass at San Francisco el Grande, he wept inconsolably. 'They have cut my last link with the world,' he confided to an aide.

As Franco became bedridden his hold on day-to-day politics became almost non-existent. His grasp of the economic crisis and his control over choosing his successor had effectively disappeared as he gave in to his wife Carmen Polo's pressure to choose the hard-line Arias Navarro as Carrero Blanco's replacement. Franco had lost his way. His legendary instinct for political survival, his Machiavellian understanding and manipulation of human weakness, and his gift for bluffing his way through, were all attributes of a leadership style that was dramatically weakened by failing health. Often so perceptive, Franco could none the less never have foreseen that within eight years, on the celebration of Picasso's centenary in 1981, the artist's Trojan Horse, *Guernica*, would finally arrive home on Spanish soil. Before that, however, there were endless negotiations and political manifestations that almost prevented *Guernica* from ever leaving Manhattan, or even, in one notorious instance, remaining intact.

In February 1974 a young Iranian artist, Tony Shafrazi, ran up to *Guernica* in MOMA and with red paint sprayed across the canvas letters spelling 'KILL LIES ALL'. Unbeknown to Shafrazi (who would later become a respectable art dealer in New York City's trendy SoHo district, pioneering the works of graffiti artists like Keith Haring, Futura 2000, Zephyr and Jean Michel Basquiat), *Guernica* had been protected with a coat of varnish after its previous restoration and it was possible for MOMA's conservators to wipe it clean. Shafrazi's act of vandalism, intervention, or, employing all the tautological reasoning of the avant-garde, his 'collaboration', was fortunately therefore not permanent. Dangerous as a precedent, his gesture nevertheless had a point. It was honest. Disgusted by President Nixon's official pardon of Lieutenant William Calley, who had been sentenced in 1969 to hard labour for life, Shafrazi wanted to draw the public's attention to Calley's imminent parole later that year and the ongoing savagery in Vietnam.

Shafrazi's iconoclastic gesture was subtly argued out. What Shafrazi loved, he explained in a recent interview, was the energy and immediacy of Pollock, Basquiat and Haring. He loved the vitality of 'dealing with the spur of the moment, the action element in painting, homing in, zeroing in on the moment, doing something'. Supported by Jean Toche and Jon Hendricks of the Guerrilla Art Action Group, Shafrazi's actions were explained in a letter to MOMA's Director, Richard Oldenburg, dated 28 February 1974.

Tony Shafrazi has now joined Picasso in a collaborative work called GUERNICA/MYLAI – each artist in his own way expressing his own anger and disgust of a genocidal action by governments against an innocent people: PICASSO, of the saturation bombing by Nazi planes of the tiny town of Guernica, SHAFRAZI, of the mass murder by the US troops of men, women, children and babies in the hamlet of Mylai. It is a compounding of the US Government crime that MOMA should have arrested Shafrazi and erased his work of art.

We as artists and as individuals, who also denounce the US

Government whitewash and cover-up of Mylai, demand the immedi-
ate release of Shafrazi and the dropping of all charges against him.

Tony Shafrazi's art action is, as was Picasso's originally, a pro-
found, tormented, humanistic expression against the callousness and
barbarity of a nation.

Toche would soon find himself behind bars for stating that Shafrazi
had performed a public service by freeing '*Guernica* from the chains
of property' and returning it to its 'revolutionary nature'. In the style
of every revolutionary art manifesto from Rusiñol's Modernista
diatribe, through the Dadaists and Marinetti on, Toche urged the
revolutionary 'kidnapping' of arts administrators, from museum
directors to their wealthy trustees. In *Making the Mummies Dance*,
Thomas Hoving, the Director of the Metropolitan Museum of Art,
recalled why his acute sense of humour failure had forced him to
alert the FBI. Picasso was fortunately not alive to witness Shafrazi's
desecration of his work. But perhaps even he would have recognised
the perverse logic of his act. *Guernica*, as a painting, was becoming
history. It had promoted a new style and influenced the development
of American art. But it had also lost its rebellious, revolutionary
anger. It had, in the opinion of Joseph Masheck, become 'too
familiar to be really disturbing, yet too disturbing to be simply
beautiful'. 'A rust of obviousness obscures it from view,' he con-
cluded. What Shafrazi argued most forcefully was that he had
repoliticised the painting, recharging it for a new generation. With
hindsight it is perhaps far easier to see that *Guernica* had run out of
steam in America. It needed new challenges and needed to relink
itself to the destiny of the country for whom it was painted first. For
New York and the United Nations the tapestry copy of *Guernica*
that Nelson Rockefeller had commissioned with Picasso's permis-
sion would soon have to suffice.

On 20 November 1975 after a year of suffering excruciating
discomfort as a result of an accumulation of dental problems,
Parkinson's disease, stomach ulcers, peritonitis and renal failure,

El Caudillo, Francisco Franco, passed quietly away. He had maintained his hold over Spain for almost forty years through a mixture of terror, political savvy, sheer bloody tenacity and a cynical abuse of power. It had been a juggling act that was at times masterfully played. But with Franco's passing it became obvious that the Spanish population had no appetite for more of the same.

In the short term very little could change. Two days after Franco's death on 22 November 1975 Don Juan Carlos was sworn in as King of Spain, in front of the Cortes, but was also immediately tied down by the necessity of swearing loyalty to the principles of the Movimiento Nacional as he had done on his succession back in 1969. Arias Navarro would continue as President. Very soon, however, it became obvious that the King's democratic ambitions outstripped anything envisaged by Arias Navarro. For many Spaniards the precedents set by Portugal and Greece the year before, where both regimes had been successfully overthrown, provided a model and an inspiration. But King Juan Carlos and other fellow reformers would have to carefully bide their time, watchful as always of the reactionary ambitions of some branches of the military and the Guardia Civil.

There is much debate about when the period described as the 'Transition' started. What is certainly irrefutable is the enormous role played by the King and his advisers at the Zarzuela Palace. Historical distance and a successful conclusion have, on the face of it, made it all seem easier than it actually was. The economic recession that was beginning to bite hard was a formidable barrier to a peaceful transition. Only so much euphoria and goodwill could counterbalance the anxiety, insecurity, impatience, frustration and inevitable disappointment some might feel. In the first three months of 1976 there were 17,731 cases of industrial action alone. Spain was in danger of grinding to a halt. The Basque problem, with its escalation in the number of assassinations on both sides, heightened the atmosphere of insecurity and fear. If this represented a real danger, what was also true was that almost no one in Spain could imagine, or contemplate, returning to a state of civil war.

On the road to democracy there were, of course, powerfully symbolic moments. One of the most difficult episodes was the *semana negra* – the Black Week – in Madrid between 23 and 28 January 1977, when ultra-right terrorists murdered a student at a pro-amnesty march, then broke into a lunch party of labour lawyers, murdering five of those present. In retaliation, GRAPO, a left-wing terrorist organisation, kidnapped a general and murdered four members of the security forces. This was perhaps the lowest point, but it also provoked a groundswell of public sympathy for those in support of the democratic process. Despite the crisis it is still the government's very real achievements that shine out today. The legalisation of the Communist Party on 1 April 1977 and the decision on 7 April to award pensions and disability allowance to Republican veterans went a long way towards healing the wounds. King Juan Carlos's sacking of the redundant Arias Navarro and his replacement with the stop-gap Prime Minister Adolfo Suárez were brave and necessary decisions. The subsequent recognition of King Juan Carlos's legitimacy by Santiago Carrillo, Secretary General of the Spanish Communist Party, was hugely significant, as was the highly emotional return from exile of Josep Tarradellas, the President of Catalonia's Generalitat. For monarchists nothing was quite so moving as the moment when Don Juan, the King's father who had been living in exile in Portugal and was never reconciled to Franco, renounced his claim to the throne and offered his unswerving support to his son. Most poignant of all, in June 1977, Suárez's democratically elected government accepted and won unanimous cross-party support for the proposal by the Basque Senator Justino Azcárate to repatriate the remains of King Alfonso XIII, along with those of the first President of the Republic, Manuel Azaña. Azcárate also stated his firm intention to bring *Guernica* back to its rightful home. There was a hunger for reconciliation. The '*pacto del olvido*' – a tacit agreement to overlook the wounds of the past in an optimistic and all-inclusive pursuit for a better future – was seen as necessary to drive the democratic process on. What almost all politicians wanted was 'normalisation' and an end to the nightmares

of the past. The progress towards democracy was most powerfully symbolised by the exiles' return.

It was against this backdrop that there were growing calls for *Guernica* to 'return' to a country where it had never been. Kick-starting the process on the international stage, Herschel B. Chipp, a professor of art history at the University of California with an encyclopaedic grasp of modern art, who had been researching *Guernica* for years, wrote an open letter to *The Times* and the *New York Times*, published on 26 November 1975. With runaway enthusiasm that perhaps failed to reflect accurately the reality on the ground, Chipp wrote:

> Picasso has upon several occasions stated that after the end of the Franco regime and when conditions were improved he wished the painting to go to Spain, a desire which has been confirmed by his lawyers. As early as 1969, both the Spanish Director of Fine Arts and Franco himself expressed their desire that *Guernica* find its permanent home in Spain, where it could be featured in Madrid's new museum of modern art.
>
> Following the death of Picasso in 1973, a nationwide clamor for the painting arose, including the voice of the Mayor of the city Guernica, whose destruction by an air attack provided Picasso with his subject.
>
> Picasso's widow and his children now have the opportunity to honor his wishes and send his painting to Spain, where once again in its history it could exert a powerful force for humanity. The gift of *Guernica* to the Spanish people could, by its message of universal suffering in warfare, help heal the wounds of the bitter civil war. It could be a stimulus toward a freer and more humane regime under their new leader, and it could even become a symbol before the world of a more unified and more liberal country.

In essence correct, Chipp's optimism and idealism clouded a more sober and measured view. His comment regarding 'a more humane regime under' a 'new leader' failed completely to recognise that Arias

Navarro and even King Juan Carlos still had a long way to go before their roles were clearly defined. Perhaps Chipp was ignorant of how deeply polemical and potentially divisive Picasso's work still was in Spain, or that Picasso's family continued to hold deep reservations about Spain's young democracy. Chipp was quickly pulled up short, not by a Spaniard but by William Rubin, Director of Painting and Sculpture at MOMA. A brilliant scholar, Rubin was both tough and opinionated. Armed with his silver-topped cane, that he needed as the result of having suffered polio as a child, Rubin was the archetypal image of the sophisticated New York Jewish intellectual, as at home with Raphael and Leonardo as he was with Caro, Pollock and Olitski or the works of de Stijl. From his summer house in Provence, the Villa l'Oubradou, Rubin had come to know Picasso better than most. As early as 9 April 1973 he had gone on record in the *New York Times* stating clearly his views on ownership of *Guernica*. 'We have merely been holding it for Picasso, and we have no hopes of keeping the picture. To my mind,' he stated bluntly, 'the decision whether a Spanish government would pass muster is now in the hands of Jacqueline Picasso. We are at her disposal.' Rubin's critics were quick to point out that as acting caretaker of *Guernica* he could hardly be impartial. Fully aware of the legalities at stake, Rubin drew attention to Picasso's specific condition that *Guernica* could travel 'only when a genuine Spanish republic had been restored'. It was perhaps a legal nicety but one worth holding on to until the political situation in Spain had become clearer.

Within ten days, reflecting the importance of Chipp's petition, Maître Dumas replied in the pages of *Le Monde*. He was quick to point out that it was he, not MOMA, who had the power of attorney. He also concluded that nothing in Spain to date convinced him that 'the conditions of a democratic situation have been fulfilled'. It was clear that in all future negotiations the key to release *Guernica* remained firmly in his possession. Dumas had a point. Spain was still in the middle of the process of democratisation. No conclusions could yet be drawn. This was most poignantly demonstrated in April 1977 at a Civil War seminar held in Madrid's

Autonoma University where the Texan historian Herbert South-
worth, who had devoted decades of scholarship to the Gernika
tragedy, pointed out that even now in 1977 his books were still not
permitted in Spain. Published by the exile house Ruedo Ibérico,
whose contribution to Spanish culture was remarkable, South-
worth's polemical studies, with their impeccable use of original
sources and documents, today remain absolutely fundamental for a
measured understanding of Franco's Spain. Southworth argued
powerfully: 'We cannot continue with a situation which has lasted
now for more than forty years, where only one version of the civil
war has been permitted, while a large proportion of the population
know from their own experience that the official version is stained
with lies.' A week later on the fortieth anniversary of the bombing,
26 April 1977, the Gernika 'truth' commission, at which South-
worth had been invited to speak, sent a telegram to Walter Schell,
the President of the Federal German Republic, announcing the
imminent conclusion and publication of their findings. In Gernika's
central plaza in front of the town hall an exact photographic replica
of *Guernica* was placed to commemorate the dead. For Gernika's
population it was the first time in forty years that they could openly
express their grief. The Picasso family sent a telegram expressing
their sympathy and solidarity with the city of Gernika during this
emotional time, and in the name of their father, Maya, Cristina,
Bernard, Claude and Paloma signed. The highly charged symbolism,
with the town bedecked in black-ribboned *ikurriñas* – the Basque
flag – found a fitting conclusion with a funeral mass in the church of
Santa Clara, while more radical elements in the streets chanted
'Presoak kalera y amnistia' ('Freedom and amnesty for political
prisoners'). For Gernika's populace it was still abundantly clear that
only the return of Spain's last exile, *Guernica*, was a fitting recom-
pense for all the bitterness and pain. But like all other Spaniards they
would have to wait patiently for Dumas to decide.

As early as July 1976 the first of many requests to borrow *Guernica*
had been put forward by the Banco Atlántico in Barcelona for an
exhibition to celebrate its seventy-fifth anniversary. Ever optimistic,

the Director, Juan Peiró, would, however, be the first of many petitioners to be frustrated by conservation experts, whose care for the painting took precedence over everything else. If *Guernica* was not yet ready to come to Spain it was increasingly obvious that political mileage could be had from making a pilgrimage to New York. On 19 November 1977 Felipe González, a charismatic young lawyer from Seville, who had recently become the leader of the Partido Socialista Obrero Español (PSOE), the Spanish Socialist Party, visited MOMA. González's kudos had been greatly enhanced by the evening reports transmitted on Europe's radio networks during the Franco period, in which he had sheltered behind the disguise of his *nom de guerre*, Isidoro. Taking an opportunity to escape for a few minutes from his schedule of back-to-back meetings with the US Democrat elite and Spain's exiled intellectuals, González had managed to steal his first viewing of *Guernica*. 'I hope that *Guernica* will soon return to Spain,' he told *El País* correspondent Soledad Alvarez-Coto. Brought up to date by MOMA's officials on the painting's legal status with regard to its possible return, González was moved by the image's universal appeal. Rumours abounded at the time that one way out of the *Guernica* stalemate was to bring it to neutral territory and hang it in the United Nations, allowing it to 'speak' to the world from this privileged space on the Lower East Side, but nothing came of it. Another possibility was that the painting might go to Mexico, where the Republican government-in-exile had found a safe haven and had remained in existence for the previous forty years.

A week after González's visit, Santiago Carrillo, the ageing Partido Comunista de España – the Spanish Communist party-leader, not to be outdone by his young rival, also visited *Guernica*. Having met Picasso on numerous occasions, Carrillo expressed his desire that the painting should hang alongside Velázquez and Goya in the Prado. And, to throw further light on the artist's requirements, he argued that he was sure that Picasso would be happy with Spain as a 'democracy', rather than insisting on it being a Republic before the picture was returned.

For many Spaniards who visited New York for their first encounter with *Guernica*, the experience was far more visceral and emotionally charged. Daniel Giralt-Miracle, who years later would become the Director of MACBA, Barcelona's contemporary art museum, and organiser of the 2002 Gaudí year, remembered the moment he first saw Picasso's gigantic canvas. 'I saw it for the first time in MOMA before it came back to Spain. A policeman arrested me for a few minutes asking me why I had touched the painting. I explained to him that my father had been a republican who had been sent to the concentration camps.' (Ricard Giralt-Miracle, who had been a student of Josep Lluís Sert and one of Catalonia's greatest and most influential graphic designers had put his skills into the service of the Republic.) For Daniel Giralt-Miracle the pilgrimage to MOMA represented a spiritual home-coming, providing him with a necessary sense of closure. To touch *Guernica* was to bring his life full circle and reunite his private world with the public world.

Soon official moves were made to link *Guernica* closely with the Spanish state in the public imagination. In March 1978 Francisco Fernández Ordóñez became the first Spanish government minister to be photographed in front of the painting. For Spanish politicians, *Guernica* as painting and symbol had once again come alive, regaining its dramatic sense of immediacy. Its return to Spain was viewed therefore as increasingly urgent. For the nascent democracy its homecoming would be read as nothing less than a complete catharsis; a recognition that a painful history had been surmounted and successfully assimilated, and that symbolically it might act as an imprimatur of the new democracy's legitimacy.

Meanwhile, back in Gernika, the investigating commission comprising Luis Ruiz de Aguirre, Angel Viñas, Tuñón de Lara, Fernando García de Cortázar and Herbert Southworth, had made significant progress on proving German culpability in the bombing of the city by wresting a firm promise from the Spanish Minister of Culture, Pío Cabanillas, and the German government to open up relevant archives. But there were also grander ambitions, supported in

principle by Pío Cabanillas, to transform Gernika into the city of Basque resistance and culture, centred on the crowning glory, Picasso's *Guernica*. From the artistic community, including the sculptor Chillida, Ruiz Ballerdi and Agustín Ibarrola, the project enjoyed enthusiastic support. They were convinced that this would also restore Gernika's fortunes by providing the beleaguered city with substantial economic benefits.

Despite the Picasso family's sympathetic gesture towards the city in spring 1977, that winter the possible repatriation of *Guernica* stalled once again. During the autumn the Catalan theatre group Els Joglars had been touring the Basque country with their new play *La Torna* – the Catalan word used to describe a makeweight. It was based on the notorious executions by *garrote vil* – a sadistic form of strangulation – of Salvador Puig Antich, a member of an Iberian freedom group, and a Polish tramp, Heinz Chez, who had both murdered members of the Guardia Civil. Puig Antich's murder was politically motivated but was tried as cold-blooded murder, whereas Chez's brutal killing of Antonio Torralbo was a random, completely unprovoked moment of insanity. Heinz Chez, whose real name from Stasi files appeared later as George M.W., was a hopeless down-and-out whose escape over the Berlin Wall had brought him only bitter resentment. Orphaned at an early age, George M.W. was a pathetic loser, a makeweight, whose only moment of fame came on Saturday, 2 March 1974 when Franco, facing almost unanimous international outrage, refused to commute either his or Puig Antich's sentence. Albert Boadella, the director of Els Joglars, was already notorious as a satirist who spared no sacred cows. The executions of Chèz and Puig Antich provided him with the ammunition to strike at the state. From the reactionary right across to the hypocritical, fashion-conscious left of the *progresistas*, no one escaped Boadella's withering gaze. In the Basque country, performances of *La Torna* had brought no problems, but it was on return to Boadella's homeland of Catalonia, and specifically at two evening shows in Mataró and Reus, that the work came to the notice of the military establishment, who

felt grievously insulted. Boadella, along with four other actors, was arrested in early December 1977 and carted off to Barcelona's Modelo jail to await his court martial. A public clamour for the release of Els Joglars was quickly followed by organised demonstrations. During the 'week of mourning', in an act of solidarity, all Barcelona's theatres closed, including the conservative Liceu Opera house, as did 80 per cent of the cinemas, dance halls and cabarets, despite threats of the staff losing their jobs. In the capital of French Catalonia, Perpignan, Nuria Espert joined the Committee for the Pro-Liberty of Expression to debate Boadella's sad predicament. After long consultation a carefully worded dossier on the injustice suffered by Els Joglars, and the breach of human rights that it implied, was forwarded to the Council of Europe. Most embarrassing of all to the authorities was the presence of a Belgian television team, whose brief to film everyday life in Catalonia focused almost exclusively on Els Joglars.

On 27 February 1978 the Els Joglars case took a dramatic twist. To get out of the Modelo, Boadella had faked nausea and vomiting fits and had been placed under guard in the Hospital Clínico. Exiting through the toilet window and walking precariously along a narrow ledge, five storeys above the street, Boadella had managed to give his guards the slip. Just twenty-four hours before his court martial had been planned to take place, he had managed to effect his escape to the safety of exile in France. It was a piece of pure living theatre, that transformed Boadella into a Catalan hero overnight. In his absence, however, his four fellow-actors were sentenced to two years in jail.

In Paris, Boadella quickly linked up with Peter Brook in his theatre Les Bouffes du Nord to orchestrate resistance. But nothing was quite as moving as the concert on 11 February 1978 in Barcelona's Palau d'Esport in which the stars Maria del Mar Bonet, Lluís Llach and Raimón called for freedom of expression in support of Els Joglars. Reminiscent for one journalist of the recent Bangladesh concert, candles and Catalan flags were waved through the marijuana-perfumed clouds as Raimón led the other musicians in a final rendition of his Catalan anthem, 'Diguem No'. Easily ignored

by the authorities, these manifestations were brushed aside by the Spanish government as representing no more than the hot air of a disaffected youth.

Far more difficult to ignore was Paloma Picasso's intervention. Paloma and Boadella were old friends from the same neighbourhood in Paris and she was outraged by the treatment of Els Joglars. On 26 April she announced, much to the Spanish Minister of Culture Pio Cabanillas's discomfort, that she was suspending all negotiations with regard to *Guernica*'s return until every member of the theatre troupe was released and Boadella officially pardoned. It was a bold threat that verged on blackmail, turning the *cause célèbre* into something with far profounder ramifications. Many Spaniards had found the idea of the French lawyer, Maître Dumas, judging their suitability as a democracy galling and an insult to their pride, but Paloma could not be so easily dismissed. Quick to jump to her support was Francesc Vicens, Director of the Miró Foundation, and the poet–artist Joan Brossa who were both convinced that Pablo Picasso would have done exactly the same. In Boadella's autobiography *El Gran Bufo* (*The Great Buffoon*, a clear reference to his self-image as the mediaeval court jester with licence to speak out the most uncomfortable truths) he acknowledged that it was Paloma's intervention more than anything else that had shifted the debate. Els Joglars and *Guernica* were now intimately linked in the battle for freedom of speech.

During the late spring the Spanish Senate debated the implications of the Els Joglars case and offered Boadella a pardon. From the safety of Paris he refused the offer, demanding a change in the military code of law so that no civilian in the future should suffer the indignity of appearing in front of a military court. At the end of the year Boadella returned to Barcelona to live in hiding but was quickly rounded up and once again incarcerated in the Modelo jail. On 28 December 1978 200 European intellectuals and artists including Costa Gavras, Peter Brook, Jean-Paul Sartre, Yves Montand and Jorge Semprun, a future Minister of Culture in Spain, delivered their petition for Boadella's immediate release to the Spanish Ambassador

in Paris. In July 1979 Boadella won provisional freedom, with his four-and-a-half-year sentence for the offensive *La Torna* commuted. Only in 1985 would *Els Joglars* receive an official pardon and apology from the Spanish state.

What the episode did show the Picasso heirs, however, was the power and effectiveness of using *Guernica* as a political pawn. It was a lesson not quickly forgotten, but one that, further down the long road of negotiation, would lose them a great deal of public sympathy in a Spain that had wrestled seriously and genuinely with all the implications of its new democratic constitution. Spain had more than come to terms with its constitutional monarchy, and was grateful to King Juan Carlos, who in his role as Supreme Chief of the Military had, with the advice of Prime Minister Suárez's Armed Forces Minister, Manuel Gutiérrez Mellado, managed to keep the reactionary and disaffected elements almost completely in check.

In Spain it was now becoming unfashionable, and indeed amounted almost to political suicide, to suggest that *Guernica* would be best left where it was. Lone voices of dissent like that of Sainz de Robles, a retired official chronicler to the Villa of Madrid dismissed *Guernica* as one of Picasso's stupidities. In mid-July 1978, across the ocean in New York, Professor José López-Rey agreed completely with Hilton Kramer, the *New York Times* art critic, and Roland Dumas that it was wise to err on the side of caution. For *Guernica*'s very last journey to the Prado it would only be prudent, suggested López-Rey, to ensure that everything in the Museum was firmly in place to receive the last exile. On 19 July José María Pita Andrade, Director of the Prado, was forced to admit to *El País* that the Museum was in no way ready for the painting. He guessed that it would take, anywhere between two and three months to organise an adequate space that fulfilled all the security and conservation requirements.

Regardless of the fall-out of the Els Joglars scandal, the *Guernica* negotiations had been painfully slow. José Maria Armero, President of Europa Press and an expert in the legalities of the case, had been

charged with pressing the government's claim. With growing frustration he had begun to contemplate the unthinkable . . . to go to the court of law. During the summer, as was his custom, William Rubin was once again taking his vacation in Provence. In the United States Congress a resolution to release *Guernica* to Spain, energetically pushed for by Senators George McGovern and Joseph Biden, had been passed on 24 May 1978 with an overwhelming majority. But Rubin could not override Dumas, who still had the last word. During August rumours were reported in the *New York Daily Press* that a positive announcement, the fruit of Rubin's conversations with Dumas, was imminent.

What had become increasingly obvious was that the battle for *Guernica* was being fought on two fronts. The Spanish press played their part, but of far greater importance was the behind-the-scenes diplomacy. Central to the negotiations was Rafael Fernández-Quintanilla, who recorded the extraordinary levels of intrigue in his book *La Odisea del Guernica*. As a successful career diplomat, he had worked as cultural attaché in the Spanish Embassy in Paris in the early 1960s. In a bizarre case of serendipity, it was there that he reacquainted himself with an aged cousin, Luis Quintanilla, who by chance had served as Press Secretary in Paris for the Republic back in 1936 alongside Ambassador Luis Araquistáin; both men had played an indispensable role in organising and commissioning work for the 1937 Republican Pavilion. It was Araquistáin who had safeguarded the Republican archive, which he deposited in Geneva, that would later prove essential in winning *Guernica* back. Another friendship that would prove useful to Rafael Fernández-Quintanilla was with Jaime Sabartés who at the time of their meeting was trying to get his Picasso Museum in Barcelona off the ground.

In autumn 1977 Fernández-Quintanilla returned to Madrid from his posting in London as Cultural Attaché. The *Guernica* issue was about to hit the headlines once again with the Els Joglars scandal. Fernández-Quintanilla wrote to the Minister of Foreign Affairs, Marcelino Oreja, to offer his help in negotiating the painting's return. What he hoped he might find was documentation proving

that Picasso had sold *Guernica* to the Republic, making Spain's claim irrefutable. While the Els Joglars scandal raged, Fernández-Quintanilla travelled to Geneva to try to persuade Finki Araquistáin, the surviving son of Luis, to furnish him with proof of a bill of sale. What turned up was remarkable. Despite having lost a great part of the archive in the hasty retreat from Figueras, at the end of the Spanish Civil War, Finki unearthed letters from Max Aub, the Cultural Attaché in the Embassy, that attested to him paying Picasso 150,000 francs to defray costs but amounted in essence to the Republic's acquisition of the masterpiece. Another two letters were found, one written by Julio Álvarez de Vayo to Araquistáin repeating Aub's contentions, and another from Araquistáin to Picasso in which he confirmed Picasso's wish to donate it to the Republic. For Fernánandez-Quintanilla this was the breakthrough he had been looking for. A quick conclusion, however, was quickly frustrated when he realised that Finki would use the discovery to try to sell off the entire archive at an extortionate price. Looking for another route out of the impasse, in January 1979, Fernández-Quintanilla decided to visit Maître Dumas secretly in Paris. It was a positive meeting, opined the diplomat, but still nothing concrete or legally binding had been put down on paper. What was needed was a meeting between Dumas and President Suárez.

In Spain there was increasing impatience. How was it possible, asked an editorial in *El País* on 24 June 1979, that nothing had been planned to commemorate Picasso's centenary, just two years away? MOMA, to celebrate its fiftieth birthday, was honouring Picasso with a one-man show, the first time the museum had ever extended such an honour to an artist. And France was also planning to inaugurate the Musée Picasso at Hôtel Salé in Paris, the fruit of six years' legal wrangling which divided up the Picasso estate of more than 43,000 works, and from which Dominique Bozo, the Director of the museum, picked the very best of the artist's work. In contrast to France and the United States, the Spanish government was more interested in the 1982 World Cup, suggested *El País*. What no one in the press could know was that the negotiations for *Guernica*'s

release were already well advanced, but for reasons of security, and the possibility of encountering last-minute pitfalls, the information was deliberately kept out of the public domain. In the same edition of *El País* it was announced that the *New York Times* had warned the American public that the Picasso retrospective, opening that October, would be their last opportunity to see *Guernica*. On 19 July 1979 the long-awaited meeting between Dumas and Suárez finally took place. The following day the news was released that *Guernica* was almost certainly on its way.

What had become increasingly pressing, however, was a clarification of the Prado's plans for the painting's installation. Just on a practical level it was estimated that *Guernica*'s arrival would increase the Museum's daily attendance from 5,000 to 20,000. Perhaps the only space capable of handling so many visitors was the central hall, but that in turn brought with it heightened problems of security. *Guernica*'s very popularity was posing the greatest problem of all. For the Prado's Director, Pita Andrade, who was naturally deeply honoured by the idea that *Guernica* was almost certain to come to his museum, it proved a logistical nightmare. In the Spanish press they could make light of it and have a little fun. What was going to happen, asked one editorial, to all those *Guernica* posters that alongside the posters of Che Guevara and Salvador Allende populated Spain's dining rooms, especially now that the colleges and the general public had been given free entrance to the Prado on Thursdays? If the posters were redundant, what was Spain going to do with its glut of drawing pins? Was Dali's *Christ* suitable as a replacement? No. It was the wrong format, it was too vertical. Might Leonardo's *Last Supper* be ready for another comeback? Or just a plainly framed mirror to reflect a new and democratic Spain?

A far more serious debate, however, quickly emerged over *Guernica*'s eventual location. The Ministry of Culture had still not made a firm decision, or, at least, was loath to make it public. At the end of August Radio Nacional de España organised an open debate between the Mayors of Madrid, Malaga and Gernika and the Director

of Barcelona's Picasso Museum, Rosa María Subirachs, all potential custodians. The claim that it was Picasso's express wish to see his work hanging in the Prado relied on purely anecdotal evidence; there were no documents or official statements. Of course, argued Madrid's Mayor, Señor Tierno, the masterpiece should hang with all the others in Spain's premier museum in Spain's capital. Less rebarbative, however, was Rosa María Subirachs who argued that Barcelona had always enjoyed a special relationship with Picasso and that *Guernica*'s presence would complete a collection that was already world class. Barcelona's Picasso Museum was a viable alternative to the Prado. A few days later Herschel B. Chipp came out in support of Barcelona's claim, as did, more significantly, José Maria Armero, who reiterated in *La Vanguardia* the accusation that Madrid had never, apart from the notable exception of Elvira González, demonstrated any real interest in Picasso. Malaga's argument, based on its claim as Picasso's birthplace, and with the third largest influx of tourists of any Spanish city, was perhaps the least convincing of all. Gernika's Mayor, Dionisio Abaitúa, on the other hand, cited all the necessary moral, artistic, historical, political, social and economic reasons for why exhibiting *Guernica* in Gernika was both recompense for the tragedy suffered and would act to heal the wounds of this Iberian Pompeii.

There were other voices, however, which were less diplomatic and which were prepared to fire up the debate. In the July issue of *Destino* the inflammatory Joaquim Ventalló was quick to remind his readership of what he described as the '*infantilismo*' attitudes of the Spanish press who treated *Guernica* as you would a new pair of shoes; slipping them on and off at will. Where were all the journalists, he asked, when the Guerrilleros de Cristo Rey were burning down bookshops and galleries? In a country whose walls were still daubed with Nazi and Falange graffiti, Ventalló concluded, there was a clear '*ausencia de autoridad*', lack of authority. *Guernica* was better off staying where it was. Later in the year, the Basque artist Agustín Ibarrola would pick up on the '*ausencia*' theme, adding a subtle twist. In his opinion it was both hypocritical and morally

dubious to allow a government born in the crucible of Francoism to take part in negotiations to repatriate *Guernica*. The painting should come to Gernika because that was the site that had inspired it, and furthermore it would stimulate a cultural renaissance. What really annoyed Ibarrola was Santiago Carrillo's contribution to the debate in the September 1979 issue of *La Calle*, where he had dismissed Gernika and Malaga's claims as merely illustrative of their provincial small-town mentality. Ibarrola was soon to find other allies. Narcis Serra, Barcelona's Mayor, always ready to fight the centralist tendencies of the Spanish government, claimed that Barcelona would not compete against Gernika but would only fight for the painting if the other option was Madrid. At an international congress celebrated in Italy in September 1979 for martyred cities and their victims, forty cities, including Berlin, Leningrad, Kiev, Warsaw and Turin, signed a petition to bring *Guernica* back to the city of its name. One of the most curious reasons cited for *Guernica*'s return to the Basque country was offered by the Basque sculptor Jorge Oteiza who argued that from prehistory to the present day the horse was an important Basque totem and central to the nation's identity. Picasso's depiction of the horse was therefore, according to Oteiza, a key image in the Basque visual lexicon.

A more comic take on the *Guernica* issue was provided by Manuel Vázquez Montalbán in a television debate timed to coincide with the publication of Faustino González-Aller's crime thriller, entitled *Operación Gernika*. *Guernica* should stay in the United States for two reasons, quipped Vázquez Montalbán: first, because New York was already effectively the capital of Spain, and, second, because Woody Allen was the only person in the world who knew how to look at the picture properly. Others, on a more serious note, still held deep reservations about *Guernica*'s homecoming. José Maria Gironella described it in *La Tarde*, a right-wing newspaper, as a deformed, monstrous piece of garbage. In his opinion, if Spain lost claim to it so much the better. It was, after all, just a lunatic poster. Pio Muriedas in a letter to the editor of *La Nueva España* suggested it be auctioned off and the money sent to the wounded of

Gernika. It would be hard to honour Picasso, who, Muriedas implied, had been too cowardly even to set foot on Spanish soil, despite his being named the Prado's Director. Saenz de Heredia in the 2 May 1980 issue of the right-wing *El Alcázar*, trotted out further anti-Picasso views claiming that to display *Guernica* in the Prado was to give recognition to a painting that was a mere travesty, and honoured an artist who was just a joke. Just months before, the Communist Party leader Santiago Carrillo had told reporters: 'In terms of culture, little has changed from Franco's time until to-day.'[290] On the left, it was Rafael Alberti who remained the most vociferous critic of the painting's imminent return and perhaps for good reasons. There was still a large part of the population who loathed Picasso and despised his work. For them, Gironella, Muriedas and Saenz de Heredia were merely brave enough to say out loud what others only dared to whisper behind closed doors. Carrillo summed it up deliciously. '*Guernica*, in particular, and the "red" Picasso, in general, have about as much appeal to the Spanish bourgeoisie as eating frogs' legs. It's something you have to do with your eyes closed, while thinking of something else.' Soon enough Alberti's fears of right-wing intolerance were confirmed. In October 1980 the artist José Ortega, who had been imprisoned by Franco and was still an active member of the Spanish Communist Party, had his retrospective closed down in Almagro, by the town Mayor Julio Ferro, on the grounds that it was an attack on the ideology of the ultra-right. 'If they can do this to me,' Ortega pointed out to *Pueblo*'s reporter, 'then I think it endangers a public viewing of *Guernica*, which is after all the ultimate pictorial expression of the battle against Francoist ideology.'

Slowly the plans to prepare the Prado annexe, the Casón del Buen Retiro, to house *Guernica* leaked out to the press. By mid-September 1980 MOMA's director Richard Oldenburg sent notice to Spain's Ministry of Culture that the painting was now officially at their disposal. MOMA, Oldenburg admitted in an interview, would be bereft without its star turn. The Picasso retrospective and *Guernica*'s imminent departure had proved a cash cow, with over a million

visitors and more than 130,000 catalogues sold. Gradually, through the cloud of misinformation and gossip a clearer picture of the painting's future slowly emerged. On 9 October the Spanish Congress refused Malaga's application to house the painting. The following day a last-minute request was put forward by the Basque Cultural Attaché Ramón Labayru and the Director of Bilbao's Museo de Bellas Artes, Javier Bengoechea, who claimed that their museum could guarantee all the conservation and security requirements. Curiously, the German magazine *Stern* reported at the end of the month that the Spanish government had given up on the idea of ever getting the painting back. Repeated in Madrid's *Sábado Gráfico*, it was a suggestion robustly denied by Iñigo Cavero, the Minister of Culture, and represented clearly yet another mischievous attempt to throw the negotiations off course. What it did provoke, however, was the setting up of a high-powered official *Guernica* commission that included the President, the Ministers of Culture and Foreign Affairs, and Javier Tusell serving as the Director General of Bellas Artes aided by Rafael Fernández-Quintanilla.

The first clear indication that the Spanish government was in the final stages of securing the painting came in December with a week-long visit to MOMA by Javier Tusell and the President of the Institute for Restoration, José Maria Cabrera, to discuss the practicalities and iron out the finer details of the complicated move. All seemed well in January, with Tusell and Fernández-Quintanilla's visit to Marseille and Aix-en-Provence to meet the Picasso heirs reported as a success in the press. This was all about to change. On 20 January 1981 Maya, the daughter of Pablo and Marie-Thérèse Walter, announced publicly that she felt Spain was not yet a credible democracy. Considering that Maître Dumas might be thinking on the same lines, this was profoundly worrying. It seemed, furthermore, that Claude Picasso shared some of the same misgivings. This was potentially far more dangerous as Claude's opinion often indicated the direction that Paloma and his half-brother Bernard might follow. Indeed, in the meeting that Tusell and Fernández-Quintanilla held with the Picasso clan there had already been

rumblings. At one moment, Bernard suggested it might be as well to wait ten years for Spain to calm down and get a clear view of how the democracy was going. To which Fernández-Quintanilla pointed out that he was sure Bernard would feel aggrieved if he was told that his inheritance was to be put off for another ten years. The moment passed. But what had really angered Claude was the central role in the negotiations that Dumas had played. In spring 1980 José Maria Armero leaked to the press that, in his opinion, the key moment in the whole negotiation had been Dumas's secret meeting back in March 1978 with King Juan Carlos, where in the name of the Picasso clan he had offered the painting back to Spain. Claude was so angry at one stage that, according to William Rubin, he had contemplated trying to divide the *Guernica* painting from its studies, and have all the oil sketches and preparatory drawings divided up as their joint heritage. The only person whom Dumas could speak for was Jacqueline, argued Claude. Indeed, back in 1970 both Paloma and Claude had taken out a bitter law suit against their father in an attempt to get themselves recognised as legal heirs. When this did not succeed, they tried to have their father declared mentally incompetent, a case that also failed.

Over the previous year the French *droit moral* – moral right – had often been raised in the *Guernica* case, and cited as relevant. It was a shadowy area, which did not apply in any Spanish or US court, but it was clearly not in Spanish interests to go against the *droit moral* of the Picasso clan. What *droit moral* protected was the Picasso family's right to insist on a professional, safe and appropriate display of *Guernica*, that in no way prostituted or denigrated the image. Claude went on the attack. In early 1980 he ordered his lawyer Jean-Denis Bresdin to alert both MOMA and Dumas that they saw Dumas's attempt to abrogate their rights as offensive. And that Dumas's self-aggrandising appearances on television completely went against his earlier promises to remain discreet. What Maya opened up, in her misgivings, however, was a far broader, often poisonous, debate with regard to Spain's suitability to receive *Guernica* at all. Having seen Paloma's successful manipulation of

the image through the Els Joglars fiasco, it was now Maya's turn to raise issues that cut right to the heart of the young and fragile democracy. What she objected to were the inflexible divorce laws, the lack of rights for children born out of wedlock, and the lack of change in personnel in both the army and the police force. She was, she told Fernández-Quintanilla, the most Spanish of all Picasso's heirs. Indeed, she had lived for a time in Madrid studying at the Lycée Français and on various occasions had been stopped by the police, questioned about her parentage and followed. What Maya insisted upon was that Pablo Picasso's requirement for a Republic to be in place before *Guernica*'s return was blatantly being fudged. Her final salvo concentrated on the recent decision not to let Spain enter immediately into the European Common Market, which she saw as highly significant, and suggested to her that the young democracy was essentially flawed. Many Spaniards prepared to look dispassionately at Maya's accusations could find themselves agreeing with many of her points. Feminism as a social phenomenon was relatively new, with the first protest march dating back to January 1976. Article 57 of the Spanish civil code, only repealed in 1975, still hinged on the concept of the *permiso marital* which stated that 'The husband must protect his wife and she must obey her husband.' With women's rights subjugated to their husbands' needs, women needed permission to do almost anything, including make a journey away from home. Upon entering marriage, women lost control over property and over their children, and in the case of a breakdown in their marriage were publicly humiliated.

In fact a new law on women's rights with regard to family finances was on the statute books even as Maya spoke. Some newspapers gently pointed out to her that democracy may function slowly, but uses the constitution, parliament and the judiciary, and relies on the due process of law. Furthermore, the *pacto del olvido* had provided an almost bloodless transference of power precisely because there had been no witch-hunts. Rafael García Serrano, in *El Alcázar*, was incandescent. Who in the hell did she think she was – Spain's conscience? A one-woman Spanish High Court? The Picasso family,

in his opinion, had always been a circus. Why, he asked, should Spaniards give into Picasso's wishes to see *Guernica* in the Prado just because he demanded it? Next, García Serrano argued, writers will be buried in the Biblioteca Nacional, just on a whim! In a less polemical piece, on 23 January 1981, Javier Tusell's assistant Alvaro Martínez-Novillo tried diplomatically to clear up the mess. Maya's opinions were personal. And, although they might complicate matters, they were not going to stop the negotiations. 'The problem of *Guernica*', suggested Martínez-Novillo, 'was a problem of national dignity.' Slowly, those claiming *Guernica* were building a consensus. Rafael Pradas, representing Barcelona City Council, retracted his claim to the painting, delaying the argument, he said, until it was firmly on Spanish soil. The Basques, however, were less willing to forfeit their claim. In mid-February, Bilbao's Museo de Bellas Artes announced its plans to house *Guernica* in a purpose-built, polycarbon cage, containing 12 kilos of anti-flammatory material and fitted with the most sophisticated infra-red security systems.

No amount of careful planning or tactful diplomacy could prepare those charged with bringing *Guernica* home for what happened next. The Spanish economy, not helped by galloping inflation brought on by the second Iran/Iraq oil crisis, was plunging into deep recession. There was growing unemployment, an increase in terrorist violence, a fall in income per capita in comparison to the rest of Europe, and a growth in days lost due to industrial action. During the first two months of 1981 the young democracy was to pass its most difficult test. President Adolfo Suárez had become arguably the first victim of 'Moncloa syndrome' whereby a beleaguered head of government retires to the calm of the Moncloa Palace and falls increasingly out of touch with deputies in the Cortes, his own party, and the country as a whole. By 1980 rumours about a possible military coup were common knowledge. On 26 January 1981 Suárez, who felt he had lost the confidence of the UCD (the Christian Democrats) party faithful, the parliament and the Zarzuela Palace, finally resigned. Within days he was replaced by his deputy, Leopoldo Calvo Sotelo,

but Suárez's televised farewell to the nation, in which he hoped that the democracy was not just 'a parenthesis in Spanish history', increased the inevitable sense of foreboding. On 23 February 1981 the Congress of Deputies met for the second time to vote on Calvo Sotelo, who had failed three days earlier to receive an absolute majority. At precisely 6.20 p.m. shots were heard in the corridors outside parliament, followed immediately by the entrance into the Congress of the moustachioed Lieutenant-Colonel Tejero and other members of the Guardia Civil. The feared coup, intent on setting back the clock, had actually begun.

There are as many versions and readings of the coup as there are conspiracy theorists ready to apportion the blame. Lieutenant-Colonel Javier Fernández Lopez, in his book *El Enigma del 23-F*, uncovered not one but three separate coups: one led by Tejero, another by General Armada, who hoped to instal the King as a puppet monarch, and finally, the military intervention in Valencia led by Milans del Bosch. Many historians favour a more simple division between a 'hard' and a 'soft' coup, with Tejero and Armada performing their respective roles. Regardless, the most important key to either success was the position adopted by King Juan Carlos, who spent a good part of the evening at the Zarzuela Palace on the phone trying to sound out how much support Armada enjoyed and encouraging wavering generals to step back from the brink. At 1.20 a.m. on 24 February 1981 the King, in full uniform as Commander-in-Chief, pronounced to the nation that he was unequivocally against any illegal action that failed to recognise the democratic Constitution. The coup had failed. But, as Calvo Sotelo later pointed out, the road to a re-establishment of confidence was far from smooth. As president he enjoyed a limited mandate from which to lead the country back to stability. His great achievement was to re-establish and maintain a full working democracy during a period in which Spain suffered from the highest unemployment since the Second World War, and there still remained a disaffected military; two further mini-coups were fortunately prevented.

The effect of 23-F on the *Guernica* negotiations could have been

catastrophic. What was remarkable, however, was the speed with which all parties, from Dumas, the Spanish government and the Picasso family to the trustees of MOMA re-established negotiations. Two days after the failed coup *El País* could report that the '*calvario*' of the repatriation was reaching its endgame. Fortunately, Dumas had signed a document just two days before the coup insisting that *Guernica* should travel as soon as possible with no further impediments put in the way, or excuses found to stall its imminent release. If Maya and Claude had been right to voice their suspicions, the Spanish government was now quick to try to coax them back on board. An official statement left no doubt: 'The Spanish government has a profound desire to include the Picasso heirs in the repatriation of *Guernica*, which symbolises a reconciliation of all Spaniards in peace and democracy.' Never had *Guernica*'s power as a symbol been so potent and essential to the well-being of the Spanish state. Never had it carried so much expectation or such much weight. In essence, it was true, Spain's passage through this latest trial and the King's remarkable test of character had paradoxically proved the democracy's maturity. Despite the alarmist and apocalyptic tone of the French press, and the reviving of 'historical demons', not even Maya's reservations could prevent the painting's return. She capitulated to the inevitable and signed her rights away.

Despite Maya's acceptance there were still other voices critical of any attempt to speed up the process of repatriation. At a Picasso homage in Barcelona, organised by the Caja de Ahorros de Barcelona in early March, Rafael Alberti again reiterated his position that this was the most dangerous moment of all to contemplate *Guernica*'s return. A month later, looking at the work for the last time in MOMA, Alberti, no doubt recalling the terrorist attacks of the previous decade, mused: 'It's a painting of great emotions. But it is also dangerous. It has to travel to a Spain that is secure and will do it no harm. The painting was painted for Spain and destined for Spain, but it certainly still has millions of enemies in its home country.' William Rubin, in the name of MOMA, pointed out that he still had

grave misgivings about the painting's release, stating correctly that the museum would be in breach of the law if it acted without Claude and Bernard's consent, which the half-brothers still withheld. On 24 March 1981 the new Minister of Culture, Iñigo Cavero, stated firmly in an interview in Paris that while it was clearly desirable, Spain was under no obligation to respect the family's *droit moral*. Soon afterwards, Jacqueline, surrounded by her friends Hélène Pármelin, Edouard Pignon and Louise and Michel Leiris at an exhibition of Picasso portraits in Lille, expressed her full support of Parmelin's statement that spoke of *Guernica*'s potentially positive role in 'consolidating the democracy'. For a successful conclusion to what many described as the longest running soap-opera on record, what was needed was people with the vision to look to the future rather than merely brooding on the failings of the past. The message seemed to reach MOMA. To counter the accusations that the museum was involved in a cynical stalling game, their spokesperson Louise Kreisberg went on record on 29 March 1981, stating categorically that in the revamp of MOMA no space had been allowed for *Guernica*. All seemed well. However, a few weeks later United Press International reported that another MOMA spokesperson, Louise Veraart, was now suggesting that the painting would not be released until the end of the year. The following day, however, it became obvious that, like the article in *Stern*, this had been yet another episode in the war of disinformation. Veraart did not exist.

In mid-May, once again, new petitions for the painting arrived from Malaga, and for the first time a serious proposal arrived from Gernika itself. In Bilbao an official jury, which included intellectuals and artists of the calibre of the Catalan architect Oriol Bohigas, the sculptor Chillida, the Italian architects Quaroni and de Feo and the social-anthropologist Julio Caro Baroja, studied proposals for a museum in Gernika to house *Guernica* and awarded the prize to the Vizcayan partnership of Ruiz and Pagola. What the competition, sponsored by the Basque government and the Vizcay County Council, hoped to provoke was an understanding in Madrid that

they were prudent, serious and competent, and that these grounds, at least, could never be used as reasons to disqualify their rightful claim. What Javier Tusell, the Director General of Bellas Artes, insisted on, once again, was that *Guernica* should arrive back in Spain before they even contemplated discussions as to its final destination.

By the end of June it became blatantly obvious in which direction the government intended to move. On 23 June 1981 the newly restored Lucas Jordaens ballroom in the Casón del Buen Retiro opened to the public, with a full-scale photographic mock-up of *Guernica* placed in its intended space. The Picasso family had still not managed to resolve their differences but promised that they would come to a final decision within fourteen days. In early July Javier Tusell received the long-awaited reply. To everyone's relief it was positive. Maya, however, used this last opportunity to express her misgivings, and to record that although the decision respected the majority wishes of the family, it was against her will. After years of behind-the-scenes negotiations the commission set up to repatriate *Guernica* had finally won. All it now required was careful and secretive planning for the painting's return. As summer turned into autumn the press continued to try to outguess Iñigo Cavero and Javier Tusell, whose answers to their probing questions had become increasingly guarded and discreet.

On 9 September 1981 Cavero confirmed that he, along with Nelson Rockefeller's widow Blanchette, had signed the official papers authorising the release and transport of Picasso's masterpiece in New York. The press predicted that *Guernica*'s return to Spain, celebrated with all due pomp and circumstance, would coincide with King Juan Carlos's forthcoming official visit at the end of the month. MOMA, however, much to the approval of the *Guernica* committee, felt this would take too long and was too risky. The museum had already been receiving anonymous threats with regard to the painting's safety.

As Cavero was signing its release, the conservation experts were already preparing to lower the image off the wall just as the last

visitors were leaving MOMA. Some of MOMA's staff were already moved to tears as *Guernica* was taken off its stretcher for the last time, rolled and crated up. Possible replacements had been earmarked: Picasso's *Charnel House* or Pollock's *One*. But nothing would ever fill the gap. By 1 a.m. the masterpiece was ready to start out on its long journey. Smuggled out of the back door, it set out through the Manhattan traffic, brought almost to a complete standstill by a power failure. Travelling out to the airport under heavy police escort, there was fortunately no repeat of the heist in June when forty of Marina's Picasso engravings had been stolen from a van. After an hour and a half's delay, flight IB 952, Iberia's appropriately named jumbo jet, *Lope de Vega* – the only Spaniard whose prolific output could ever rival Picasso's – took off across the Atlantic. In amongst the passengers, plainclothes detectives remained vigilant throughout the seven-hour flight. For Cavero and Tusell, both on board, it was a defining moment. For almost four years, aided by Fernández-Quintanilla, the President and the King, they had doggedly persevered, despite the setbacks. 'I'm emotional. Very emotional,' Cavero told a select group of reporters, poised ready with a glass of champagne. '*Guernica*'s return to Spain symbolises the consolidation of democracy and the end of the transition.' Waiting for them nervously on the tarmac at Barajas airport in Madrid were Justino Azcárate, who years earlier in the Senate had called for its return, Joaquín Tena, Rafael Fernández-Quintanilla, Pita Andrade, representing the Prado, and the artist Eusebio Sempere. At 8.30 p.m. on Thursday, 10 September 1981, the *Lope de Vega* touched down. The welcome committee appeared moved as they watched the wooden case lowered down slowly from the plane. Iñigo Cavero observed poignantly, 'Today the last exile has returned to Spain.' It was a fitting tribute.

The following day, 11 September 1981, the *El País* art critic Francisco Calvo Serraller, in tune with the general mood, stated unequivocally that *Guernica*'s arrival on Spanish soil meant nothing less than 'the return of our national dignity'. 'Its exile',

Guernica arrives in Spain, 1981.

he argued 'has always been an offence to our dignity . . . and highlighted our inability to live in peace.' *Guernica*'s arrival brought back dignity. That was indisputable. But it also led on to the ultimate unresolved question as to exactly where it should go. Cavero, as Minister of Culture, had unequivocally pronounced the Prado as the fitting place. But the PNV – Basque Nationalist Party – spokesman was aggrieved and felt deeply humiliated: 'We gave the dead, while you get the painting.' Dionisio Abaitúa, Gernika's Mayor, was also angry at the hijacking of the image. Now, if ever, was the right time to do justice to the Basque country. Carlos Garaikoetxea, the Basque President, stated in no uncertain terms that *Guernica*'s return to Gernika was the moral reparation due to them in part-payment for having suffered such an appalling histor-ical drama. For the moment, the Ministry of Culture remained deaf to their emotional pleas. It had more immediate considerations, namely, the successful installation of the painting before Picasso's centenary on 25 October.

A 200-peseta stamp had been designed to celebrate the painting's

arrival. But it was clear that what the public really wanted was to see the image in the flesh.

In the Casón del Buen Retiro the bomb- and bullet-proof protective glass screens that had been placed a safe 5 metres distance away from the image, were already in place, as too were the electronic surveillance systems and climate control. All that remained was the long-awaited arrival of the painting and the careful coordination between the Prado's experts and two MOMA conservators flown in specially to oversee the restretching. By 15 October 1981 everything had fallen into place. In just nine hours *Guernica* was restretched and carefully treated to remove the creases and stop them from developing into cracks. Under the vigilant eyes of the MOMA personnel, José Maria Cabrera's team completed their work without a single hitch. A week later the official celebrations were ready to begin. On 23 October 1981 a semi-official pre-preview had been planned for the Madrid art world and some of Picasso's friends and family. Paloma, it seemed, was the only one

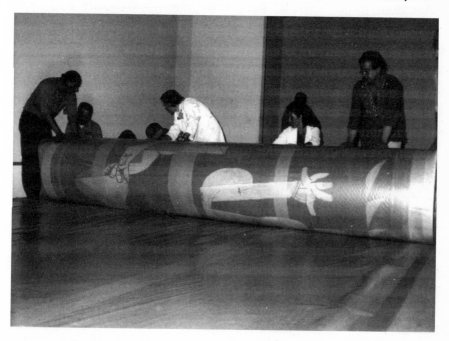

Guernica, it's final unrolling, 1981.

prepared to come. Having been kept completely in the dark as to the timing of *Guernica*'s departure from MOMA, the family were almost unanimous in their disapproval of the Spanish government's handling of the whole episode. As far as they were concerned the government, through bad manners and bad faith, had forfeited the right at any time in the future to expect any sort of help with possible loans. It was a strong reproach, but not strong enough to spoil the party.

By midday the Casón del Buen Retiro was beginning to fill. Joan Miró had declined the invitation gracefully, stating that it was Picasso's day and he might be overcome by emotion. But slowly faces from Spain's past began to arrive. There was Eugenio Arias, Picasso's barber and friend, Josep Lluís Sert, Josep Renau, the Director General of Bellas Artes for the Republic in 1937. All had come to pay homage and witness the historical event. What an incredible distance Spain had travelled in just ten years, acknowledged *El País*. In 1971 there had been official prohibitions against any celebrations, and attacks on Picasso's work. But now *Guernica* was transformed into a symbol of reconciliation, an image that stood for peace. Just a few months before, reproductions of the painting were visible everywhere at anti-NATO demonstrations in Cordoba and Madrid. Now, gathered together in the Casón del Buen Retiro, the group of distinguished visitors could reflect on their collective destiny and encounter an image that had shaped their visual and moral world like no other. Nothing, however, according to Daniel Giralt-Miracle, could compare that morning to the extraordinary moment that seemed completely unchoreographed and brought together so many different worlds. As Javier Tusell introduced *Guernica*'s new installation he suddenly offered the select group a unique chance to enter the protective glass cage to see the painting face to face. Alongside Sert and Renau stood the legendary Dolores Ibárruri, 'La Pasionaria', Communist Party activist and Civil War heroine of the Republic, and next to her Leopoldo Calvo-Sotelo, President of Spain, whose monarchist family had been intimately linked to the

beginnings of the Civil War with the assassination of the right-wing José Calvo-Sotelo. On either side of the group stood the Guardia Civil in their tricorn hats protecting an image whose essential meaning had been attacked just eight months before by Lieutenant-Colonel Tejero on F-23.

Iñigo Cavero, as Minister of Culture, briefly took the lead. '*Guernica* is a scream against violence, against barbarism, against the horrors of war, against the denials of civil liberties that an armed insurrection implies. This painting is no longer the banner of any single group. *Guernica* is now the patrimony of all of Spain.' Daniel Giralt-Miracle turned to his colleague the art historian Maria Luisa Borras and whispered, 'We are living history.' There was a moment's silence. And then 'La Pasionaria', whose extraordinary gift for rhetoric had fired up so many Republican soldiers during the Civil War as they lay in hopeless trench positions trying to save Madrid, spoke quietly: 'The Civil War has ended.' Spain had won back its *Guernica* after a battle of more than forty years.

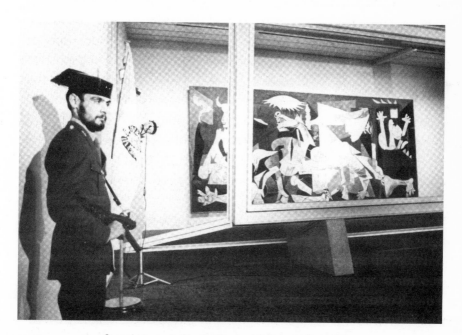

Guernica guarded in the Casón del Buen Retiro, 1980s.

11

The Final Journey

Dawn is breaking over Spain, and that dawn is today, breaking with the shadows of the past.

Dolores Ibárruri, 'La Pasionaria'

In art there are only two types of people: revolutionaries and plagiarists. And, in the end doesn't the revolutionary's work become official, once the state takes it over?

Paul Gauguin, *The Writings of a Savage*

For Josep Lluís Sert his re-encounter with *Guernica* in its new setting in the Casón del Buen Retiro almost certainly overwhelmed him with a host of conflicting emotions, ranging from anger to nostalgia, and from disappointment to pride. The Casón as an exhibition space was overbearingly formal, heavy and imperial. It was in complete contrast to Sert's 1937 pavilion, where the pared-down Mediterranean classicism, flooded with natural light, had provided the perfect counterpoint to Picasso's *Guernica*. In Paris, this setting had energised the image. It was also the first time that the public had ever seen the painting. Four decades later, in the revamped Casón, all that wild, hopeless optimism and the thrill of coming to the painting fresh had disappeared. Instead, it was Jordaens and his baroque depiction of the triumph of the Golden Fleece, covering the entire ceiling, that cast its long shadow over the Casón. In such circumstances *Guernica* could not help but appear an intruder.

Since Franco's death, life in Spain had changed dramatically. But *Guernica* too had changed. Where once it had appeared shockingly

novel, it was now transformed into a world-famous icon, increasingly weighed down by the heavy baggage of forty-four years in the public domain. In its cocoon of bomb-proof glass in the Casón it appeared heavily sedated, like a modern-day holy relic that was no longer quite part of our immediate physical world. Distanced from touch, and breathing a different air, it had somehow become less vital than before. And, as a fragment of history, it appeared now as precious as a rare Egyptian papyrus and as fragile as the Roman frescoes in the the Villa of the Mysteries. Had it lost its power to shock? Or, as Alberti had warned, its danger? It was too early to conclude. Through its own transformation *Guernica* had helped psychologically to facilitate Spain's transition into a democracy. This was its new meaning. For that reason alone it was better to play safe and keep it guarded in its gigantic glass catafalque.

On that first afternoon, Sert wondered at the almost Surrealist absurdity of seeing President Calvo-Sotelo alongside 'La Pasionaria', and both introduced to *Guernica* by the Director of the Prado, himself an ex-priest. It was a scene straight out of a movie by Buñuel. Sert pondered over the power of the image and the changes that had occurred. Surveying the scene, he could only have concluded that the only common ground shared by Jordaens, nicknamed '*fa presto*', and *Guernica* was in speed of execution. There was something disjointed and melancholy about the awkward installation, something disturbing about seeing one of the twentieth century's most brutal images in a palace setting. *Guernica*'s presence in the Casón had transformed a seventeenth-century ballroom into a morgue; a place of pilgrimage, like descending down into the Royal Pantheon at El Escorial, past the putrefaction chambers, to pay homage in the chilling surroundings to the long-dead Spanish kings. 'Here it is now,' observed Sert, 'in the neolithic Casón, just like a primitive cave painting trapped in intensive care.' It was a poignant observation.

Despite the uncomfortable surroundings *Guernica*'s power of attraction had in no way diminished. For the satirist and political commentator Francisco Umbral its hold over the Spanish public

was reminiscent of the queues waiting on the other side of the Paseo del Prado at the devotion of the Christ of Medinaceli. For Umbral, despite *Guernica*'s state of internal exile, caged as it was in its giant glass urn, people were witnessing the birth of a new cult. In the first two days alone more than 5,000 visitors passed through the Casón's doors. And, as has now become the norm, the *Guernica*-inspired merchandise, from stamps, posters and catalogues to bags, flew off the shelves. No wonder MOMA had been only too happy to remain its custodian for as long as the negotiations had taken. It was curious but also powerfully symbolic that, at the large Picasso retrospective opening on the other side of Madrid at the Museo de Arte Contemporáneo in celebration of Picasso's centenary, the wooden packing case that had brought *Guernica* back from MOMA across the Atlantic to Spain was carefully displayed like a holy relic.

As King Juan Carlos and Queen Sofía arrived on 6 November 1981 to see *Guernica*, to the rapturous applause of the assembled crowd, it was obvious that the picture's repatriation had been a complete success. There were few people ready to complain. Douglas Cooper, the great collector of Picasso's Cubist period, thought it magnificent. Paloma Picasso grudgingly admitted that she felt it was better displayed in the Casón than it had been at MOMA. But there were already some dissenting voices. The Basques were not about to relinquish their claim to the painting. Nor, more specifically, was the population of Gernika. Other critics were quick to point out that however it was dressed up, or however much sophistry was employed, the Casón was not the Prado. It was an argument that over the years would slowly gain weight. It was obvious that displaying *Guernica* in the Casón del Buen Retiro had been no more than an improvised solution, a quick fix to speed up its repatriation. But the longer it stayed there and the more *Guernica*'s status had become normalised and less polemical, the easier it was to begin to judge the painting's display by other criteria. *Guernica* in the Casón was a travesty. In terms of curatorship and museology it was a failure. Sidelined in the unfortunate context of the Casón, the painting had

the freakish air of an outdated anachronism that no longer played a central role in the history of Spanish art.

In late October 1982 the Spanish electorate underscored their dramatic transformation into a full democracy by voting in the PSOE Socialist government of Felipe González. For the great majority of the population it was a moment for riotous celebration, symbolising as it did the final nail in Franco's coffin. But for González and the PSOE this was not a time to sit back and reflect on the past, but a moment to leap up and grab the possibilities of the future. Much of the subsequent criticism of PSOE has been coloured by remembering too closely their final declining years in power from 1993 until their defeat by President Aznar's right-of-centre Partido Popular in 1996, accompanied as these years were by numerous financial and political scandals, rumours of dirty tricks in the war against the Basques and a dramatic economic downturn. It is harder perhaps to think ourselves back to the heady optimism of the 1980s as the PSOE juggernaut drove Spain forward towards the mythic year of 1992 when Seville hosted the Expo, Barcelona the Olympic Games and Madrid was named Cultural Capital of Europe. These were the years of Madrid's 'Movida', an irreverent and dynamic youth movement whose hedonistic explosion of creativity was captured in the films of Almodóvar, and the nervous faux-naif energy that was distilled in the graphics of Mariscal.

After PSOE's 1982 election victory it quickly became clear that President Felipe González held extraordinary ambitions for Spain. Wedded to the European Social Democratic organisation, González was essentially an internationalist whose visions of the future were not prescribed by an obsessive Hispanocentrism. One of his first moves was to name the prestigious economist Miguel Boyer as Minister of Economy. Trained at the Bank of Spain, Boyer brought continuity to an economy that, despite growing unemployment, would soon enter an almost decade-long boom. But it became apparent that PSOE also had far-reaching ambitions for culture that went way beyond merely disarticulating the suffocating

structures of patronage and censorship that had been constructed under the Franco dictatorship. It was a moment to re-read Spanish culture. A moment to give voice to the shibboleths that might come to symbolise the new Spain. By 1987 it had become obvious that the Ministry of Culture was already envisaging *Guernica*'s new role in this changing state. In December 1987 Javier Tusell, who had returned to his role as one of Spain's pre-eminent contemporary historians, wrote an open letter to the editor of *El País*. It was with some anger that he responded to the rumours that *Guernica* was about to be moved elsewhere, a suggestion which ran contrary to all the promises made to MOMA and the Picasso family. If this was to happen, concluded Tusell, and counter to all of Picasso's personal wishes, the work would be better off exhibited in Gernika itself.

Aware of Tusell's pleas, the Ministry of Culture nevertheless continued to rethink the possibility of using *Guernica* as part of a larger plan to re-energise the concept of a new and vital Museum of Contemporary Art. This was not an entirely novel idea. It was exactly the role that *Guernica* had played back in the late 1930s and '40s when Barr had so successfully projected across the world the image of the pioneering Museum of Modern Art. In the Casón, *Guernica* had been sidelined. In some senses it was already dead, removed as it had been to the status of historical artefact. But it proved perhaps more than coincidental that the Museo de Arte Contemporáneo, isolated and unvisited as it was out in the University quarter, despite the enormous boost given to it by the Picasso retrospective back in 1981, was also terminally ill and haemorrhaging cash. The Ministry of Culture had now begun to focus on a new project to rival Mitterrand's '*grands projéts*' like La Défense, and one which might eventually rival even Washington's Mall. If successful, it would put to sleep for ever the isolationist, self-obsessed discourse of the Franco era. At the heart of the project lay the Prado, a unique and unrivalled institution. But modern art also needed a venue. Opposite the Atocha railway station was Sabatini's austere eighteenth-century General Hospital de San Carlos – perhaps an unlikely space for a contemporary art museum, but its very

blandness played in its favour, lending it an immense flexibility, a quality essential when exhibiting the scale, range and complexity of contemporary art. Since the building's opening as an art centre in 1986, Carmen Giménez, Director of Exhibitions, had used the temporary space to put together some of the most exquisitely hung exhibitions ever seen. From the staggering display of all the Matisses in Russian collections to a careful selection of the masterpieces from Washington's Phillips Collection, from the encyclopaedic Nasher collection of modern sculpture to the unrivalled collection of Count Panza di Biumo's conceptual art, the Spanish art-loving public was taken on a breathtaking, breakneck tour of twentieth-century art. Through exhibitions of Joan Miró, Julio González, Pablo Picasso and Sert's 1937 Spanish Pavilion, many of the audience were introduced for the very first time to the defining moments and manifestations in the history of both modern art and modern Spanish art. On 27 May 1988 the Museo Nacional Centro de Arte Reina Sofía (MNCARS) known colloquially as the Reina Sofía, the name of its patron, gained official museum status.

For many of its curators and directors the early years of the Reina Sofía proved as dynamic as they were blighted. One problem was the immense space available, that begged to be filled. Another problem, closely related to the first, was that due to Franco's policy of cultural isolationism the contemporary art collection still in storage over at the Museo de Arte Contemporáneo was poor, if judged by international standards. In the interim years the art of Miró, Picasso, Dalí, Gris and González had also become impossibly expensive whenever exceptional pieces came up on the open market. Another far more subtle problem, and one that would take more than a decade to readdress, was that Franco's isolationism resulted in an almost total ignorance outside Spain of the work produced under the dictatorship, causing the 'writing out' of Spanish art from the history of modern art – excepting, of course, the work of the exiles like Picasso who had been branded 'honorary' Frenchmen, and the fortunate few like Chillida and Tàpies who escaped the Francoist stigma. This resulting sense of cultural inferiority, a self-fulfilling

concomitant of Franco's cultural policy, could only be combated by transforming the Reina Sofía into an internationally recognised museum where the best of home-produced art could face up to the challenge of the best of world art and live comfortably beside it. Central to the achievement of this ambition would be *Guernica*.

Within a month of the Reina Sofía acquiring national museum status, Carmen Giménez was ignominiously dismissed, to be replaced by Tomás Llorens, the founder of IVAM, Valencia's contemporary art museum. In September 1990 Llorens, despite very real achievements that included the setting up of the research library, went the same way as Giménez. Sacked by the Minister of Culture, Jorge Semprún, an ex-Communist militant, Llorens suggested that it was his request for *Guernica* that had provoked his demise. What was certainly true was that the Reina Sofía often resembled a building site. From its initial architect Antonio Fernández Alba, who resigned, and on through the teams of Vellés and Feduchi, and the Catalans Correa, Elías Torres, Bach and Mora, the Reina Sofía restoration project eventually passed to Antonio Vázquez de Castro and José Luis Íñiguez de Onzoño. Despite the architects' best attempts, the rapid turnover of Ministers of Culture and Museum Directors made life difficult. A lack of continuity and ever-changing criteria turned the Reina Sofía into a designer's hell. Slowly, however, the giant project was brought under control. The driving force was a new director, María de Corral, brought in from the commercial art world where she had been a dealer and later head of acquisitions for the Catalan bank La Caixa. She was dynamic, opinionated and well connected. Her passion, which would later bring an imbalance to the collection, was for American-inspired conceptual art. To her credit, however, she also forced through the rationalisation of the collection inherited from the Museo de Arte Contemporáneo, and formalised the ceding of key works by Picasso, Miró and Dalí to the Reina Sofía. Her greatest achievement was without a doubt her hand in the negotiations to transfer *Guernica* from the Prado to the Reina Sofía. Where Llorens and Semprún had come unstuck, Corral in contrast enjoyed the full support of the new

Minister of Culture, Jordi Solé Tura, who in turn drew on the direct confidence and authority of President Felipe González.

It soon became obvious that *Guernica*'s power to stoke up heated debate and bitter polemic had not been entirely extinguished by its stay in the Casón. This time, however, it had nothing to do with the prickly issue of where it was best seen and whether the Basques' moral right to exhibit the picture was legitimate. Instead, it was *Guernica*'s enduring ability, even in reproduction, to provoke intense feelings that was to explode in the press. Picasso's work had only rarely been used in advertising. It was too expensive and the rights were too carefully controlled. (As early as 1939 *Time* magazine had jokingly suggested that as Picasso enjoyed such prodigious output one day there might even be a tie-in with Citroën – a Picasso with every car.) In September 1990 the Federal German Republic's armed forces, the Bundeswehr, chose *Guernica* as an advertising image. The choice of image was both crass and grossly insensitive. Günter Grass, only months after German unification, was quick to criticise his own government and Armed Forces Minister. If anyone had forgotten that it was German Heinkels and Junkers of the Condor Legion that had visited their holocaust upon Gernika back in 1937, Grass forcefully reminded them of their historic responsibility. Bordering the image, alongside the emblematic iron cross that had so terrorised earlier generations, the text read, 'Hostile images of the enemy are the fathers of war.' With no mention of Germany's part in Gernika, the text lent the composition a confusing ambiguity. What is the hostile image? And hostile to whom? Whose war? Which war, which enemy? Only months after the collapse of the Berlin Wall, and with German military involvement in the first Gulf war, Grass felt that the use of *Guernica* in an officially sanctioned Bundeswehr advert was both dishonest and misleading, and nothing short of a profanation of Picasso's sacred work. At the very least, Grass demanded, President Richard von Weizsacker should request that the German Minister of Defence offer an apology to the people of Gernika.

Those in Gernika were perhaps less harsh than Grass. Gernika's

Mayor Eduardo Vallejo de Olejua requested that the Bundeswehr desist, on grounds of bad taste, from employing the image for advertising. Germany's Defence Ministry argued that it was precisely because of *Guernica*'s power to scream outrage against all brutal wars that they had chosen the image to waken up Germany's collective conscience and provoke a public debate. The image, they suggested, was so well known that it hardly needed explaining that German bombs had destroyed the Basques' spiritual home. It was true, even some Basques were prepared to agree, that the German army of today, predominantly a peace-keeping force, bore no relation to its Nazi past. For the artist Agustín Ibarrola, however, the advert was a direct insult, not far in its thinking from that which had occasioned the original act. Juan Gutiérrez, a member of Gernika Gogoratuz – In Memory of Gernika – found the mere choice of the image as an advertisement for a military force alarmingly perverse. For reasons of tact the adverts were suppressed.

Mayor Vallejo de Olejua now had other more pressing concerns. Rumours of *Guernica*'s imminent move to the Reina Sofía provoked an immediate reaction from him. If the painting was now fit to move, why not to Gernika, he asked. At every twist and turn the Madrid government had put up obstacles. First, Vallejo pointed out, the Ministry of Culture had declared that there was no adequate space. The Palacio del Conde de Montefuerte was acquired. Then they demanded security, to which Vallejo responded with a guarantee of twenty-four-hour vigilance and protection. Then there was the problem of transport. If it could travel to the Reina Sofía, why not just a few hundred kilometres more, argued Vallejo. 'We will keep demanding it until the day it's here,' he told reporters on 23 October 1991.

Just days before Vallejo's pronouncement the Reina Sofía handed out a press release explaining that, although it had reopened for the second time a year before, it would have to embark upon yet another round of lengthy renovation works. What was becoming obvious to the public was that the Reina Sofía, like its predecessor the Museo de Arte Contemporáneo, was draining the Ministry of Culture's coffers

at a frightening rate. What Jordi Solé Tura needed was a guaranteed success. A success that was bought, some cynics argued, on the back of *Guernica*. All eyes at the Ministry, harped those critical of the impending move, were transfixed by the image of whirring turnstiles rather than readdressing the problems of the painting's display.

Solé Tura was not easily put off. As a choice for Minister of Culture he would prove inspirational. From early beginnings as a left-wing intellectual to his leading role as one of the 'fathers of the constitution' in 1978, he had become recognised as a highly effective politician of immense integrity; principled yet pragmatic, always discreet yet counterbalanced by a disarming honesty. The announcement of the proposed move of *Guernica* demanded a carefully orchestrated publicity campaign, calling for support from Spain's intelligentsia, press and artists, and required strong pressure to be placed on the Prado trustees to relinquish the work. May 1992 was the key month to play out the strategy, which if successful would release *Guernica* from its years of imprisonment and allow it to play a vital role in the ongoing story of Spanish modern art. Naturally, the first to raise his voice against the plan, and not without justification, was Mayor Eduardo Vallejo. However, there were other temporary claims, most notably from the city of Barcelona, whose Mayor Pascual Maragall had sponsored the painstaking reconstruction of an exact facsimile of Sert's Republican Pavilion near to the new Olympic installations up in the Colserrola hills at Vall d'Hebron. To complete the exhibition, Picasso's *Guernica* would have transformed it for a few months at least, while the eyes of the world were focused on Barcelona, into a mecca for art lovers, historians and the general public, affording a unique insight into a different world and offering a moving and privileged view of the Republican Golden Age. The fact that both Solé Tura and the Vice-President Narcís Serra came from Barcelona suggested to some that Maragall's petition might enjoy favour. But it was not to be. In what would soon become an increasingly familiar story, it was just one more unique opportunity missed. *Guernica* was too sick to travel. Too fragile to risk anything but its final, final move.

Of immense importance in the whole issue of the transfer was the favourable opinion of Spain's living artists. There were a few dissenting voices, and brave ones; considering that to disagree with Ministry of Culture policy jeopardised the possibility of showing, in the short term at least, in what was destined to be Spain's premier museum. For José María Sicilia, perhaps forgetting that the Spanish state had actually acquired the painting back in 1937, it was merely a question of etiquette. 'If you accept a present, you should respect the conditions under which it was given.' But Sicilia was isolated. Most artists welcomed the idea of bringing *Guernica* back into circulation: without it, it was difficult to make any real sense of twentieth-century Spanish art. Not surprisingly, for Antonio Saura, for whom *Guernica* represented nothing less than the image of the twentieth century, the arrival at the Reina Sofía would bring the image back to life, instead of allowing it to moulder away in its mothball existence in the pompous Casón. Perhaps the most powerful voice in favour was that of Antoni Tápies. Subconsciously or not, Tápies' choice of phraseology echoed exactly the words used by Picasso on hearing of Paul Cézanne's death. 'In the Reina Sofía,' argued Tápies movingly '*Guernica* will be the star piece that makes sense of all the rest of Spanish contemporary art. It's as if, finally, contemporary art is back in the presence of its father.'

Within parliament Jordi Solé Tura enjoyed almost unanimous cross-party support for his plans. Once again only the Catalan and Basque parties remained in opposition, confirming what they saw as the underlying 'centralism' of all of Madrid's policies regarding the periphery. From outside Spain, however, there was blistering criticism. Hélène Pármelin and Edouard Pignon were absolutely scandalised by the move, claiming that they had heard from Picasso's own lips no less than a hundred times his desire to see his work hanging in the Prado alongside Velázquez, El Greco and the lacerating Goyas of the 'Black Paintings', the *Caprichos*, the *Desastres* and the devastating *Third of May*. William Rubin was equally opposed to the move that ran counter to all the conditions of the

picture's release from MOMA just eleven years before. On 13 May 1992 Solé Tura put an end to any speculation. *Guernica*, if agreed by the Prado trustees, would only leave the Casón to travel the 800 metres to the Reina Sofía. All other petitions would be ignored. Confirming what Mayors Vallejo and Maragall already suspected, Solé Tura added: '*Guernica* is a symbol of the whole nation. The most logical and coherent way forward is to exhibit it in the national state museum for contemporary art.' Having previously discounted Barcelona and Gernika's claim, on the grounds of safety, it was a logic that was hard to refute.

That the vote of the Prado's Patronato, the twenty-three governing trustees, was already a foregone conclusion was signalled by the Ministry of Culture's prior scheduling of an official press briefing, featuring the Presidents of the Reina Sofía and Prado's board of trustees, to take place immediately after the vote. On the day of the vote, 19 May 1992, Francisco Calvo Serraller, Spain's most influential art critic, went on the attack. In a woundingly direct analysis, Calvo Serraller's article, entitled 'Por qué?' ('Why?'), has taken on the mythic proportions of Zola's *J'Accuse* within the world of Guerniciana. For Calvo Serraller, the *Guernica* transfer was nothing more than the most cynical form of window-dressing, a way, he argued emphatically, for the successive Reina Sofía directors to disguise their inability to create a coherent collection. If they had done so, *Guernica*'s arrival would be a coronation, a 'happy ending'. But, what Calvo Serraller balked at was the Ministry's secrecy and reckless imprudence in rushing through the move before the Reina Sofía's identity and reputation had been firmly established. It was a clear case, in his opinion, of putting the cart before the horse. How, he asked, could the Ministry legitimately deny the Basques and Catalans their rights, while constantly insisting over the previous decade that Picasso's heartfelt wish was to see his historic masterpiece hanging in the Prado?

As expected, the Prado's Patronato voted almost unanimously in favour of the transfer, with only four abstentions. It was perhaps a curious decision, considering today's obsession with audience

ratings. But the Prado, cushioned by its extraordinary holdings of Golden Age art, could afford to follow government policy. Indeed, the rationalisation of the two museums brought some nineteenth-century masterpieces over to the Prado where previously they had languished in the storerooms of the Reina Sofía. If rationalisation was the prime objective behind *Guernica*'s move, the spill-over effect was to revitalise that whole area of Madrid. Rafael Moneo had restored the nineteenth-century cast-iron Atocha railway station into an astonishing tropical garden ready to receive the first travellers from Seville's Expo on the AVE high-speed train. Across the road rose the Reina Sofía, and on the other side of the busy roundabout the imposing Beaux Arts edifice of the Ministry of Agriculture, that Solé Tura hinted might one day locate a nineteenth-century museum not unlike Paris's Musée d'Orsay. With *Guernica* at the Reina Sofía, a redistribution of world-quality masterpieces balanced the scales, particularly important as opposite the Prado the legendary Thyssen-Bornemisza collection was scheduled to open to the public later that October. What González and Solé Tura had read perhaps better than anyone else was the intimate link between culture, tourism and urban regeneration. It was a lesson that the Basques had also learnt as they were midway through the process of committing themselves, against a barrage of mockery and jokes about tilting at windmills, to the building of Frank Gehry's landmark Guggenheim Museum amidst the industrial decay of Bilbao.

All that now remained was to prepare the fine detail of the technical and security requirements for an effective and foolproof transfer of the masterpiece. It was clear that in the case of an accident, an act of terrorism, or some other tragic outcome, no one would ever forgive or forget those who had assisted in the destruction of such an emblematic icon. Careers and reputations, and possibly even the PSOE government, depended on a successful outcome to the events that had been set in play. In recent reminiscences Jordi Solé Tura re-emphasised the dangers. With the move, 'you gamble absolutely everything, because if by chance anything

had gone wrong they would have assassinated me'. Never in the history of art, save perhaps the restoration of Michelangelo's Sistine Chapel or Leonardo's *Last Supper*, has an art work's state of health been so painstakingly documented. From the earliest meetings with the Prado's conservation experts and curatorial staff the decision was taken that *Guernica* could never again afford to be unstretched and rolled. Its vast dimensions required an innovative system. Already work had taken place to ensure that the Reina Sofía's service lift could accommodate the painting. But to keep *Guernica* stretched immediately demanded that the wall of the Casón would have to be broken through, endangering the safety of Jordaens' work, and that a transporter would have to be customised. In the Reina Sofía María Corral had allocated *Guernica* a recessed alcove on the south-facing wall of the second floor, nicknamed El Grano (the grain store), which had the advantage of being easily closed off by protective glass in a way that was far less intrusive than at the Casón. All along the route, with a few options kept open until the very last minute, Guardia Civil officers and more discreet security would maintain the utmost vigilance. By the last week of July all the plans, dummy runs and preparations had been completed.

On the night of Saturday, 25 July 1992, Barcelona hosted the spectacular official opening of the Olympic Games. Escaping from the partying, Jordi Solé Tura rushed across to Ricardo Bofill's recently opened airport, El Prat de Llobregat, and along with his wife caught the last shuttle down to Madrid. For nights he had been unable to sleep, worrying whether every last detail had been checked and double-checked. Fraught with nerves, at six in the morning Solé Tura was already at the Casón, to be joined by Garin and Corral. At that time on a Sunday morning, Madrid was still asleep, except for the last late-night revellers finding their way home. By 8 a.m. the Casón was floodlit for the camera crews to witness *Guernica*'s final journey. For the whole of the previous week the preparations had been moving forward with deliberate caution.

First the picture was protected with thin plywood sheets in case the glass cage shattered as it was dismantled. Then it was placed in

an aluminium frame that overlapped the existing border. Next it was carefully wrapped in a special thermal blanket to maintain the correct humidity and temperature and finally lowered into a protective case fitted with sensors to act as alarms if there were any noticeable variations. Meanwhile, the Prado conservation department had taken every microscopic record possible of the painting's surface to register any further damage on arrival at the Reina Sofía.

As the large packing case was slowly winched out of the Casón on the Sunday morning the crowd broke into spontaneous applause. Once the case was on the truck the motorcade, surrounded by twelve police armoured vans and followed from above by a police helicopter, crawled down the Paseo del Prado, avoiding the power lines and traffic lights that had been specially moved to permit the truck to roll underneath. Fifteen minutes later the painting was waiting at the back of the Reina Sofía to enter the lift. On the front of the museum protesters had sprayed graffiti reclaiming *Guernica* for Gernika but that was the only disturbance recorded, except for some Japanese tourists who had broken through the police cordon to photograph the historic event. Everything seemed to have run like clockwork. At the very last minute, however, an embarrassing disaster threatened to reduce the meticulously planned transfer to the level of farce. It appeared that the lift was not large enough. The technicians quickly reassured the Minister that they had allowed for 3 centimetres leeway. 'Whether it's four or two centimetres,' he thought to himself, 'I don't care as long as it gets in.' 'Personally,' Solé Tura remembered years after the event, still clearly emotionally moved, 'it was one of the most extraordinary moments of my life.' *Guernica* was safe.

For Spain it had been an extraordinary year. The Expo, the Olympics and Madrid's year as Cultural Capital had by the autumn, at least, been judged an outstanding success. Many of the ghosts and clichés associated with Spain had been put to rest. In a profound sense this had been right at the core of government policy. Among the PSOE intellectuals there had been a real wish to 'normalise' Spain, to show the outside world that its young democracy was

Guernica enters the Reina Sofía, 1992.

robust and that Spanish mentality was neither anarchic nor isola-
tionist but, in fact, essentially European. Over the year, King Juan
Carlos had also chosen, with an almost unerring feel for the
appropriate symbolic gesture, to help put the unfortunate chapters
in Spain's history to rest. With Spain celebrating the 500th anni-
versary of the discovery of America, King Juan Carlos chose firstly
to apologise for Isabel and Ferdinand's expulsion of the Sephardi
Jews. Closer to home, and potentially far more explosive, was the
King's wish that Franco's mausoleum at the Valle los Caidos, always
associated exclusively with the right, should now function as a
monument to all the Spanish dead lost in the bloody Civil War.

The most moving moment of all came at the opening of the
Republican Pavilion at the Vall d'Hebron. King Juan Carlos and
Queen Sofía attended, to be received by the Catalan dignatories
standing in the shade of Sert's building alongside a perfect facsimile
of *Guernica*. Unscripted, it seems, the architect Beth Gali ap-
proached the King to offer him a lapel pin sporting the Republican
flag. It was an awkward moment whose symbolism could so easily
have been mischievously misread. 'Pin it to my left, dear madam,' he
responded warmly, 'that way it will be closer to my heart.'

From belligerence to reconciliation the road had been a long one.
And *Guernica*, too, had trod the same path. To be 'normalised', the
painting still had to become a painting, an image made not of flesh
and blood but of oil paint and resin and linen and jute. It had to be,
as many argued, 'desacralised'. The transfer from the Casón to the
Reina Sofía had been the first step. But now, entering the hallowed
vacuum of El Grano's shimmering white walls, it was set to rejoin
the history of modern Spanish art. To help *Guernica* lose the
terrifying weight of its historical burden, the artist Antonio Saura
published in *El País* on Monday, 27 July 1992 his extraordinarily
cathartic 'Auto da fé Réquiem para el "Guernica"'. Following in the
tradition of Salvador Dalí's famous 'five principal perfidies' (in
which he proclaimed that 'those who have not smelled the odour
of sanctity are traitors'), Saura set about his litany of hatred which
he hoped might allow people to approach *Guernica* with a fresh and

innocent gaze. Scorn, detestation and hatred are poured with wilting satire on each and everyone who had played a role in the *Guernica* circus:

> I detest the Sevillian architect Roberto Luna whose glass screen still protects *Guernica*'s obscene dance.
>
> I hate the El Corté Ingles supermarket window display that is *Guernica*.
>
> I detest the transfer of *Guernica* to the central bus depot of the MNCARS Reina Sofía.
>
> I detest Dore Ashton, the American art critic, who was so clever as to declare *Guernica* is not contemporary art, it's history.

Those who took Saura's theatrical manifesto at face value clearly misunderstood its intent. Lluís Permanyer was one of the first critics to understand that Saura was trying to clear out all the dead wood and give *Guernica* a chance to be relevant again.

Unaffected by national politics David Sylvester was more direct in his appreciation: 'At the Reina Sofía I have suddenly seen it, probably because of the lighting, as Picasso's – and therefore the century's – most important painting. I have had the pleasure of perceiving that like, say, Michelangelo's *Last Judgement* or Beethoven's Ninth, it is not just colossal and portentous and famous but marvellously good.'

Very quickly *Guernica* became the lynchpin of the Reina Sofía collection, and with El Grano placed on the axis of the building, it meant that it was symbolically positioned like the sun around which all other planets spun. After the Alhambra and the Prado, the Reina Sofía had leapfrogged up the attendance charts to take third equal place, with Gaudí's *Sagrada Família* registering 1.4 million visitors a year. For the Casón, however, it proved a disaster. Filled with nineteenth-century historical paintings to accompany Antonio Gisbert's imposing 6-metre-wide *Torrijos and the Firing Squad*, its attendance dropped overnight from 50,000 to 5,000 per month. Signature works of the nineteenth century, still so unfashionable then,

like the highly accomplished *Lovers of Teruel* by Muñoz Degrain, Pradilla's enchanting *Doña Juana la Loca* and Eduardo Rosales's famous *Testament of Isabel the Catholic*, though far more in keeping with Jordaens' sweeping *Allegory of the Institution of the Golden Fleece* than *Guernica* had ever been, could not find their audience. *Guernica* had left a vacuum that was almost impossible to fill.

Despite the highly publicised statements from the Ministry of Culture stating unequivocally that *Guernica* had just completed its very last journey, requests for its loan still arrived on the Director of the Reina Sofía's desk. In September 1994 María Corral's fervent globalisation of the Reina Sofía, that some saw as kowtowing to the MOMA, Guggenheim–Tate–Dokumenta nexus of power, to the clear detriment of home-grown Spanish art, brought about her long-predicted demise. The new Minister of Culture, Carmen Alborch, a glamorous, fiery redhead who as the recent director of IVAM had promoted Spanish art with characteristic passion, demanded a change. Corral was replaced by José Guirao, whose mission was to showcase the unique contribution that Spain had made to the history of art. His subtle, provocative and often inspired rebalancing act between the demands and requirements of regional, national and international art could never disguise the fact, however successful the programme, that the Reina Sofía's ongoing success relied, as always, on the presence of its star turn.

In 1995, in recognition of *Guernica*'s universality as a symbol decrying the horrors of war, Japan requested the painting's presence to commemorate the fiftieth anniversary of the bombing of Hiroshima and Nagasaki at the end of the Second World War. Early the following year, President François Mitterrand, an intimate ally and supporter of the increasingly lacklustre PSOE government, even went so far as to petition King Juan Carlos to intervene on his behalf to request the release of *Guernica* for the giant retrospective of Picasso's work planned for that December at the Centre Georges Pompidou. To each request, pre-empting the Patronato of the Reina Sofía's final decision, the response from Minister of Culture Carmen Alborch was an affirmative no.

There was one request, however, that was more difficult to ignore. Gernika's Mayor Eduardo Vallejo de Olejua's bald statement of 23 October 1991, in which he had expressed that 'We will keep demanding it until the day it's here,' had come back to haunt. It was to be expected. But now the Basque landscape, with the Guggenheim Museum in the process of construction, was also changing. So too was the political landscape in Spain as a whole. One clear and highly significant indication was Alborch's brave decision, which would prove to be one of her last, to remove the protective glass from *Guernica* as it was moved from El Grano just 25 metres across the same floor in the Reina Sofía.

Considering the implicit threats against *Guernica*'s safety made back in the 1970s, it was obvious that the symbolic removal of the protective glass measured a significant change in both public opinion and public order, perhaps, representing like no other gesture, how embedded the principles of democracy had actually become. In the first week of March 1996 President-elect José Maria Aznar's Partido Popular, after fourteen years of PSOE power, won the general election. PP's need to make a pact with the Catalan and Basque minority parties suggested that the right-of-centre party would have to listen carefully to the needs and requests of these autonomous regions if they wanted to remain in power.

The real pressure to allow *Guernica* to move once more, and the only request that really merited serious consideration, came from the nascent Guggenheim Museum. Right at the beginning of the process, according to Juan Ignacio Vidarte, its young Director, there was already the idea that with a world-class contemporary art museum in Bilbao, just thirty minutes from Gernika itself, there was a driving logic and a moral duty to permit the painting's loan for a limited time. 'This was not a discussion about ownership,' according to Vidarte, nor had it anything to do with the thorny issue of 'where does the painting belong?' Nevertheless, even from the earliest date the planning of the titanium-skinned extravaganza built in a viable space for *Guernica*'s display on the third floor, overlooking the atrium, that Frank Gehry had christened 'The

Chapel'. At the beginning of 1996, while planning the content of the inaugural exhibition, it was suggested that in light of the importance of the opening coinciding with the sixtieth anniversary of the bombing of Gernika, there would never be a better opportunity to put forward to the Reina Sofía the Guggenheim's request. For Vidarte this was absolutely central to the meaning of the Guggenheim as, in his words, 'the museum hoped to be a symbol of what the Basque country wanted to be in the future'. Within the Basque country, however, there never had been unanimous support for the Guggenheim project, which some, like the sculptor Jorge Oteiza, saw as representing the kind of outmoded notion of globalisation so strongly supported by María Corral at the Reina Sofía, or worse still, as a latterday form of Yankee cultural imperialism.

Vidarte, however, pushed on in the face of opposition. Approaching the Reina Sofía, his 'subtle explorations' as to the possibility of *Guernica*'s transfer enjoyed, according to him, positive but unofficial support. Returning to Bilbao, Vidarte's team quickly put together a large dossier which acknowledged all the potential conservation problems, outlined their reasons for requesting the painting, and suggested that it should be the Reina Sofía that elected the time period for the loan. Vidarte also knew that it was best, for as long as possible, to keep the request out of the public arena where the ensuing debate would quickly become heated and damage the chance for calm, measured reflection.

In October 1996 the parliament of Vizcaya, of which Bilbao was the capital, made a direct petition to President Jose María Aznar to interecede on their behalf. With the backing of the Partido Popular in Vizcaya it seemed as if progress was being made. During King Juan Carlos's visit to study work in progress on the Guggenheim, Frank Gehry took the opportunity to point out the space where *Guernica* would go. It lost the architect no friends in the Basque country but it was one area where the King was wise not to tread. One of the first indications that there would be opposition came directly from Bernard Picasso who was adamant that *Guernica* should never move again. Regardless of the legitimacy of the

Guggenheim's wishes, or widespread sympathy in many quarters for the Basque's claim, Bernard had brought the debate on *Guernica*'s domicile into the public arena.

On 26 April 1997, exactly sixty years after the bombing, Gernika finally received a belated message from Germany's President Herzog that afforded the traumatised city some sense of closure. Germany accepted full responsibility for the tragedy in a spirit of atonement. As a bell taken from the rubble tolled in the cemetery, Ambassador Henning Wegener bowed his head and read out a statement on behalf of Germany.

> I want to take responsibility for this past and expressly acknowledge the blame of German aircraft involved. On 26 April 1937 Gernika was the victim of an air attack by the Condor Legion squadron which converted the name of this town into an emblem of aggression which overtook the defenceless population by surprise, making it a victim of the most terrible atrocities.

In reply, Mayor Eduardo Vallejo announced resignedly, 'This is a good occasion to bury for always what happened.' And, with less reserve, he let slip to a foreign journalist, 'The German apology is all right. With that they admitted the truth. Now the German parliament has done what the Spanish parliament and the Spanish military never did.' There was also, however, the outstanding issue of whether Picasso's painting might travel to the Basque country and finally staunch the wound.

In early May 1997 the Basque Congress passed a resolution to support the Guggenheim Museum's request to appeal for the release of *Guernica*. At times, however, the careful language of diplomacy was drowned out by growing frustration. Thomas Krens, Director of the Solomon R. Guggenheim Foundation in New York, who had been the brains behind the concept of franchising out the Guggenheim like a cultural McDonald's, declared unequivocally, 'The Basque people paid for the painting with their blood.' In the same spirit, the President of the PNV, Xabier Arzalluz, had already gone

on record with the provocative pronouncement, 'We got the bombs but Madrid has got the art.' Iñaki Anasagasti, a Congress member of the PNV, had earlier stated his opinion:

> If people in Madrid truly believe the Basque country is part of Spain, then why couldn't the painting be here, at least temporarily? After all, Picasso titled it *Guernica*, not *Madrid*. But because of a very strange bureaucratic process, technicians, rather than the politicians who represented the people, were controlling where the painting could be and where it could not be. We understood the concerns about the painting's fragile condition, but please, this is an era in which we have put men on the moon. Surely we could safely bring *Guernica* to Gernika.

President Aznar, unusually for once, found himself on the same side of the argument as Anasagasti and used all his powers of leadership to push for cross-party agreement in the Cortes in support of the Guggenheim's claim ahead of the 13 May scheduled meeting for the Reina Sofía's Patronato.

The President of the Patronato, Valeriano Bozal, acting, as he argued, in good faith and as the painting's ultimate custodian, refused to allow it to travel. He had behind him the weight of the as yet unpublished fully illustrated 300-page tome entitled *Estudio sobre el Estado de Conservación del 'Guernica' de Picasso*, edited by the Reina Sofía's conservation department, which highlighted every microscopic crack, and the painting's general state of wear and tear. There was one glaring contradiction, however, to which Javier Tusell had drawn the public's attention earlier in the year. If *Guernica* had arrived in Spain in 1981 in what the experts declared as perfect condition, how come it had suddenly deteriorated? It was a question that was never answered. For Juan Ignacio Vidarte the refusal, though perhaps not entirely unexpected, came as a blow. For him, 'it was clearly politics' disguised behind conservation requirements. For Vidarte, the request for *Guernica* had never been about visitor numbers, as some critics felt free to suggest. For him it was all about celebrating 'a beautiful moment'. And, 'too

naively', he has since come to think, 'we thought it might even have been a gesture to normalise the relationship between Spain and the Basque country'.

Once again, the future of *Guernica* was linked with that other great symbol of Spanish cultural identity, *La Dama de Elche*, housed in the National Archaeology Museum in Madrid. In the last week of June the Vice-President Francisco Álvarez-Cascos suggested a last-minute improvised proposal, never intended to be law, to facilitate both works of art travelling on a temporary basis back to their respective spiritual homes of Gernika and Elche. 'I don't want to enter into conflict with anyone,' declared Álvarez-Cascos, but it was also obvious that the resolution, even if approved, would not change the outcome. For any real chance of bringing an end to the stalemate, the government would have to change the law and the powers of the Patronato, which many said would transform Spain into the laughing stock of the museum world.

In the summer of 1997 Antonio Saura also entered the battle and in his inimical style set about rubbishing the Guggenheim's legitimate and carefully thought-out request. It was, in his opinion, a bad start for a new museum to put political pressure on the national museum, considering that it would have to work with it in the future. Furthermore, like Bernard Picasso and the Patronato, he felt that *Guernica* should never move again. Surprisingly, the Basque sculptor Eduardo Chillida declared the potential move to be 'sheer madness', with the super-realist painter Antonio López describing the covert political pressure as 'an intolerable abuse of power'. Bozal's refusal was, it seemed, expected. And it was a decision whose finality seemed to ensure that *Guernica* would never leave Madrid.

It is a great shame, even allowing for the circumstances and the conservation requirements, that Gernika and Bilbao have still not enjoyed the opportunity to reconnect with this totemic work, so integral to their identity and history. A symbolic opportunity for reconciliation was missed. But day by day, as people pass by *Guernica* the painting, it acts as a memorial and a reminder of what that town suffered, just as it also remains a powerful cry

against repression while symbolising an overwhelming desire for peace. In the Reina Sofía today it looks as poignant and as powerful as ever. As I walked along the long, cool corridors of the Reina Sofía, accompanied by the museum's librarian, Miguel Vallé-Inclan, he suddenly turned round and said: 'Perhaps, it is difficult to say, but perhaps, we are the first generation that can look at *Guernica* as just a painting.'

It is still, of course, a moot point as to whether the 'normalisation' of *Guernica* has in essence weakened the painting's impact. The reaction of the spectators at the Reina Sofía on their first encounter with the painting suggests otherwise. Thousands every day are dumbstruck and mesmerised by the power and scale of the image as they stare wide-eyed at the painful drama acted out before them. Transfixed, they gaze in reverential contemplation. *Guernica*'s power to shock has, despite the millions of reproductions, never gone away. Its rejection of human barbarity and its cry for liberty and peace remain as insistent today as the day Picasso put down his brush back in 1937.

Acknowledgements

Only now, twenty years on, do I realise how much I owe to the inspired teaching at the Courtauld Institute of Anthony Blunt, John Golding, Christopher Green, and my external supervisor Tim Hilton. My love for American art was further nurtured by John Kasmin at the Knoedler Gallery, Sir Anthony Caro and Clement Greenberg. Thank you to Luke Piper and the Piper family for permission to quote from Myfanwy Evans. With generosity Marilyn McCully found the time to search out *Guernica* material, as too did Elizabeth Cowling who was always ready to give encouragement, kindness and good advice. It goes without saying that any errors in the book are purely my own.

Many institutions, libraries and museums provided wonderful working conditions and patient advice. Without a doubt the most charming and least well known was the Museo Picasso in Buitrago de Lozoya in the basement of the town hall. Thanks also to the Museo de la Paz de Gernika. In England I am indebted to Exeter University Library, the Courtauld Institute, the British Library, the Institute of Historical Research, Bridport Library and the research library and conservation department at Tate Britain. Searching out the itinerary for *Guernica*'s tour through Britain was only made possible by the help of many other libraries as well as newspapers, several of whom were prepared to place free adverts to help fill in the missing gaps. I thank Helen Drury at the Centre for Oxfordshire Studies, staff at the John Rylands, Oriel College library, the *Manchester Evening News*, City Art Gallery Leeds, Janeen Haythornthwaite at the Whitechapel Art Gallery and the Rt. Hon Lord Healey of Riddlesden. In Edinburgh Ann Simpson and

Jane Furness at the Roland Penrose Archive at the Scottish National Gallery of Modern Art were also helpful and instrumental in finally putting *Guernica*'s travels into the correct order.

In Barcelona, as with all previous books, my work was always fed by the friendship and kindness of Deborah Chambers. Libraries and archives in the Ciudad Condal were opened with characteristic efficiency. I am grateful to Marguerita Cortadella at the Museo Picasso, Lourdes Prades at the Pavelló de la Segunda Republica, the Biblioteca de Catalunya, the archive at MNAC and last but not least Sergio Vila-Sanjuan, Carles Salmurri and José Luis Garcia Abril at La Vanguardia. History only really comes alive with people and, in Barcelona, I am grateful to Jordi Gracia García, Jordi Solé Tura, the late Manuel Vázquez Montalbán, Lluís Permanyer, Manuel Pallares, Josep Palau i Fabre, Daniel Giralt-Miracle, and Juan-José Lahuerta for sharing memories and feeding me ideas. In Bilbao, at the Guggenheim, Juan Ignacio Vidarte was equally generous.

Anyone working on *Guernica* and its return to Spain is indebted to Javier Tusell, whose writings on the subject quite literally provided the inspiration for this book. In Madrid my centre of investigation was naturally the Reina Sofía museum, MNCARS. I thank Concha Iglesias, Ian Gibson, Elena Garrido, Soledad de Pablo but particularly Miguel Vallé Inclan and Juan Manuel Bonet whose encyclopeadic knowledge of twentieth-century Spanish art and the associated literary life is staggering. Even in shorthand it was difficult to keep up with the avalanche of ideas, highways, byways, crossroads and long diversions that nevertheless had the reassuring ability to finally come circling back. On the steps of the Reina Sofía I was treated to a passionate exposition on *Guernica*'s relationship to Rubens by Saturnino Moreno Soria. The Biblioteca Nacional, the press department at the Prado, the archive at *El País* and the inspired staff of the Museo Esteban Vicente, in nearby Segovia, also helped me to understand the culture of exile, as, more importantly, did a friendship with Harriet Vicente and her late husband Esteban. It was through them I came to meet the Madrid art dealer Elvira González whose passionate support of Picasso features in this book, and who

was generously prepared to dredge up painful memories. Tom Burns Marañón was equally forthcoming with ideas, contacts and sound advice. All work in Madrid was finally made civilized and comfortable by Peter Wessel and Margarita Lucas's wonderful hospitality in Lavapies, which came with the added bonus of delicious gourmet delights.

In Paris I thank Nick and Josette Bray, for sending me information, and at the Musée Picasso, Anne Baldassari. Many years ago I started to trawl through the American Art Archives in Washington, and those at MOMA in New York. I never realised it would take so long to see the fruits of that work. To those exemplary institutions I add the Sert Archive at the Frances Loeb library at the Harvard Design School, as well as the New York Public Library and the Clark Institute at Williamstown.

Back in London I was again helped by Michael Jacobs's deep knowledge of Spain, and to an extraordinary degree, by the kindness, genorosity and knowledge – that often came in five-page long tightly typed letters – written by the Spanish Civil War historian Gerald Howson. That my home from home in London happened to be in the welcome warmth of his daughter Rebecca Howson's house, shared with husband Tom, to whom this book is dedicated, was just an added bonus. Xavier Bray has often shared his ideas, as too did Michael Barker who sent me his manuscript essay on the 1937 Expo. My work colleagues Fiona Urquhart and Martin Randall have often given me the chance to try out new ideas, and for those – too many to mention – who have travelled with me the length and breadth of Spain, you will recognise many of your own observations have come back here and found their home on the printed page.

Manuscripts only ever become books with the help of literary agents and publishers. Right from the beginning, at Curtis Brown, I was fortunate to have the passionate support of Jane Bradish-Ellames and Euan Thorneycroft. Early support also came from my Spanish publisher Plaza y Janés at Random House Mondadori with Deborah Blackman's infectious enthusiasm. This book, however, has benefitted at every stage from the editorial and design team

at Bloomsbury. From the very first day Bill Swainson has encouraged, teased, coaxed and supported the project. To Pascal Cariss I owe sound judgement that encouraged me to refocus my gaze. Along with Sarah Marcus, Nicola Barr and the designer Nathan Burton, Bill managed to foster the illusion that this was the only book they were publishing this year.

At home, of course, my wife Alex, and Driky, Rosa and Hetty have lived with another reality. For the fact that you have created such a happy haven when my head was away in the wars, I thank you. Midway through writing the book my father Piet died. As a fourteen-year-old boy he had arrived in Europe for the first time on 18 July 1936. As his ship sailed through the Straits of Gibraltar he knew his life was about to begin. It's only now I realise that his life and the trajectory of *Guernica* have gone hand in hand, from war to forgiveness, to final reconciliation. The last time I saw him happy was sitting at a table with our Spanish friends Loli and Peter. It meant a great deal to him. He loved the Spanish life. Every time I pick up my phone book the pages fall open on a Spanish name . . . Sevi, Calixto, Victor, Cristina, Nicolas, Sara, Marta, Javi, Martin, Nieves, Loles, Cruz, Avito, Vicky, Mercedes, Montsé and many many more . . . I realise that this book is for you.

Notes

Introduction

Page
1 **The world has changed** UN Press release SG/SM/6782, 3 November 1998.
2 **Throughout the debate** *Toronto Star*, 9 February 2003.
6 **We have not lacked** US Congressional Record, 23 September 1998.

Chapter 1 The Nightmare Made Real

Page
9 **The driving energy** In many senses, the Café Madrid was a northern Spanish satellite of Madrid's legendary Café Pombo where the critic Ramon Gómez de la Serna reigned supreme. And it was Gómez de la Serna who in 1917 had organised the first Spanish homage to Picasso and in 1931 had published his 386-page groundbreaking study, entitled *Ismos* of which Picassismo takes the lion's share. Gómez de la Serna, R., Ismos (Madrid: Biblioteca Nueva, 1931)
10 **Picasso had many friends** Bonet, J. M., *Diccionario de las Vanguardias en España* (Madrid: Alianza, 1995).
10 **intellectual driving force** He was founder of the hugely influential *La Gaceta Literaria*.
10 **At the age of twenty-seven** Sanz Esquide, J. A., *Real Club Náutico* (Almeria: Colegio de Arquitectos de Almeria, 1995).
10 **And it was there** Giménez Caballero, E., *Arte y Estado* (Madrid: Gráficas Universal, 1935).
10 **Picasso already knew him** Chipp, H. B., *Picasso's Guernica* (London: Thames and Hudson, 1989), p.4.
11 **All they could offer** The Director General of Arts at the time, Ricardo Orueta, had made enquiries with the Spanish Ambassador in Paris, the famous writer Salvador de Madariaga, whether after living so long abroad Picasso was still actually a Spanish citizen. Madariaga confirmed that he was, but also informed Orueta that his frequent refusal to meet the Ambassador of his country and his inability to respond to invitations was just plain 'unmannerly'. Orueta took de Madariaga's advice and the project was abandoned. Puente, J. de la., *Guernica – The Making of a Painting* (Madrid: Silex, 1997), p. 75.
11 **Seizing the moment** Giménez Caballero, E., *Arte y Estado* (Madrid: Gráficas Universal, 1935).
12 **The scale of the repression** Low, R., *La Pasionaria – The Spanish Firebrand* (London: Hutchinson, 1992), p. 4.

13 **The juggernaut that** Preston, P., *The Spanish Civil War* (London: Weidenfeld & Nicolson, 1986), pp. 9–10.

16 **Picasso was always** Stein, G., *Picasso* (London: Batsford, 1938), pp. 32–33.

19 **The bearded man** Unamuno, and particularly Ortega y Gasset in his influential book *The Dehumanization of Art* (*La deshumanización del arte*), 1925, had come close to arguing themselves away from liberalism towards the notion of a cultural elite.

21 **That one fateful decision** Preston, P., *The Spanish Civil War* (London: Weidenfeld & Nicolson, 1986), p. 60.

23 **The most baffling** Orwell, G., *Collected Essays* (London: Secker & Warburg, 1975), p. 218.

23 **the raised fist** Utley, G., *Picasso: The Communist Years* (New Haven: Yale University Press, 2000), p. 15.

24 **The popular press** Weber, E., *The Hollow Years – France in the* 1930's (London: Sinclair Stevenson, 1995), p. 88.

24 **After all, I was only** Brassaï, *Conversations with Picasso* (Chicago: University of Chicago Press, 1999), p. 198.

27 **What do you think** Téry, S., *Picasso n'est pas officier dans l'armée française*, 24 March 1945 *Les Lettres Françaises* trans. from Oppler, E. C., *Picasso's Guernica* (New York: Norton, 1988), pp. 152–153.

27 **fandango of shivering owls** Oppler, E. C., p. 184.

29 **Proud and self-important** Critics have pointed out a relationship to Alfred Jarry's *Ubu Roi*.

29 **Franco is reduced** Puente, J., *Guernica – The Making of a Painting* (Madrid: Silex, 1997), p. 94.

32 **German airmen in** Southworth, H. R., *Guernica! Guernica!* (Berkeley: University of California Press, 1977), p. 16.

33 **They're not fingers** *El País*, 22 November 1981.

33 **According to Ucelay** Considering that President Aguirre only left Bilbao on 14 June this would come very close to Picasso's completion of *Guernica*.

34 *Guernica*, **demanded Negrín** Southworth, H. R., p. 14.

35 **If submission is** Southworth, H. R., pp. 188–189.

36 **Some of the shops** Preston, P., *Franco* (London: Fontana Press, 1993), pp. 242–4.

36 **It was horrific** Interview with author, October 1997.

37 **In the next war** Weber, E., *The Hollow Years* (London: Sinclair Stevenson, 1995).

41 **The most appalling** Southworth, H. R., p. 12.

41 **I have seen many** Southworth, H. R., p. 12.

41 **At 2 a.m. to-day** *The Times*, 27 April 1937, Southworth, H. R., p. 14.

43 **At Bilbao the Marxists** Southworth, H. R., pp. 175–6.

43 **As Sven Lindqvist** Lindqvist, S., *A History of Bombing* (London: Granta, 2001).

44 **In the French** Weber, E.

45 **It would be most interesting** Zervos, C., *Conversations with Picasso* (Paris: Cahiers d'Art, 1935).

47 **a painting is** Ashton, D., *Picasso on Art*, (London: Thames and Hudson, 1972), p. 38.

50 **Herschell B. Chipp** Chipp, H. B., p. 127.

51 **all tremendously lively** Russell, J., *Sunday Times*, 17 December 1961.

52 **'There,' said Picasso** Penrose, R., *Picasso* (London: Granada, 1981), p. 306.

52 **I have a child** Gilot, F., *Life with Picasso* (London: Virago, 1990), pp. 200–1.

53 **Finally, Marie-Thérèse** ibid.

53 **If peace wins** ibid.

Chapter 2 A Silent Requiem

Page

54 **there are forms** Gilot, F., p. 116.

54 **having plumbed the depth** Palau I Fabre, J., *Child and Caveman: Elements of Picasso's Creativity* (New York: Rizzoli, 1978), p. 5.

56 **I asked him** Gilot, F., p. 110.

59 **It bowled me over** 'Notes d'un touriste á l'exposition', *Cahiers d'Art* 12, Paris 1937. Also Oppler, E. C., pp. 214–15.

64 **Like so many** Daniels, M., 'Art and Power' (London: Hayward catalogue, 1995), p. 64.

66 **An exterior ramp** Pierre Patout, in the pavilion for the *Société des Artists-Decorateurs*, had also used the same device. It is an idea that has been frequently copied since, with Frank Lloyd Wright's Fifth Avenue Guggenheim, and more recently, Rafael Moneo's Thyssen in Madrid, as the best known examples.

66 **The telluric pull** Alberto's studio in Madrid would also be flattened during the bombing, destroying much of his work.

68 **Think of it: a Spaniard** Machado, A., *Selected Poems* (Cambridge: Harvard University Press, 1997), pp. 143–5 trans. Alan Trueblood.

69 **Unfortunately, precise records** To further complicate an exact reconstruction of the pavilion there was a serious attempt to rotate as many works as possible, excepting the large commissioned works.

70 **It also drew** Martín Martín, F., *El Pabellon Español* (Sevilla: Universidad de Sevilla, 1982), p. 34.

71 **It seems almost impossible** Aub, M., *Hablo como Hombre* (Mexico: Joaquín Mautiz, 1967) and Oppler, E. C., p. 204.

71 **We would have** Martín Martín, F., p. 36.

72 **Surprisingly, considering the** *El País*, 22 November 1981.

72 **But, it has** ibid.

72 **If President Aguirre** ibid.

72 **as a work of art** ibid.

72 **As for the working class** Weber, E.

72 **hodgepodge of body parts** Freedberg, C. B., *The Spanish Pavilion* (New York: Garland, 1986).

74 **Sunday: I am writing** *Cahiers d'Art* 12 and Oppler, E. C., pp. 214–5.

74 **How dreadful all** ibid.

75 **The painting is disillusioning** *Spectator*, 6 August 1937.

76 **the Spanish like violence** Brassaï, p. 154.

76 **limited coterie of aesthetes** *Spectator*, 8 October 1937.

76 **middle-class doctrinaires** *Spectator*, 15 October 1937.

76 **virtually in the marketplace** ibid.

77 **Picasso has done** Evans, M., *The Painter's Object* (London: Curwen Press, 1937), p. 6.

79 **In *Guernica*, expressed** *Cahiers d'Art* 12, 'Histoire d'un tableau de Picasso'. Also Oppler, E. C., p. 206.

80 **I think there** *Guernica* symposium at MOMA, 25 November 1947.

80 **Goya is brought** *Cahiers d'Art* 12 and Oppler, E. C., p. 209.

81 **black-and-white exhalations** *Cahiers d'Art* 12 and Oppler, E. C., p. 210.

81 **It tells us the truth** *Cahiers d'Art* 12 and Oppler, E. C., pp. 211–2.

Chapter 3 Homer at the Whitechapel

Page

83 **We want the exhibition** Elizabeth Cowling generously alerted me to this correspondence. I would also like to thank the RPA, the Roland Penrose Archive at the Scottish National Gallery of Modern Art and Tony Penrose for permission to quote original letter, addressed to Penrose from the *Conseil pour l'Expansion de la culture espagnole – l'etranger* RPA 717.

83 **Since that dinner** Penrose, R., *Picasso* p. 275 and *Scrap Book* p. 103.

84 **Imagine for a moment** Liddell Hart, B. H., *Paris or the Future of War* (London: E. P. Dutton, 1925).

85 **Grigson proposed a** *Axis*, 1 January 1935.

85 **Leafing through the** *AiA – The Story of the Artist's International Association* (Oxford: MOMA, 1983).

86 **I've seen a few** The Spanish Civil War exhibition catalogue (London: Imperial War Museum, 2001), p. 27.

87 **humourless headmistress** Dictionary of National Biography.

87 **fire which smouldered** ibid.

88 **Marx Brothers of Art** Ades, D., *Dada and Surrealism Reviewed exhibition catalogue* (London: Hayward Gallery, Arts Council 1978).

90 **The exhibition was** In 9 October 1938 issue of the *Sunday Times* Eric Newton described *Guernica* as a disappointment, a 'big mouse' in comparison to the preliminary works. Jan Gordon in 9 October 1938 issue of the *Observer* was in agreement, describing it as 'fumbling and rather careless'.

90 **The etchings cannot** *Spectator*, 8 October 1937.

91 **little dissenting sects** Carter, M., *Anthony Blunt*, (London: Macmillan, 2001).

91 **In private, away** Carter, M., p. 208.

91 **It is not sufficient** *London Bulletin*, October 1938.

91 **By 1969 Blunt** Blunt, A., *Guernica* (London: OUP, 1969).

91 **horses with maddened expressions** *Oxford Times*, 22 October 1938.

91 **Denis Healey** correspondence with Lord Healey of Riddlesden CH MBE. The Oxford exhibition seems to have been almost completely forgotten.

92 **Leeds City Art Gallery** *Yorkshire Post*, 10 December 1938.

92 **Lady Ivy Chamberlain** Ignacio Zuloaga catalogue, New Burlington Gallery 1938.

92 **Lady Ivy's husband** D.N.B.

92 **For many years** Ignacio Zuloaga catalogue, New Burlington Gallery 1938.

93 **flags and guns** Beevor, A., *The Spanish Civil War* (London: Cassell, 1999), p. 170.

93 **seminal Demoiselles d'Avignon** Richardson, J., *A Life of Picasso Vol 1* (London: Jonathan Cape, 1991), pp. 429–31 and *A Life of Picasso Vol 2* (London: Jonathan Cape, 1996), p. 17.

93 **The whole Zuloaga show** Penrose suggests in Penrose, R., *Picasso: His Life and Work* (London: Granada, 1981 p. 320) that the two shows were contemporaneous and that Zuloaga's was always empty. This is plainly wrong. There is no indication that Zuloaga's show was any more of a failure than *Guernica* – a fact that Penrose admitted in private correspondence with Picasso. RPA.

94 **London's East End** There has been much confusion about the dates and venues for the British tour. Penrose suggests in *Picasso: His Life and Work* that the venues included Liverpool, but in private correspondence mentions only Leeds and Oxford. Chipp in *Picasso's Guernica* (London: Thames and Hudson, 1989) includes Manchester but erroneously dates the Whitechapel show to November. Leeds is included, but did not show *Guernica*. Despite placing adverts in Liverpool newspapers and researching archives there is no record of *Guernica* in Liverpool.

94 **I want to give** *Musée Picasso* archive, Paris.
94 **If once Fascism** *News Chronicle*, 9 January 1939.
94 **Today Fascism is weak** ibid.
95 **The *Guernica* show** *East London Advertiser*, 7 January 1939.
95 **Every evening 'talking films'** Busby. W. J. A., *The Voice of East London*, January 1939.
95 **Herbert Read, Eric Newton** ibid.
95 **The need for help** *Manchester Evening News*, 31 January 1939.
95 **It is felt by** ibid.

Chapter 4 To the New World

Page
98 **Throughout the Civil War** Preston, P., *Franco*.
98 **On 28 March 1939** ibid.
98 **Today, with the** Preston, P., *The Spanish Civil War*.
98 **The bloody Spanish** Jackson, G., *The Spanish Republic and the Civil War* (Princeton: Princeton University Press, 1965).
99 **The arms dealers** Howson, G., *Arms for Spain* (New York: St Martin's Press, 1999).
99 **the Campaign's list** Chipp, H. B., p. 60.
100 **I am sorry** Ashton, D., *Picasso on Art*, p. 145.
101 **Their deep pockets** Fitzgerald, M., *Making Modernism: Picasso and the Creation of the Market for 20th Century Art* (Berkeley: University of California Press, 1996).
102 **Cracks from movement** For a detailed study of *Guernica*'s state of conservation see: *Fundación Marcelino Botín El Guernica y los problemas éticos y técnicos de la manipulación de obras de arte*, Botín, Santander 2002, and MNCARS: *Estudio sobre el estado de conservación*, (Madrid: Ministerio de Educación y Cultura, 1998).
102 **art for art's sake** van de Lemme, A., *Art Deco* (London: Appletree Press, 1992).
104 **The WPA guide** *WPA Guide to New York City* (New York: Federal Writers' Project, 1939).
104 **Through its programme** ibid.
105 **Symbolic of liberty** Oppler, E. C., p. 90.
106 **Art, luxury, and elegance** *WPA Guide*.
107 **the most crowded** Genauer, E., *New World Telegram*, 21 August 1937.
108 **a half-dollar well spent** *Springfield Republican*, 21 May 1939.
109 **found his soul** ibid.
110 **After closing time** Matossian, N., *Black Angel – A Life of Arshile Gorky* (London: Pimlico, 2001), p. 284.
111 **How that painting** ibid.
111 **Armory Show** Conn, S., *Museums and American Intellectual Life 1876–1926* (Chicago: University of Chicago Press, 1998).
111 **To maintain the momentum** Whelan, A., *Alfred Stieglitz: A Biography* (New York: Da Capo Press, 1997).
112 **despite the generosity** Doezama, M., and Milroy, E., *Reading American Art* (New Haven: Yale University Press 1998), and Miller, C., *American Iconology* (New Haven: Yale University Press, 1993).
112 **They want Americans** Ludington, T., *Marsden Hartley* (Boston: Little, Brown, 1992).
112 **America has the same** Whelan, A.

112 **If only America** Sandler, I., *The Triumph of American Painting* (New York: Harper & Row, 1970).

114 **The American art community** ibid.

115 **some of us woke up** Ashton, D., *The New York School* (New York: Viking Press, 1972).

115 **For years surprising Picassos** Schapiro, M., exhibition catalogue, Arshile Gorky, Whitney Museum of Art, New York 1957.

118 **His gift, almost bordering** Barr, A. H., *Defining Modern Art* (New York: Harry N. Abrams, 1986).

118 **Modern art is** ibid.

118 **our minds and muscles** ibid.

119 **If fifty years** ibid.

119 **Royal Cortissoz** Chipp, H. B., p. 166.

120 **grotesque shapes, human** *New York Times*, 11 May 1939.

120 **chicanery** *Boston Post*.

120 **average gallery-goer** *Parnassus*, 11 December 1939.

120 **the mood of horror** Morris, G. L. K., 'Picasso: 4000 years of his Art', *Partisan Review*, 1940.

120 *Guernica* **remains the final** ibid.

120 **The result is a canvas** *Springfield Republican*, 21 May 1939.

121 **Henry McBride** *New York Sun*, 6 May 1939.

121 **Picasso was 'prodigal'** ibid.

121 **disunity of structure** Morris, G. L. K.

121 **an extraordinary achievement** *New York Sun*, 6 May 1939.

122 **as did fellow exiles** Chipp, H. B., p. 163.

122 **It seemed the poet** Kazin, A., *New York Jew* (New York: Alfred A. Knopf, 1978).

122 **The *Herald Express*** *Herald Express*, 3 August 1939.

122 **Worse was to come** *Los Angeles Examiner*, 3 August 1939.

122 **an ardent communist** *New York Sun*, 6 May 1939.

122 **I will never make art** Ashton, D., *Picasso on Art*, p. 148.

123 **It is no part** Chipp, H. B., p. 165.

124 **rather complex problem** Fitzgerald, M., p. 246.

125 **Picasso had uncovered** Sandler, I., p. 72.

125 **I could smell** ibid.

Chapter 5 The Death of Paris

Page

127 **The steady stream** Caws, M. A., *Picasso's Weeping Woman* (Boston: Little, Brown, 2000).

127 **had been packed off** Gasman, L., *Mystery, Magic and Love in Picasso* (Ann Arbor, University Microfilms, 1981).

129 **fell like a fly** Sabartés, J., *Picasso, Portraits et Souvenirs* (Paris: Louis Carré et Maximillien Vox, 1946) and footnote 11 Sabartés, J., *Picasso: An Intimate Portrait* (New York: Prentice Hall, 1948).

130 **He believes (Picasso)** ibid.

131 **Normally superstitious** Fitzgerald, M., pp. 262–3.

133 **Otto Freundlich was arrested** Cone, M., *Artists under Vichy* (Princeton: Princeton University Press, 1992).

133 **Oh, they're from** ibid.

135 **anti-Semitic and** Golan, R., *Modernity & Nostalgia* (Yale University Press, 1995).
136 **when Kahnweiler's Picassos** Fitzgerald, M. pp. 54–6.
136 **A specialist in** Cone, M., p. 214.
137 **in the same boat** Brassaï, p. 62.
137 **a second report** Daix, P., and Israël, A., Pablo Picasso – Dossiers de la Préfectore de Police 1901–1940 (Paris: Editions des Catalogues Raisonnés, 2003), pp. 115–34.
137 **Not afflicted by** Preston, P., *Franco*.
138 **Weisbader Armistice Commission** Political Intelligence Dept. Foreign Office Ref: FO 371/28228/25643
138 **No one in the world** Brassaï p. 89.
141 **a clandestine orgy** Penrose, R., *Picasso: His Life and Work* (London: Granada, 1981).
142 **elect for 're-education'** Beevor, A. and Cooper, A. *Paris after the Liberation 1944–1949* (London: Penguin, 2004). pp. 131–44.
143 **warfare on paper** Cone, M., p. 154.
144 **Little love tokens** Lord, J., *Picasso and Dora* (New York: Farrar Straus Giroux, 1993) and Caws, M.A.
148 **the terrible news** Cone, M., p. 234.
149 **Paris was liberated** Beevor, A., Paris, p. 71.
150 **I have always** Utley, G., p. 208.
151 **New York had** 'New York Painting only Yesterday', *Art News* No.4, 1956.
151 **in a sort of passive** Gilot, F., Paris, p. 38.

Chapter 6 The Big Bang
Page
155 **New York was triumphant** Kazin, A., p. 152.
155 **New York in 1943** Kazin, A., pp. 59–60.
156 **For the past ten years** Oppler, E. C., pp. 146–151.
157 **Picasso's clean edge** Rosenberg, H., *Gorky: The Man, The Time, The Idea* (New York: Horizon Press, 1962), p. 66.
157 **We are failed** Naifeh, S., and White Smith, G., *Jackson Pollock – An American Saga* (London: Pimlico, 1992), p. 340.
158 **The Americans drew** Polcari, S., *Abstract Expressionism and the Modern Experience* (Cambridge: Cambridge University Press, 1991), p. 29.
166 **preppie in the Gashouse gang** Danto, A., *The State of the Art* (New York: Prentice Hall Press, 1987), p. 50.
166 **tell-tale holes** Polcari, S., p. 32.
169 **Sometimes Jackson came** Naifeh, S., p. 349.
170 **a true son of Picasso** Langhorne, E., 'Pollock, Picasso and the Primitive', *Art History*, Vol. 12, No. 1, March 1989.
171 **I've been a Jungian** Naifeh, S.
173 **Americans are in the stage** Oppler. E. C., pp. 146–151.
174 **Rite of Spring** Anfam, D., *Abstract Expressionism* (London: Thames & and Hudson, 1990), p. 100.
174 **a cosmic frame** Leja, M., *Jackson Pollock in Reading American Art* (New Haven: Yale University Press, 1998), p. 454.
175 **'pulverised' Picasso's 'closed forms'** Sandler, I., p. 107.
176 **the atomic bomb** Guilbaut, S., *How New York Stole the Idea of Modern Art* (Chicago: University of Chicago Press, 1983), pp. 96–7.

Chapter 7 Reds under the Beds

Page
179 *Picasso at Seventy-Five* Greenberg, C., *Art and Culture* (Boston: Beacon Press, 1961), pp. 59–69.
180 **Perhaps Picasso has succumbed** ibid.
182 **Arendt, Hannah,** *The Origins of Totalitarianism* (New York: Harcourt Brace, 1973).
183 **paladins of democracy** Podhoretz, N., *Making It* (New York: Random House, 1967), pp. 288–9.
185 **Picasso was technically outside** Stonor Saunders, F., *Who Paid the Piper*, (London: Granta Books, 1999), p. 37.
186 **My joining the Communist Party** Utley, G., p. 208.
187 **An artist multi-millionaire** Bjelajac, D., *American Art – A Cultural History* (London: Laurence King, 2000), p. 356.
188 **I'm no politician** *Atlantic Monthly*, July 1957.
188 **Let's say I were** ibid.
189 **It was secret** Kuspit, D., *The Cult of the Avant-Garde Artist* (Cambridge: Cambridge University Press, 1993), p. 3.
190 **Instead of soaring** Barr, A. H., p. 32.
191 **Only substituted Gertrude Stein** Kees, W., *The Nation*, 3 June 1950.
191 **resisted any attempt** ibid. p. 11.
191 **Politically, there is** ed. Phillips & Rahv, *The Partisan Reader: Ten Years of Partisan Review* (New York: Dial Press, 1946).
193 **Within a few years** Utley, G., p. 211.
194 **malodorous waters** Kennan, G. F., *Memoirs Vol II* (Boston: Little, Brown & Co., 1972), p. 190.
195 **If there is a single** Stonor Saunders, F., p. 256.
196 **Picasso is politically naive** Utley, G., p. 247, note 68.
197 **In view of his** Mitgang, H., 'When Picasso Spooked the FBI', *New York Times*, 11 November 1990.
197 **Arriving at the Sheffield** *Guardian*, 25 November 2000.
198 **I'm hated everywhere** Gilot, F.
199 **their atomic skies** Utley, G., p. 200.
200 **French blood is** ibid, p. 194.
200 **the evil spirit of** ibid, p. 93.
201 **The American inquisitors** Kazin, A., p. 189.
202 **There on the screen** ibid, p. 225 also read Howe, I., *A Margin of Hope*, (New York: Harcourt Brace Jovanovich, 1984), p. 215.
203 **That picture threw people** Cabanne, P., *Picasso: His Life and Times* (New York: Morrow, 1977).
205 **the face of war** Utley, G., p. 165.
205 **let us keep our eyes** Barr, A. H., p. 225.
206 **The Reds weren't** Stonor Saunders, F., p. 47.
206 **the Diaghilev of America's** ibid, p. 19.
211 **Only once morey** MNCARS *Estudio sobre el estado de conservación* (Madrid: Ministerio de Educación y Cultura, 1998).
212 **work, for artists** *New York Times*, 22 June 1980.

Chapter 8 The Silent Resistance

Page

214 **The most powerfully symbolic** Lafuente, I., *Esclavos por la Patria*, (Madrid: Temas de Hoy, 2002).

215 **The regime never** Crawford, L., *Financial Times* magazine, 5 July 2003, pp. 22–7.

215 **In a brave** Gracia García, J., and Ruiz Carnicer, M., *La España de Franco (1939–1975) – Cultura y vida cotidiana*, (Madrid: Editorial Sintesis, 2001).

216 **the most important thing** ibid.

221 *La Dama de Elche* Reuben Holo, S., *Beyond the Prado* (Liverpool: Liverpool University Press, 1999).

222 **What Franco was alluding** Preston, P., *Franco*, p. 414.

222 **Art is inspired** *Jornada*, 5 January 1946.

222 **hippopotamus in bed** ibid.

222 **Fortunately, in nature** ibid.

223 **many a modern celebrity** ibid.

223 **This egg with glasses** *¡Arriba!*, 12 September 1948.

223 **great enemy of Spain** ibid.

223 **It is sterile** ibid.

223 **a quasi Communist** ibid.

223 **infantile and elephantine** ibid.

223 **Has Picasso forgotten** ibid.

224 **It is since 1935** *ABC*, 1 June 1956.

224 **instinct for butchery** ibid.

224 **fiery Malagan blood** ibid.

225 **In a pact of blood** Moradiellos, E., *La España de Franco – Política y sociedad* (Madrid: Editorial Sintesis, 2000), p. 15.

225 **Throughout this long period** Preston, P., *Franco*.

225 **mad by power** ibid.

225 **sick with his** ibid. p. 572.

227 **Anti-Spain was beaten** ibid. p. 679.

227 **The enemies of Spain** ibid.

228 **These cultural events** *Gran Via*, 23 July 1960.

228 **Barcelona is a** *Destino*, 23 July 1960.

229 **Sempronio does alert** *Gran Via*, August 1960 (no. 434).

230 **'sur' Picasso** *Gran Via*, December 1960 (no. 452).

230 **Juan Vidal Ventosa** ibid.

231 **it already smelled** ibid.

231 **Oriol Bohigas** ibid.

231 **If someone has** ibid.

232 **I suppose there** *Destino*, 17 December 1960.

232 **The municipal architect** *La Vanguardia*, 29 December 1960.

232 **enormous and heterogeneous queue** *La Vanguardia*, 19 January 1961.

232 **Picasso's voice had** ibid.

232 **We must accept** ibid.

233 **a great silence** ibid.

223 **In Spain there** ibid.

223 **the phoenix from** *La Vanguardia*, 11 August 1961.

234 **every other European city** *La Vanguardia*, 3 May 1962.

235 **ageing Republican spy** Crusells, M., *La guerra civil Española: cine y propoganda*, (Barcelona: Ariel, 2000).

236 **It was the last film** It would be a further fifteen years, on Easter Saturday 1977,

before *Viridiana* was premièred in Spain under Franco's successor the Prime Minister Adolfo Suárez.

238 **The orgy of Picasso's forms** *La Vanguardia*, 6 March 1963.

239 **Julián Gállego's enthusiastic** Martín Martín, F., p. 12.

239 **Penrose's Spanish edition** RPA 589.

239 **Having sent his piece** Interview with author, October 2002.

Chapter 9 *Operación Retorno*

Page

241 **In his variations** Brown, J., *Picasso and the Spanish Tradition* (New Haven: Yale University Press, 1996) and Galassi, S. G., 'Picasso in the Studio of Velázquez', p. 119.

242 **I represent Spain** Gilot, F., p. 188.

243 *mundillo español* Otero, R., catalogue *La Última Tertulia* (Valencia: IVAM, 2002).

245 **this clichéd image** Burns Marañón, T., *Hispanomanía* (Barcelona: Plaza y Janés, 2000)

247 **longing and anger** Otero, R., pp. 260–1.

247 **the portrait of the history** ibid.

249 **In a modest** Lloréns, T., and Calvo Serraller, F., *El Siglo de Picasso* exhibition catalogue (Madrid: Reina Sofía)

253 **These are not pictures** ed. Gies, D. T., *Cambridge Companion to Modern Spanish Culture* (Cambridge: Cambridge University Press, 1999), pp. 143–4.

253 **In the words of** Hopewell, J., *El cine español después de Franco* (Madrid: Ediciones El Arquero, 1989).

254 **a certain synchronicity** Sánchez Vidal, A., *El Cine Español y la Transicion in Del Franquismo a la Post-modernidad* (Madrid: Editorial Akal, 1995).

254 **Recently the students** *Tele/Expres*, 28 February 1968.

256 **Yes, but then** *El Adelantado*, 28 October 2003.

257 **The Long Goodbye** Preston, P., *Franco* p. 744.

258 **at a press luncheon** Chipp, H. B., p. 170–4.

258 **the cultural patrimony** ibid.

Chapter 10 The Homecoming

Page

263 **Pérez Embid** Fernández-Quintanilla, R., *Odisea del Guernica* (Barcelona: Planeta, 1981), p. 58.

263 **the greatest painter since Goya** ibid.

263 **Making excuses on** ibid.

263 **As is often** ibid.

263 **Judging his audience** ibid.

264 **To imagine that** *El País*, 23 September 1981.

264 **Don't do anything** Fernández-Quintanilla, R., p. 68.

265 **You have agreed** Chipp, H. B., pp. 170–2.

265 **I confirm anew** ibid.

266 **Dumas, it appeared** *Economist*, 20 March 2003. Also see Vilallonga, J.L., *La Puta de la Republica* and 'Opinion' *La Vanguardia*, 11 January 1999.

266 **made a scapegoat** *Guardian*, 2 March 2000.
267 **With a dish-cloth** *Tele/Express*, 26 October 1971.
269 **Soy beata de Picasso** Interview with author, 8 November 2003.
270 **a prison in Zamora** Preston, P., *Franco*, p. 737.
271 **I do not intend** ibid. pp. 751–2.
271 **Carrero Blanco** *Moradiellos*, E., p. 177.
272 **an open letter** *La Vanguardia*, 27 November 1971.
273 **replacing the Crucifixion** Oppler, E. C., p. 120.
273 **made to dramatise** ibid. pp. 236–8.
274 **What the US Government** ibid. p. 240.
274 **In hanging** *Guernica* ibid. p. 242.
275 **They have cut** Preston, P., *Franco*, p. 762.
275 **He loved the vitality** *Guardian*, 3 March 1999.
276 **Tony Shafrazi has** Oppler, E. C., p. 244.
277 **too familiar to** Masheck, J., 'Guernica as Art History', *Art News LXVI*, December 1967.
278 **17,731 cases of** Powell, C., *España en democracia, 1975–2000*, (Barcelona: Plaza y Janés, 2001), p. 152.
280 **Picasso has upon** *The Times*, 26 November 1975.
280 **a more humane regime** ibid.
281 **We have merely** *New York Times*, 9 April 1973.
281 **the conditions of** *Le Monde*, 5 December 1975.
282 **We cannot continue** *El País*, 19 April 1977 and *El País*, 21 April 1977.
283 **I hope that** *Guernica* *El País*, 19 November 1977.
284 **I saw it for** interview with author, October 2002.
286 **Lone voices of** *El Alcázar*, 20 September 1980.
290 **What turned up** Fernández-Quintanilla, R.
291 **What was going to happen** see *El País*, 25 July 1979 and Francisco Umbral, *El País*, 28 October 1981.
292 **In his opinion** *El País*, 4 October 1979 and 22 November 1981.
293 **What really annoyed Ibarrola** *La Calle*, September 1979.
294 **Saenz de Heredia** *El Alcázar*, 2 May 1980.
294 **eating frog's legs** *La Calle*, no. 78, 18–24 September 1979.
294 **If they can do** *El País*, 10 October 1980 and *Pueblo*, 17 October 1980. Also for Alberti's misgivings see *El País*, 12 March 1981 and *El País*, 30 April 1981. Bergamin described it as '*un artefacto explosivo*', *El País*, 24 October 1981.
296 **Claude was so angry** Fernández-Quintanilla, R., p. 127.
297 **she had lived** ibid, pp. 154–5.
297 **Feminism as a** Hooper, J., *The New Spaniards* (London: Penguin, 1995), pp. 166–7.
298 **The problem of** *Guernica* *El País*, 23 January 1981.
298 **Moncloa syndrome** Powell, C., p. 281.
299 **His great achievement** ibid, p. 303.
300 **The Spanish goverment** *El País*, 15 October 1981, 23 October 1981 and 25 October 1981.
307 **Millions of enemies** *El País*, 12 March 1981, 30 April 1981 and 24 October 1981.
303 **I'm emotional** *El País*, 10 September 1981.
303 **Today the last exile** ibid.
303 **offence to our dignity** *El País*, 11 September 1981.
307 **a scream against violence** *El País*, 23 October 1981.

Chapter 11 The Final Journey

Page

309 **Here it is now** *El País*, 31 October 1981.

314 **Within a month** After subsequently working as a curator at New York's Guggenheim, Giménez has since made a triumphant return to Spain heading up Malaga's Picasso museum.

314 **Sacked by the** Reuben Holo, S., p. 43.

315 **a Picasso with every car** As crazy predictions go, for Henri Cartier-Bresson, at least, the decision to name even a motor car after Picasso – a machine capable of killing innocent bystanders – the Citroën Picasso, is a disgusting travesty of his close friend's work.

315 **In September 1990** *El País*, 12 March 1991.

316 **We will keep demanding** *El País*, 23 October 1991. Also see *La Nación*, 29 April 1997.

318 **If you accept** *El País*, 7 May 1992.

318 **in the presence** ibid.

319 *Guernica* **is a symbol** *El País*, 13 May 1992.

319 **happy ending** *El País*, 19 May 1992. For views against see *El País*, 8 May 1992 where Pármelin and Pignon voice their reservations.

321 **you gamble absolutely** Interview with author, May 2003.

322 **I don't care** ibid.

324 **terrifying weight of** *El País*, 27 July 1992.

324 **five principal perfidies** Descharnes, R., & Prévost, C., *Gaudí – The Visionary* (London: Patrick Stephens, 1971), pp. 5–8. Dalí's five perfidies or crimes against Gaudí are listed as follows: 1. those who have not seen his militant vision; 2. those who have not touched the bony structures and the living flesh of his delirious ornamentation; 3. those who have not heard the chromatic, glowing stridence of his colour, the striking polyphony of his organ-pipe towers, and the clash of his mutating decorative naturalism; 4. those who have not tasted his superbly creative bad taste; 5. those who have not smelled the odour of sanctity.

324 **I detest the** *El País*, 27 July 1992 and *The Art Newspaper*, No. 21, October 1992.

324 **Lluís Permanyer was** Interview with author, May 2003.

325 **At the Reina Sofía** *Independent on Sunday*, 27 September 1992.

327 **not a discussion** Interview with author, June 2003.

327 **the museum hoped** ibid.

329 **a good occasion** *El País*, 27 April 1997 and see *Telegraph*, 28 April 1997.

329 **The German apology** *New York Times*, 12 May 1998.

329 **We got the bombs** *El País*, 25 May 1997 and 28 June 1997.

329 **If people in Madrid** Speech in *Cortes*, 6 May 1992; see *El País*, 7 May 1992 and also in Martin, R., *Picasso's War* (London: Dutton, 2002), p. 246.

330 **a beautiful moment** Interview with author.

330 **I don't want to** *El País*, 21 June 1997.

331 **In the summer** *El País*, 10 July 1997.

331 **sheer madness** *El País*, 26 June 1997.

331 **abuse of power** ibid.

Bibliography

PICASSO

Ashton, D. *Picasso on Art* (London: Thames and Hudson, 1972)
Berger, J. *The Success and Failure of Picasso* (London: Penguin, 1966)
Blunt, A. *Picasso: The Formative Years* (with Phoebe Pool) (London: Studio Books, 1962)
Bonet Correa, A. *Picasso 1881–1981* (Madrid: Taurus, 1981)
Brassaï. *Conversations with Picasso* (Chicago: University of Chicago Press, 1999)
Brown, J. *Picasso and the Spanish Tradition* (New Haven: Yale University Press, 1996)
Caws, M. A. *Picasso's Weeping Woman* (Boston: Little, Brown and Co., 2000)
Cowling, E. *Picasso: Style and Meaning* (London: Phaidon, 2002)
Cowling, E. *Interpreting Matisse Picasso* (London: Tate Publishing, 2002)
Daix, P. and Israel, A. *Pablo Picasso–Dossiers de la Préfecture de Police 1901–1940* (Paris: Editions des Catalogues Raisonnés, 2003)
Fitzgerald, M. *Making Modernism: Picasso and the creation of the market for 20th century art* (Berkeley: University of California Press, 1996)
Gasman, L. *Mystery, Magic and Love in Picasso* (Ann Arbor: University Microfilms, 1981)
Gedo, M. M. *Picasso: Art as Autobiography* (Chicago: University of Chicago Press, 1980)
Gilot, F. *Life with Picasso* (London: Virago, 1990)
Golding, J. *Cubism* (London: Faber and Faber, 1998)
Gomez de la Serna, R. *Ismos* (Madrid: Biblioteca Nueva, 1931)
Hilton, T. *Picasso* (London: Thames and Hudson, 1985)
Lord, J. *Picasso and Dora* (New York: Farrar Straus Giroux, 1993)
McCully, M. A. *Picasso Anthology* (London: Thames and Hudson, 1981)
O'Brien, P. *Picasso* (London: Collins, 1976)
d'Ors, E. *Pablo Picasso* (Barcelona: El Acantilado, 2001)
Olivier, F. *Loving Picasso* (New York: Harry N. Abrams, 2001)
Penrose, R. *Picasso: His Life and Work* (London: Granada, 1981)
Picasso, M. *Picasso: My Grandfather* (London: Chatto & Windus, 2001)
Richardson, J. *A Life of Picasso*, 2 vols (London: Jonathan Cape, 1991 and 1996)
Richardson, J. *The Sorcerer's Apprentice* (London: Jonathan Cape, 1999)
Sabartés, J. *Picasso, Portraits and Souvenirs* (Paris: Louis Carre, 1946)
Stein, G. *Picasso* (Boston: Beacon Press, 1938)
Utley, G. R. *Picasso: The Communist Years* (New Haven: Yale University Press, 2000)

EXHIBITION CATALOGUES

El Siglo de Picasso (Madrid: Centro de Arte Reina Sofía, 1987)
De Picasso a Bacon (Segovia: Museo Esteban Vicente, 1999)
Matisse Picasso (London: Tate Gallery, 2003)
On Classic Ground (London: Tate Gallery, 1990)
Pablo Picasso (New York: Museum of Modern Art, 1980)
Picasso Alberti – La Última Tertulia (Valencia: IVAM, 2002)
Picasso and the War Years, ed. Stephen Nash (San Francisco: Fine Arts Museum, 1998)
Picasso en Las Colecciones Españoles (Segovia: Museo Esteban Vicente, 2000)
Picasso: Sculptor Painter (London: Tate Gallery, 1994)

GUERNICA

Arnheim, R. *The Genesis of a Painting: Picasso's Guernica* (Berkeley: University of California Press, 1962)
Blunt, A. *Guernica* (London: Oxford University Press, 1969)
Calvo Serraller, F. *El Guernica* (Madrid: T F Editores, 1999)
Chipp, H. B. *Picasso's Guernica* (London: Thames and Hudson, 1989)
Doumanian Tankard, A. *Picasso's Guernica after Rubens's Horrors of War* (Philadelphia: The Art Alliance Press, 1984)
Larrea, J. *Guernica* (New York: Curt Valentin, 1947)
Fernández Quintanilla, R. *Odisea del Guernica* (Barcelona: Planeta, 1981)
Fundación Marcelino Botín. *El Guernica y los Problemas Éticos y Técnicos de la Manipulación de Obras de Arte* (Santander: Botín, 2002)
Gervereau, L. *Autopsie d'un chef d'oeuvre* (Paris: Paris-Méditerranée, 1996)
Guernica-Legado (Madrid: Museo del Prado, 1981)
Haim, P. *La Novela de Gernika* (San Sebastian: Artola, 1999)
Martin, R. *Picasso's War* (New York: Dutton, 2002)
Martín Martín, F. *El Pabellon Español* (Sevilla: Universidad de Sevilla, 1982)
Morgan-Witts, M. and Thomas, G. *The Day Guernica Died* (London: Hodder and Stoughton, 1976)
MNCARS *Estudio sobre el Estado de Conservación* (Madrid: Ministerio de Educación y Cultura, 1998)
Oppler, E. C. *Picasso's Guernica* (New York: Norton, 1988)
Palau Fabre, J. *El Guernica de Picasso* (Barcelona: Blume, 1979)
Puente, J. de la. *Guernica – The Making of a Painting* (Madrid: Silex, 1997)
Ramírez, J. A. *Guernica* (Madrid: Electa, 1999)
Rankin, N. *Telegram from Guernica* (London: Faber and Faber, 2003)
Russell, F. D. *Picasso's Guernica* (Montclair: Allanheld and Schram, 1980)
Rutledge, H. C. *The Guernica Bull* (Athens, Georgia: University of Georgia Press, 1989)
Southworth, H. *Guernica! Guernica! A Study of Journalism, Diplomacy, Propaganda and History* (Berkeley: University of California Press, 1977)

GENERAL

Adolf, S. *Spanje Achter de Schermen* (Amsterdam: Prometheus, 2001)
Alpert, M. *A New International History of the Spanish Civil War* (London: Macmillan, 1998)

Anfam, D. *Abstract Expressionism* (London: Thames and Hudson, 1990)
Ashton, D. *The New York School* (New York: Viking Press, 1972)
Balfour, S. *Dictatorship, Workers and the City* (Oxford: Clarendon-Press, 1989)
Barr, A. H. *Defining Modern Art* (New York: Harry N. Abrams, 1986)
Baxter, J. *Buñuel* (London: Fourth Estate, 1994)
Beevor, A. *The Spanish Civil War* (London: Cassell, 1999)
Beevor, A. and Cooper, A. *Paris: After the Liberation* (London: Penguin, 2004)
Bjelajac, D. *American Art – A Cultural History* (London: Laurence King, 2000)
Bond, B. *War and Society in Europe* (London: Fontana, 1984)
Bonet, J. M. *Diccionario de las Vanguardias* (Madrid: Alianza, 1999)
Bozal, V. *Pintura y Escultura Española del Siglo XX* (2 vols) (Madrid: Espasa Calpe, 1993)
Brihuega, J. *La Vanguardia y la República* (Madrid: Cátedra, 1982)
Burns Marañon, T. *Hispanomanía* (Barcelona: Plaza y Janés, 2000)
Calvo Serraller, F. *Del Futuro al Pasado: vanguardia y tradición en el arte española contemporáneo* (Madrid: Alianza, 1988)
Cambridge Companion to Modern Spanish Culture, ed. Gies, D. T. (Cambridge: Cambridge University Press, 1999)
Carr, R. *The Republic and the Civil War in Spain* (London: Macmillan, 1971)
Carter, M. *Anthony Blunt* (London: Macmillan, 2001)
Cirici Pellicer, A. *La Estética del Franquismo* (Barcelona: Gustavo Gili, 1977)
Cone, M. *Artists under Vichy* (Princeton: Princeton University Press, 1992)
Conn, S. *Museums and American Intellectual Life 1876–1926* (Chicago: University of Chicago Press, 1998)
Crow, T. *Modern Art in the Common Culture* (New Haven: Yale University Press, 1996)
Crusells, M. *La Guerra Civil Española: cine y propaganda* (Barcelona: Ariel, 2000)
Danto, A. *The State of the Art* (New York: Prentice Hall Press, 1987)
Doezama, M. and Milroy, E. *Reading American Art* (New Haven: Yale University Press, 1998)
Etherington-Smith, M. *Dalí* (London: Sinclair-Stevenson, 1992)
Evans, M. *The Painter's Object* (London: Curwen Press, 1937)
Feinstein, A. *Pablo Neruda* (London: Bloomsbury, 2004)
Fontana, J. *España Bajo el Franquismo* (Barcelona: Crítica, 2001)
Freedberg, C. B. *The Spanish Pavilion* (New York: Garland Press, 1986)
Fusi, J. P. *El País Vasco: Pluralismo y nacionalidad* (Madrid: Alianza, 1984)
García Delgado, J. L., with essays by Juan Pablo Fusi, Santos Juliá, Stanley G. Payne. *Franquismo – El Juicio de la Historia* (Madrid: Temas de Hoy, 2000)
Gibson, I. *Federico García Lorca* (London: Faber and Faber, 1989)
Gibson, I. *The Shameful life of Salvador Dalí* (London: Faber and Faber, 1997)
Giménez Caballero, E. *El Arte y el Estado* (Madrid: Gráficas Universal, 1935)
Golan, R. *Modernity and Nostalgia* (New Haven: Yale University Press, 1995)
González Egido, L. *Miguel de Unamuno* (Valladolid: Junta de Castilla y León, 1997)
Gracia García, J. and Ruiz Carnicer, M. A. *La España de Franco – Cultura y vida cotidiana* (Madrid: Sintesis, 2001)
Green, C. *Cubism and Its Enemies* (New Haven: Yale University Press, 1987)
Greenberg, C. *Art and Culture* (Boston: Beacon Press, 1961)
Guilbaut, S. *How New York Stole the Idea of Modern Art* (Chicago: University of Chicago Press, 1983)
Herbert, J. D. *Paris 1937: Worlds on Exhibition* (Ithaca, New York: Cornell University Press, 1998)
Hererra, H. *Arshile Gorky* (London: Bloomsbury, 2003)

Hooper, J. *The New Spaniards* (London: Penguin, 1987)

Hoving, T. *Making the Mummies Dance* (New York: Simon and Schuster, 1993)

Howe, I. *A Margin of Hope* (New York: Harcourt Brace Jovanovich, 1982)

Howson, G. *Arms for Spain* (New York: St Martin's Press, 1999)

Jackson, G. *The Spanish Republic and the Civil War* (Princeton: Princeton University Press, 1965)

Jardí, E. *Eugenio d'Ors* (Barcelona: Ayma, 1967)

Jauristi, J. *El Bucle Melancólico* (Madrid: Espasa Calpe, 1997)

Johnson, P. *Modern Times* (London: Weidenfeld & Nicolson, 1983)

Jordan, B. *Writing and Politics in Franco's Spain* (London: Routledge, 1990)

Kazin, A. *New York Jew* (New York: Alfred A. Knopf, 1978)

Koestler, A. *Spanish Testament* (London: Gollancz, 1937)

Krauss, R. *The Originality of the Avant-Garde and Other Modernist Myths* (Cambridge, Ma.: MIT Press, 1994)

Kurlansky, M. *The Basque History of the World* (London: Vintage, 2000)

Kuspit, D. *The Cult of the Avant-Garde Artist* (Cambridge: Cambridge University Press, 1993)

Legarreta, D. *The Guernica Generation* (Reno: University of Nevada Press, 1984)

Leja, M. *Jackson Pollock* in *Reading American Art* (New Haven: Yale University Press, 1998)

Lindqvist, S. *A History of Bombing* (London: Granta Books, 2001)

Llorente, A. *Arte e Ideologia en el Franquismo* (Madrid: Visor, 1995)

Low, R. *La Pasionaria – The Spanish Firebrand* (London: Hutchinson, 1992)

Ludington, T. *Marsden Hartley* (Boston: Little, Brown & Co., 1992)

Manguel, A. *Reading Pictures* (New York: Random House, 2000)

Martín Casas, J. and Carvajal Urquijo, J. *El Exilio Español* (Barcelona: Planeta, 2002)

Matossian, N. *Black Angel – A Life of Arshile Gorky* (London: Pimlico, 2001)

McCullagh, F. *In Franco's Spain* (London: Burns Oates, 1937)

Miller, C. *American Iconology* (New Haven: Yale University Press, 1993)

Moffitt, J. F. *The Arts in Spain* (London: Thames and Hudson, 1999)

Monleón, B. *Del Franquismo a la Postmodernidad* (Madrid: Akal, 1995)

Moradiellos, E. *La España de Franco – Politica y Sociedad* (Madrid: Sintesis, 2000)

Moreno Galván, J. M. *Introducción a la Pintura Española Actual* (Madrid: Publicaciones Españoles, 1960)

Naifeh, S. and White Smith, G. *Jackson Pollock – An American Saga* (London: Pimlico, 1992)

Ortega y Gasset, J. *La Deshumanizacion del arte* (Madrid: Espasa Calpe, 1987)

Orwell, G. *Collected Essays* (London: Secker and Warburg, 1975)

Paxton, R. *Vichy France: Old Guard and New Order* (New York: Alfred A. Knopf, 1972)

Payne, S. G. *Basque Nationalism* (Reno: University of Nevada Press, 1975)

Peer, S. *France on Display* (Albany, New York: State University of New York Press, 1998)

Pérez Sánchez, A. *La Pintura Española*, 2 vols (Madrid: Electa, 1995)

Podhoretz, N. *Making It* (New York: Random House, 1967)

Polcari, S. *Abstract Expressionism and the Modern Experience* (Cambridge: Cambridge University Press, 1991)

Powell, C. *España en Democracia, 1975–2000* (Barcelona: Plaza y Janés, 2001)

Preston, P. *Comrades* (London: HarperCollins, 1999)

Preston, P. *Franco* (London: Fontana Press, 1993)

Preston, P. *The Spanish Civil War* (London: Weidenfeld & Nicolson, 1986)

Reuben Holo, S. *Beyond the Prado* (Liverpool: Liverpool University Press, 1999)

Ridruejo, D. *Casi Unas Memorias* (Madrid: Planeta, 1976)

Rose, B. *American Art since 1900* (New York: Praeger, 1967)

Rosenberg, H. *Gorky: The Man, The Time, The Idea* (New York: Horizon Press, 1962)

Sandler, I. *The Triumph of American Painting* (New York: Harper & Row, 1970)

Silva, U. *Arte e Ideología del Fascismo* (Valencia: Fernando Torres, 1975)

Silver, K. *Esprit de Corps: The Art of the Parisian Avant-Garde* (Princeton: Princeton University Press, 1989)

Steer, G. *The Tree of Gernika* (London: Hodder and Stoughton, 1938)

Stewart-Murray, K., Duchess of Atholl. *Searchlight on Spain* (London: Penguin, 1938)

Stonor Saunders, F. *Who Paid the Piper?* (London: Granta Books, 1999)

Talón, V. *Arde Guernica* (Madrid: San Martin, 1970)

Tellitu, A., Esteban, I. and González Carrera, J. A. *El Milagro Guggenheim* (Bilbao: Diario El Correo, 1997)

Thomas, H. *The Spanish Civil War* (London: Penguin, 1984)

Urbano, P. *Garzón* (Barcelona: Plaza y Janes, 2002)

Van Bruggen, C. *Frank O. Gehry Guggenheim Museum* (New York: Guggenheim Publications, 1998)

Van de Lemme, A. *Art Deco* (London: Appletree Press, 1992)

Weber, E. *The Hollow Years – France in the 1930s* (London: Sinclair Stevenson, 1995)

Whelan, A. *Alfred Stieglitz, A Biography* (New York: Da Capo Press, 1997)

WPA Guide to New York City (New York: Federal Writers' Project, 1939)

Yglesias, J. *The Franco Years* (Indianapolis: Bobbs-Merrill, 1977)

EXHIBITION CATALOGUES

AIA – The Story of the Artists' International Association (Oxford: MOMA, 1983)

American Art in the 20th Century (London: Royal Academy, 1993)

Art and Power (London: Hayward Gallery, 1995)

Dada and Surrealism Reviewed (London: Hayward Gallery, 1978)

Equipo Crónica (Valencia: IVAM, 1989)

Pabellón Español 1937 (Madrid: Centro de Arte Reina Sofía, 1987)

The Spanish Civil War (London: Imperial War Museum, 2001)

Picture Credits

Plate Section:

Weeping Woman Paris, October 1937 (oil on canvas, 60 × 49 cm). *Tate Gallery, London / DACS*

Guernica, 1937 (oil on canvas, 349.3 × 776.6 cm). *Museo Nacional Centro de Arte Reina Sofía / DACS*

Night Fishing at Antibes, August 1939 (oil on canvas, 205.7 × 345.4 cm). *MOMA, New York / Scala*

Pictures integrated into text:

Page

x Picasso painting *Guernica*, 1937, (Photo by Dora Maar). *Museo Nacional Centro de Arte Reina Sofía / ADAGB*

9 Maquette for the cover of *Minotaure*, May 1933 (collage of pencil on paper, corrugated cardboard, silver foil, ribbon, wallpaper painted with gold paint and gouache, paper doily, burnt linen leaves, tacks, and charcoal on wood 48.5 × 41 cm). *MOMA, New York / DACS*

16 *Minotauromachy*, Spring 1935 (etching and scraper 49.5 × 69.7 cm). *Museo Nacional Centro de Arte Reina Sofía / DACS*

22 *Composition with Minotaur* (Curtain for Le 14 Juillet of Romain Rolland India ink with gouache, 44 × 54.5 cm). *RMN / DACS*

28 *Songe et Mensonge de Franco, I* (Dream and Lie of Franco I), 8 January 1937 (etching and aquatint 31.4 × 42.1 cm) *Museo Nacional Centro de Arte Reina Sofía / DACS*

29 *Songe et Mensonge de Franco, II* (Dream and Lie of Franco II), 8–9 January, June 7 1937 *(etching and aquatint 31.4 × 42.1 cm). Museo Nacional Centro de Arte Reina Sofía / DACS*

31 An early design for the Spanish Pavilion mural – *Painter and Model*, 19 April 1937 (pen and ink on paper 18 × 28 cm). *RMN / DACS*

33 *Asesinos* (Assassins) (Republican propaganda poster illustrating dead children from the Madrid bombing 1937). *Richard Bristow / Biblioteca del Pavelló de la República (Universitat de Barcelona)*

34 *Acusamos* (We accuse the Fascist assassins – republican propaganda poster

1937). *Richard Bristow / Biblioteca del Pavelló de la República (Universitat de Barcelona)*

35 Gernika before the bombing. *Gernikazarra Historia Taldea*

37 Gernika – a devastated city, May 1937. *Gernikazarra Historia Taldea*

38 Gernika in flames. *Gernikazarra Historia Taldea*

39 Peasants escaping from Gernika, 27 April 1937. *Gernikazarra Historia Taldea*

40 A bombed car in the boulevard San Juan. *Gernikazarra Historia Taldea*

41 Women salvaging furniture from a girls' school. *Gernikazarra Historia Taldea*

46 First preparatory sketch for *Guernica*, 1 May 1937 (pencil on blue paper 21 × 27 cm). *Museo Nacional Centro de Arte Reina Sofía / DACS*

47 *Study no. 6*, 1 May 1937 (pencil on white paper 53.7 × 64.8 cm). *Museo Nacional Centro de Arte Reina Sofía / DACS*

48 *horse and Mother with Dead Child*, 8 May 1937 (pencil on paper 24.1 × 45.4 cm). *Museo Nacional Centro de Arte Reina Sofía / DACS*

49 *Composition Study*, 9 May 1937 (pencil on paper 24.1 × 45.4 cm). *Museo Nacional Centro de Arte Reina Sofía / DACS*

50 *Guernica*, state no.1 (photo by Dora Maar). *Museo Nacional Centro de Arte Reina Sofía / ADAGP*

51 *Guernica*, state no.4 (photo by Dora Maar). *Museo Nacional Centro de Arte Reina Sofía / ADAGP*

57 *Guernica*, in the Spanish Pavilion with Calder's *Mercury Fountain* in the foreground, 1937. *Frances Loeb Library, Harvard Design School / Foto Kollar*

60 Exterior of the Spanish Pavilion with Alberto's sculpture, *The Spanish people have a path that leads to a star*, 1937. *Frances Loeb Library, Harvard Desgin School / Foto Kollar*

62 A view of the Exposition Internationale looking towards the Palais de Chaillot. In foreground left the Soviet Pavilion and on the right the pavilion of Nazi Germany, obscuring its neighbour the Spanish Pavilion. *Foto Kollar*

64 Josep Lluís Sert in 1937. *Frances Loeb Library, Harvard Design School*

68 The vitrine display in homage to Federico García Lorca in the Spanish Pavilion, 1937, *Frances Loeb Library, Harvard Design School / Foto Kollar*

73 Interior of the Spanish Pavilion looking towards *Guernica* from the stage. On the left the tables of Rementaria's café-restaurant. *Frances Loeb Library, Harvard Design School / Foto Kollar*

75 *Para Salvar el arte de Espana Hay que aplaster el Fascismo* (To save art in Spain the Fascists must be crushed) (Republican propaganda poster, 1937). *Richard Bristow / Biblioteca del Pavelló de la República (Universitat de Barcelona)*

88 Programme for the New Burlington Gallery exhibition 1938, front. *Xavier Bray*

89 New Burlington Gallery programme, back. *Xavier Bray*

94 Opening of the Whitechapel Art Gallery *Guernica* exhibition, 1938, with Major Attlee, centre, and Roland Penrose on the right. *Whitechapel Art Gallery, London*

117 Alfred H. Barr in MOMA, New York, c.1930. *Scala*

127 Picasso and Dora Maar on the beach, Mougins, 1937. *Photo by Roland Penrose / courtesy Roland Penrose estate*

128 Picnic at Mougins, 1937; from left to right Nusch Eluard, Paul Eluard, Roland Penrose, Man Ray and Ady. *Photo by Lee Miller / courtesy Lee Miller archive*

129 'Déjeuner sur l'herbe', Mougins, 1937. From left to right: Nusch Eluard, Paul Eluard, Lee Miller, unknown, Man Ray and Ady. *Photo by Roland Penrose / courtesy Roland Penrose estate*

131 Picasso and Sabartés, Villa La Californie Cannes, 1956. *Photo by Lee Miller / courtesy Lee Miller archive*

149 Picasso and Lee Miller at rue des Grands-Augustins, 1944, with plaster of *Man*

with a Sheep in background. *Photo by Lee Miller / courtesy Lee Miller archive*

159 Arshile Gorky, *Study for 'They Will Take My Island'*, 1944 (pencil and wax on paper 56 × 76.2 cm). *Courtesy Brooklyn Museum, Brooklyn / DACS*

161 Adolph Gottlieb: *Black Silhouette*, 1949 (oil and enamel on canvas 69.85 × 54.45 cm). *Adolph and Esther Gottlieb Foundation / DACS*

162 William Baziotes, *Untitled*, 1939 (watercolour and graphite on paper 26.4 × 19.8 cm). *Estate of William Baziotes / DACS*

164 Willem de Kooning, *Attic*, 1949 (oil, enamel, and newspaper transfer on canvas 157.2 × 205.7 cm). *Metropolitan Museum of Art / DACS*

165 Robert Motherwell, *At Five in the Afternoon*, 1949 (casein on composition board 33 × 44 cm). *Dedalus Foundation / DACS*

168 David Smith, *Medals for Dishonour: Propaganda for War*, 1939–40 (bronze 23.8 × 28.9 × 2.24 cm). *Estate of David Smith / DACS*

172 Jackson Pollock, *untitled*, CR 521 (pencil on paper 35.5 × 27.9 cm). *DACS*

172 Jackson Pollock: *untitled*, CR 531 (pencil on paper 35.5 × 27.9 cm). *DACS*

175 Jackson Pollock: *Mural*, 1943. *American Art Archive: Herbert Matter papers*

176 *Guernica* in MOMA, 1947. *Courtesy MOMA*

204 *Massacre in Korea*, 18 January 1951 (oil on plywood 109.5 × 209.5 cm). *RMN / DACS*

250 Antonio Saura, *El Gran Muchedumbre*, 1963 (oil on canvas 220 × 515 cm). *Museo Nacional Centro de Arte Reina Sofía / DACS*

259 Equipo Cronica, *La Visita*, 1969 (acrylic on canvas 120 × 120 cm). *DACS*

260 Equipo Cronica, *El Banquete*, 1969 (acrylic on canvas 122 × 122 cm). *DACS*

261 Equipo Cronica, *El Intruso*, 1969 (acrylic on canvas 140 × 200 cm). *DACS*

269 *Blind Minotaur Guided by a Little Girl in the Night*, Paris November 1934 (aquatint, drypoint and scraper 24.6 × 34.6 cm). *Museo Nacional Centro de Arte Reina Sofía / DACS*

304 *Guernica* arrives in Spain, 1981. *El País*

305 *Guernica*, its final unrolling, 1981. *El País*

307 *Guernica* guarded in the Casón del Buen Retiro, 1980s. *World Wide Photo*

323 *Guernica* enters the Reina Sofía. *El País*

Index

A NOTE ON THE AUTHOR

Gijs van Hensbergen lectures on architecture and is the author of *Art Deco* (1986), *In the Kitchens of Castile* (1992, re-issued 2002) and the acclaimed biography *Gaudi* (2001).